ULTIMATE KITCHEN DESIGN

teNeues

ULTIMATE KITCHEN DESIGN

Editor in chief: Paco Asensio

Project coordination and texts: Alejandro Bahamón

Art director: Mireia Casanovas

Layout: Nil Solà

Copy editing: Cristina Doncel

English translation: Jane Wintle

German translation: Martin Fischer

French translation: Marion Westerhoff

Italian translation: Maurizio Siliato

Produced by Loft Publications
www.loftpublications.com

Published by teNeues Publishing Group

teNeues Publishing Company
16 West 22nd Street, New York, NY 10010, USA
Tel.: 001-212-627-9090, Fax: 001-212-627-9511

teNeues Book Division
Kaistraße 18, 40221 Düsseldorf, Germany
Tel.: 0049-(0)211-99 45 97-0, Fax: 0049-(0)211-99 45 97-40

teNeues Publishing UK Ltd.
P.O. Box 402, West Byfleet, KT14 7ZF, Great Britain
Tel.: 0044-1932-403509, Fax: 0044-1932-403514

teNeues France S.A.R.L.
4, rue de Valence, 75005 Paris, France
Tel.: 0033-1-55 76 62 05, Fax: 0033-1-55 76 64 19

teNeues Iberica S.L.
Pso. Juan de la Encina 2-48, Urb. Club de Campo
28700 S.S.R.R., Madrid, Spain
Tel./Fax: 0034-916 595 876

www.teneues.com
© 2006 teNeues Verlag GmbH + Co. KG, Kempen

ISBN-10: 3-8327-9056-X
ISBN-13: 978-3-8327-9056-1

Editorial project: 2006 LOFT Publications
Via Laietana 32, 4º Of. 92
08003 Barcelona, Spain
Tel.: +34 932 688 088
Fax: +34 932 687 073

e-mail: loft@loftpublications.com
www.loftpublications.com

Printed by: Anman Gràfiques del Vallès, Spain
www.anman.com
anman@anman.com
2005

Bibliographic information published by
Die Deutsche Bibliothek.
Die Deutsche Bibliothek lists this publication
in the Deutsche Nationalbibliografie;
detailed bibliographic data is available
in the Internet at http://dnb.ddb.de

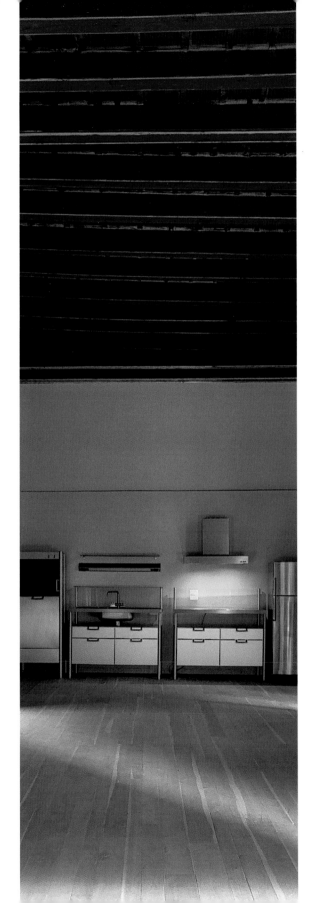

CONTENTS

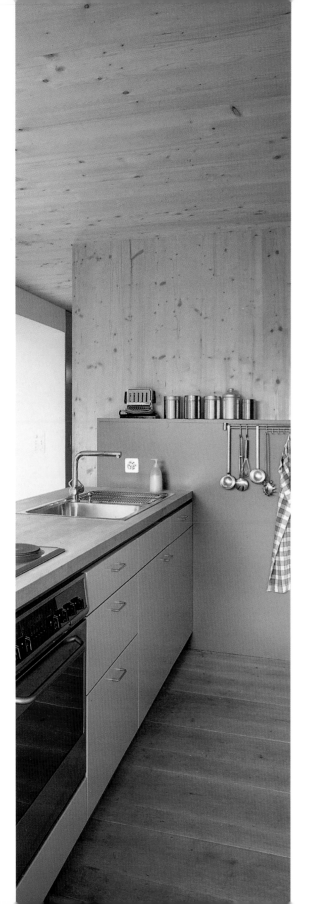

INHALT

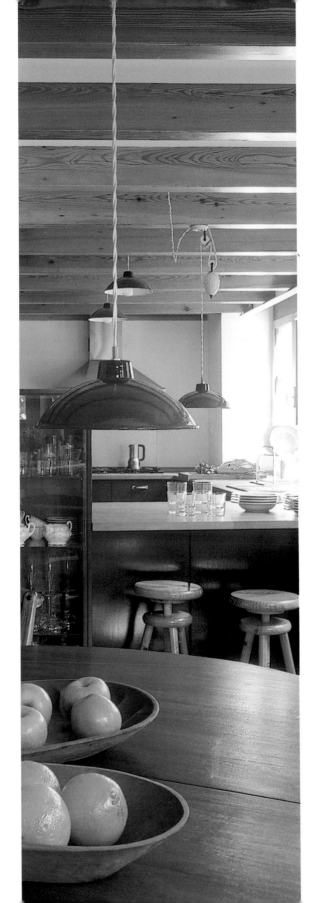

INDEX

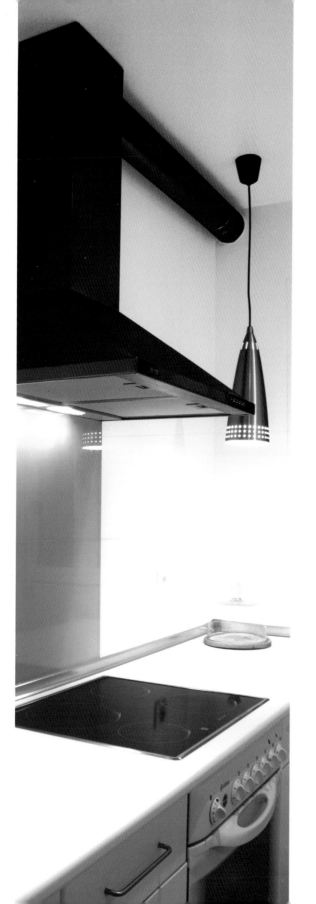

ÍNDICE

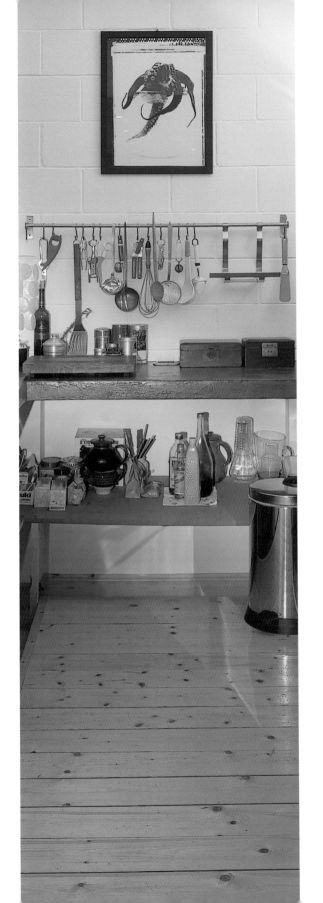

INDICE

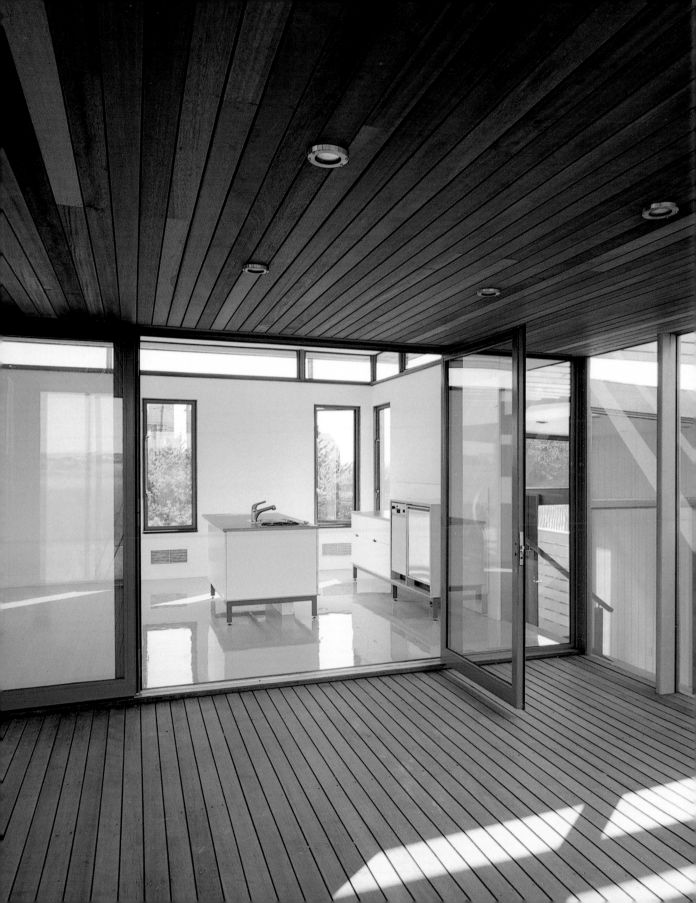

INTRODUCTION

It is undoubtedly in the kitchen where new technologies and styles have most noticeably brought changes to our homes.

Until just a few decades ago, this was a space set apart in the house and occupied by servants, but today the kitchen has become an important social hub, a meeting point in the home, which has caused it to evolve rapidly and to come to the fore.

Those isolated, poorly lit, ill-ventilated areas, looked upon solely as food-processing workshops, have flourished into spaces full of light, perfectly integrated in the layout of the house and enjoying the same functional and aesthetic principles applied to the whole building.

All the latest technologies have a stake in the kitchen: materials that withstand extreme temperatures, for example, or domestic appliances that are more efficient in terms of size, functionality and energy consumption. Thanks to these developments, is it now feasible to build a complete kitchen in a small fitted cabinet which can be closed off from view when convenient.

This book sets out to show an extensive variety of kitchens grouped into five chapters according to their style and function: modern, country-style, minimalist, small and industrial kitchens. It is intended as a source of inspiration, for designers and owners alike, in the unlimited task of creating the heart of the contemporary home.

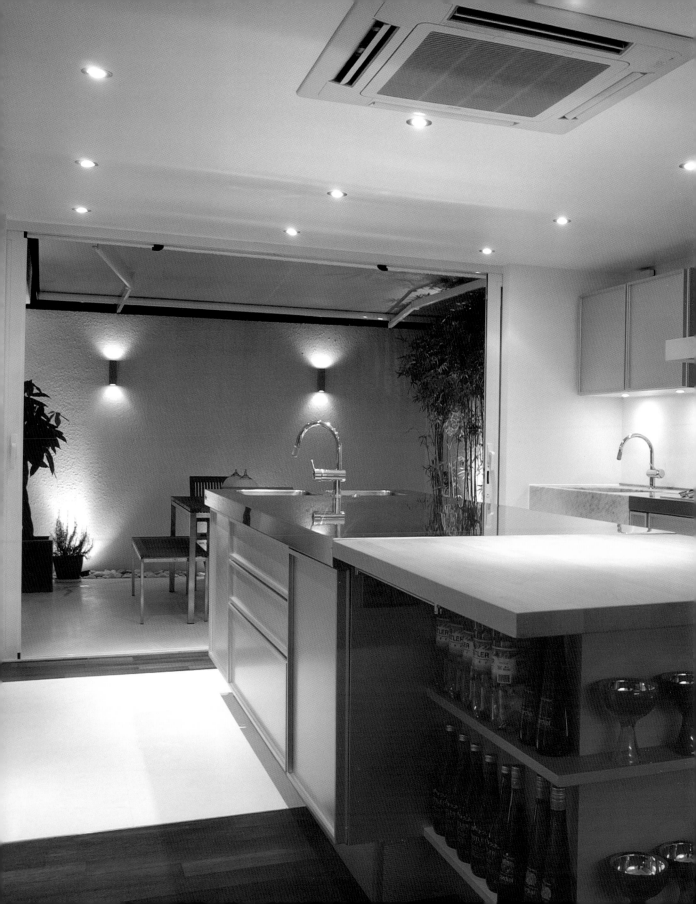

EINLEITUNG

Die Küche ist zweifellos der Ort, an dem sich Veränderungen durch technischen Fortschritt und neue Stilrichtungen am ausgeprägtesten zeigen.

Es ist nur wenige Jahrzehnte her, da war sie ein abgesonderter Raum innerhalb des Hauses, der vornehmlich den Dienstboten vorbehalten war. Heute jedoch ist die Küche zum wichtigsten Treffpunkt innerhalb des privaten Wohnbereiches geworden, der eine rasante Entwicklung durchgemacht und sich in den Vordergrund geschoben hat.

Früher waren Küchen oft abgelegene, schlecht beleuchtete und belüftete Räume, die nur der Zubereitung von Mahlzeiten dienten. Heute dagegen sind sie hell, in die anderen Wohnbereiche eingegliedert und nach den gleichen funktionalen und ästhetischen Prinzipien ausgerichtet, wie alle anderen Räume eines modernen Hauses.

In der Küche trifft man auf die neuesten Errungenschaften: gegen Temperaturschwankungen resistente Materialien und immer kleinere und dennoch funktionale Hausgeräte mit besserer Energieausnutzung. Es ist heute möglich, eine komplette Küchenausstattung in einem Wandschrank unterzubringen, der den Blick auf die Küche verhindert, wenn es gewünscht wird.

In dem vorliegenden Buch wird eine breitgefächerte Auswahl von Küchen vorgestellt. Die fünf Kapitel unterscheiden Stile und funktionale Merkmale: moderne, ländliche, minimalistische, kleine und industrielle Küchen. Das Buch versteht sich als Anregung für Designer und Hausbesitzer: Wie kann man den Raum gestalten, der schon längst zum Herzstück des zeitgenössischen Wohnraumes geworden ist?

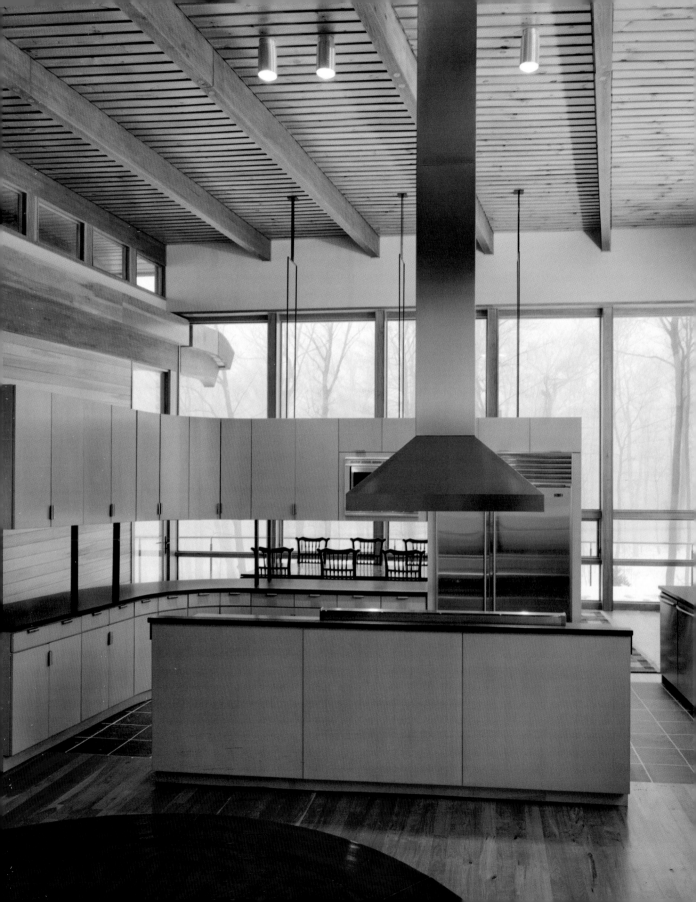

INTRODUCTION

La cuisine est, sans doute, la pièce de la maison qui reflète le plus clairement l'évolution, les progrès technologiques et les styles relatifs à l'habitation.

En effet, il n'y a encore que quelques décennies, la cuisine était un espace réservé exclusivement aux domestiques. Aujourd'hui, il est devenu le lieu de rencontre et d'accueil le plus important de la maison. Cette différence est ce qui a le plus influencé son évolution et son emplacement.

La cuisine d'antan, une pièce isolée, mal éclairée et très mal ventilée, conçue exclusivement comme un laboratoire de fabrication d'aliments, s'est métamorphosée en un lieu lumineux, intégré aux autres pièces du foyer et soumis aux mêmes critères fonctionnels et esthétiques que le reste de l'habitation.

La cuisine nous permet d'apprécier la dernière technologie de pointe : matières résistantes au froid et à la chaleur, appareils ménagers électriques de plus en plus puissants, fonctionnels et petits. Grâce à ces progrès, il est aujourd'hui possible de concevoir une cuisine complète dans une petite armoire encastrée, escamotable au gré des besoins.

Ce livre présente un large éventail de cuisines, réparties en cinq chapitres selon leur style et fonctionnalité : modernes, rustiques, minimalistes ou petites et industrielles. C'est une source d'inspiration où architectes d'intérieur et propriétaires pourront puiser différentes idées utiles à la configuration d'un espace devenu le cœur de la demeure contemporaine.

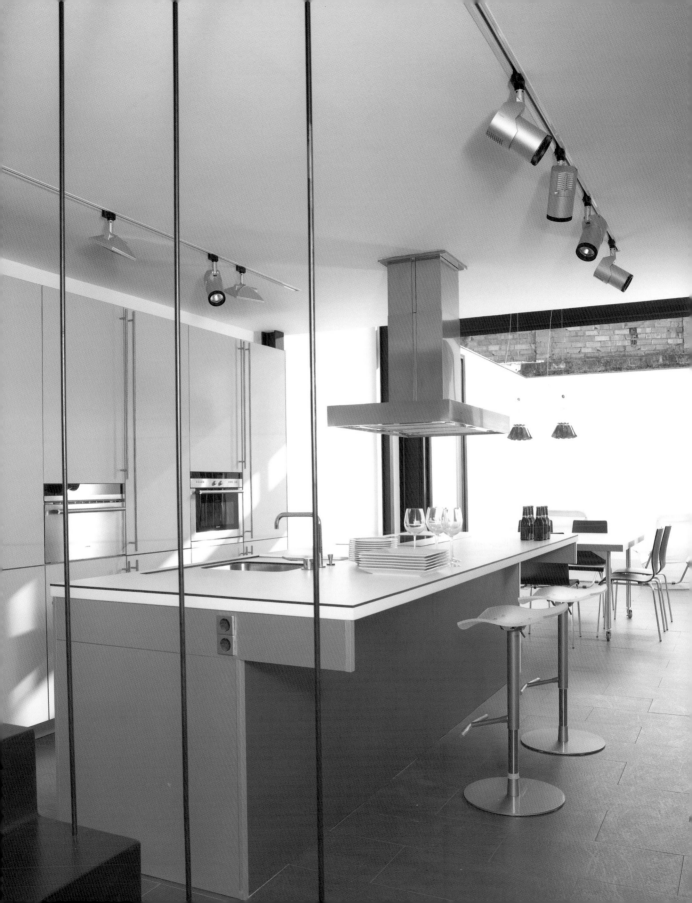

INTRODUCCIÓN

La cocina es, sin duda, la estancia de la casa donde se reflejan con mayor claridad la evolución, los avances tecnológicos y los estilos que afectan a la vivienda.

La cocina, hasta hace pocas décadas un espacio reservado exclusivamente a la servidumbre, se ha convertido hoy en día en el lugar de encuentro y socialización más importante de la vivienda, lo que ha influido notablemente en su evolución y ubicación.

Lo que antes era una estancia aislada, mal iluminada y peor ventilada, concebida como laboratorio de fabricación de alimentos, se ha convertido hoy en un lugar luminoso, integrado en el resto de las estancias del hogar y que sigue los mismos principios funcionales y estéticos que el resto de la vivienda.

En ella podemos apreciar la última tecnología: materiales resistentes al frío y al calor, electrodomésticos cada vez más potentes, prácticos y pequeños; gracias a estos avances, es posible diseñar una cocina completa en un pequeño armario empotrado que puede ocultarse según convenga.

Este libro presenta un amplio abanico de cocinas, repartidas en cinco capítulos según su estilo y funcionalidad: modernas, rústicas, minimalistas, pequeñas e industriales, y es una fuente de inspiración para diseñadores y propietarios sobre las diferentes maneras de configurar un espacio que se ha convertido en el corazón de la vivienda contemporánea.

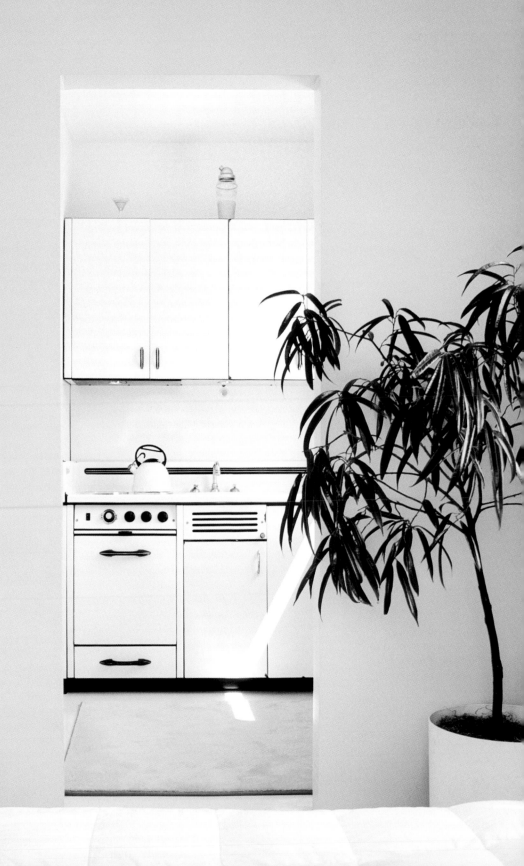

INTRODUZIONE

Senza alcun dubbio, la cucina è la stanza della casa che rispecchia con maggiore chiarezza l'evoluzione, i progressi tecnologici e gli stili che riguardano l'intera abitazione.

Il fatto che la cucina, uno spazio riservato fino a pochi decenni fa esclusivamente alla servitù, sia diventata oggi giorno il luogo di incontro e socializzazione più importante della casa è ciò che ha influito di più sulla sua evoluzione ed ubicazione.

Ciò che anticamente era una stanza isolata, con scarsa illuminazione e poca ventilazione, concepita esclusivamente come laboratorio per l'elaborazione degli alimenti, si è trasformato attualmente in un ambiente luminoso, integrato al resto delle stanze della casa e che segue gli stessi principi funzionali ed estetici di tutta l'abitazione.

In cucina trovano posto gli ultimi ritrovati tecnologici: materiali resistenti al freddo e al calore, elettrodomestici sempre più potenti, funzionali e di ridotte dimensioni; grazie a questi progressi, per esempio, è persino possibile disegnare una cucina completa, all'interno di un armadio a muro, che può essere occultata secondo le esigenze.

Questo libro presenta una vasta gamma di cucine, suddivise in cinque capitoli a seconda del loro stile e della loro funzionalità: moderne, rustiche, minimaliste, piccole e industriali. Il volume costituisce un'eccellente fonte di ispirazione per designer e proprietari sui diversi modi di configurare un ambiente che è ormai diventato il cuore delle abitazioni contemporanee.

Modern >>>>>>>>

The modern kitchen emerged with the industrial revolution, heavily influenced by the American lifestyle. New alternatives were being devised to gain the maximum return from housework, and the different functions present in the kitchen were combined into a single, efficient unit.

A feature common to all the various designs for these new kitchens is their vitality, airiness, user-friendliness and accessibility. Furniture design follows ergonomic principles in the quest for enhanced efficiency and comfort, and every advance in technology is immediately introduced in new domestic appliances.

The choice of functional elements makes these spaces, above all else, eminently practical, and their rational layout is based on different uses. Continuous worktops, instead of different surfaces for each use, allow a far better use of the available space and more comfortable workstations.

Modern kitchen design is open to an infinite range of finishes; from traditional ceramic tiles to the highly sophisticated carbon wafer panels used as thermal insulation. Classics such as wood or marble still find their way into the modern kitchen, but laminated materials, stainless steel or seamless postformed acrylic resin surfaces are preferred. The use of brilliant finishes, intense colors and sharp contrasts complement and highlight these materials' properties.

Kitchen unit layouts can be personalised, combining units to suit individual requirements, and use of the cabinet interiors can be optimised with metal wire storage structures. The most common kitchen layouts are linear, L or U shaped, or designs with an island in the centre.

The modern kitchen emerged with the industrial revolution, heavily influenced by the American lifestyle.

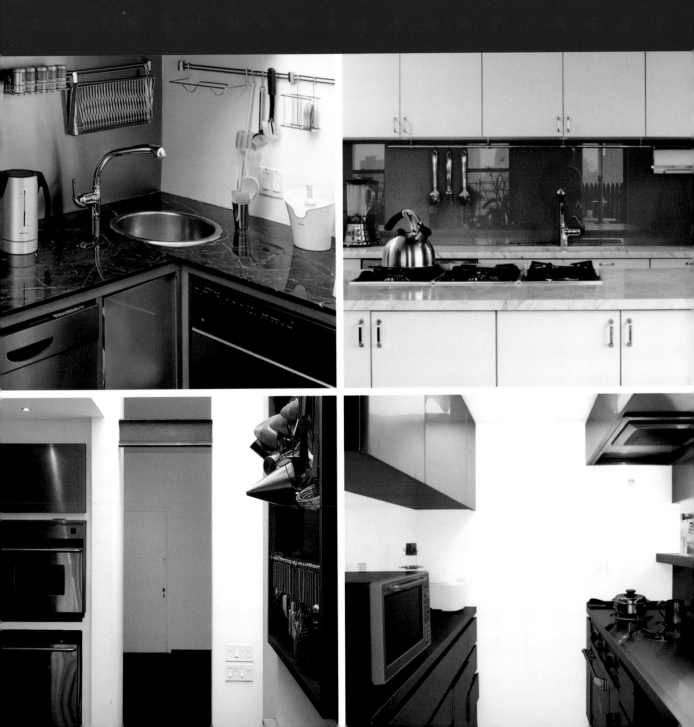

Modern

Die moderne Küche, stark beeinflusst vom amerikanischen Lebensstil, wurde während der industriellen Revolution entwickelt, vor allem im Zusammenhang mit der effizienteren Organisierung des Haushalts und der funktionalen Vereinheitlichung der Küche.

Den unterschiedlichen Gestaltungsmustern dieser Art von Küche sind einige Punkte gemeinsam: Dynamik, Leichtigkeit, Benutzerfreundlichkeit und Zugänglichkeit. Das Design der Möbel folgt ergonomischen Prinzipien, um eine bequeme und effektive Handhabung zu ermöglichen. So wird jede technische Errungenschaft sofort für elektrische Hausgeräte nutzbar gemacht.

Die Betonung der Funktionalität lässt diese Küchen zu praktisch eingerichteten Räumen mit gut durchdachten Nutzungsbereichen werden. Die möglichst durchgehend angelegten großzügigen Arbeitsflächen ermöglichen, im Gegensatz zu einem Modulsystem mit unterteilten Arbeitsbereichen, eine weitaus bessere Nutzung des vorhandenen Raums und erleichtern die Aufteilung der Arbeiten.

Bei der Gestaltung der Oberflächen in der modernen Küche kommen die verschiedensten Materialien zum Einsatz, von den traditionellen Keramikfliesen bis hin zu edlen Kohlefaserlaminaten, die als Wärmeisolierung dienen. Obwohl sich auch klassische Materialien wie Holz oder Marmor in der modernen Küche finden, werden Laminate, Edelstahl oder fugenlose Flächen aus Kunstharz immer mehr bevorzugt. Glanz, leuchtende Farben und Kontraste lassen die einzelnen Materialeigenschaften voll zu Geltung kommen.

Durch die Kombination der Module ist die individuelle Anordnung der Möbel problemlos möglich. Der Innenraum der Schränke kann durch Metallgitter optimal ausgenutzt werden. Die gebräuchlichsten Anordnungen der Küchenmöbel sind die einfache Reihung, die L- oder U-Form oder auch die Schaffung einer zentralen Kochinsel.

Both pages
Design by Resolution: 4 Architecture
Photo © Eduard Hueber

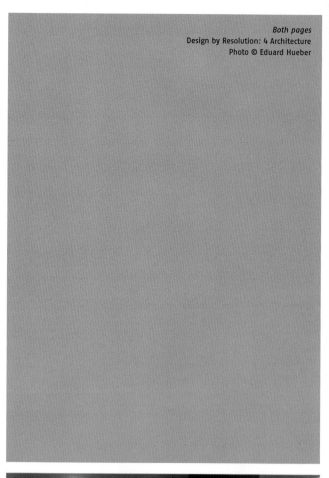

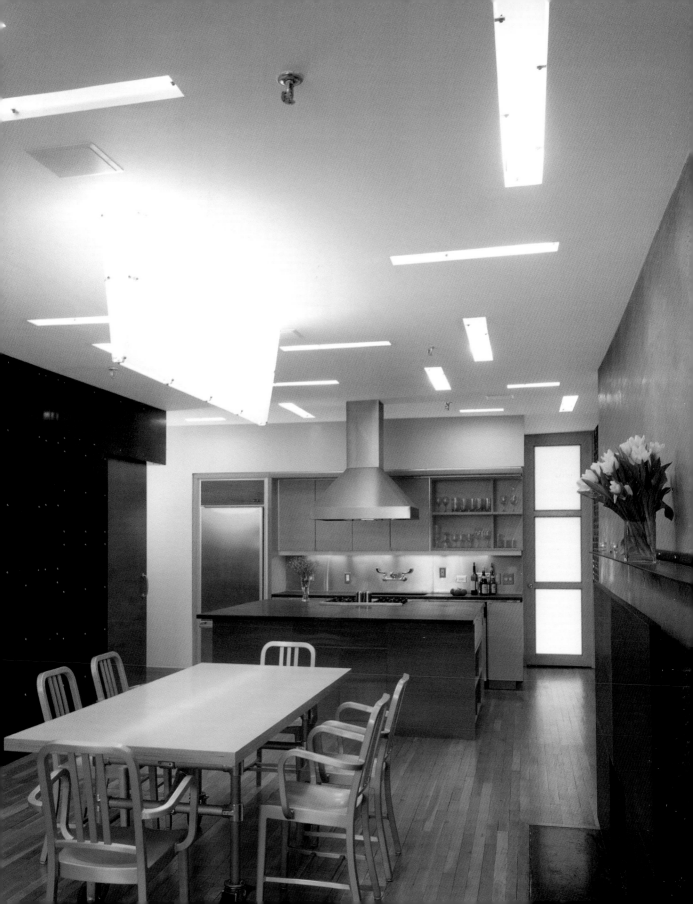

Modernes

La cuisine moderne, fortement influencée par le mode de vie américain, est née dans le sillage du processus d'industrialisation, entraînant la conception de diverses alternatives pour rentabiliser les tâches ménagères et intégrer les différentes fonctions de la cuisine à un ensemble unitaire efficace.

Les diverses conceptions de ce type de cuisine présentent des caractéristiques communes : dynamisme, légèreté, facilité d'utilisation et accessibilité. Le design du mobilier suit les normes ergonomiques pour une efficacité optimale et un maximum de confort, tout en essayant d'intégrer les appareils électroménagers à la pointe de la technologie.

Ces cuisines, dotées d'éléments fonctionnels, se convertissent en espaces pratiques dont la distribution rationnelle permet de différencier les usages. Les surfaces continues, à l'inverse du système de modules dont les surfaces varient au gré des activités, permettent de tirer parti de l'espace et de créer des plans de travail plus commodes.

Le design d'une cuisine moderne permet d'utiliser une grande variété de finitions, depuis les traditionnels éléments en céramique jusqu'aux plus sophistiquées en plaques de carbones, servant d'isolant thermique. Les matériaux classiques, à l'instar du bois ou du marbre sont encore employés dans ce type de cuisine, même si les laminés, l'acier inoxydable et les surfaces fluides comme les résines, jouent un rôle de plus en plus important. Les surfaces brillantes, les couleurs intenses et les contrastes complètent et rehaussent les propriétés des matériaux.

La disposition du mobilier peut être personnalisée en combinant les modules pour obtenir la distribution souhaitée. Il est aussi possible d'optimiser l'intérieur des armoires par le biais de structures métalliques. Les compositions de cuisine les plus communes sont la linéaire, la disposition en en L ou en fer à cheval, et, enfin celle dotée d'un îlot central.

Both pages
Design by Tutt Renovation
Photo © Pep Escoda

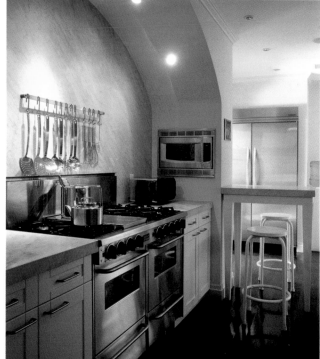

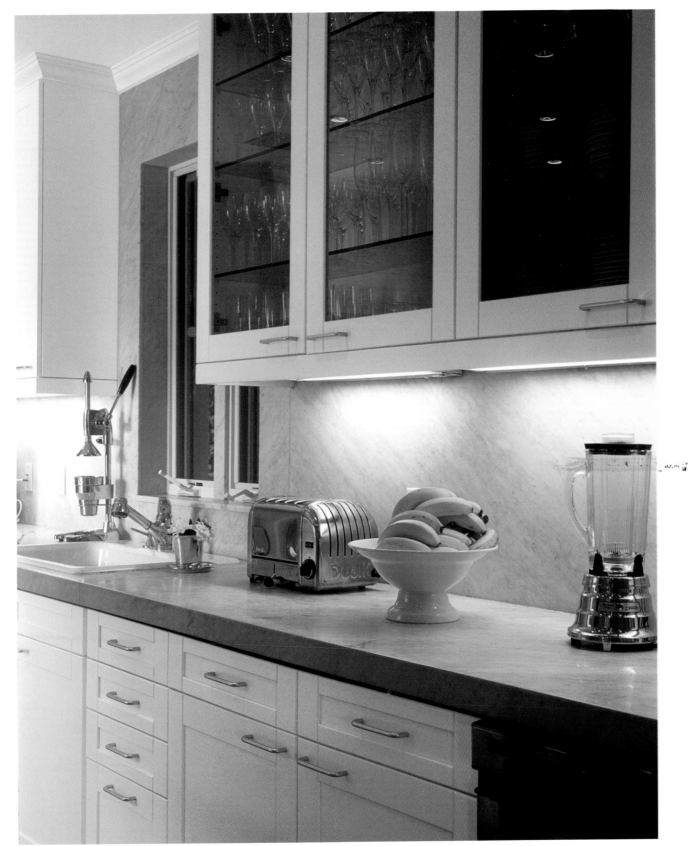

Modernas

La cocina moderna, fuertemente influida por el modelo de vida estadounidense, nace con los procesos de industrialización, cuando se comienza a pensar en diversas alternativas para rentabilizar las tareas del hogar y para integrar las diferentes funciones de la cocina en un conjunto eficiente y unitario.

Los diseños variados de este tipo de cocina presentan características comunes: dinamismo, ligereza, facilidad de uso y accesibilidad. En el diseño del mobiliario se siguen las normas de la ergonomía para obtener la mayor eficacia y el máximo confort, a la vez que se intenta incorporar la última tecnología en electrodomésticos.

En estas cocinas se apuesta por elementos funcionales que las convierten en espacios prácticos, cuya distribución racional se basa en la diferenciación de los usos. Las superficies continuas, al contrario de las que presentarían distintos módulos dedicados a cada actividad, permiten aprovechar el espacio y crear lugares de trabajo más cómodos.

En el diseño de una cocina moderna es posible emplear una amplia variedad de acabados, desde las tradicionales piezas cerámicas hasta las más sofisticadas con láminas de fibra de carbono, que sirven de aislante térmico. Materiales clásicos como la madera o el mármol siguen siendo parte de este tipo de cocinas, aunque adquieran un protagonismo cada vez mayor los laminados, el acero inoxidable y las superficies continuas como las resinas. El brillo, los colores intensos y los contrastes complementan y subrayan las propiedades de los materiales.

La disposición del mobiliario puede ser personalizada combinando los módulos hasta obtener la distribución deseada, y es posible optimizar el interior de los armarios mediante estructuras metálicas. Las configuraciones más comunes son la lineal, la disposición en forma de L o de U, y la que presenta una isla central.

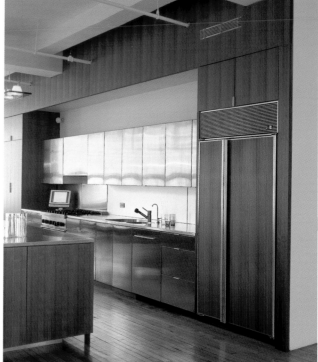

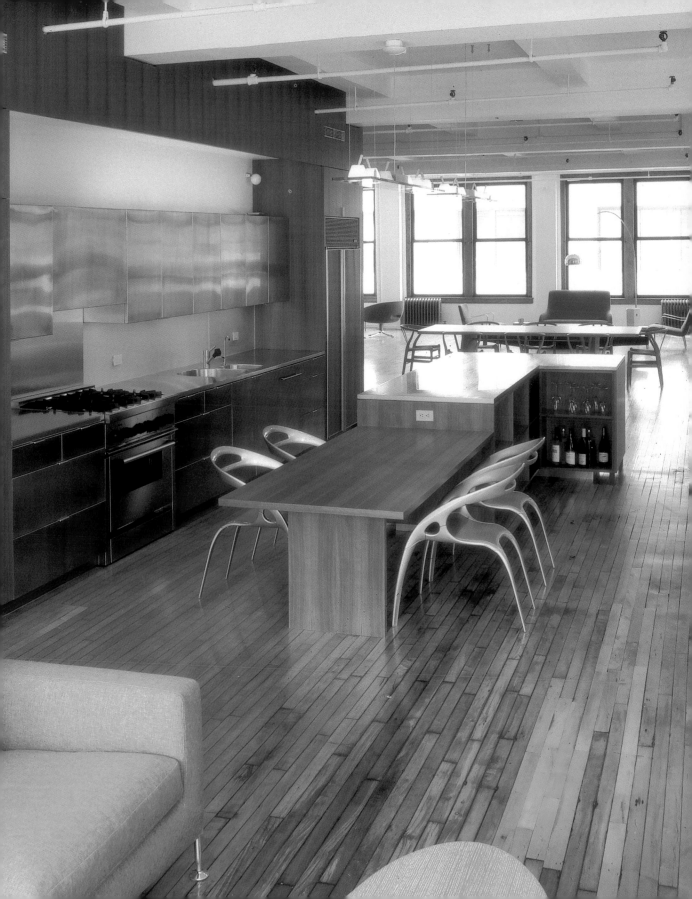

Moderne

La cucina moderna, fortemente influenzata dallo stile di vita americano, nasce con i processi di industrializzazione, quando si inizia a pensare a diverse alternative per rendere meno pesanti i lavori di casa ed integrare le varie funzioni della cucina in un unico ambiente dotato di efficienza e praticità.

I vari disegni di questo tipo di cucina presentano caratteristiche comuni: dinamismo, leggerezza, facilità d'uso ed accessibilità. Per il disegno dei mobili si seguono precise norme ergonomiche al fine di ottenere la maggior efficacia e comfort, e si cerca anche di utilizzare elettrodomestici dalla tecnologia più avanzata.

In queste cucine si punta su elementi funzionali che le trasformano in spazi pratici, la cui distribuzione razionale si basa sulla differenziazione degli usi a cui adibire le varie zone. Le superfici continue, contrariamente a quelle che presentano diversi moduli dedicati ad ogni attività, consentono di sfruttare meglio lo spazio e di creare piani di lavoro più comodi.

Per l'arredamento di una cucina moderna è possibile utilizzare una vasta varietà di finiture, da quelle tradizionali come la ceramica fino a quelle più sofisticate di lamine in fibra di carbonio, che servono anche come isolante termico. Materiali classici come il legno o il marmo continuano ad essere comunemente adoperati in questo tipo di cucine, sebbene stia prendendo sempre più piede l'uso del laminato, dell'acciaio inossidabile e le superfici continue come le resine. La lucentezza, i colori intensi e i contrasti completano e mettono in risalto le proprietà dei materiali.

La disposizione dei mobili può essere personalizzata combinando i vari moduli fino ad ottenere la distribuzione desiderata; inoltre, è possibile ottimizzare lo spazio interno degli armadi mediante apposite strutture metalliche. Le configurazioni più comuni sono quella lineare, la disposizione a L o ad U e quella che presenta un'isola centrale.

Both pages
Design by Cullen Feng
Photo © Murray Fredericks

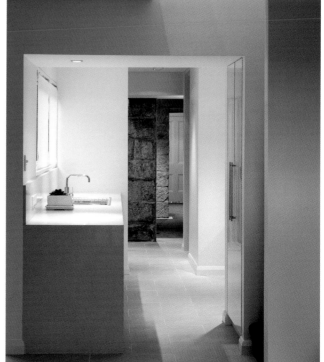

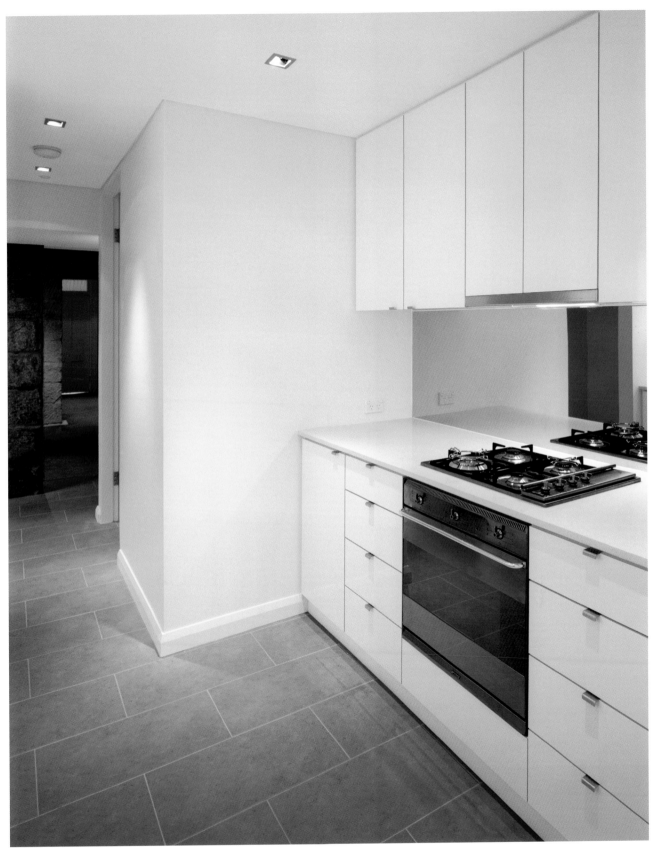

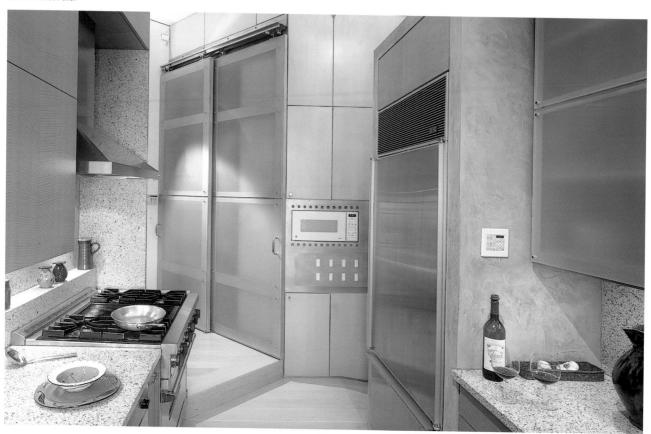

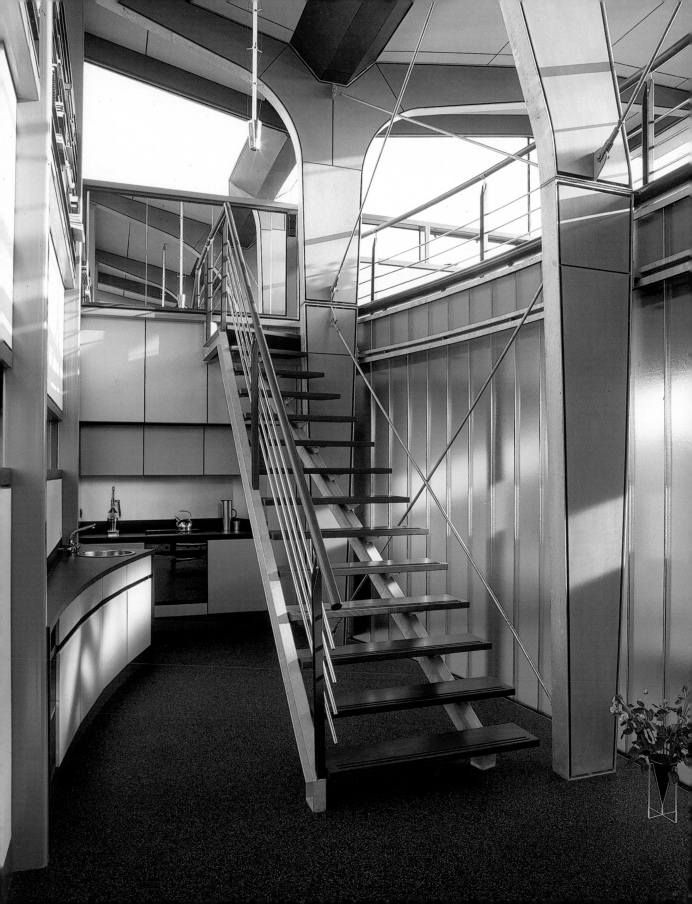

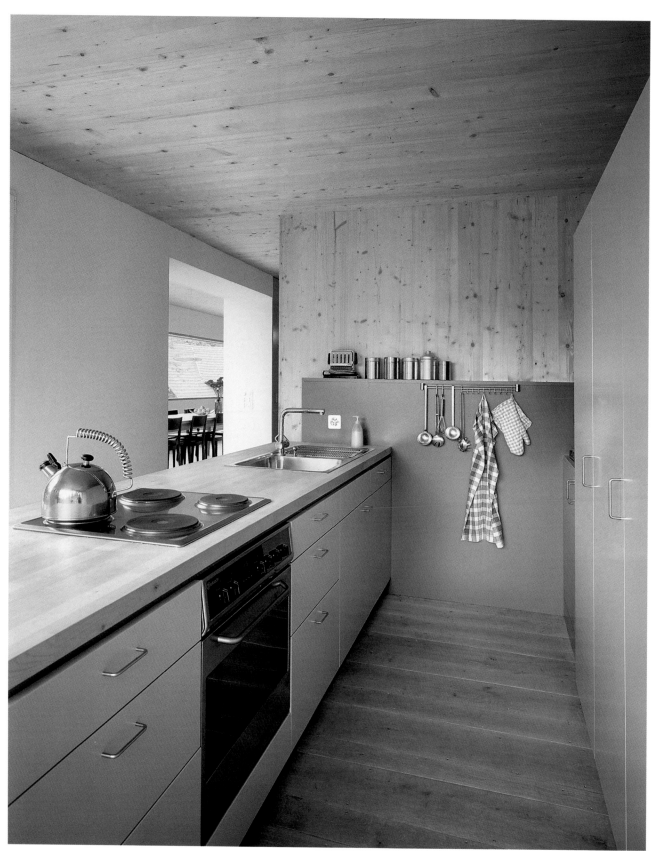

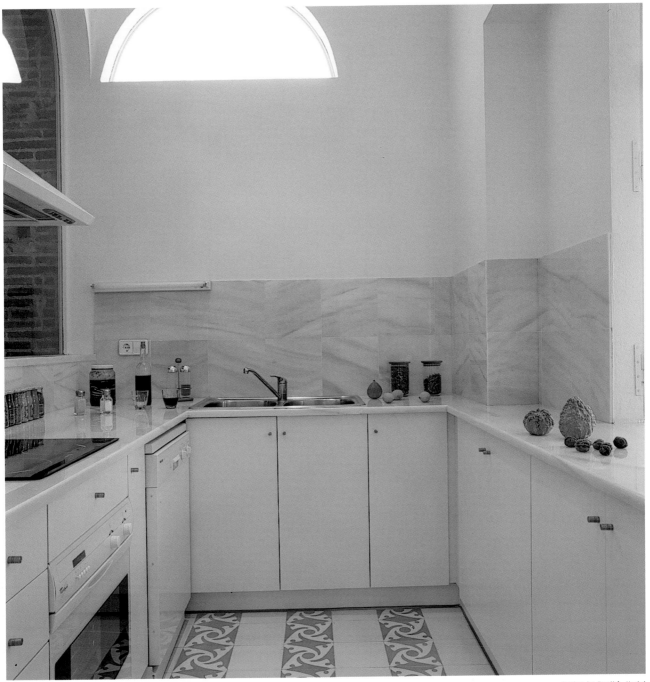

Design by Escribà, Nadal
Photo © Eugeni Pons

Design by Cukrowicz Nachbaur Architekten
Photo © Albrecht Immanuel Schnabel

Design by C. Aglás, P. Martinez
Photo © Jose Luis Hausmann

Design by Guilhem Roustan
Photo © Daniel Moulinet

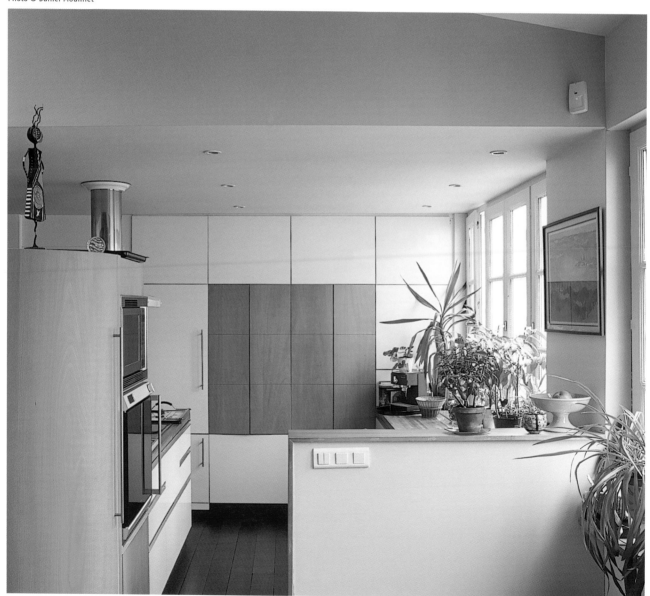

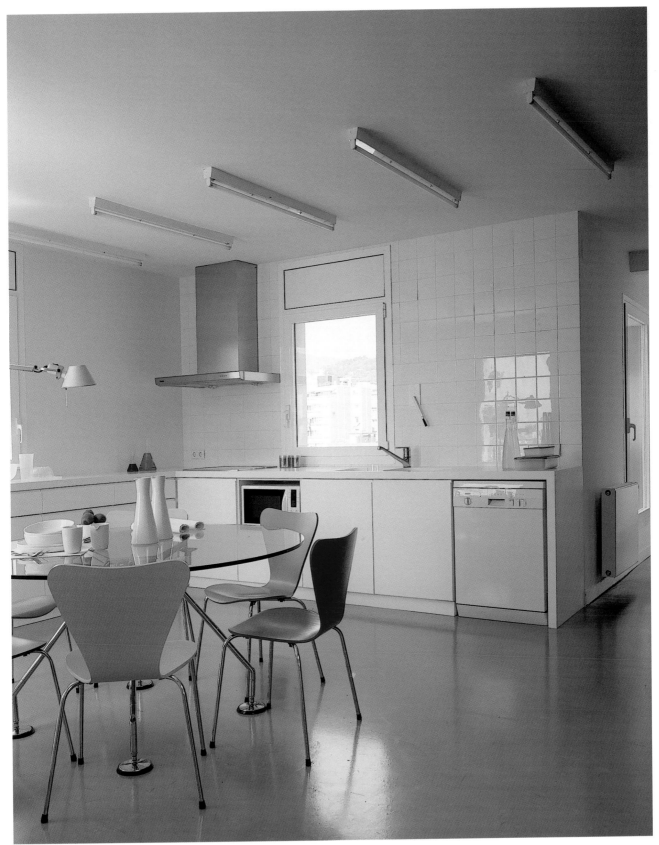

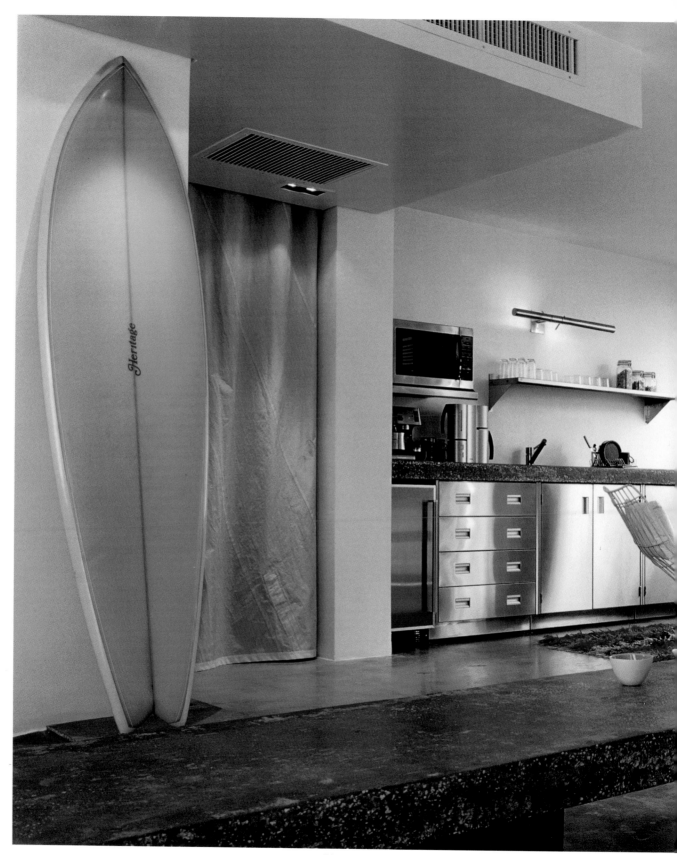

Design by Studio Uribe
Photo © Pep Escoda

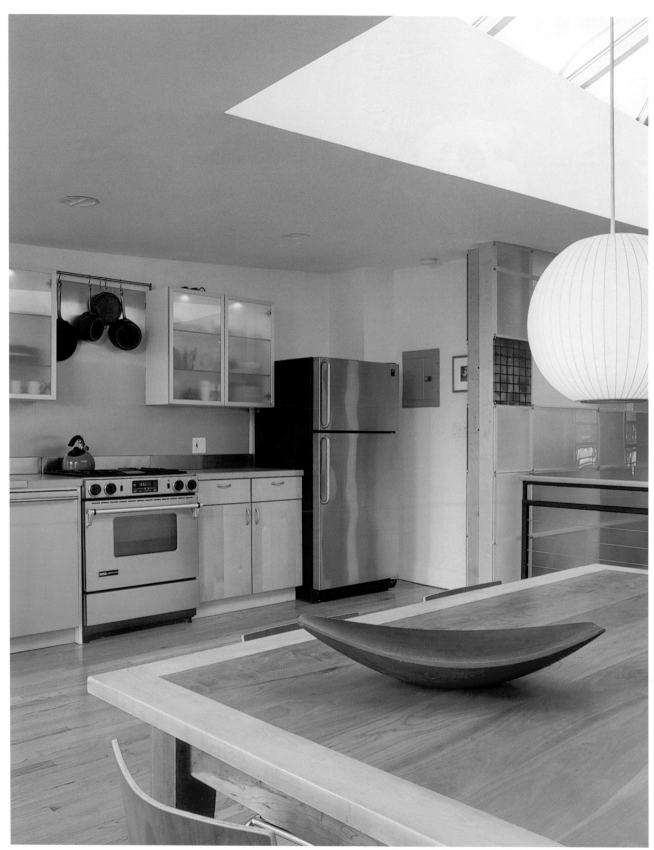

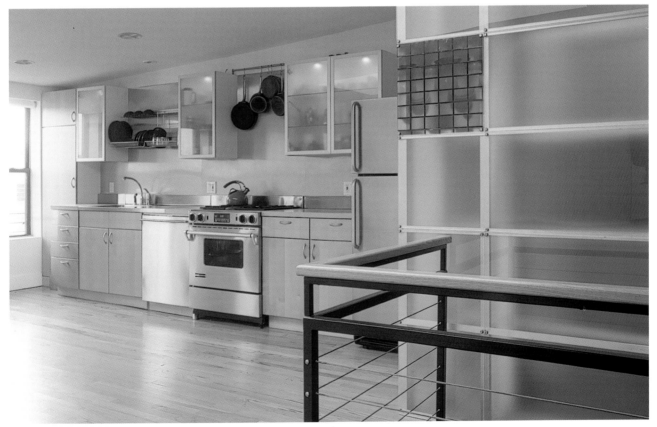

White

Design by Neal R. Deputy
Photo © Pep Escoda

Whether the kitchen is an independent space or opens onto other rooms in the house, white is the ideal color to create a uniform, brightly illuminated volume.

Nicht nur in geschlossenen Küchenräumen, sondern auch bei Küchen, die in die Wohnräume des Hauses integriert werden, ist Weiß die ideale Farbe, um einen hellen homogenen Gesamteindruck zu erzeugen.

Que ce soit dans les cuisines indépendantes ou dans celles qui sont intégrées à d'autres pièces de la maison, l'emploi du blanc est idéal pour assurer un ensemble homogène et lumineux.

Tanto en las cocinas independientes como en aquellas que están integradas en otras estancias de la casa, el empleo del color blanco es ideal para que el conjunto sea homogéneo y luminoso.

Sia nelle cucine indipendenti che in quelle integrate ad altre stanze della casa, l'uso del bianco è ideale per rendere tutto l'insieme omogeneo e luminoso.

Design by Renato D'Ettorre
Photo © Willem Rethmeier

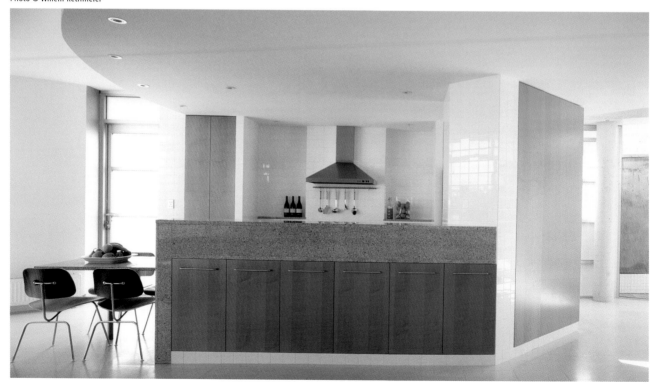

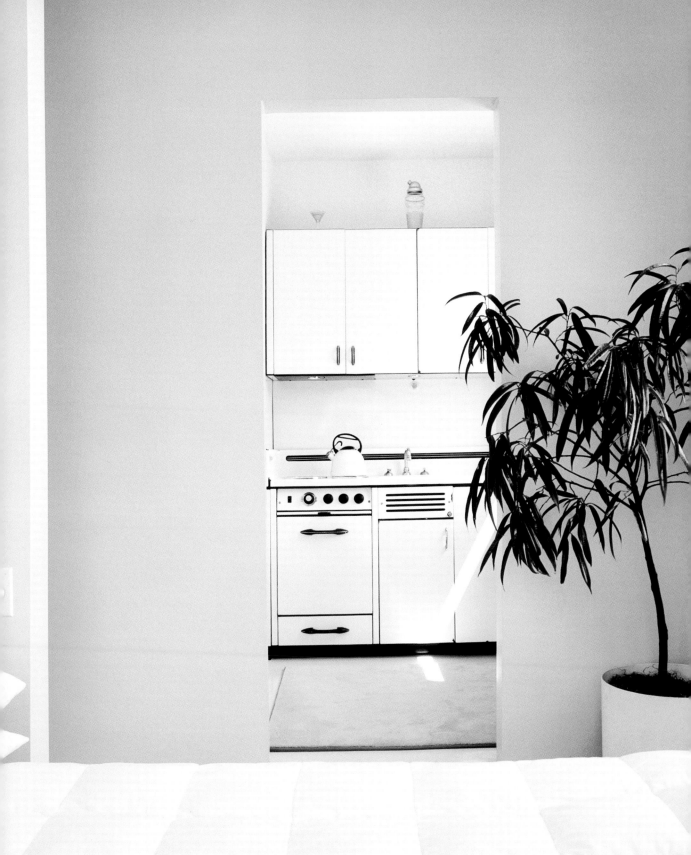

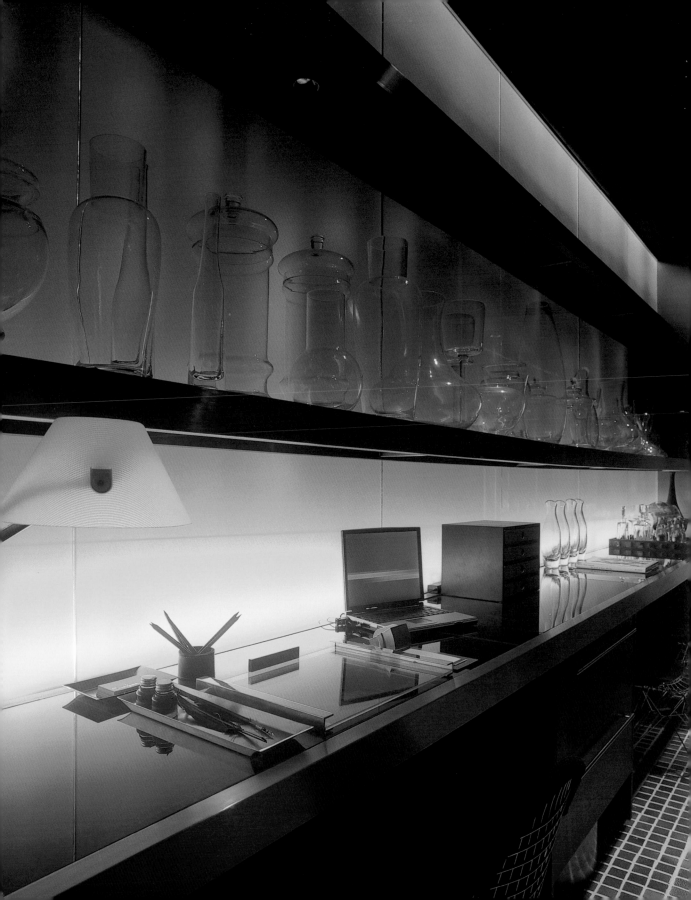

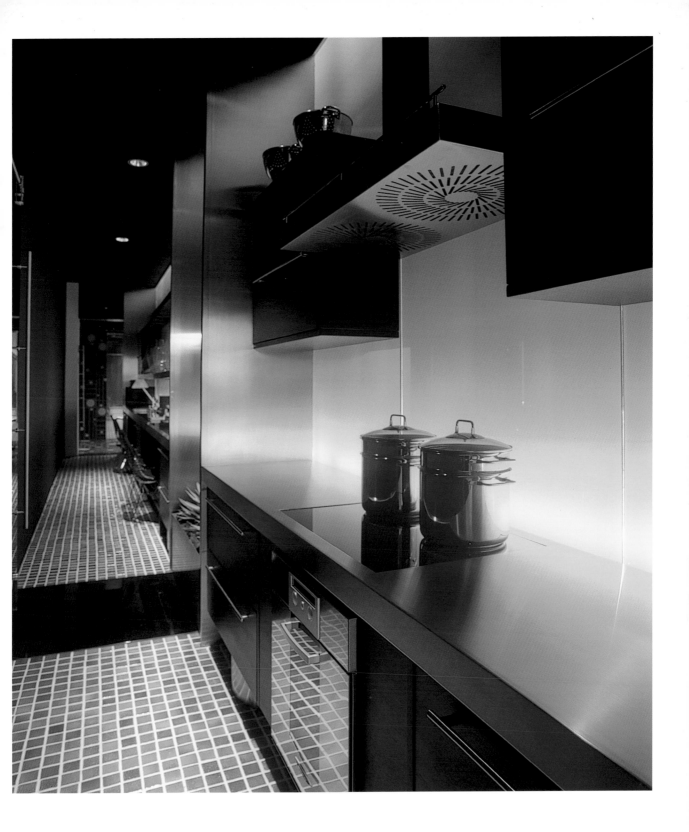

Both pages
Design by Brunete Fraccaroli
Photo © Tuca Reinés

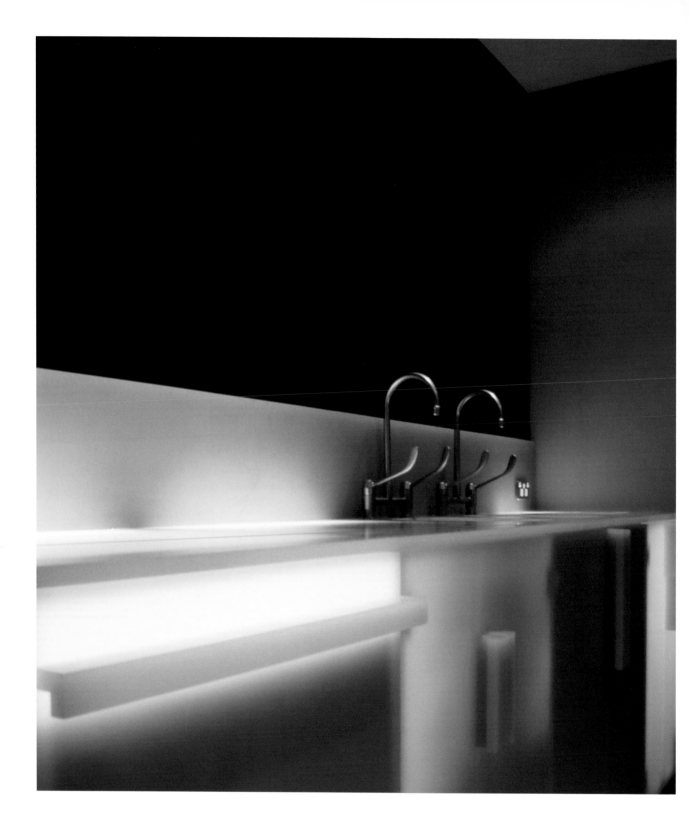

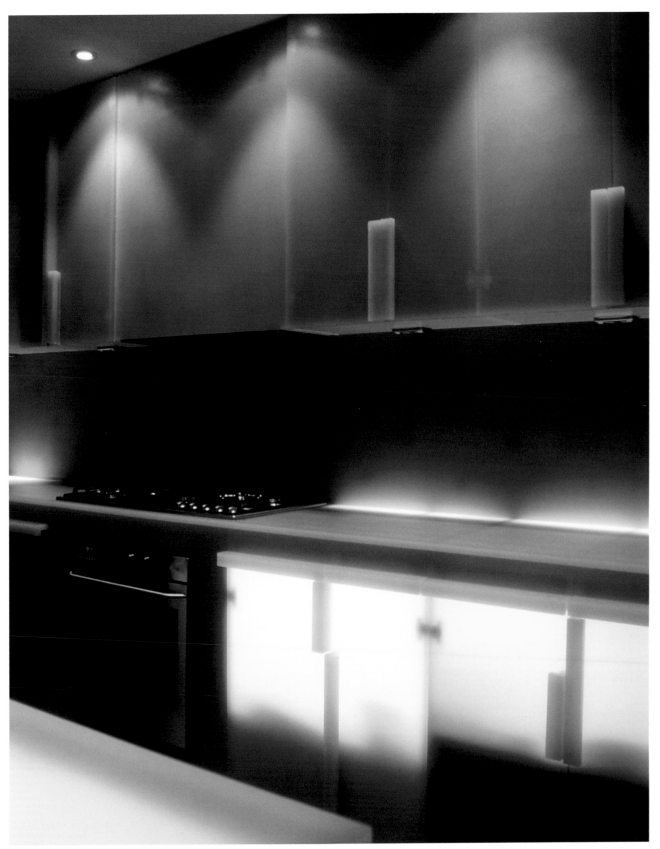

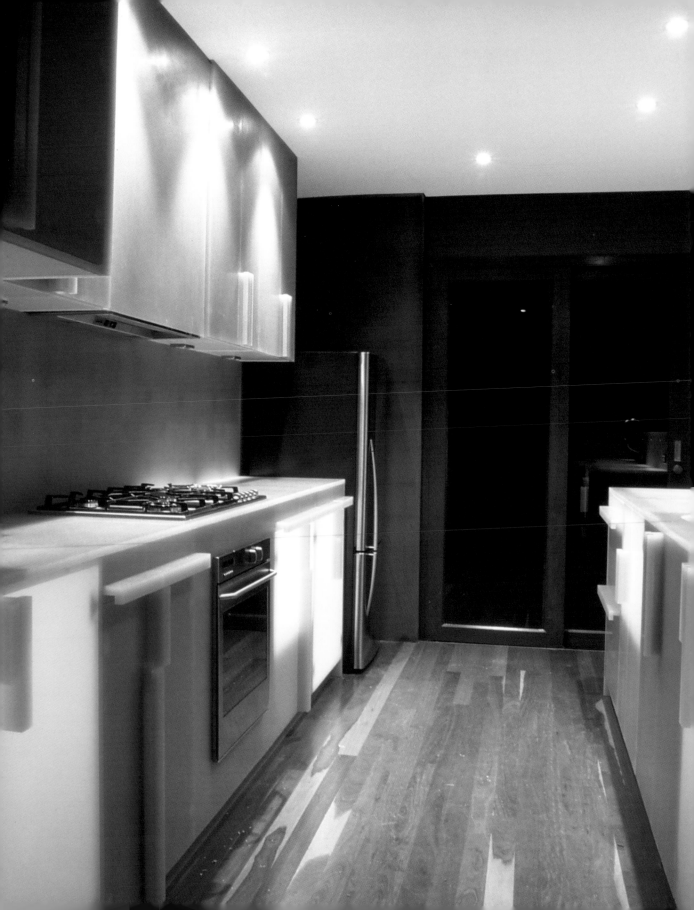

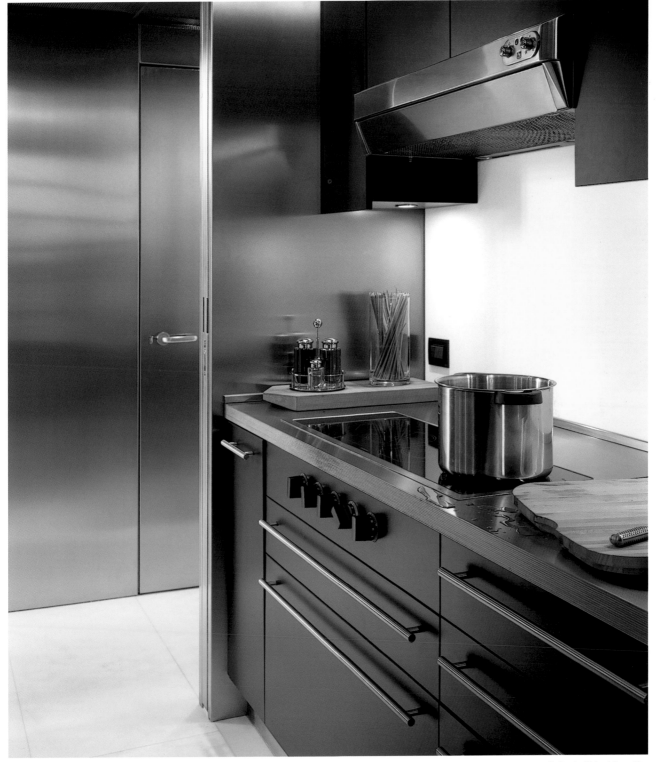

Design by Michael Carapetian
Photo © Andrea Martiradonna

Design by Stephen Varady Architecture
Photo © Stephen Varady

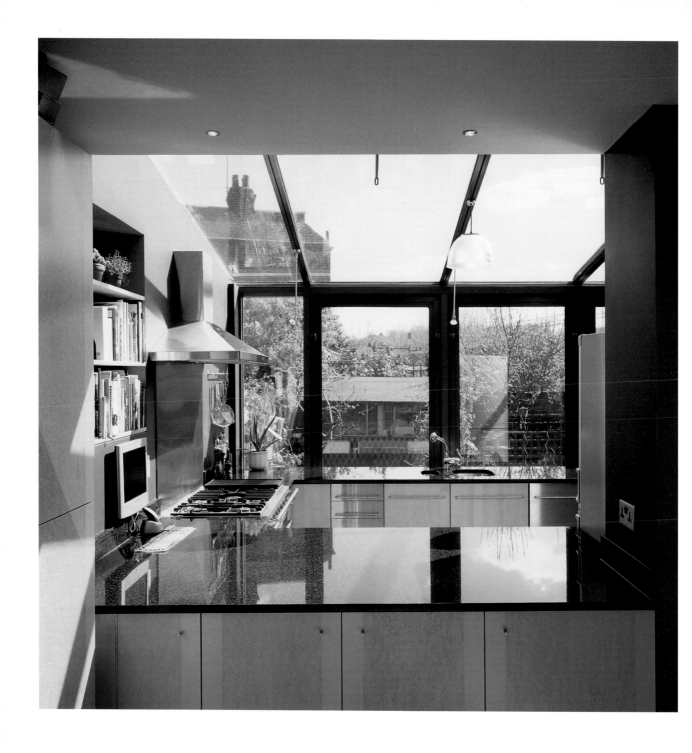

Both pages
Design by Fletcher Roger Associates
Photo © Paul Ratigan

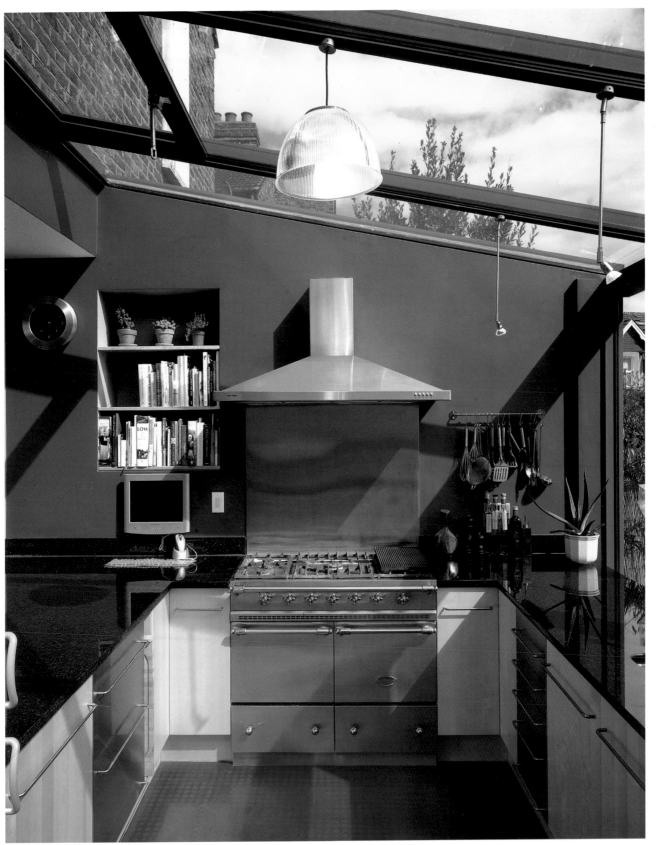

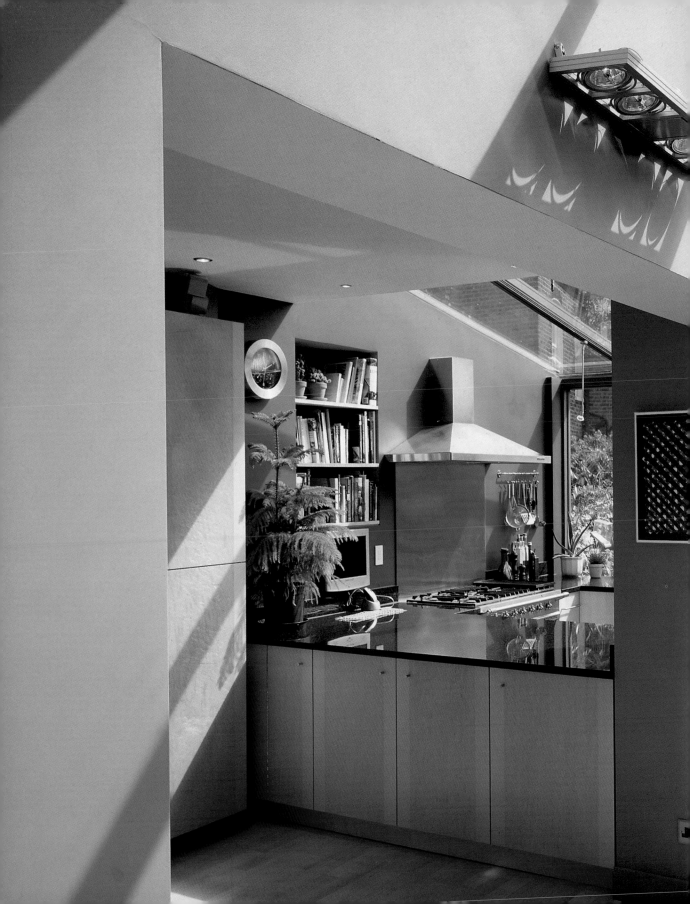

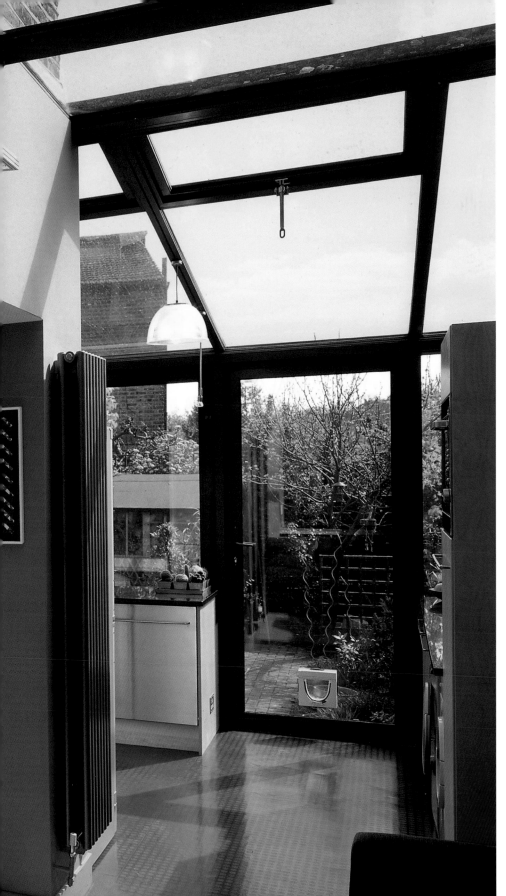

Design by Fletcher Roger Associates
Photo © Paul Ratigan

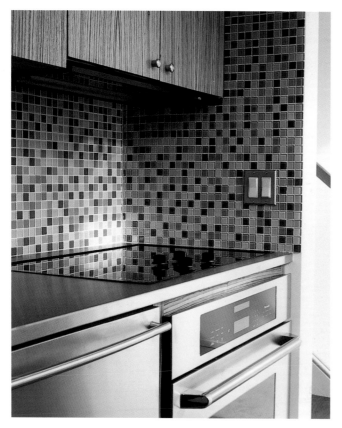

Both photos
Design by Craig Steely Architecture
Photos © Roger Casas

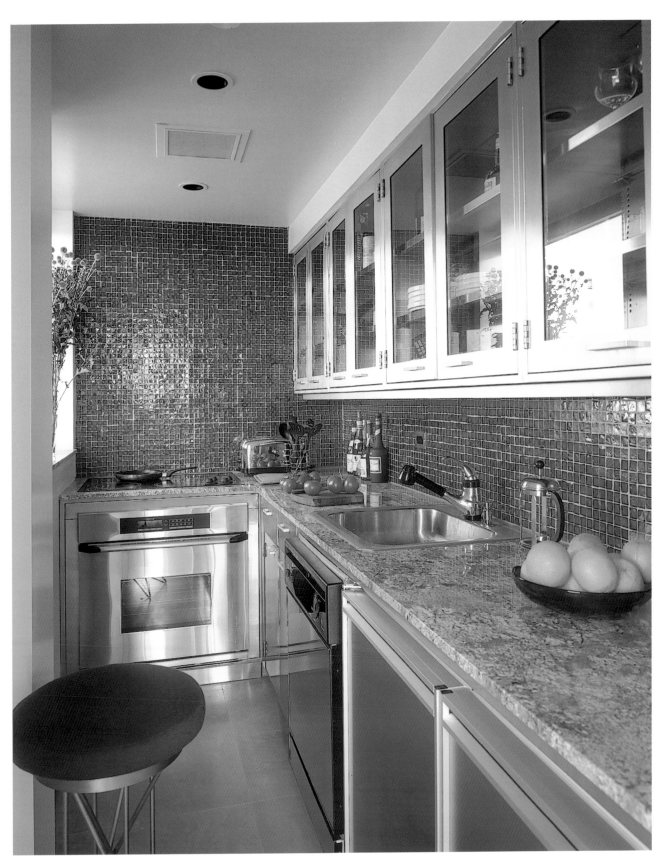

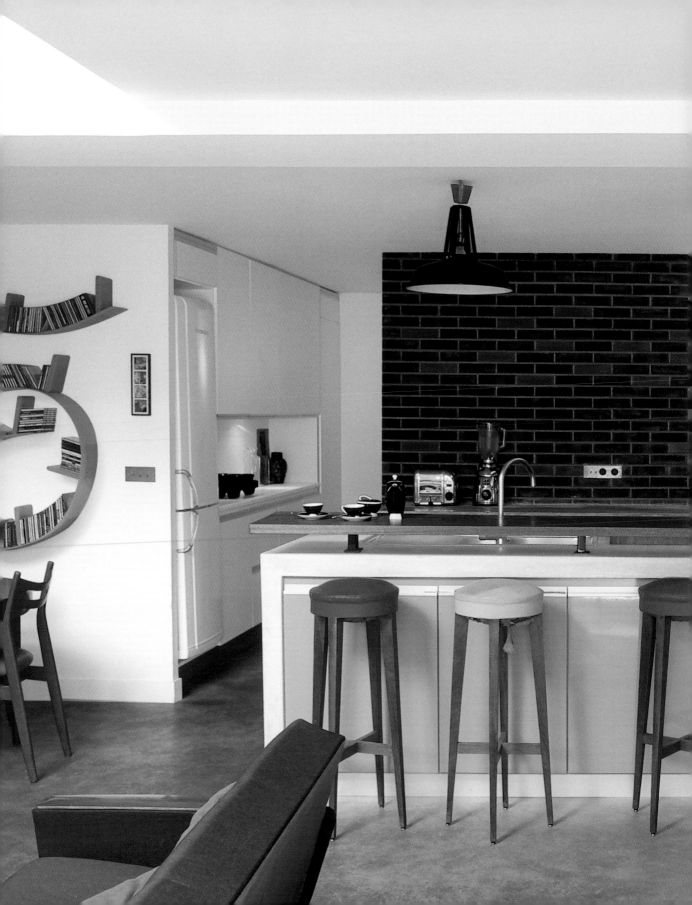

Design by Stéphane Zamfirescu
Photo © Olivier Hallot

Shape

Both pages
Design by Peanutz Architekten
Photo © Thomas Bruns

A U-shaped configuration makes optimum use of available space and allows the three chief activities to be clearly differentiated: food preparation, cooking and washing up.

Die Anordnung in U-Form nutzt den zur Verfügung stehenden Platz optimal aus und erlaubt eine Differenzierung der drei wichtigsten Tätigkeiten in der Küche: Vorbereitung, Zubereitung und Spülen.

La configuration en forme de fer à cheval optimise au maximum l'espace disponible et permet de différencier les trois activités principales de la cuisine : préparation, cuisson et vaisselle.

La configuración en forma de U optimiza al máximo el espacio disponible y permite diferenciar las tres actividades principales de la cocina: preparación, cocción y fregado.

La configurazione ad U ottimizza lo spazio disponibile e consente di differenziare le tre attività principali svolte in cucina: preparazione, cottura e pulizia.

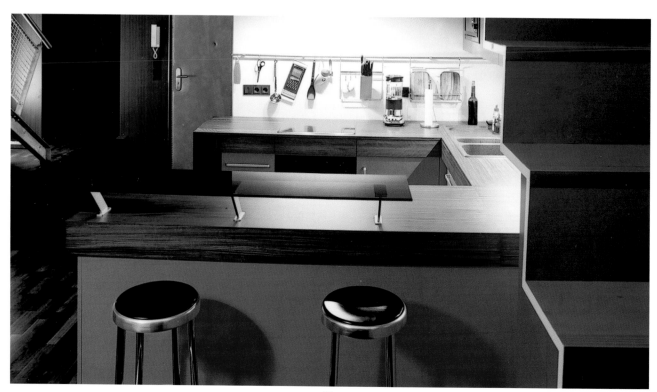

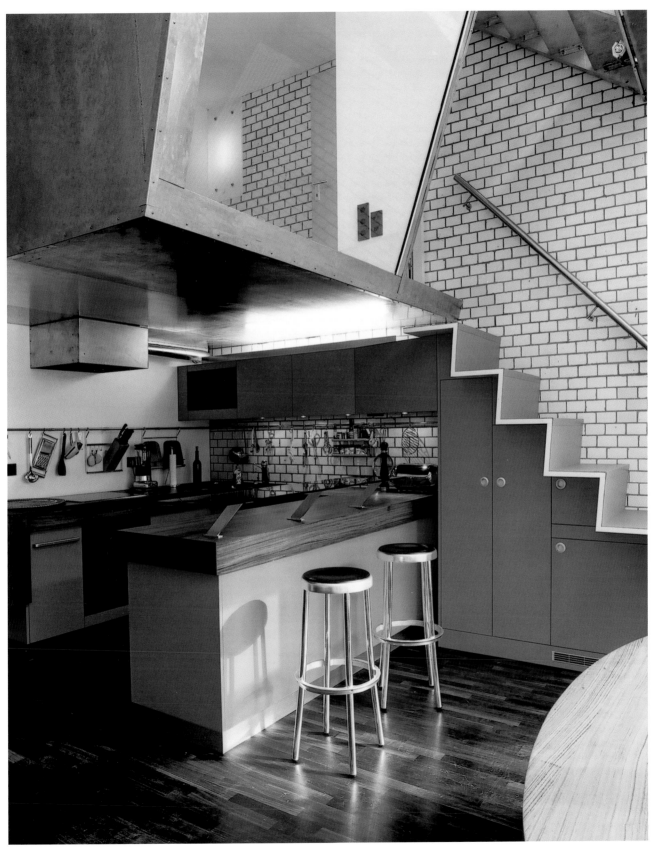

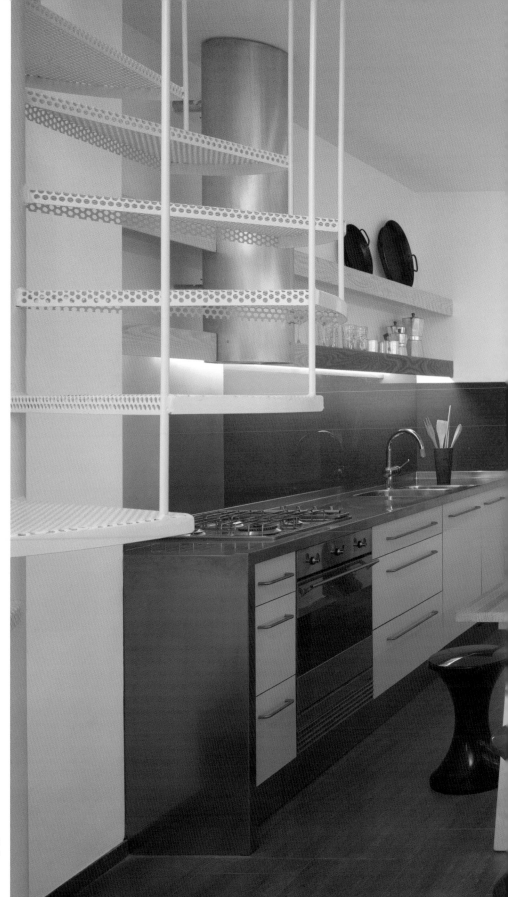

Design by A. Bugugnani, M. Pascual
Photo © Eugeni Pons

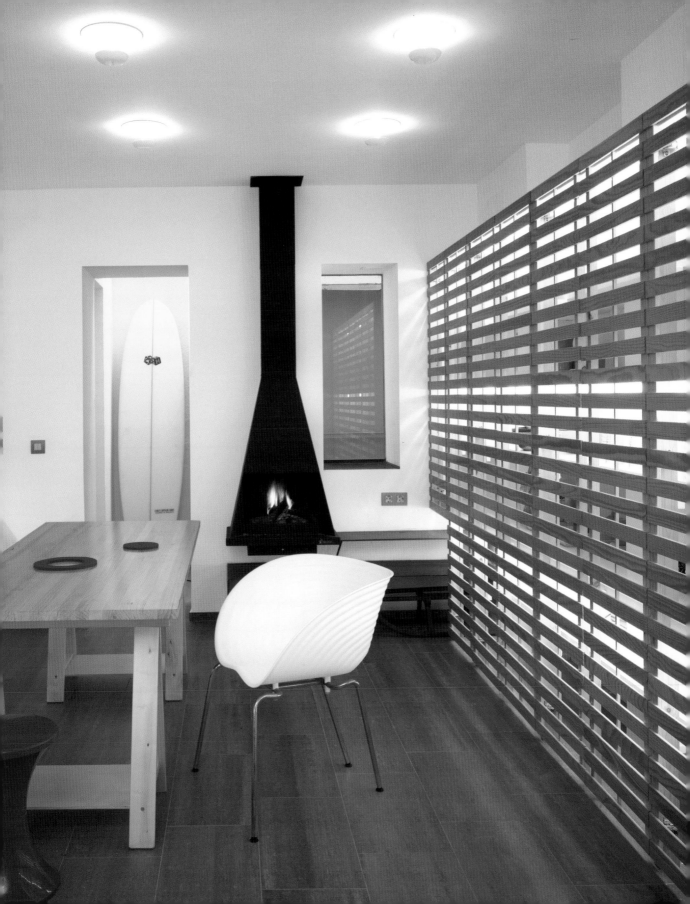

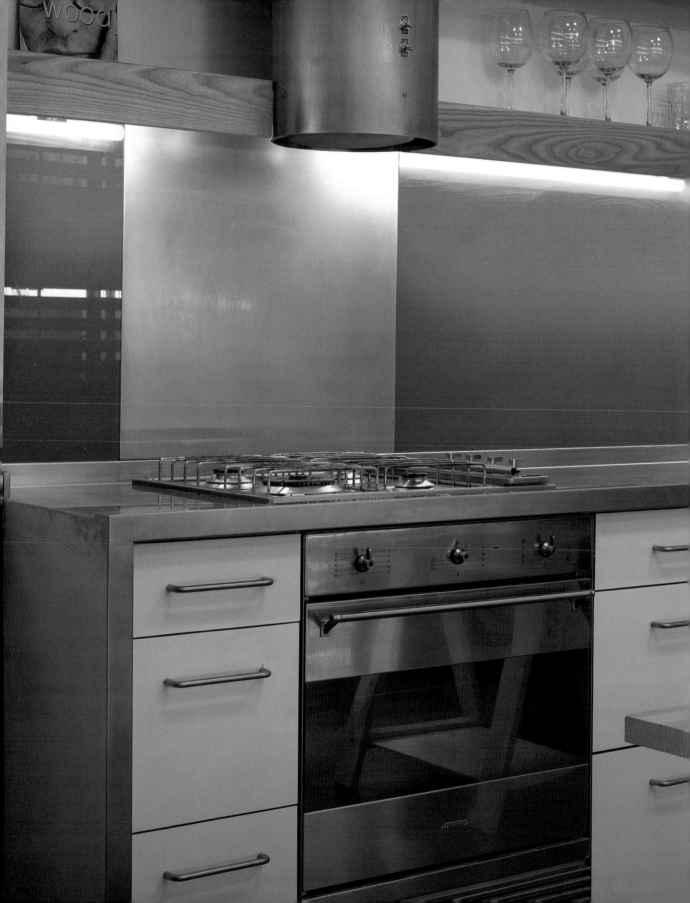

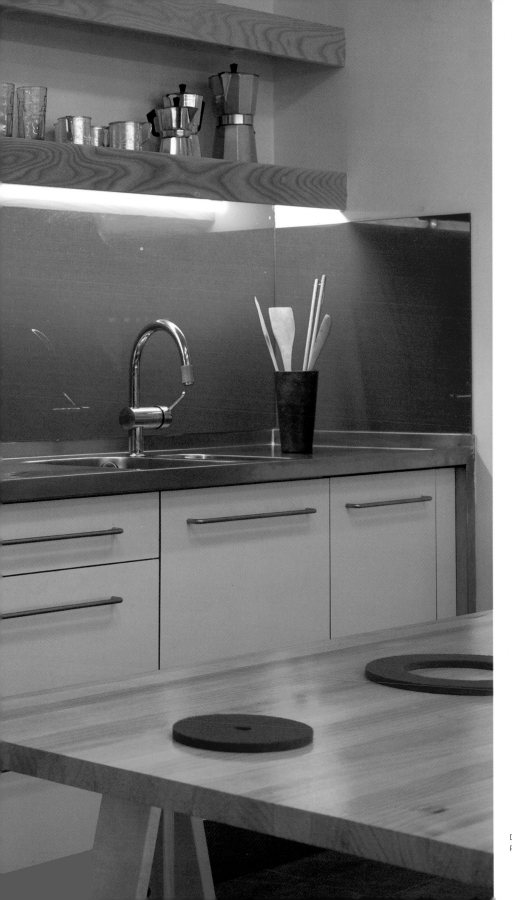

Design by A. Bugugnani, M. Pascual
Photo © Eugeni Pons

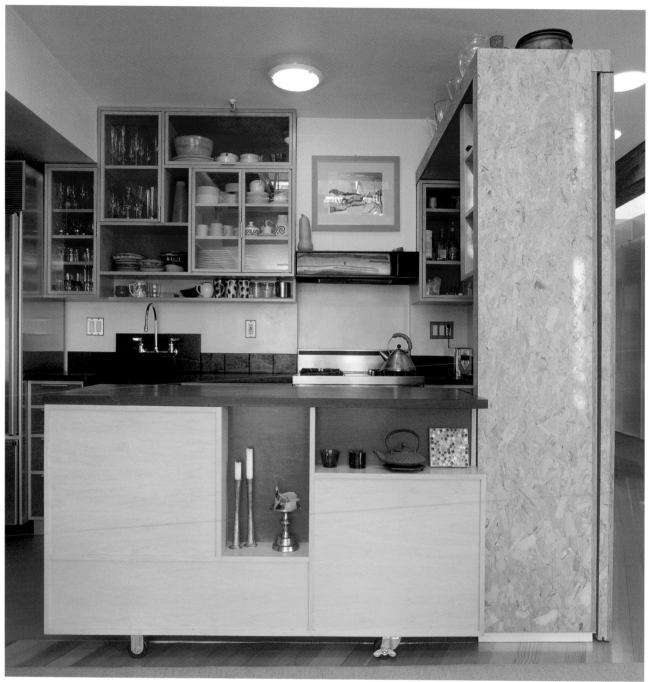

Design by Moneo Brock Architects
Photo © Jordi Miralles

Design by Felipe Assadi
Photo © Guy Wenborne

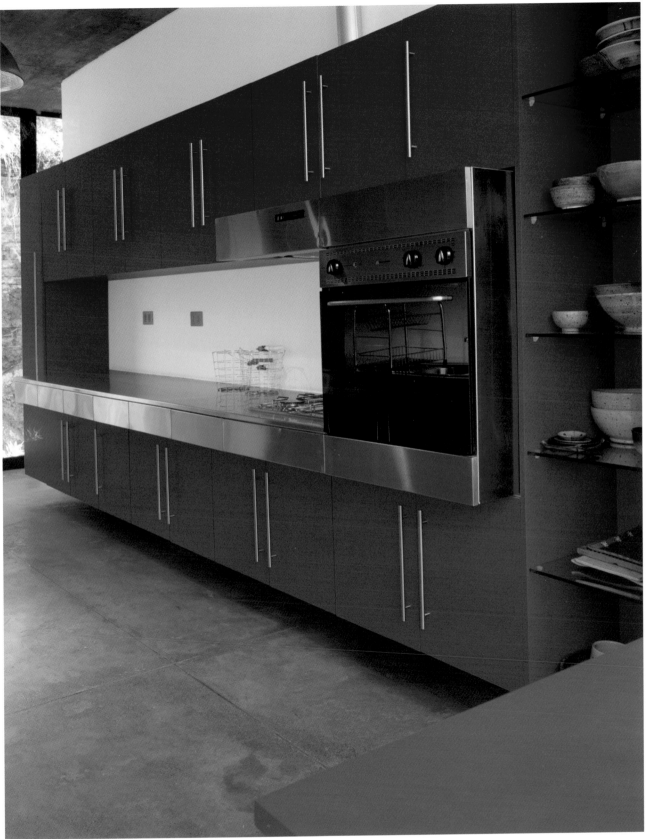

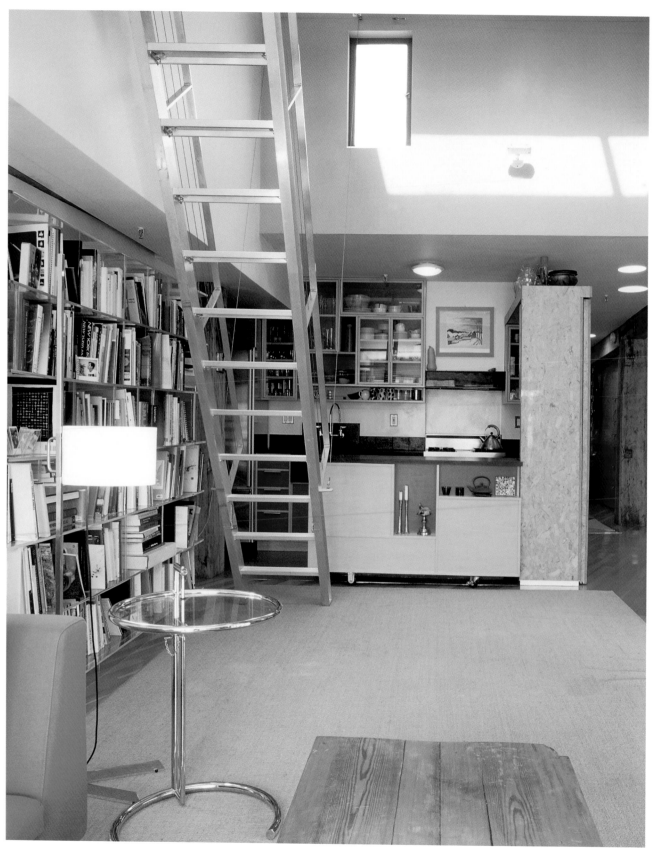

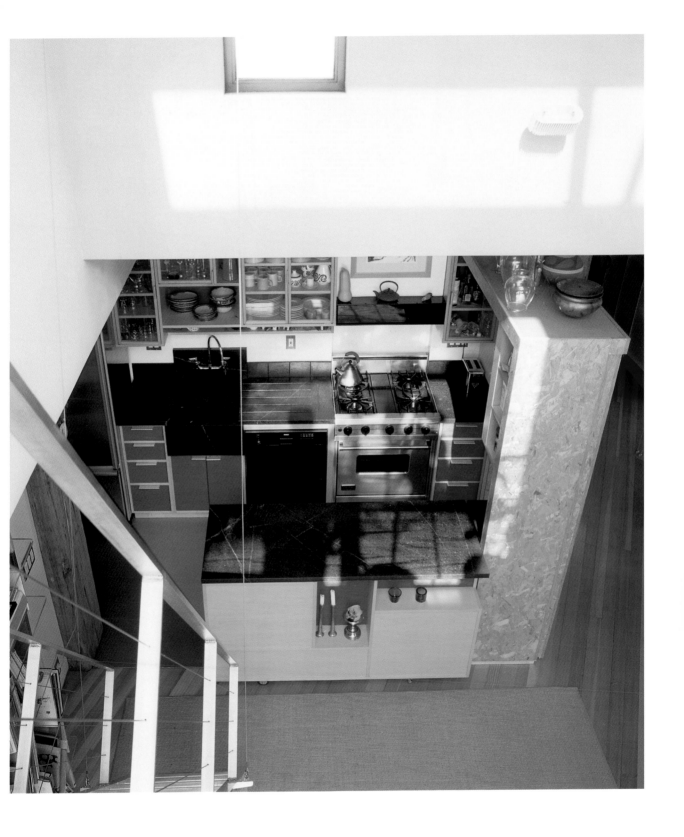

Both pages
Design by Moneo Brock Architects
Photo © Jordi Miralles

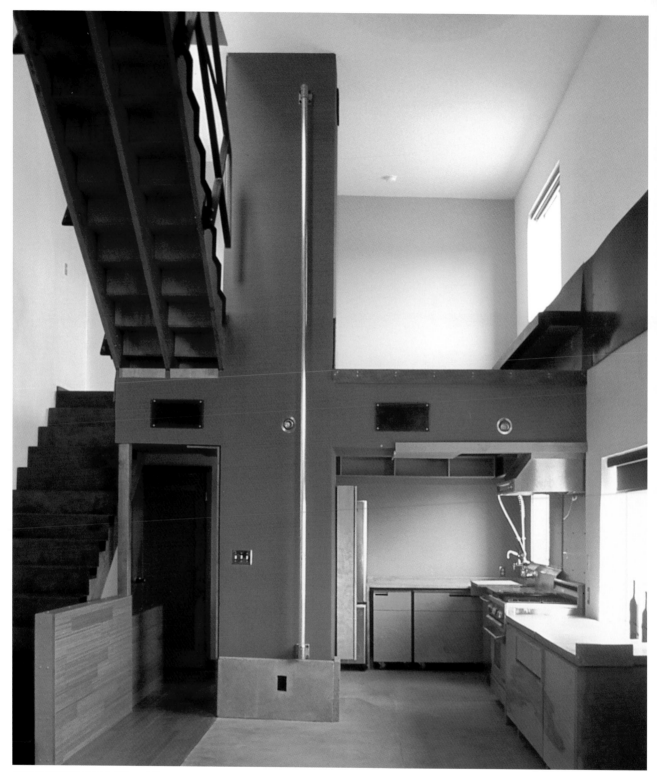

Design by Joshua R. Coggeshall/Cogwork Shop
Photo © Deborah Bird

Design by Tezuca Architects
Photo © Katsuhisa Kida

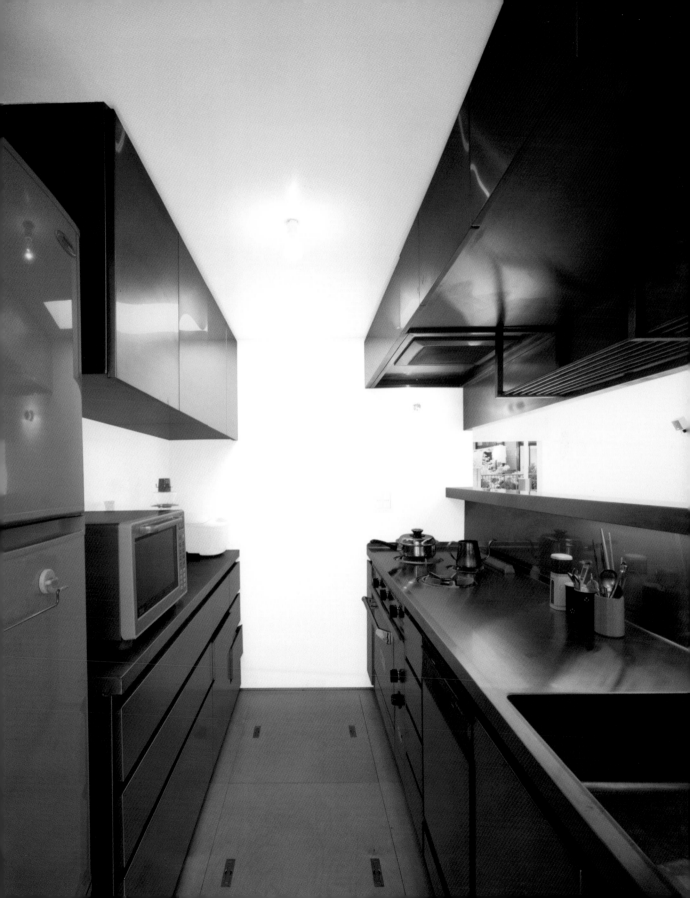

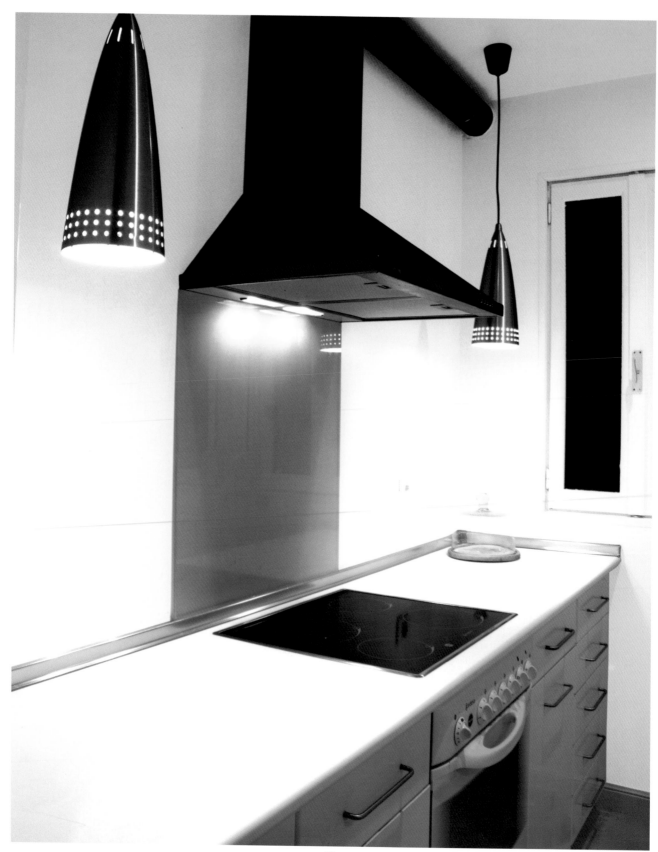

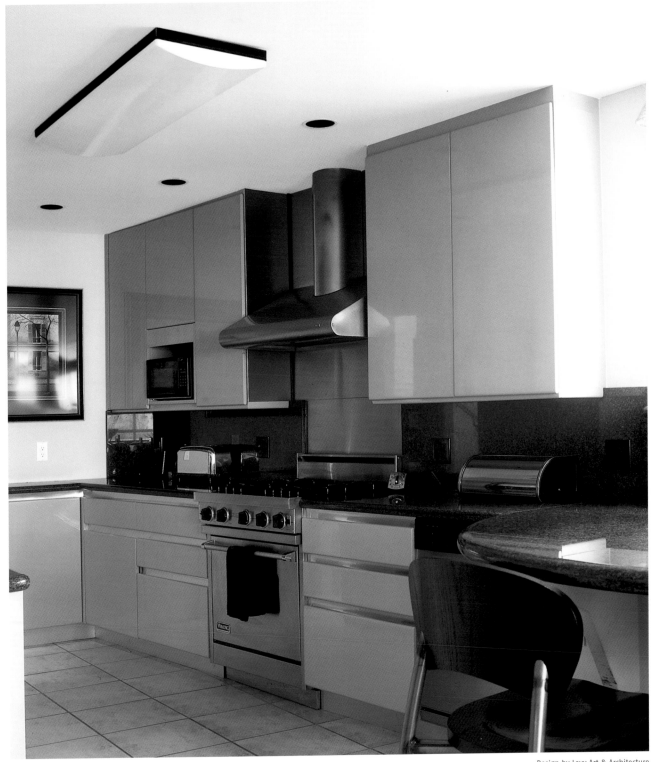

Design by Levy Art & Architecture
Photo © Roger Casas

Design by Carmen Abad Ibáñez de Maturo
Photo © Alberto Martínez

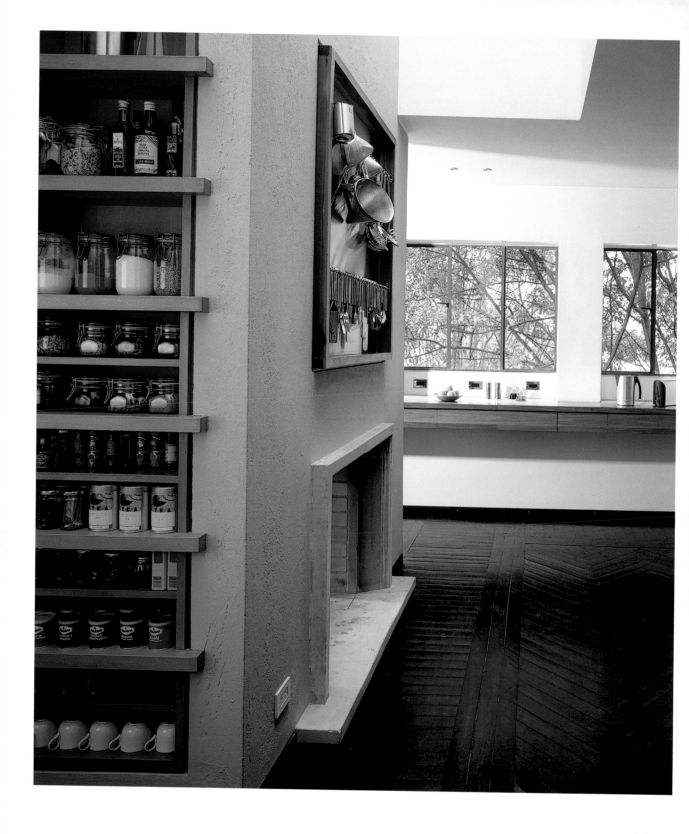

Both pages
Design by Guillermo Arias
Photo © Eduardo Consuegra

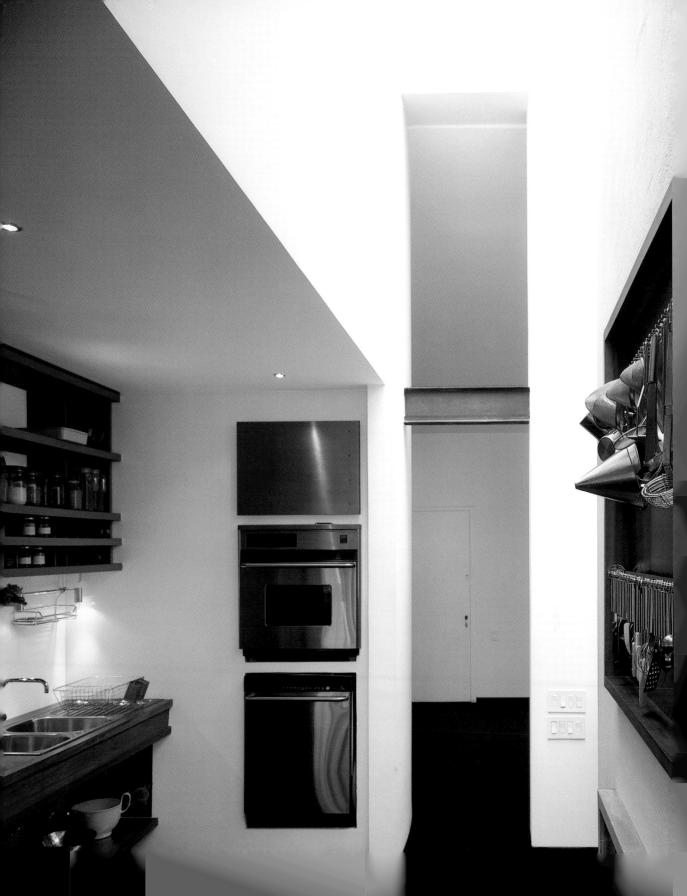

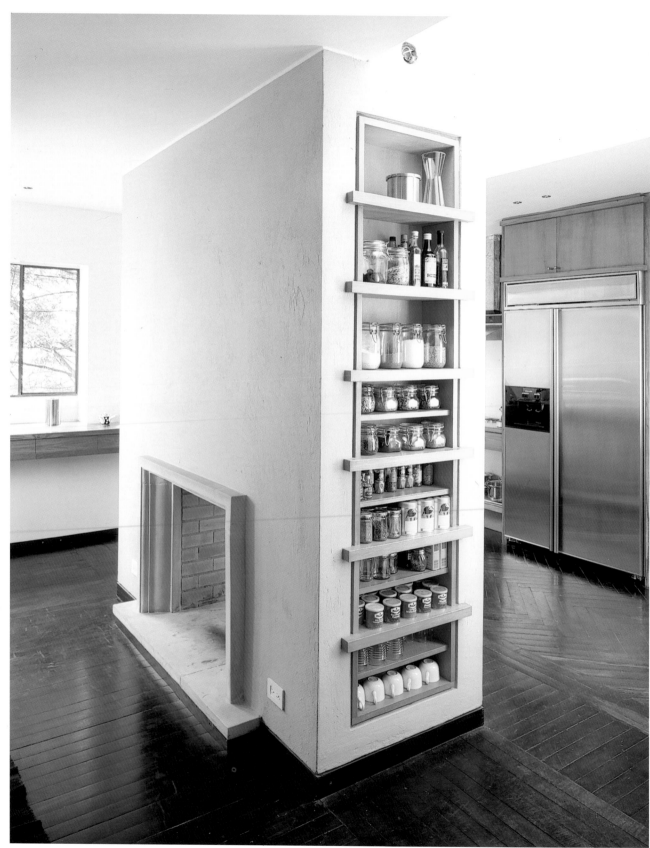

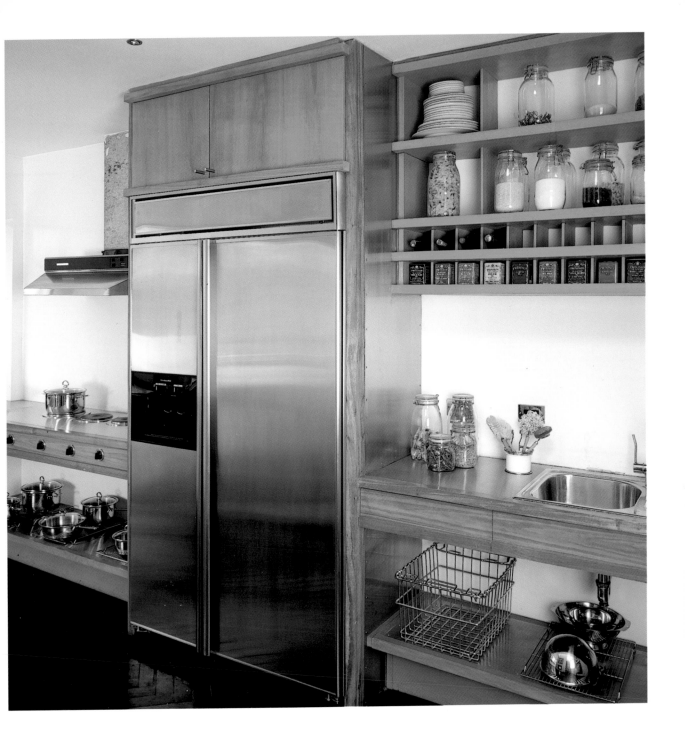

Stainless steel

Design by Williams Burton Architects
Photo © James Knowler

Stainless steel, used on work surfaces, electrical appliances and cabinets, is extremely hardy and helps to create a luminous atmosphere in the kitchen.

Edelstahl kommt heute bei Kochflächen, elektrischen Haushaltsgeräten und sogar Schränken zum Einsatz, weil es ein sehr widerstandsfähiges Material ist, das dem Raum Glanz und Helligkeit verleiht.

L'acier inoxydable, présent sur les plans de travail, dans l'électroménager et même sur les armoires, est très résistant et dote l'espace d'éclat et de luminosité.

El acero inoxidable, presente en encimeras, electrodomésticos e incluso armarios, es muy resistente, y confiere brillo y luminosidad al espacio.

L'acciaio inossidabile, presente in piani di lavoro, elettrodomestici e persino armadi, è molto resistente e conferisce lucentezza e luminosità allo spazio.

Design by Hoyer & Schindele
Photo © Concrete

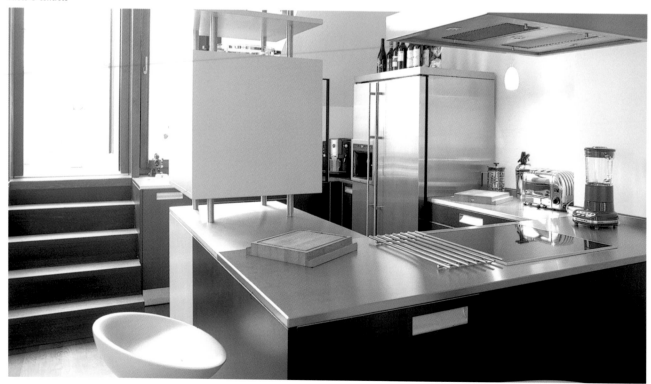

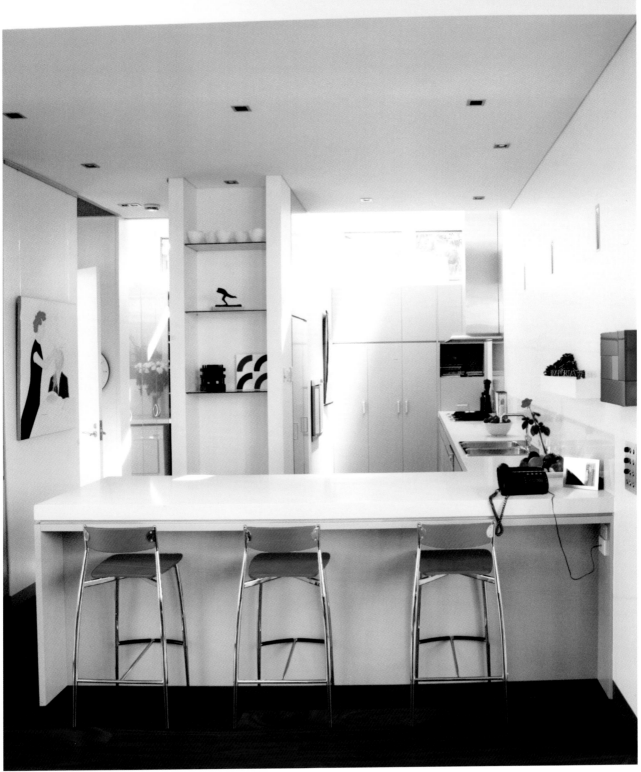

Design by Sarah Wigglesworth, Jeremy Till
Photo © Paul Smoothy

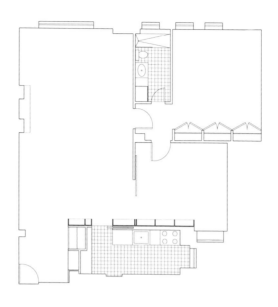

Design by Tow Studios
Photos © Björg Photographer

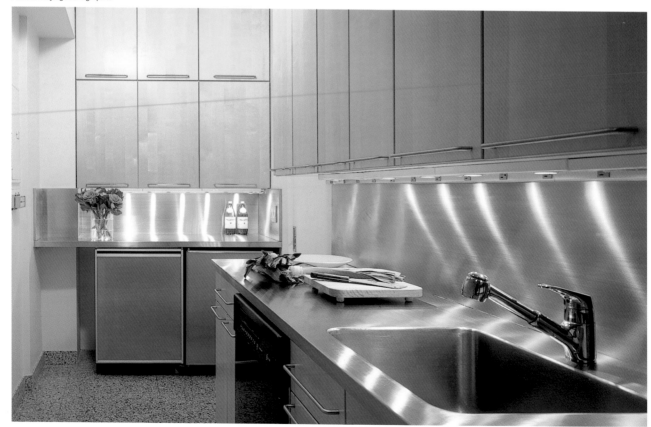

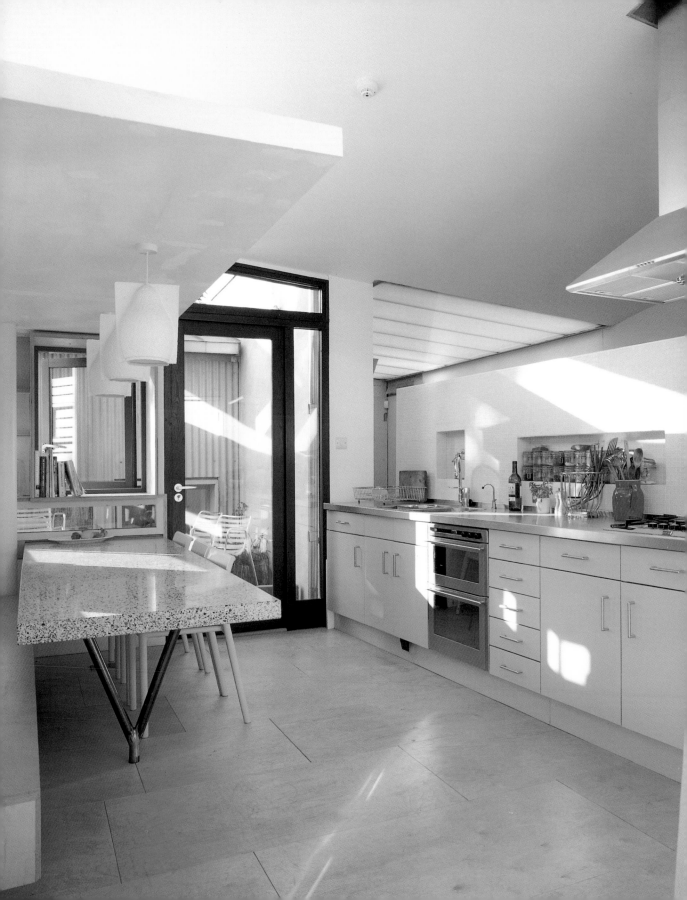

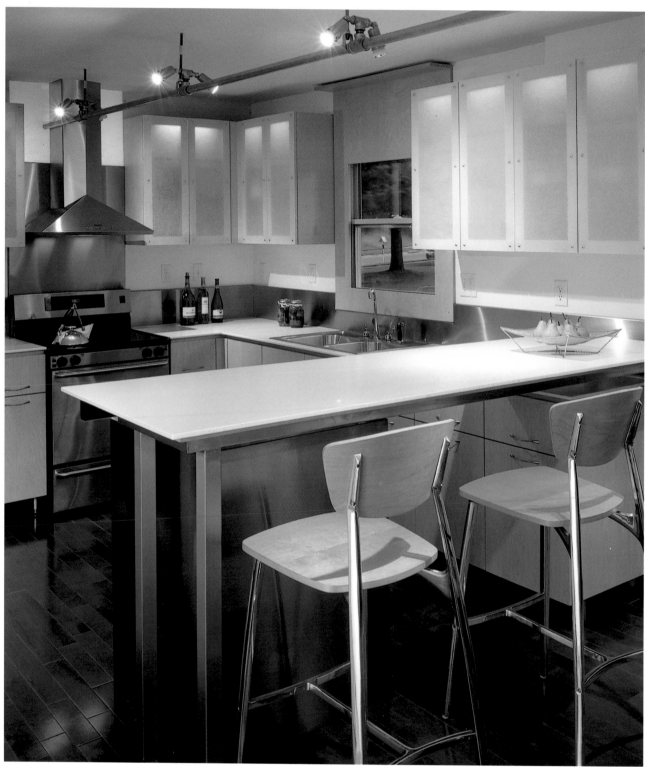

Design by Randy Brown Architects
Photo © Farshid Assassi

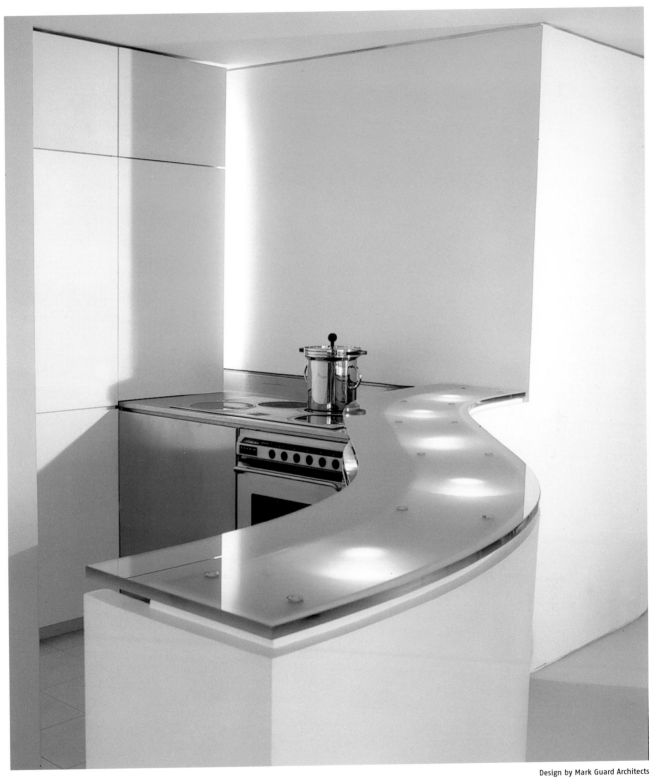

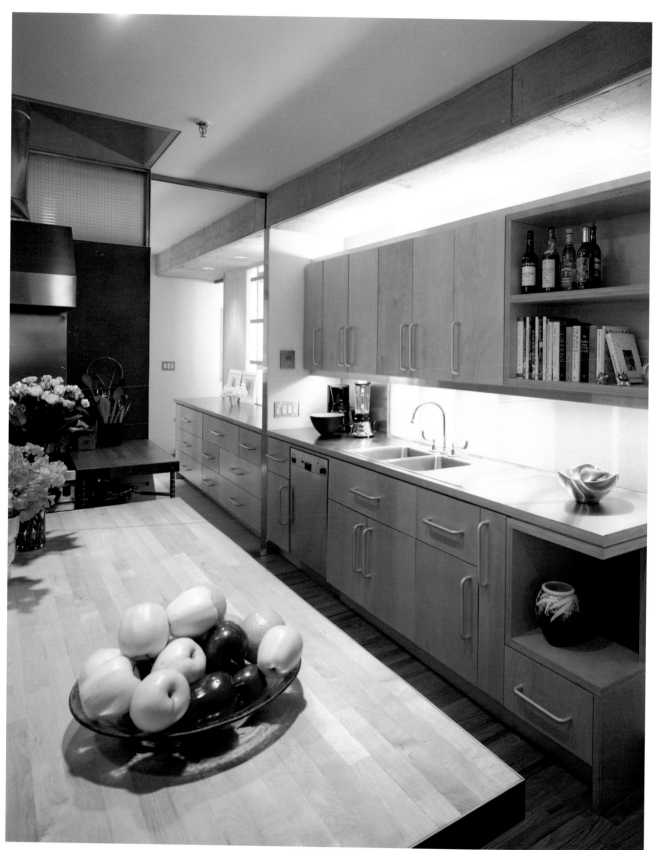

Both pages
Design by Resolution: 4 Architecture
Photo © Paul Warchol

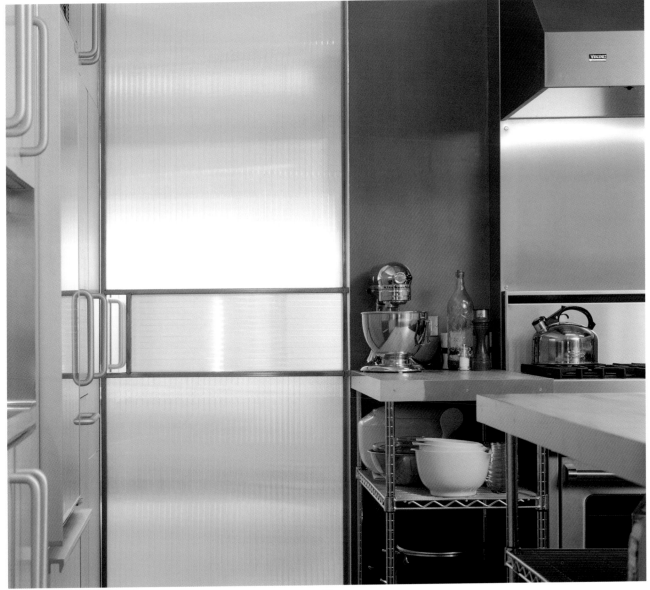

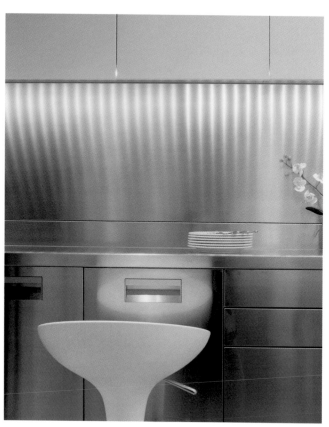

Both pages
Design by Jordi Galí
Photos © Jordi Miralles

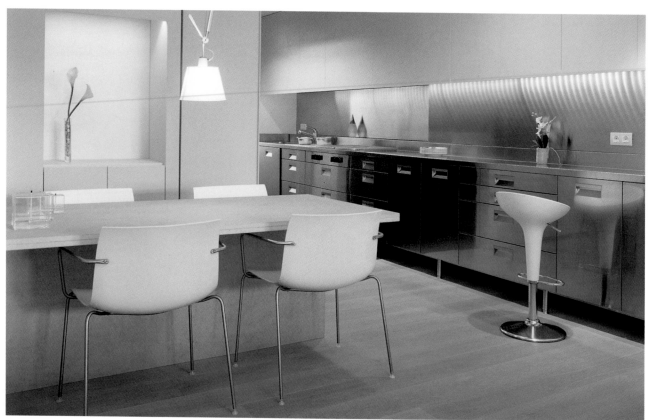

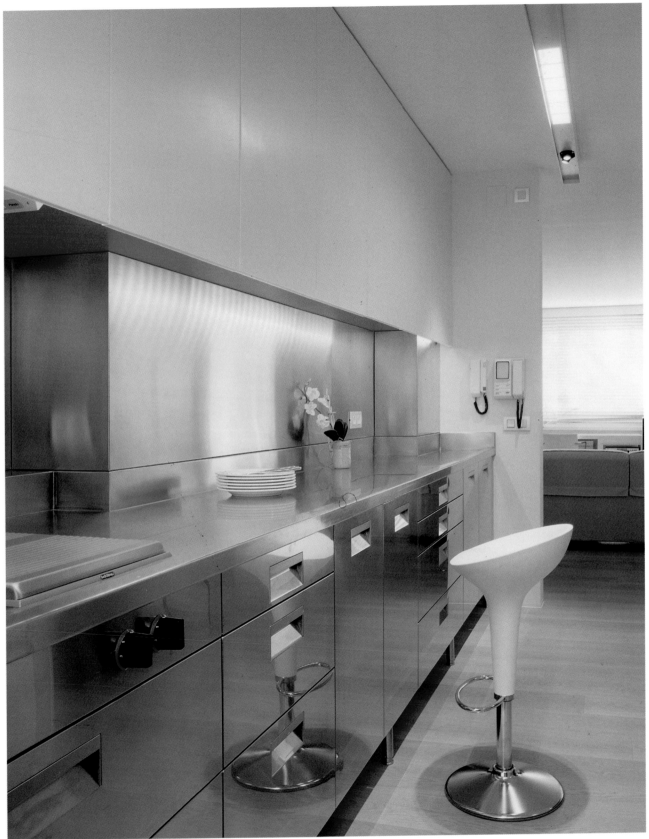

Design by M. Véronique de Hoop Scheffer
Photo © Virginia del Guidice

Design by House + House Architects
Photo © Roger Casas

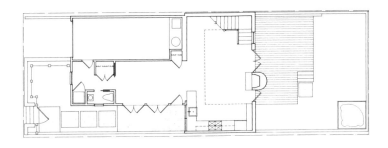

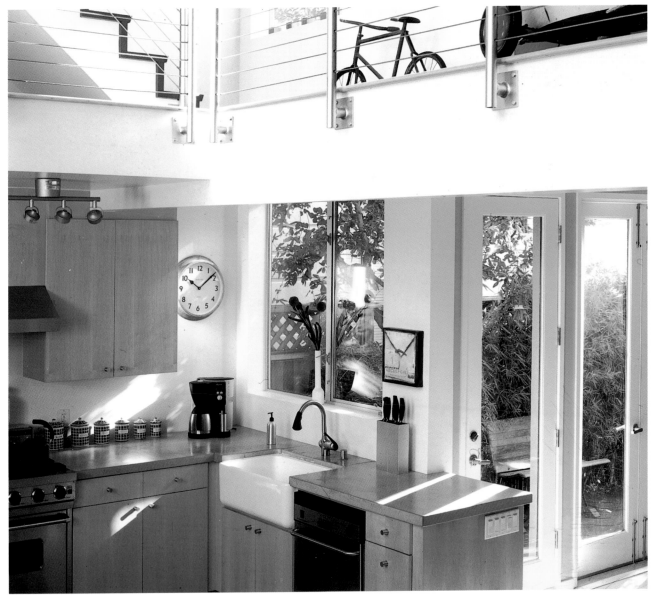

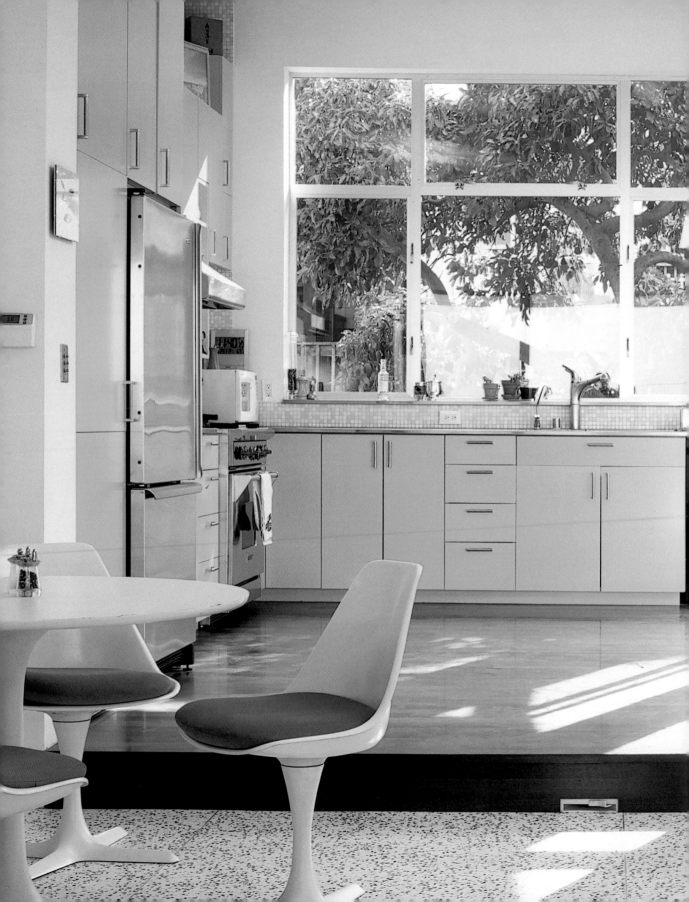

Design by Craig Steely Architecture
Photo © Roger Casas

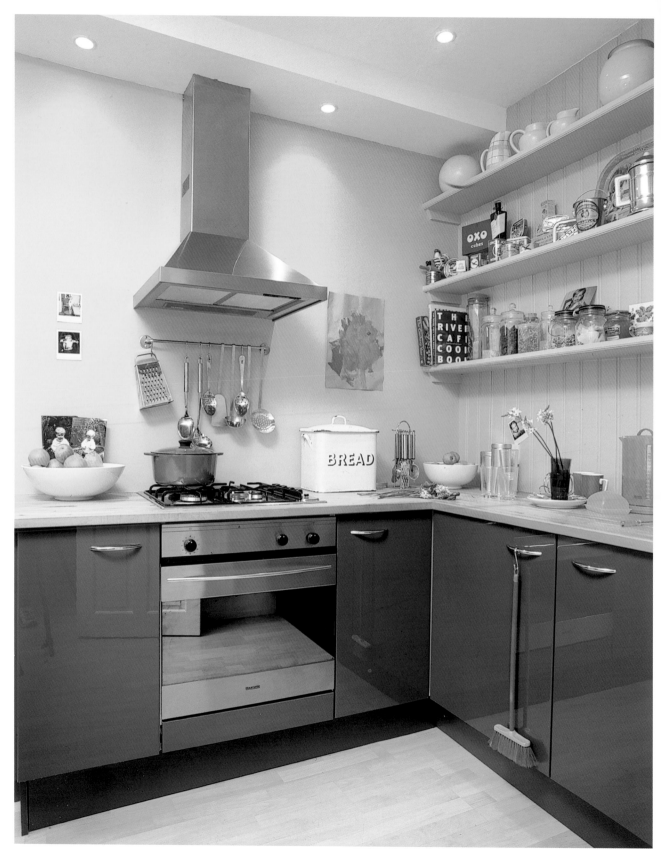

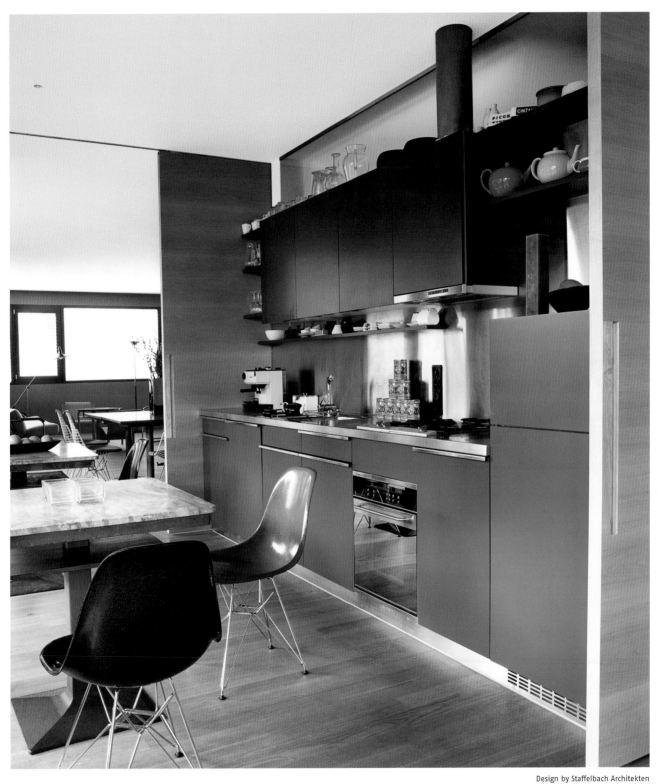

Design by Staffelbach Architekten
Photo © Agi Simoes/Zapaimages

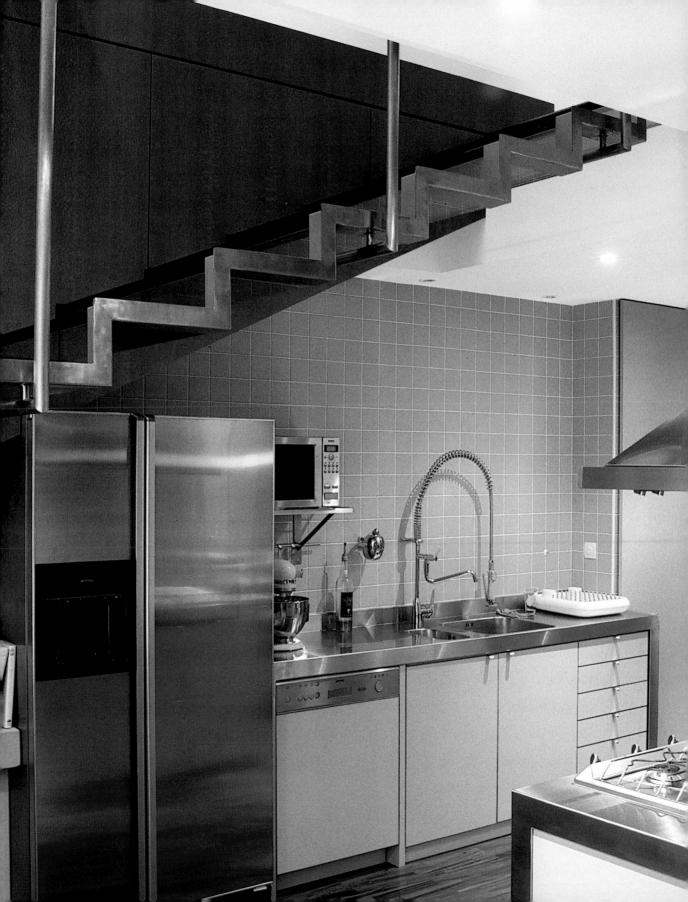

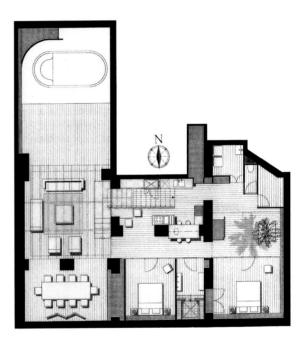

Design by Philippe Demougeot
Photo © Daniel Moulinet

Open kitchen

Design by Luis Felipe Infiesta
Photo © Jordi Sarrá

The contemporary lines of open kitchens co-existing with tradition-al decor in the dining room or the lounge area, provides a striking contrast of styles.

Wenn die Küche sich zum Wohn-oder Eßbereich öffnet, kann ein reizvoller Kontrast zwischen dem zeitgenössischen Stil der Küche und dem rustikalen Mobiliar der Wohnung entstehen.

Dans les cuisines ouvertes sur la zone de séjour et sur la salle à manger, il est possible de jouer avec le contraste entre les lignes contemporaines de la cuisine et le mobilier rustique de la demeure.

En cocinas abiertas a la zona de estar y al comedor se puede jugar con el contraste entre las líneas contemporáneas de la cocina y el mobiliario rústico de la vivienda.

Nelle cucine aperte alla zona soggiorno e alla sala da pranzo si pos-sono creare contrasti tra le linee contemporanee della cucina e i mobili in stile rustico delle altre stanze.

Design by S. Bastidas/B&B Estudio de Arquitectura
Photo © Pere Planells

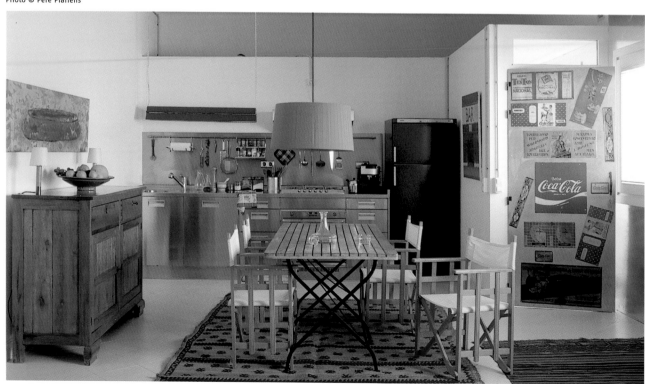

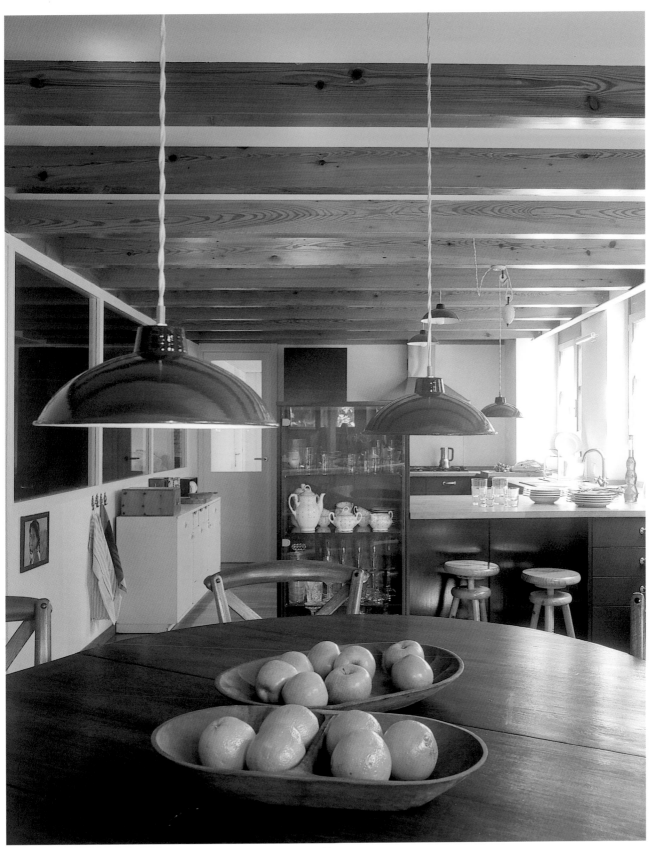

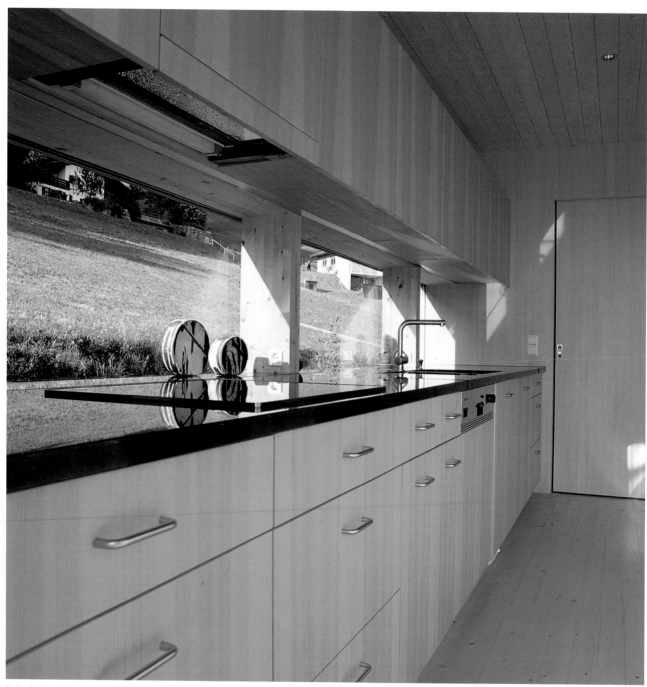

Design by Marcel Blum & Stefan Grossenbacher
Photo © Francesca Giovanelli

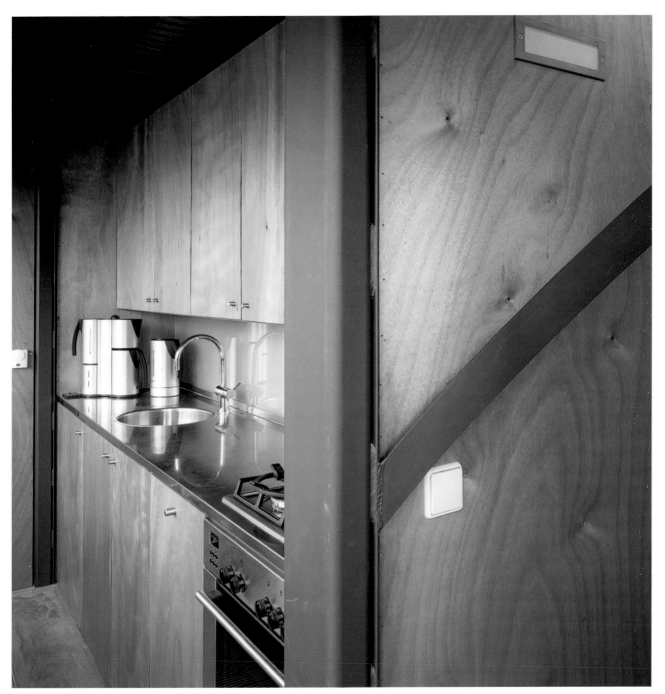

Design by Sluijmer & van Leeuwen
Photo © Herman van Doorn

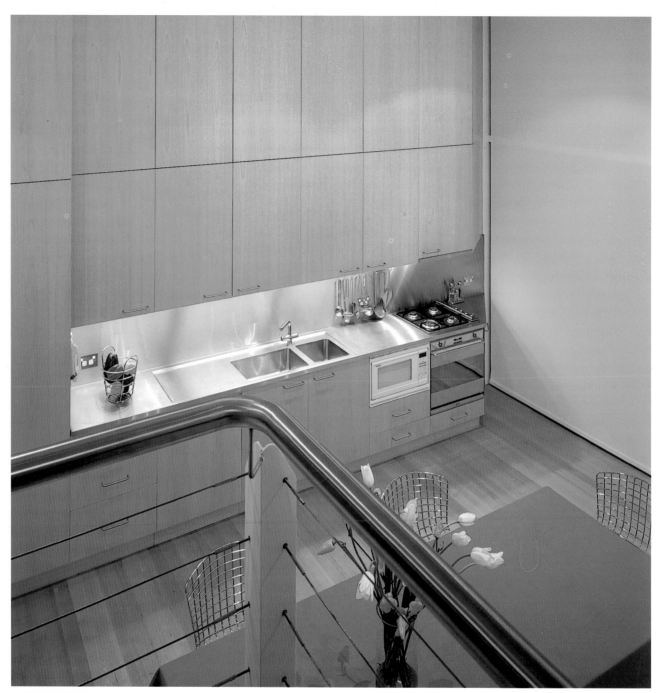

Design by Ed Lippmann Associates
Photo © Farshid Assassi

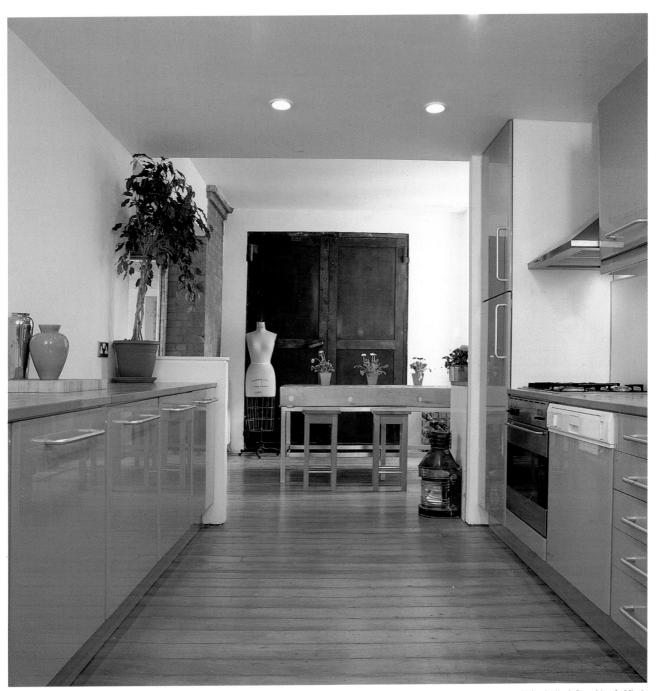

Design by Hugh Broughton Architects
Photo © Carlos Domínguez

Design by Lahz Nimmo Architects
Photo © Brett Broadman

Design by Utz-Sanby Architects
Photo © Marian Riabic

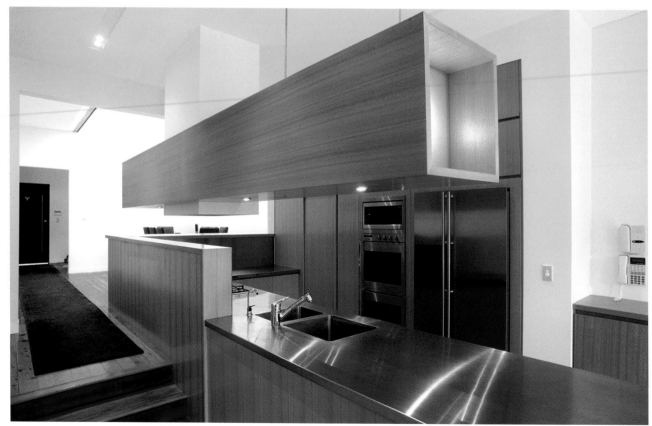

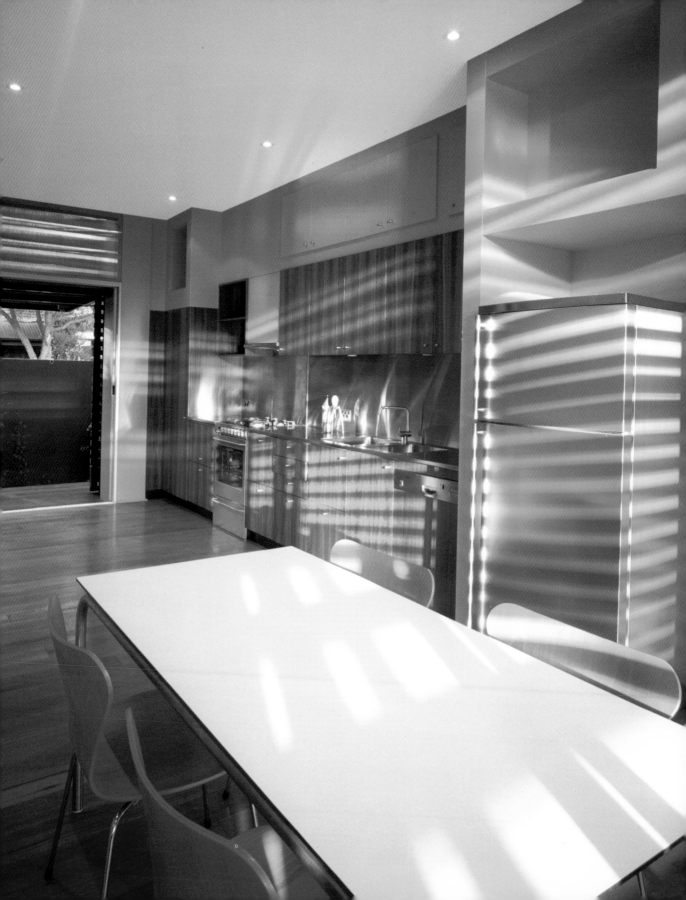

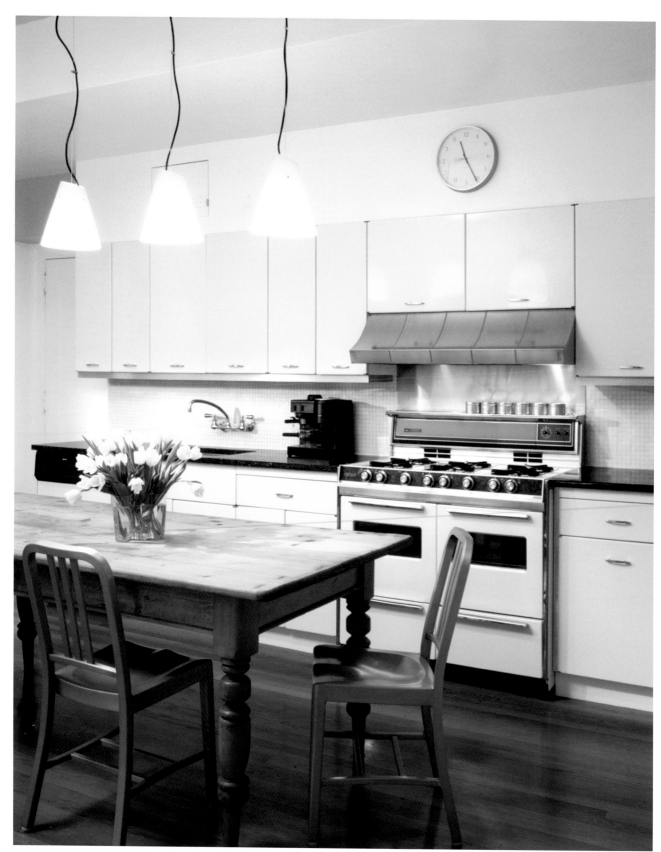

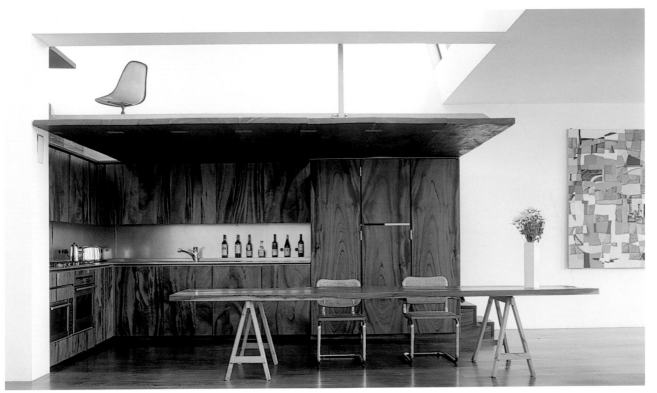

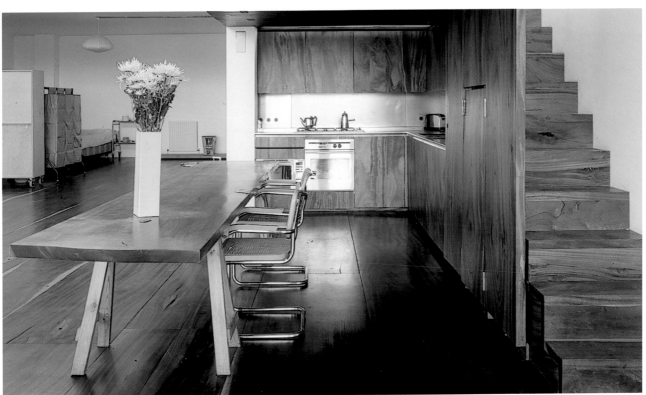

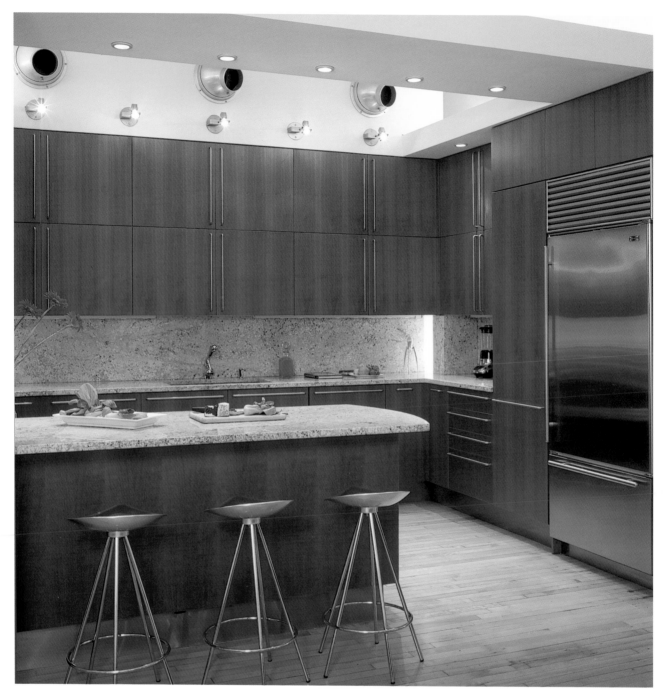

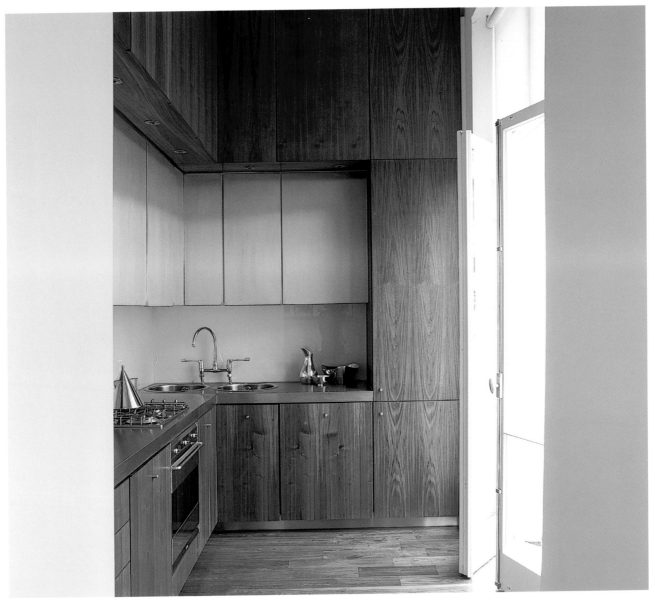

Design by Jonathan Clark Studio
Photo © Jan Baldwin/Narratives

Integration

Both pages
Design by Choon Choi
Photo © Paul Warchol

A bar counter separating the kitchen from the living area is a favourite feature of modern kitchens, as it effectively communicates these two vital areas, in a dynamic but informal use of space.

Die Bartheke ist die ideale Ergänzung der modernen Küche, denn sie integriert den Wohnbereich und betont gleichzeitig den informellen und dynamischen Charakter des Raumes.

Le bar américain complète de manière idéale la cuisine moderne, car il l'intègre à la zone de séjour et accentue le caractère informel et dynamique de l'espace.

La barra americana es el complemento ideal de la cocina moderna, ya que la integra en la zona de estar y enfatiza el carácter informal y dinámico del espacio.

Il bancone all'americana è un complemento ideale della cucina moderna, visto che ne facilita l'integrazione alla zona soggiorno evidenziando il carattere informale e dinamico dello spazio.

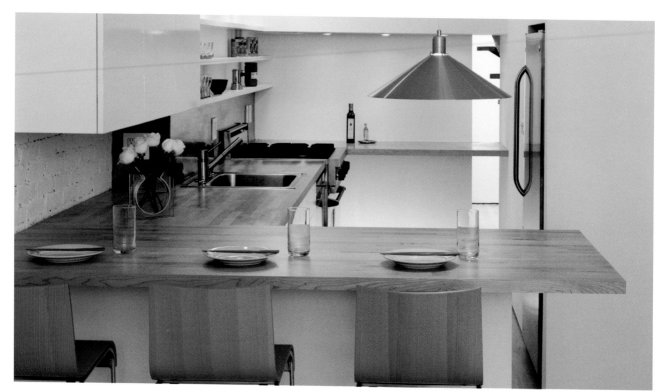

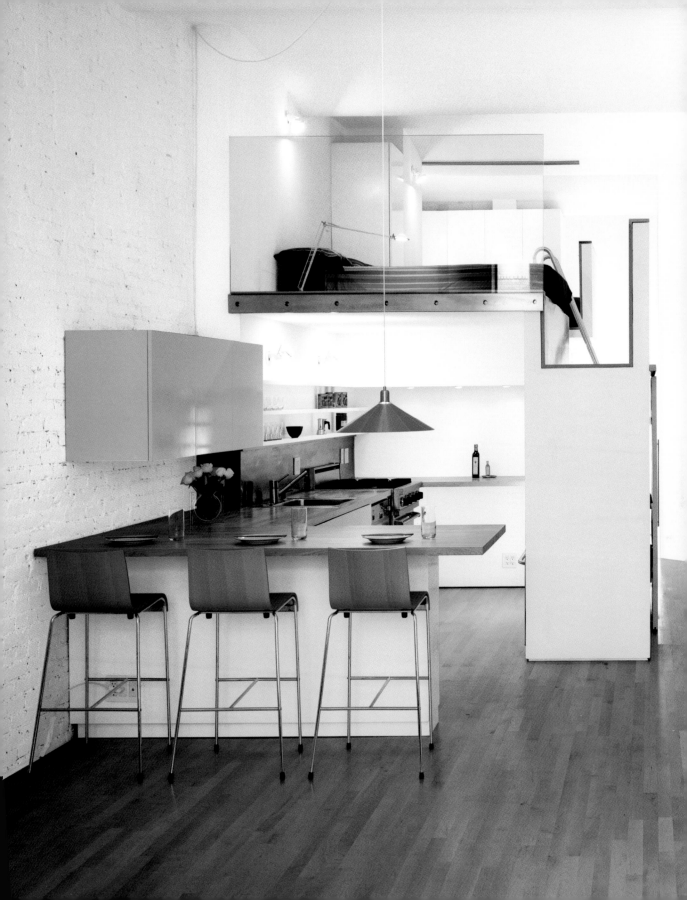

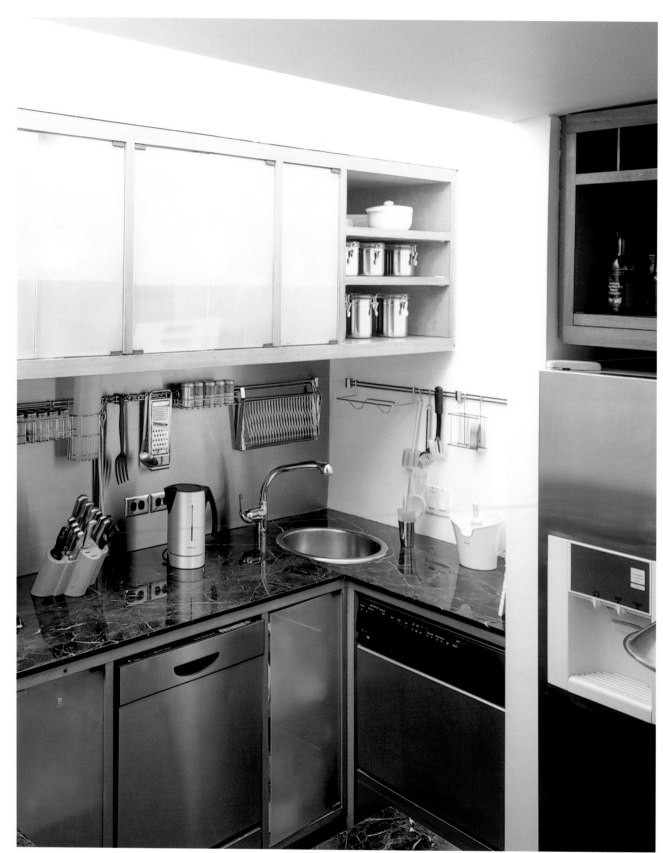

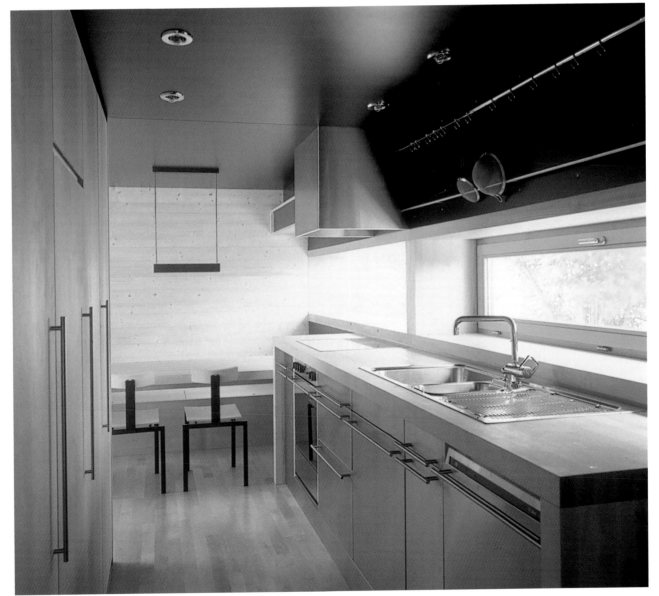

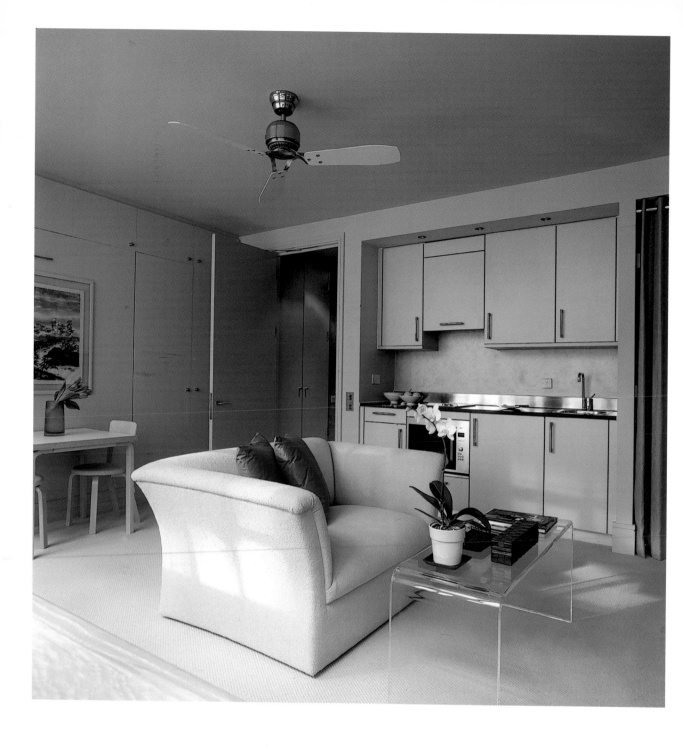

Both pages
Design by René Dekker
Photo © James Silverman

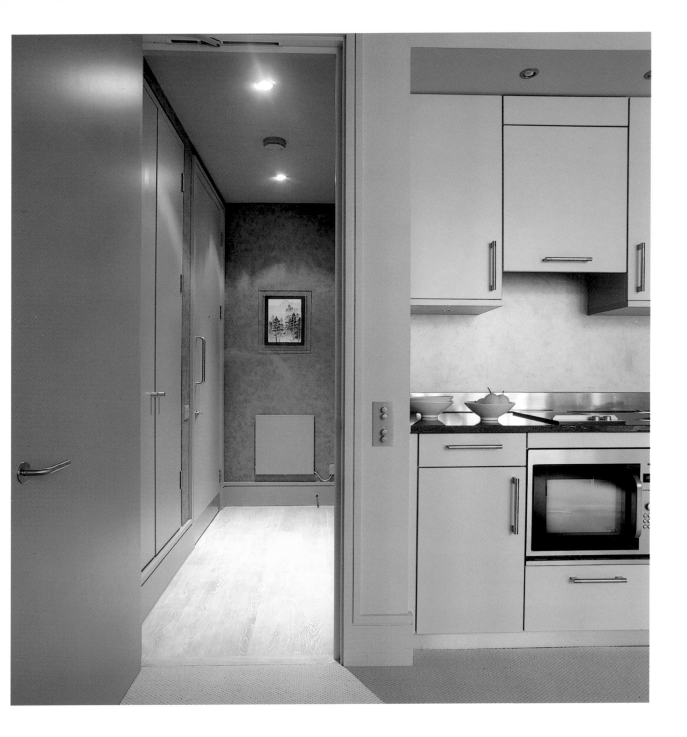

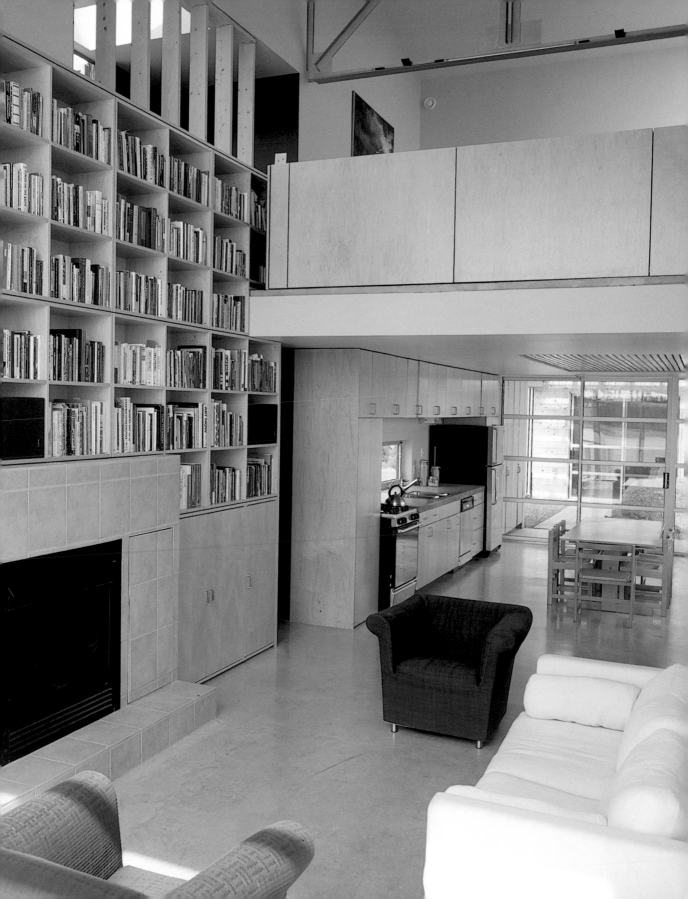

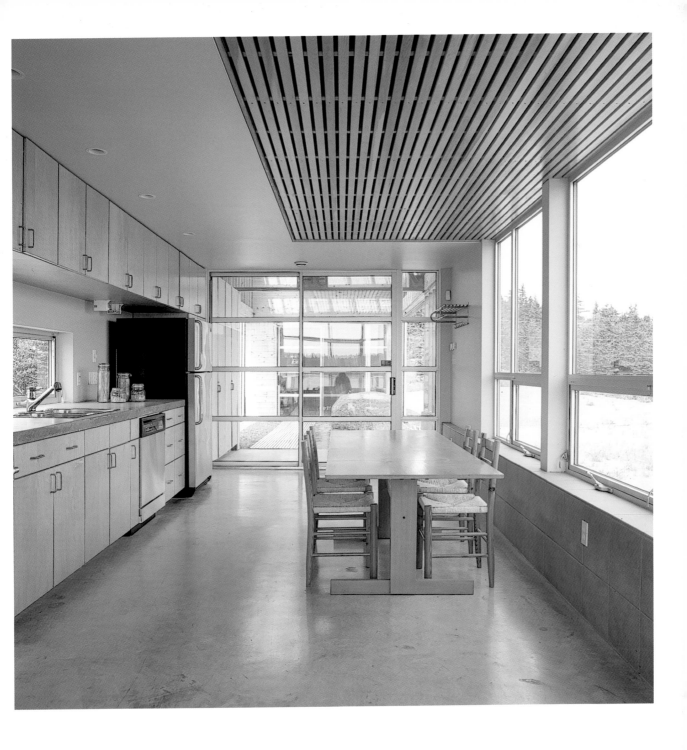

Both pages
Design by Bryan MacKay-Lyons
Photo © Undine Pröhl

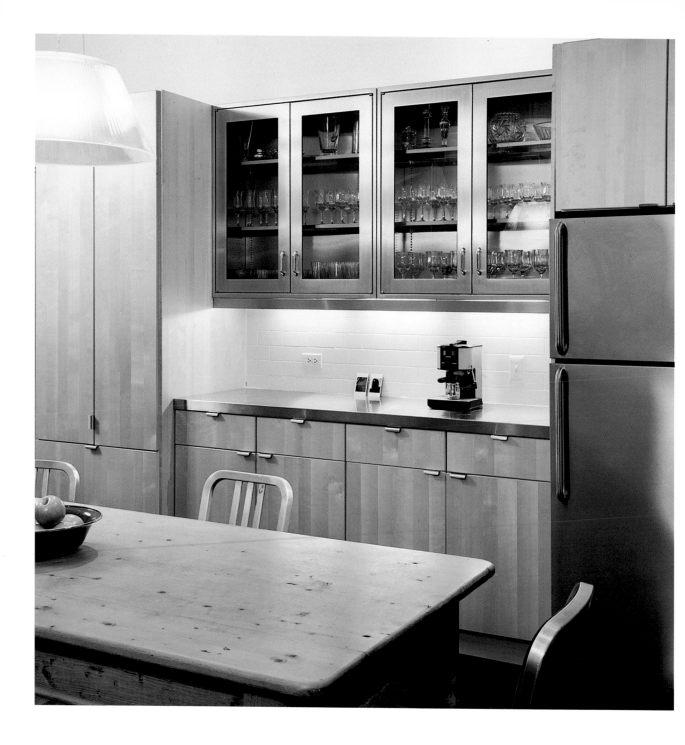

Both pages
Design by Messana O'Rorke Architects
Photo © Elizabeth Felicella

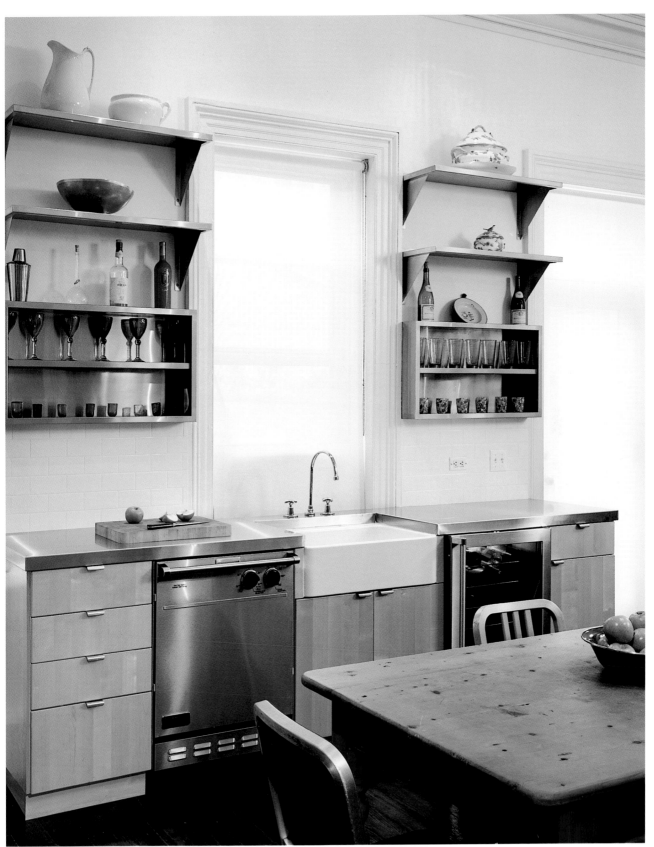

Both pages
Design by Messana O'Rorke Architects
Photo © Elizabeth Felicella

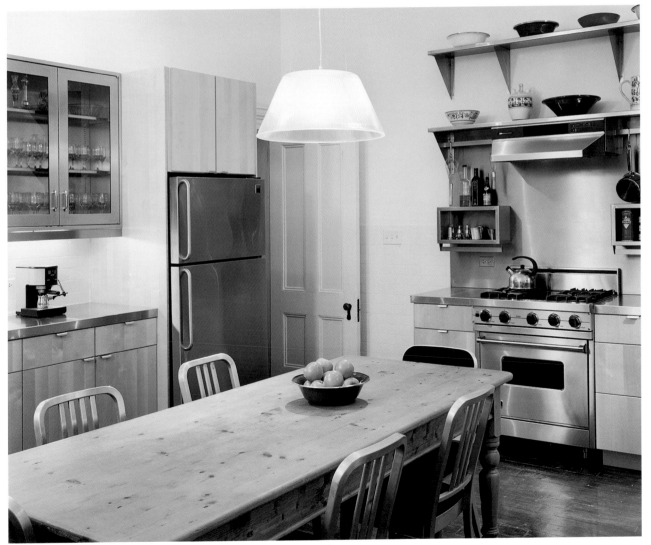

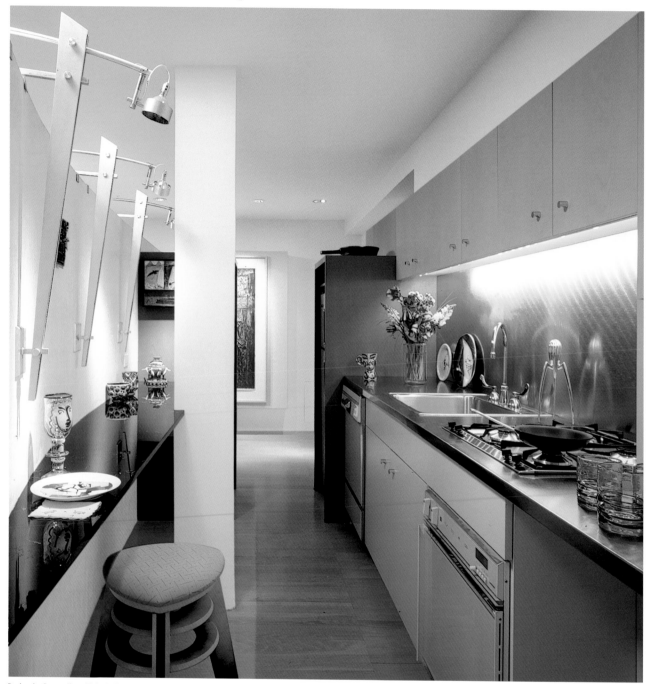

Design by Pasanella + Klein Stolzman + Berg
Photo © Chuck Choi

Design by Leddy Maytum Stacy Architects
Photo © Roger Casas

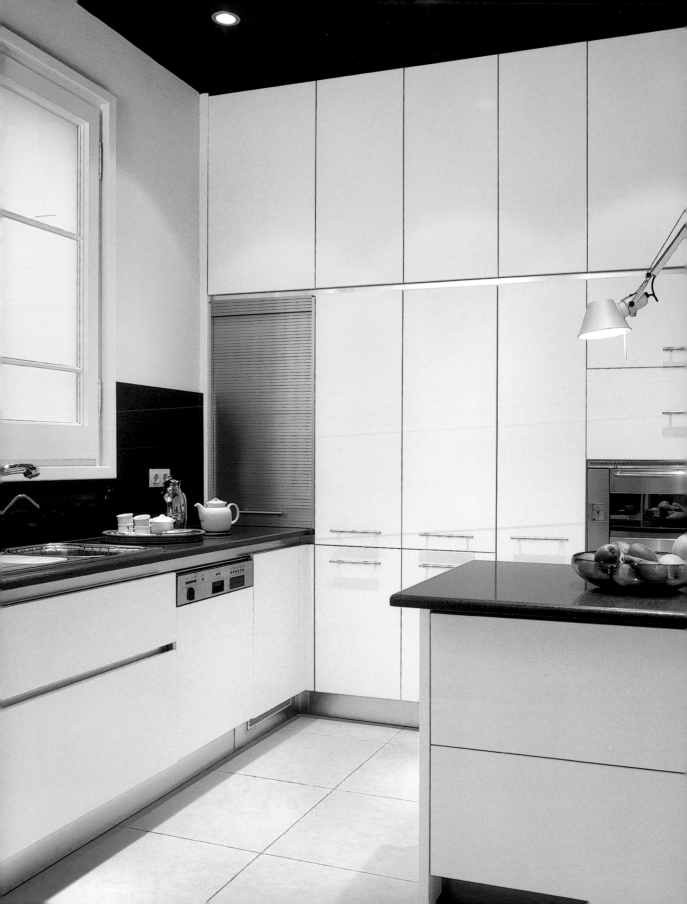

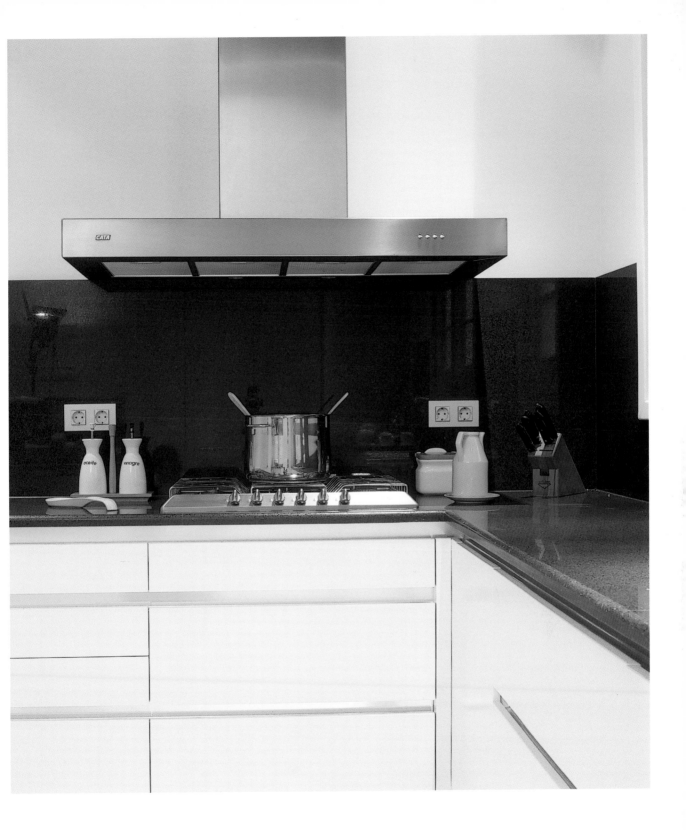

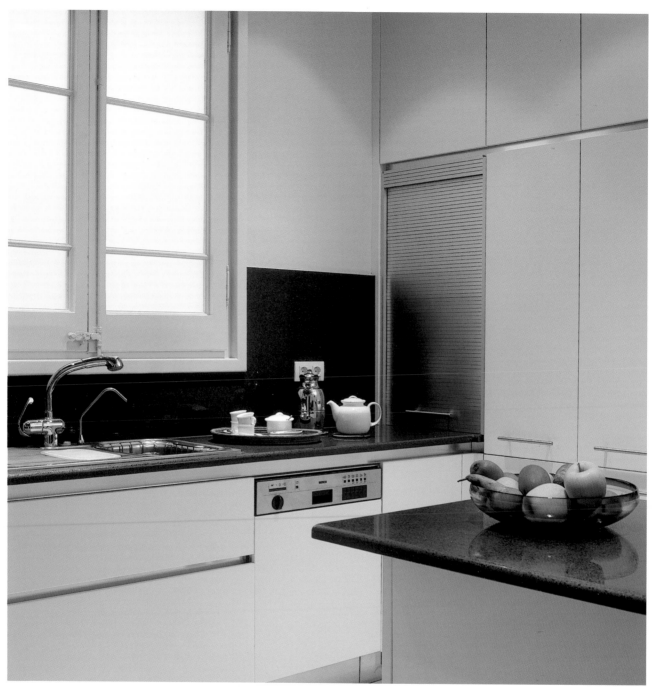

Design by L'Eix
Photo © Jose Luis Hausmann

Design by Voon Wong Architects
Photo © Henry Wilson

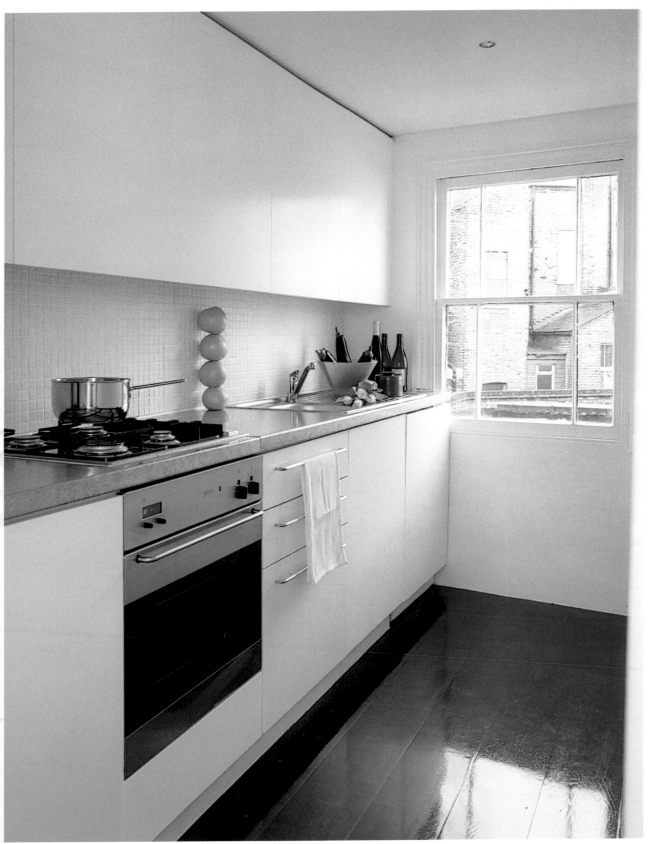

Island

Design by Graftworks Architecture + Design
Photo © David Joseph

Kitchens featuring an island are especially inviting for bringing social activities closer to the work areas, and are perfect for gourmet get-togethers.

Die Kochinsel in der Mitte der Küche lädt zum Treffen um den Arbeitsbereich ein und ist daher bestens geeignet für alle, die sich gern über ihre neuesten kulinarischen Erfahrungen austauschen möchten.

Un îlot central, intégré à la cuisine, favorisant les contacts autour du plan de travail, est la configuration idéale pour se rencontrer et pour les échanges culinaires entre passionnés de cuisine.

La cocina que incorpora una isla central favorece el encuentro alrededor de la zona de trabajo y es ideal para el trato social así como para los aficionados a los intercambios culinarios.

La cucina che presenta un'isola centrale favorisce l'incontro attorno alla zona di lavoro, ed è ideale per momenti di socializzazione e per gli amanti degli scambi culinari.

Design by Geli Salzman
Photo © Ignacio Martínez

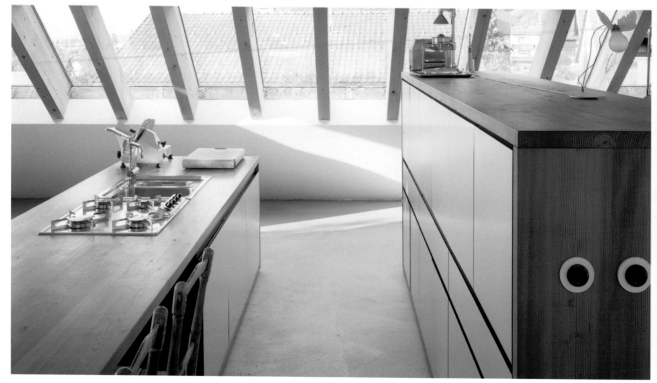

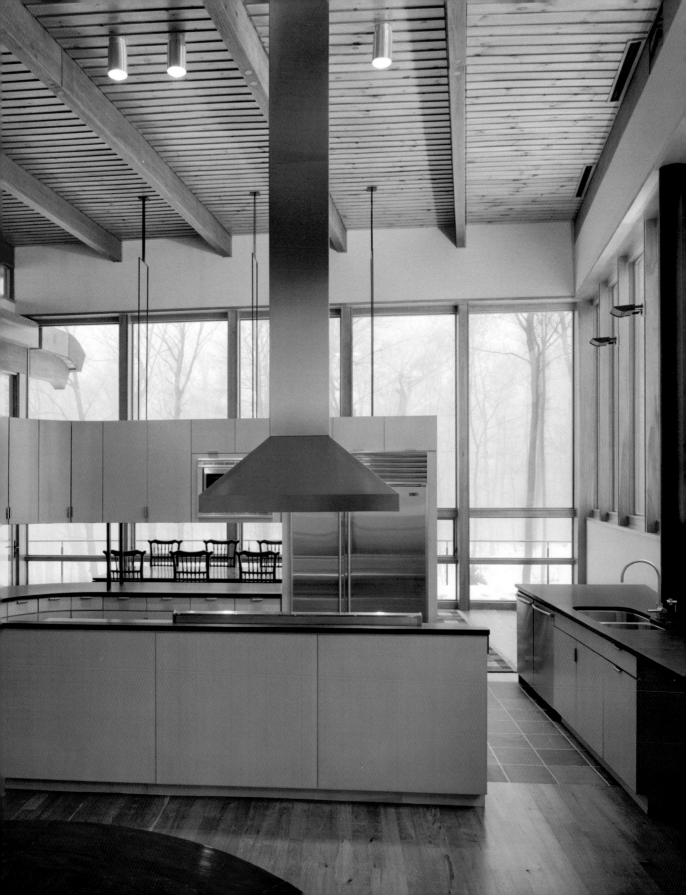

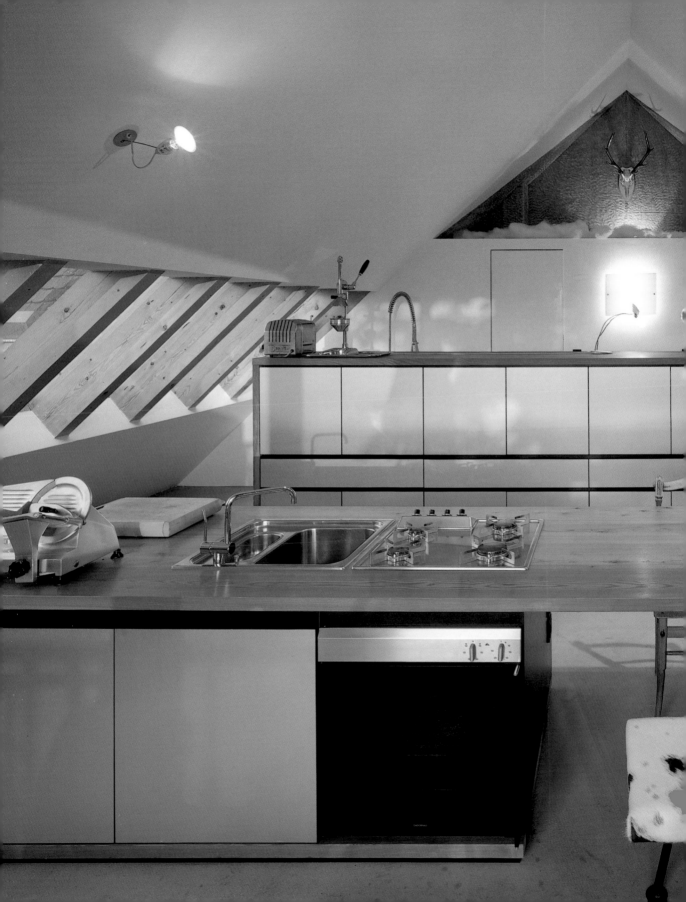

Design by Geli Salzmann
Photo © Ignacio Martínez

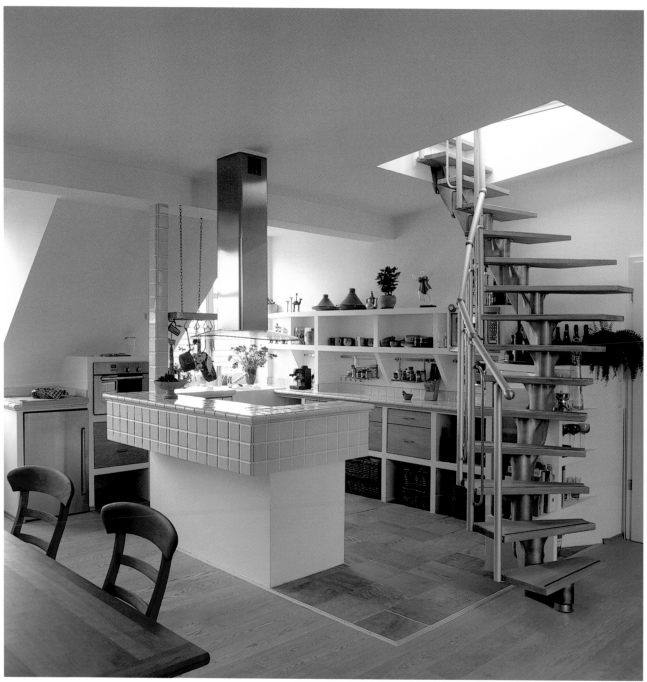

Design by Mike Haas
Photo © Wini Sulzbach

Design by Odile Veillon
Photo © Hervé Abbadie

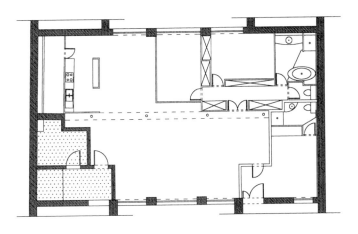

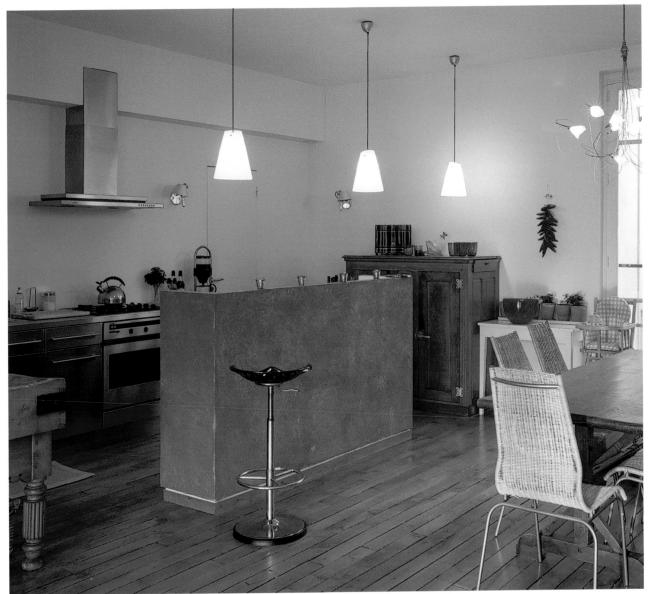

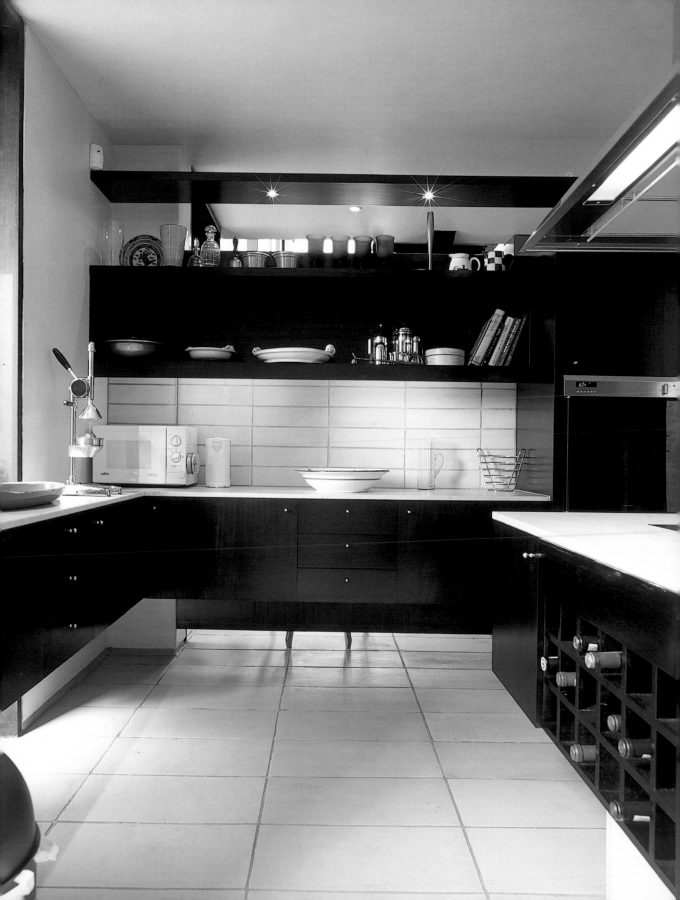

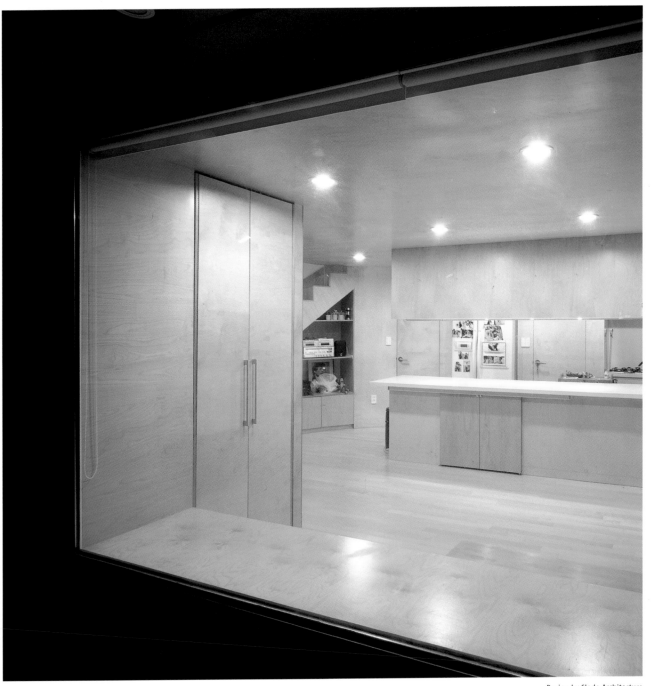

Design by Slade Architecture
Photo © Yong Kwan Kim

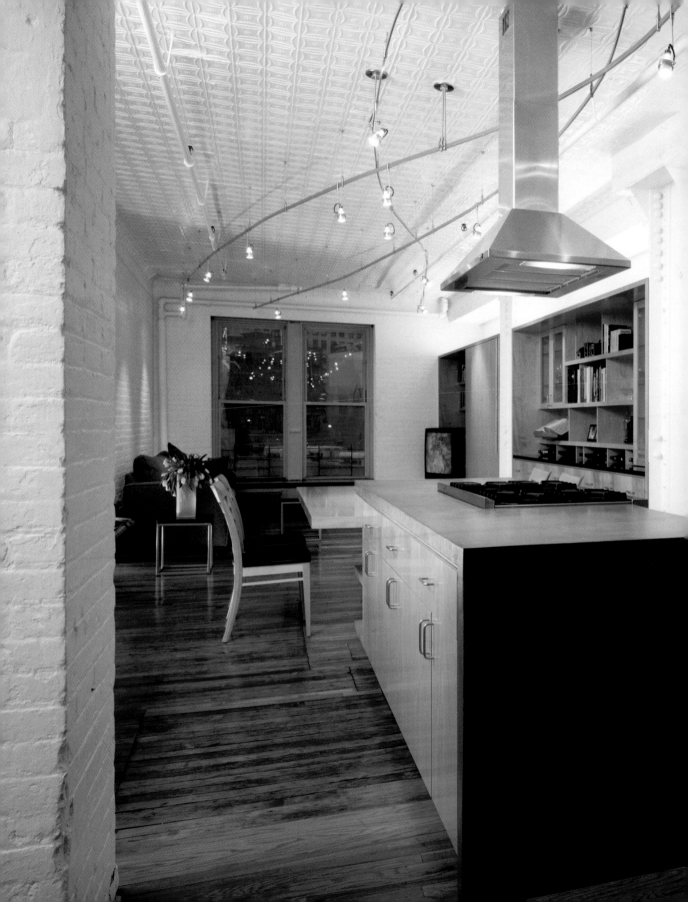

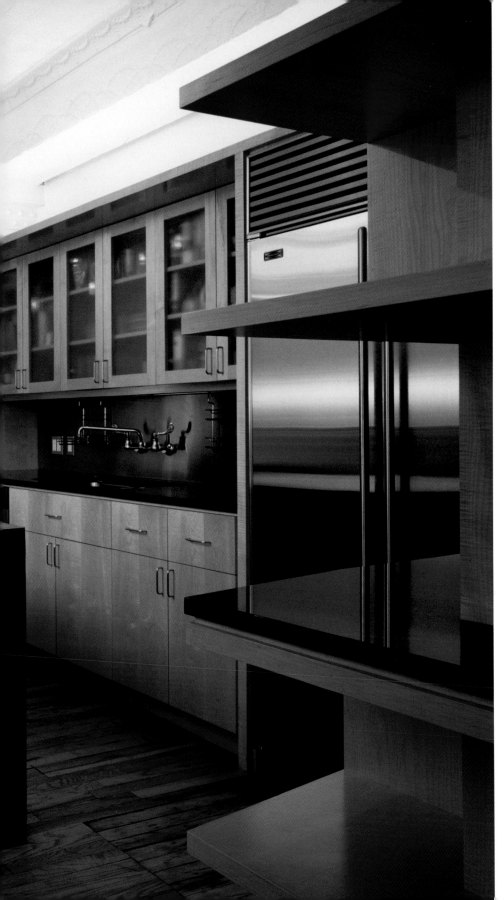

Design by Resolution: 4 Architecture
Photo © Eduard Hueber

131

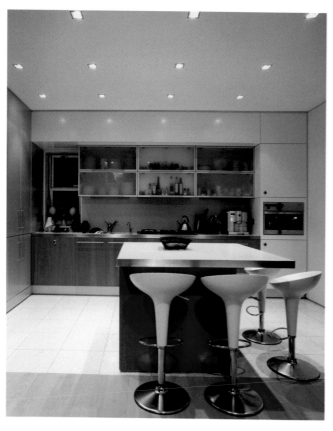

Both photos
Design by X.Pace Design Group
Photos © Marian Riabic

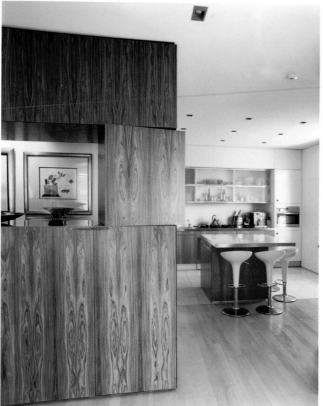

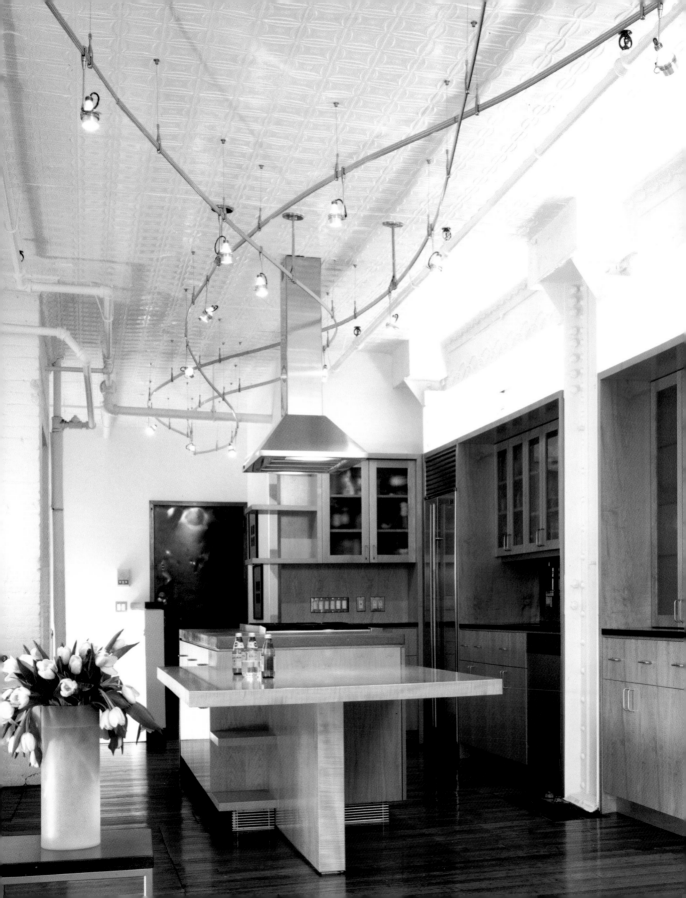

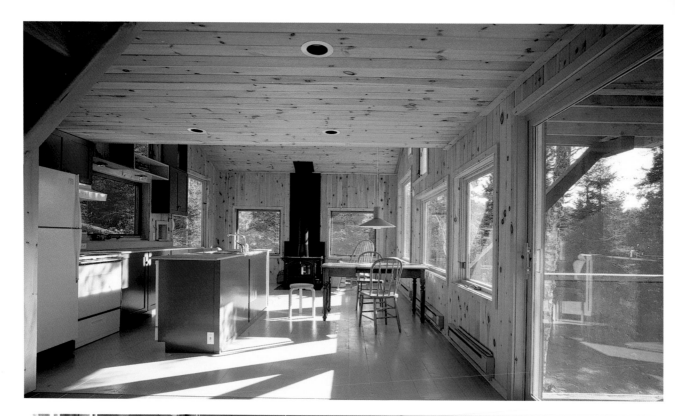

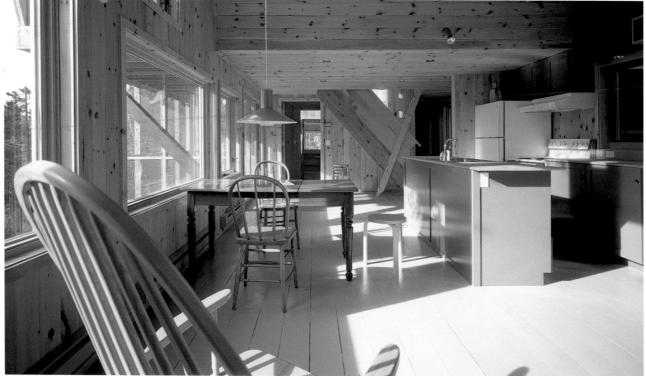

Both photos
Design by David Salamea
Photos © Peter Kerze

Design by Deborah Berke
Photo © Catherine Tighe

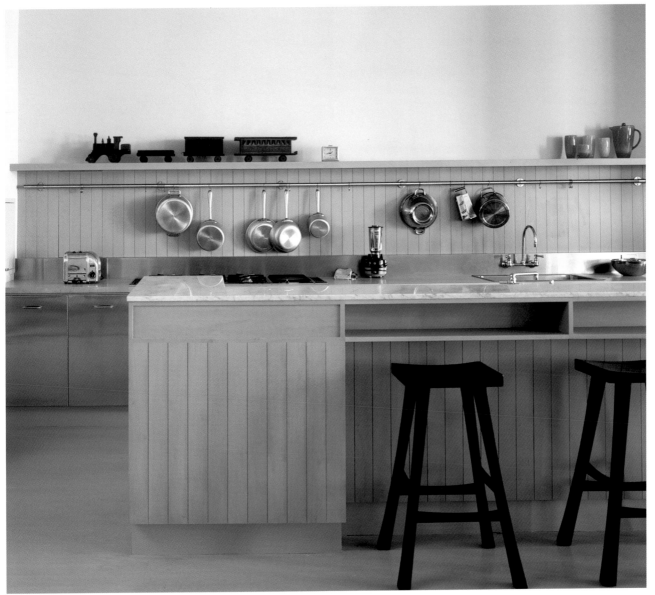

Furniture

Design by Lab Design
Photo © Heltmut Hilb

A wooden table is an ideal complement to central work stations, placed close or next to the island, either as a supplementary work surface or as a place to serve meals.

Zusätzlich zur Mittelinsel findet man in der Nähe oft einen Holztisch, der als Abstellfläche dient, aber auch zum Essen genutzt werden kann.

L'îlot central peut être agrémenté d'une table en bois à proximité ou attenante, pour servir de surface d'appoint où prendre les repas.

La isla central puede complementarse con una mesa de madera, cercana o adyacente, que sirva de superficie de apoyo o para comer.

L'isola centrale si può completare con un tavolo in legno aggiuntivo, disposto attiguamente o attaccato alla struttura centrale, che serva da superficie di appoggio o tavolo dove consumare pasti.

Design by Architectenbureau K2
Photo © Herman van Doorn

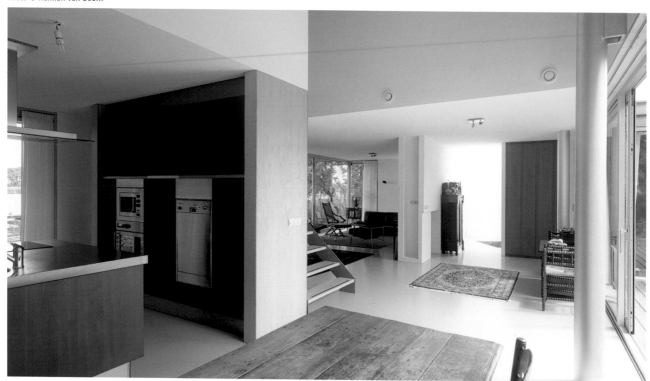

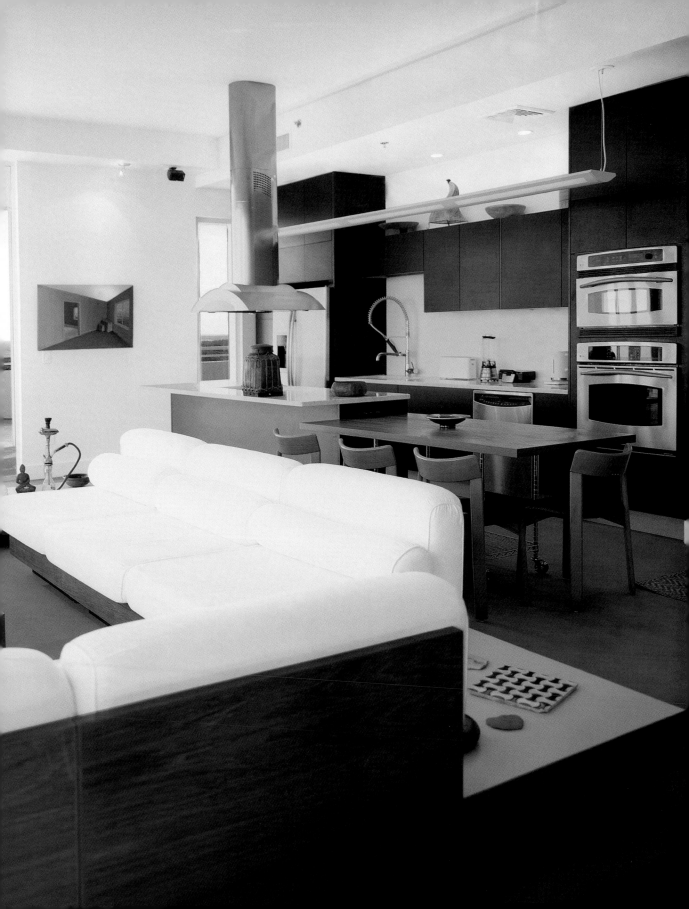

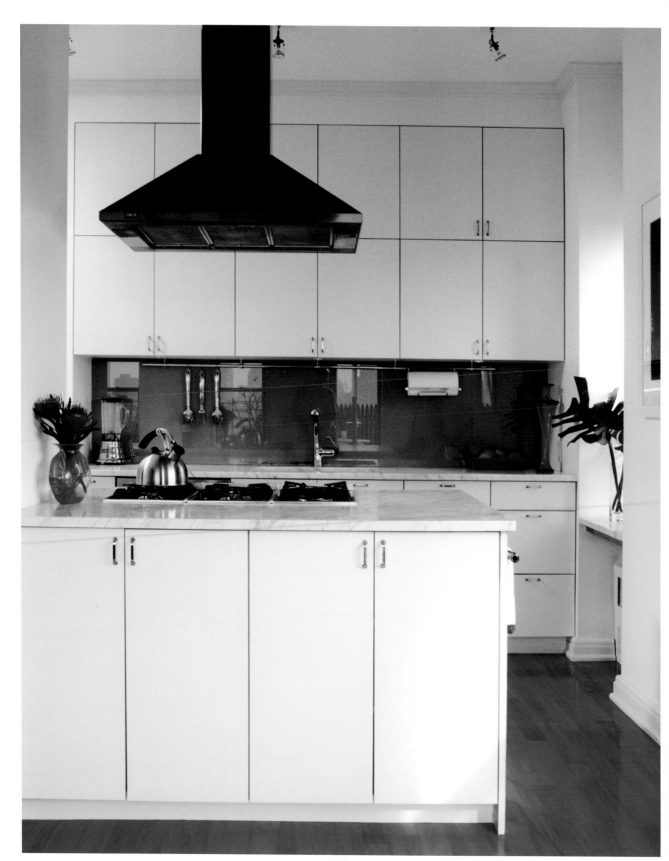

Both pages
Design by EFM Design
Photo © Michael O'Neill

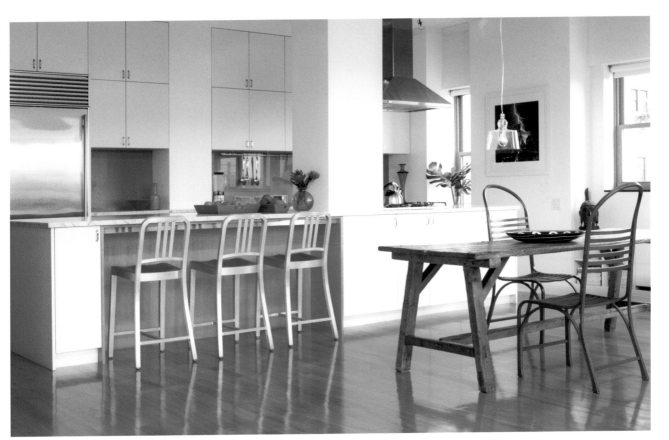

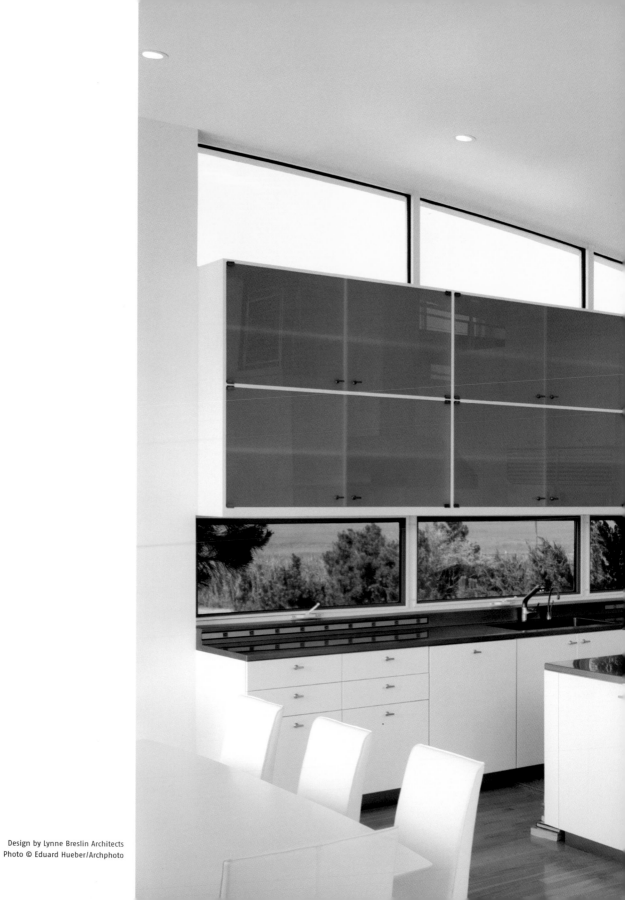

Design by Lynne Breslin Architects
Photo © Eduard Hueber/Archphoto

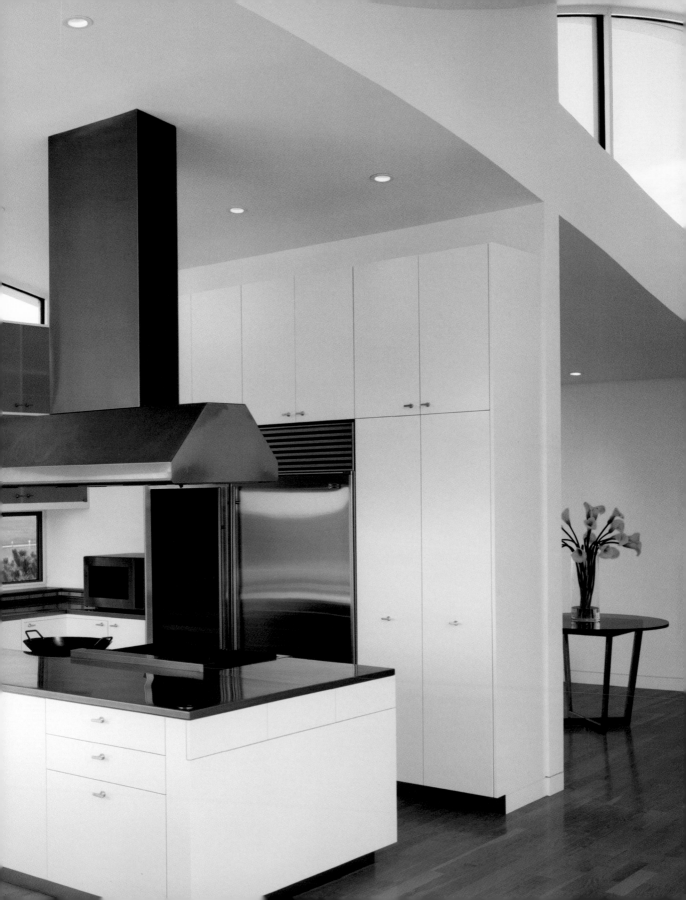

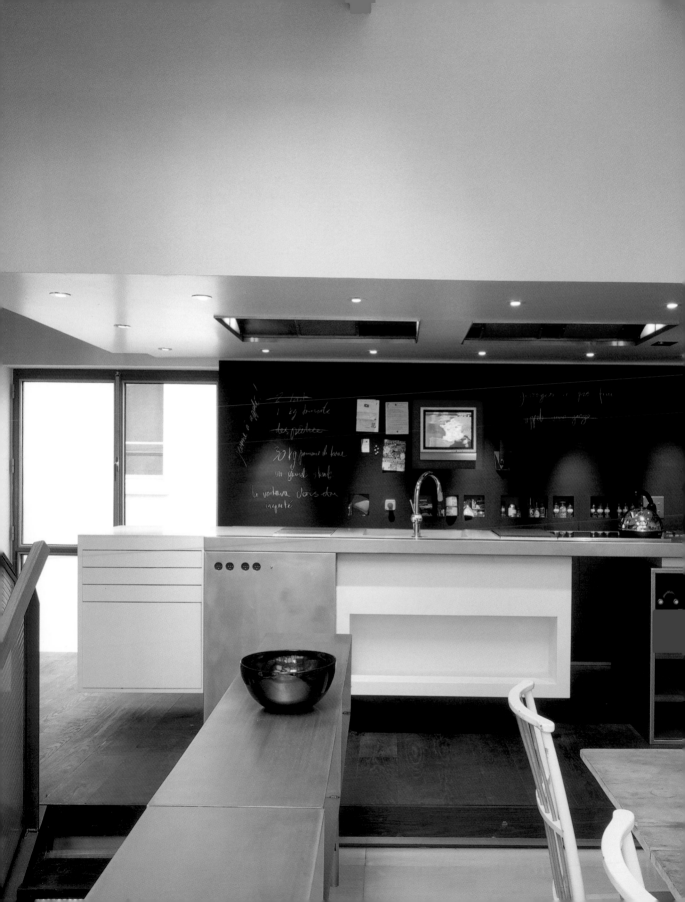

Both pages
Design by Insite Architecture
Photo © Georges Fessy

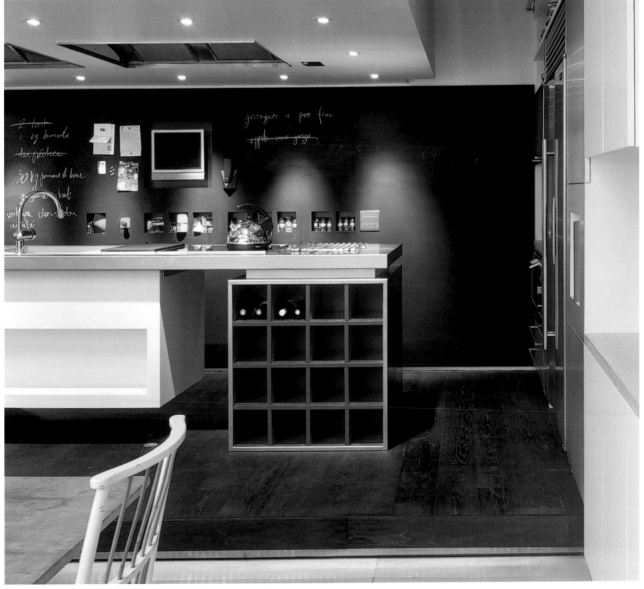

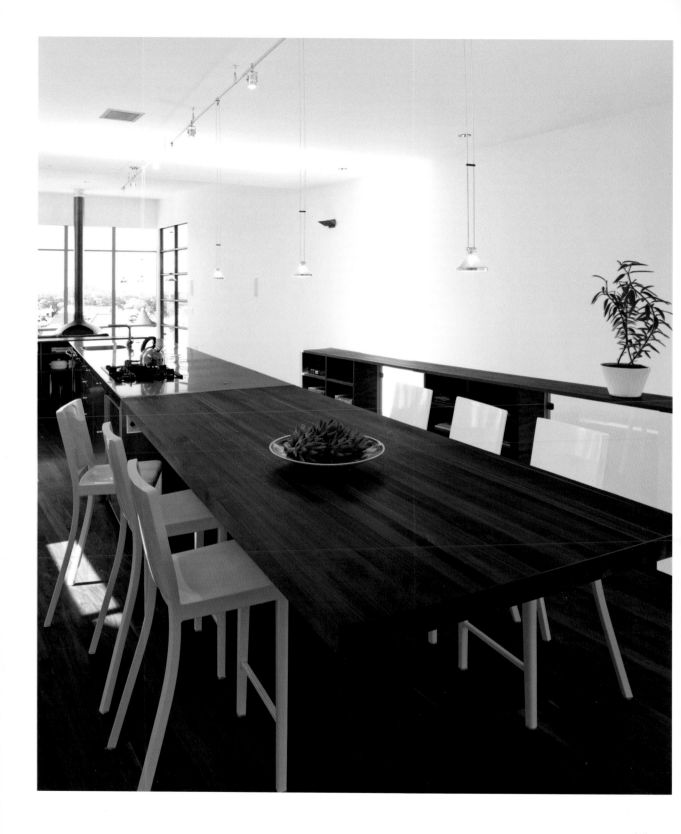

Both pages
Design by CCS Architecture
Photo © Tim Griffith

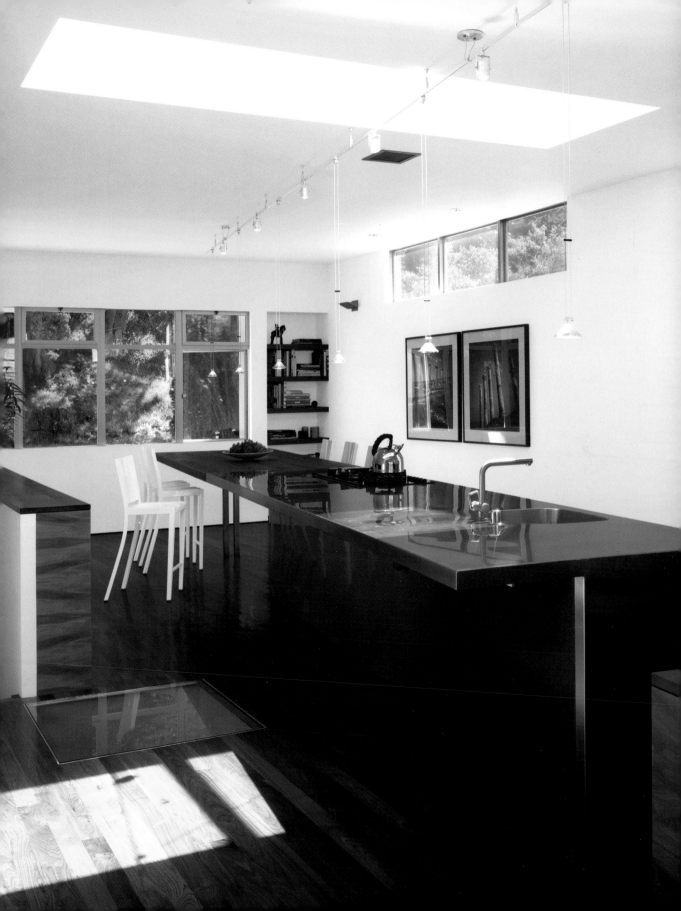

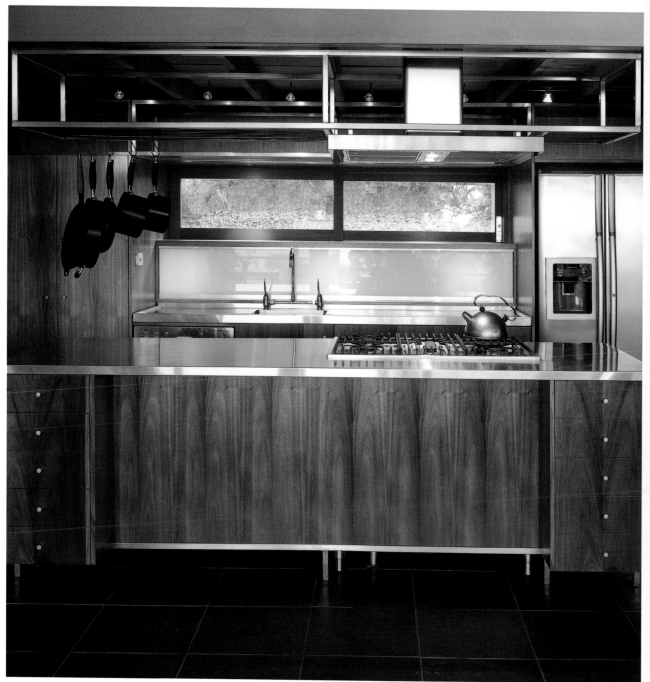

Design by C+C Design
Photo © Murray Fredericks

Design by Prima Design
Photo © Giorgio Baroni

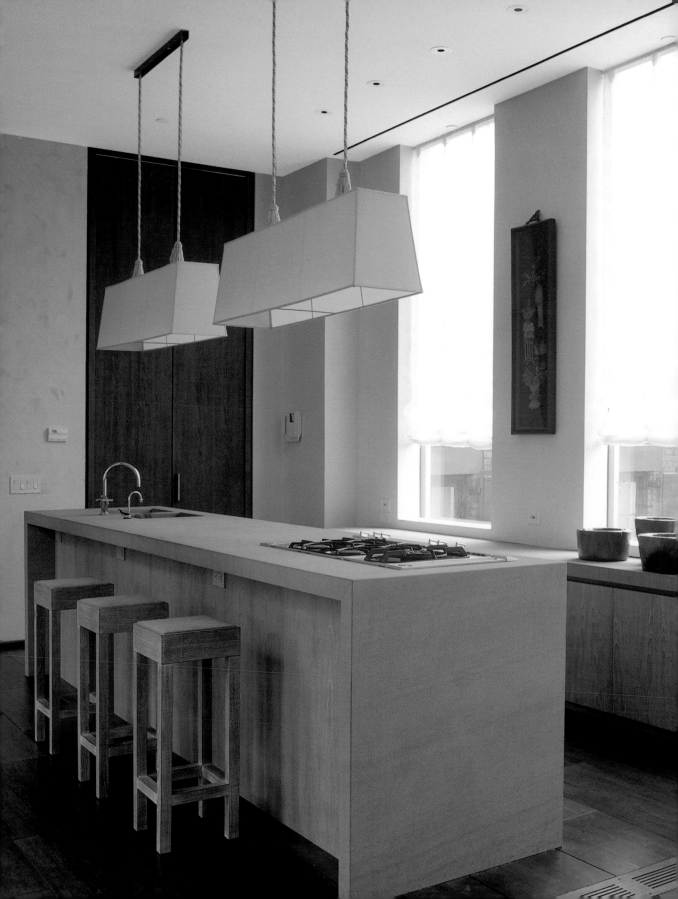

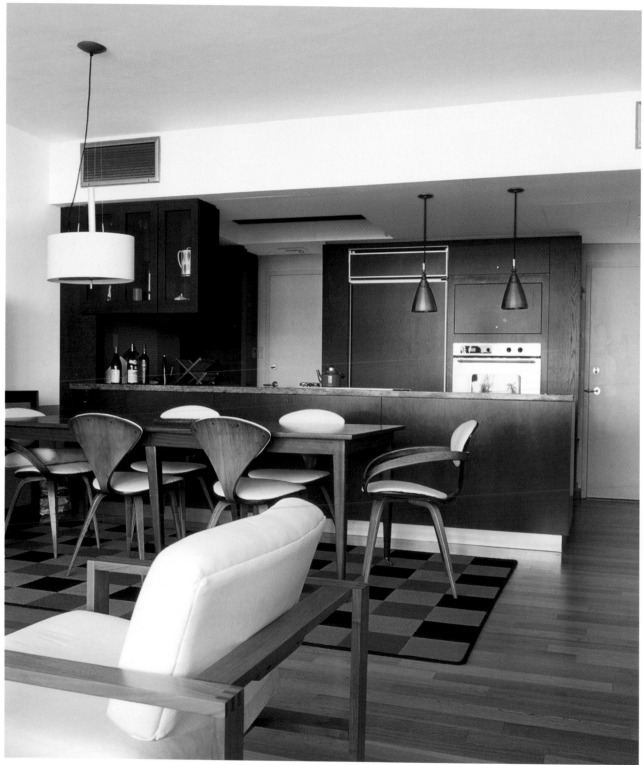

Design by Allan T. Shulman
Photo © Pep Escoda

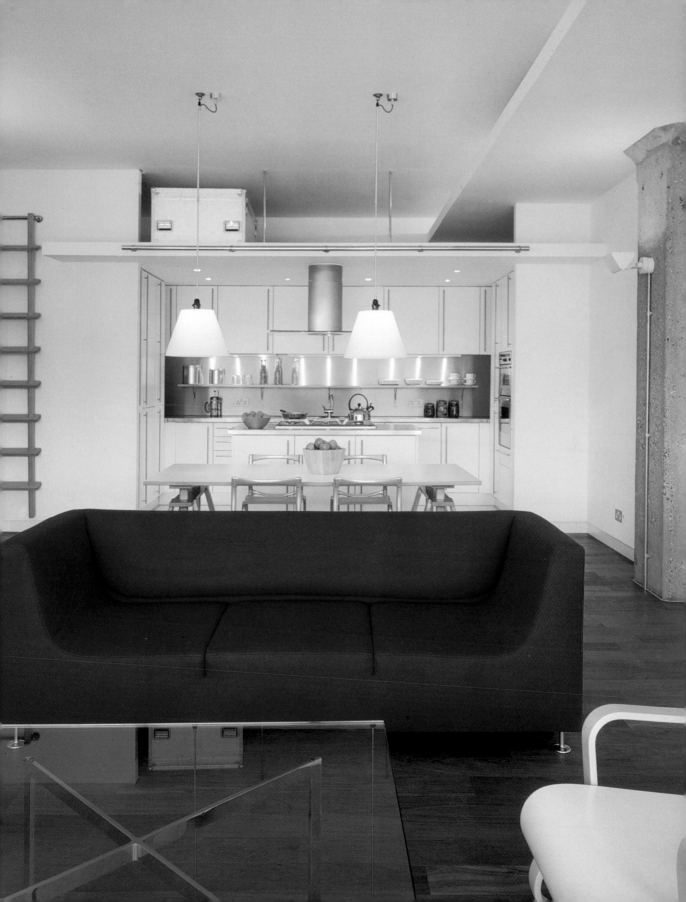

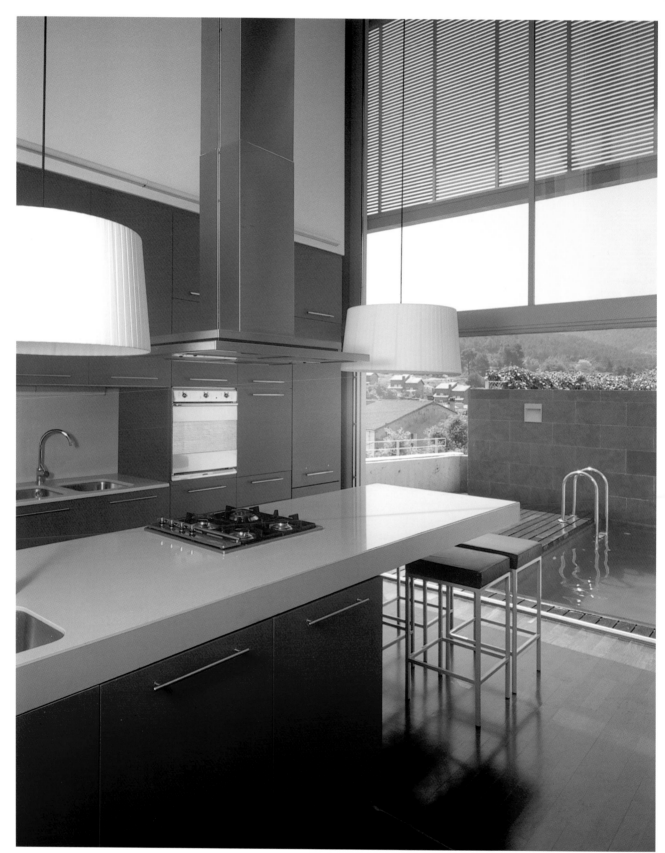

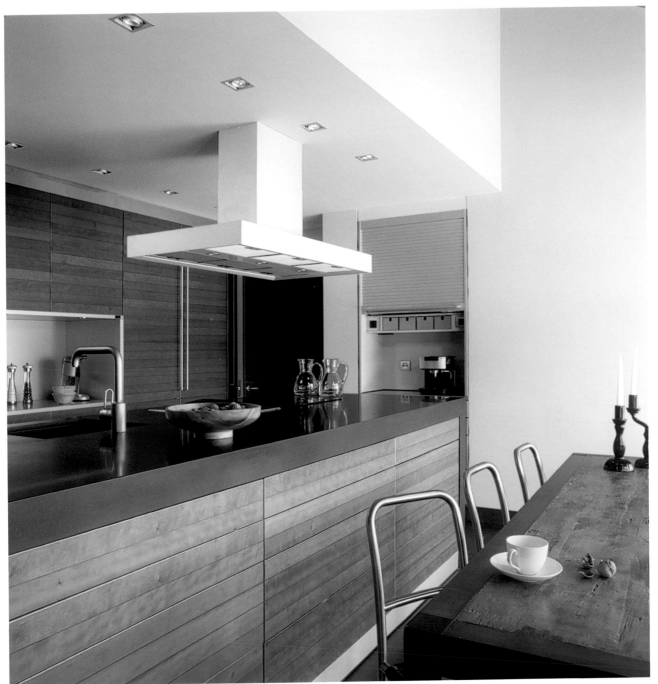

Design by Fátima Vilaseca
Photo © Jordi Miralles

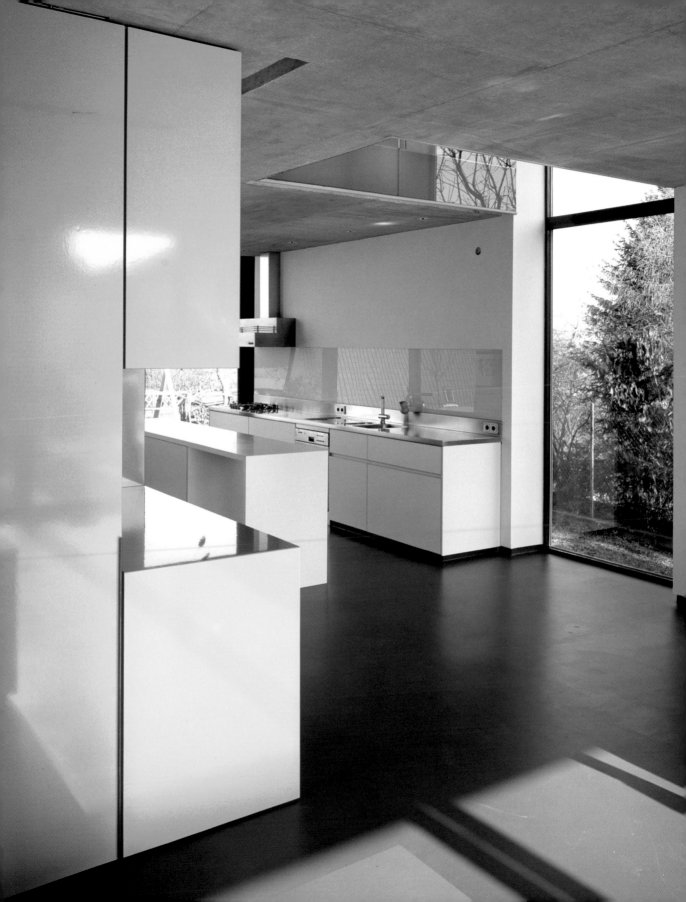

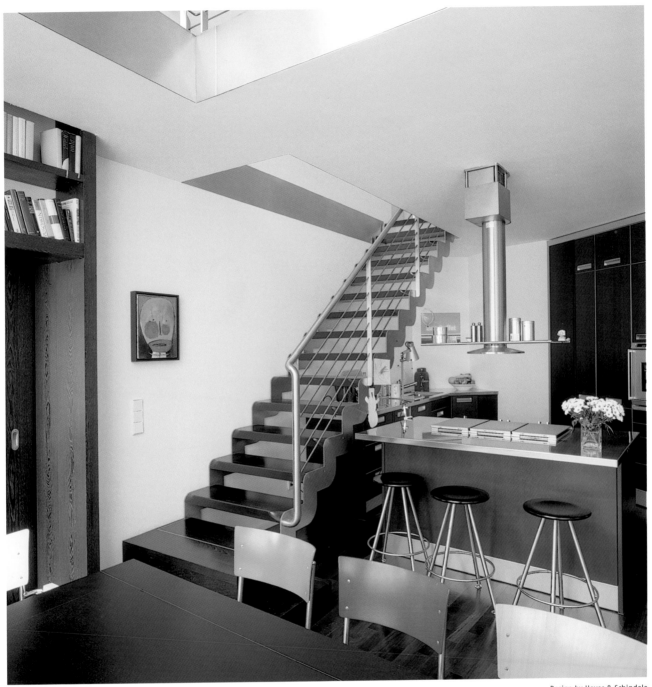

Design by Hoyer & Schindele
Photo © Concrete

Design by Netzwerk Architekten
Photo © Jörg Hempel

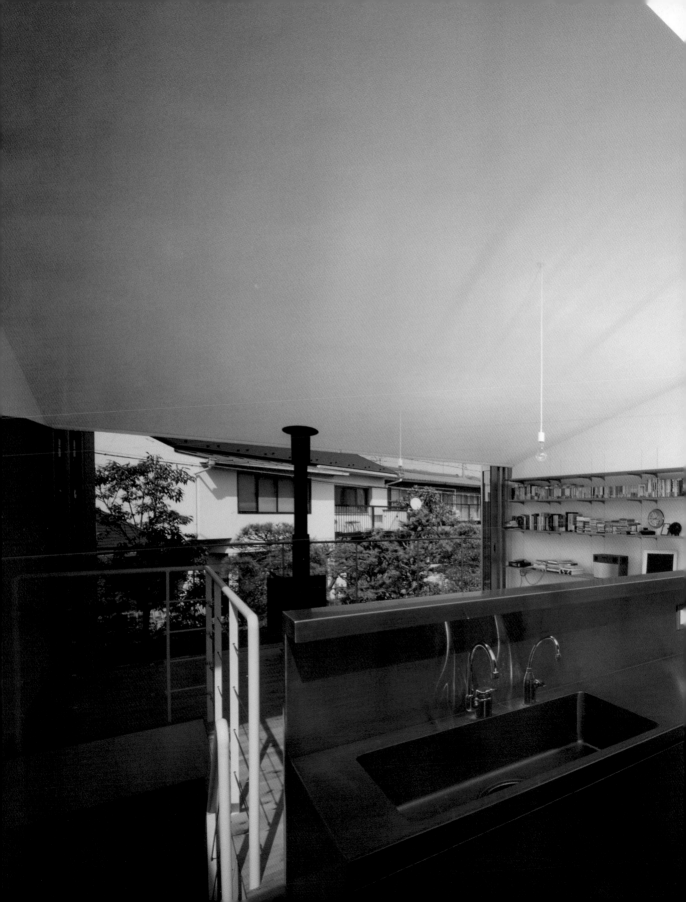

Design by Tezuka Architects, Masahiro Ikeda
Photo © Katsuhisa Kida

Mixed areas

Design by Bonetti/Kozerski Studio
Photo © Matteo Piazza

An island fitted lengthways is very handy when the kitchen floor-space needs to be divided: for instance, when the circulation space for a flight of stairs is shared with the kitchen.

Eine langgestreckte Kochinsel ist angebracht, wenn man verschiedene Bereich definieren muss, z.B. um die Küche vom Durchgangsbereich einer Treppe zu trennen.

Un îlot longitudinal est pratique pour diviser l'espace de la cuisine, notamment lorsqu'il faut le partager avec la zone d'accès à l'escalier.

Una isla longitudinal resulta práctica a la hora de dividir el espacio de la cocina, por ejemplo cuando éste tiene que ser compartido con la zona de circulación de una escalera.

Se lo spazio della cucina va separato, un'isola longitudinale può risultare pratica, per esempio quando l'ambiente va condiviso con la zona di passaggio di una rampa di scale.

Design by Ebers Architekten
Photo © Linus Lintner

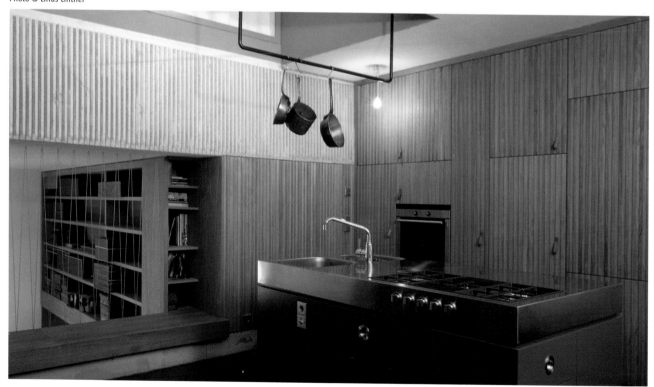

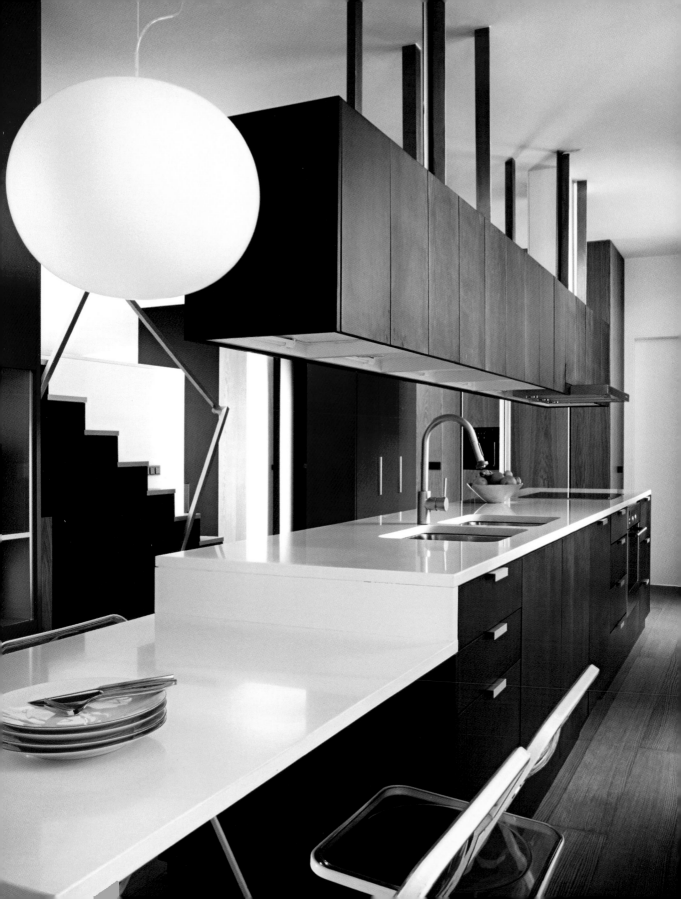

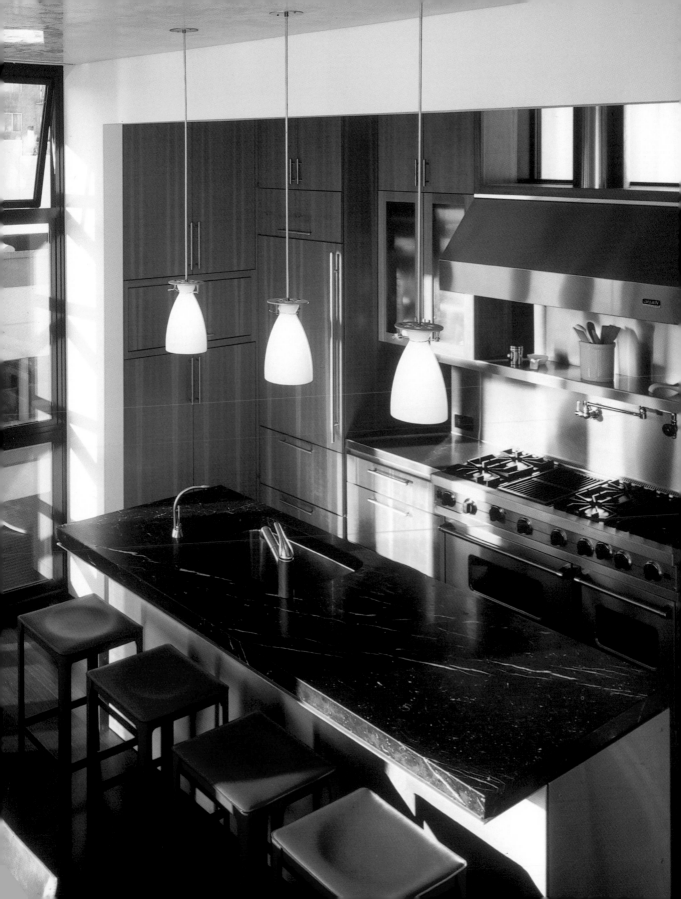

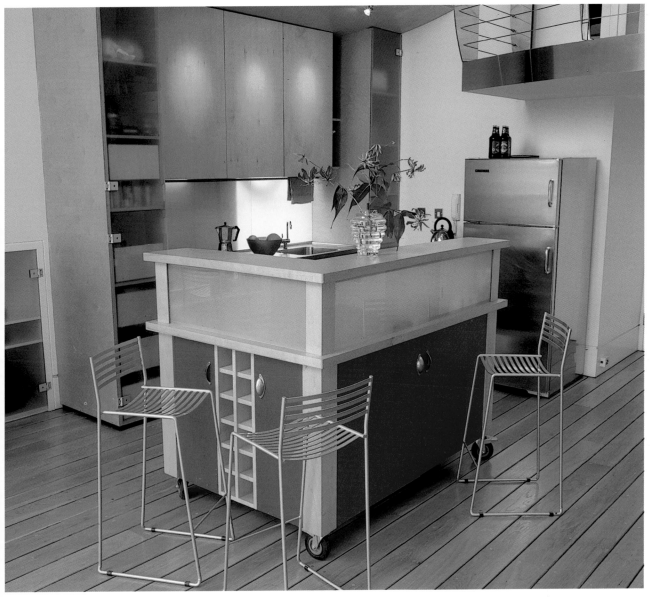

Design by Thomas de Cruz Architects/Designers
Photo © Nick Phibedge

Design by Leddy Maytum Stacy Architects
Photo © Richard Barnes

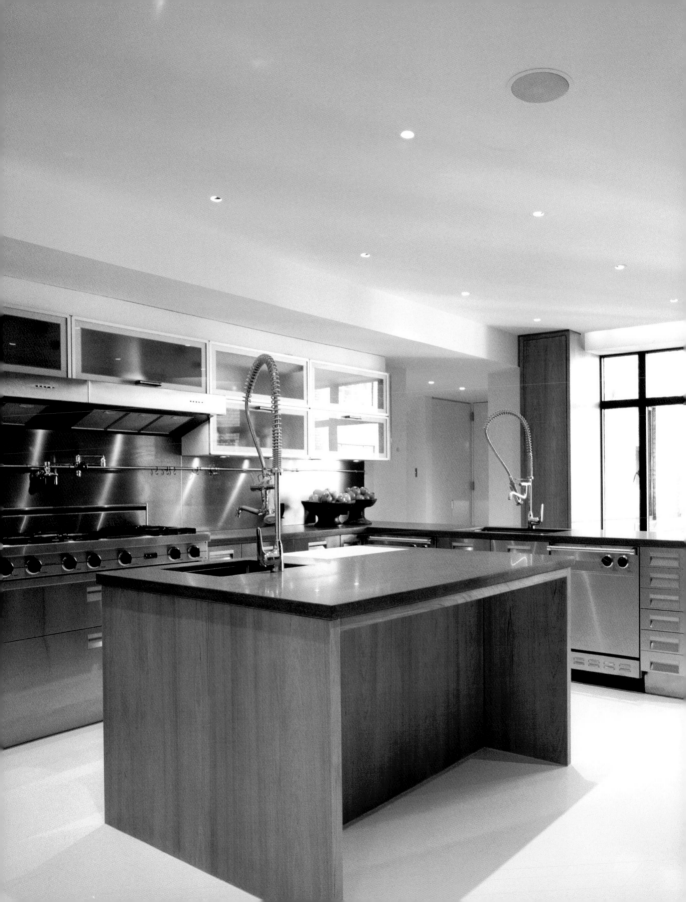

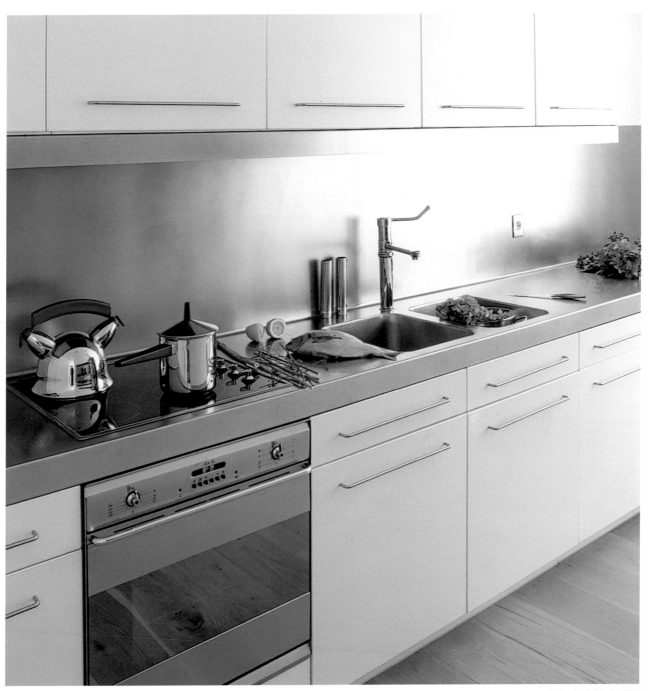

Design by Christophe Pillet
Photo © Jean François Jaussaud

Design by Ramón Pintó
Photo © Jordi Miralles

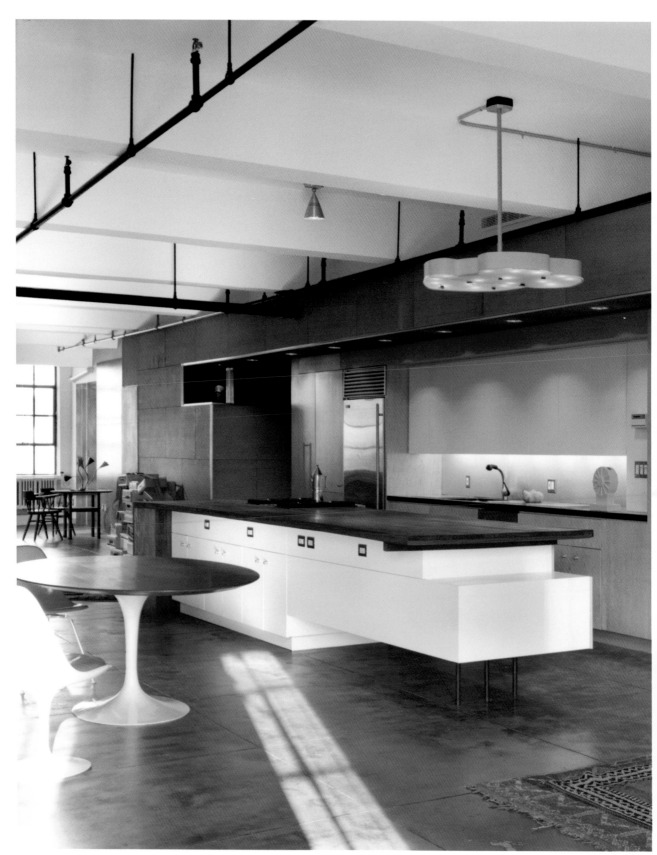

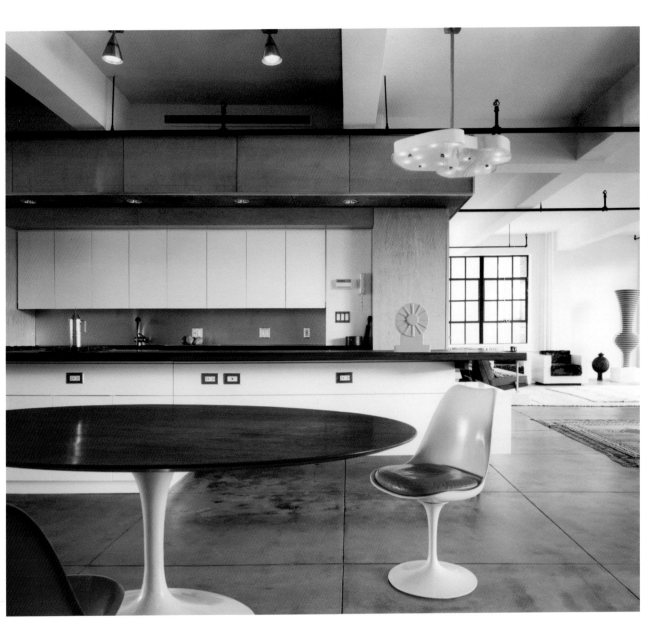

Both pages
Design by Resolution: 4 Architecture
Photo © Eduard Hueber

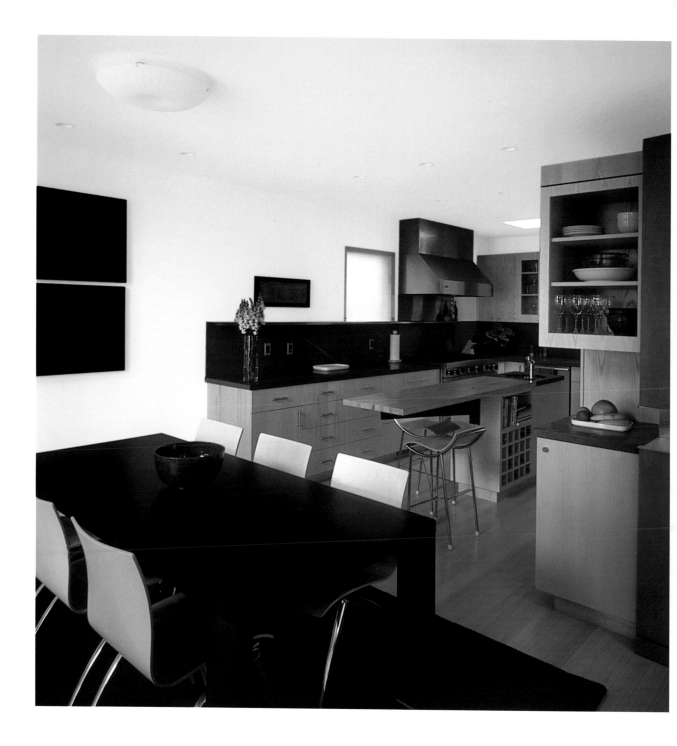

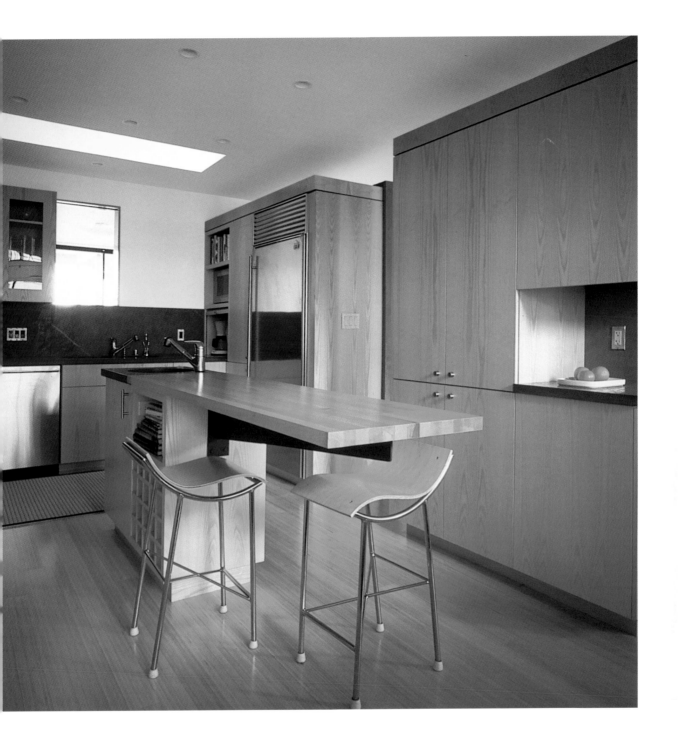

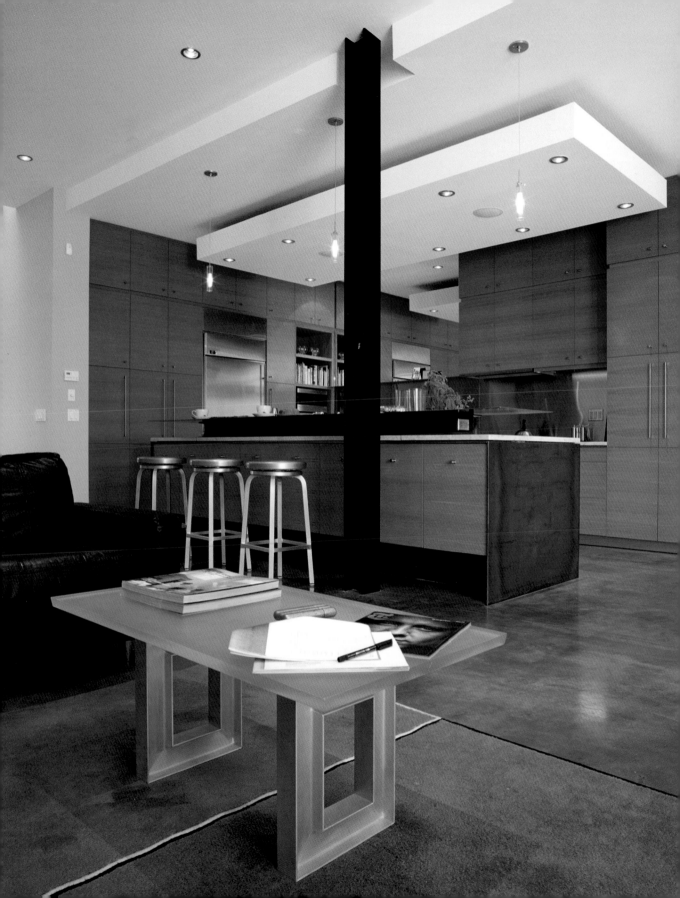

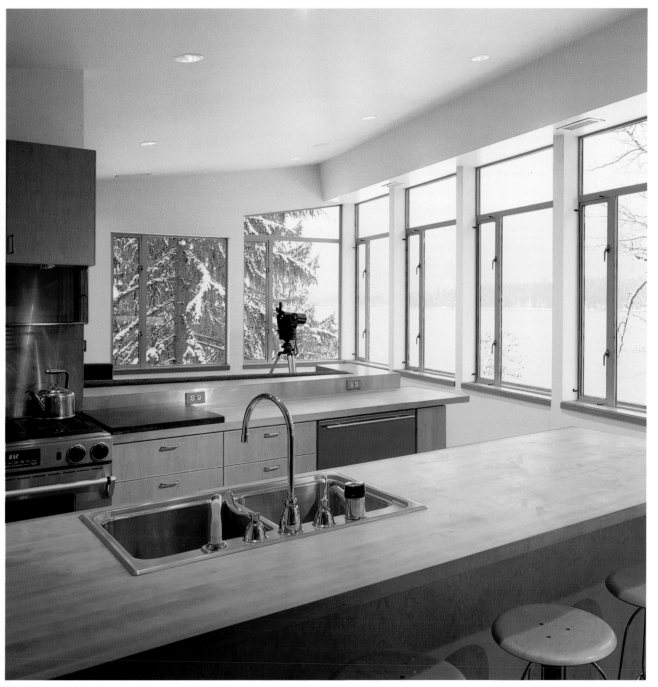

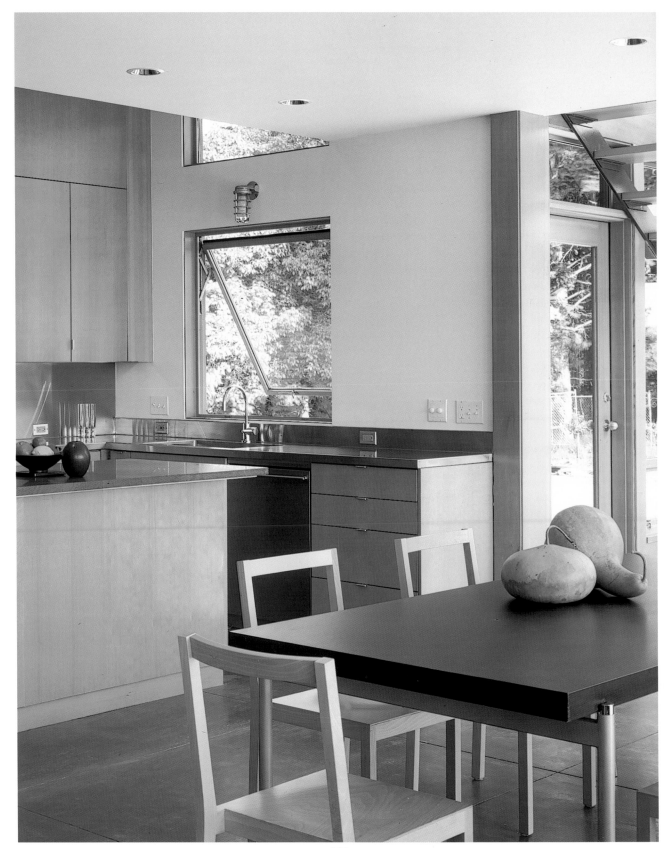

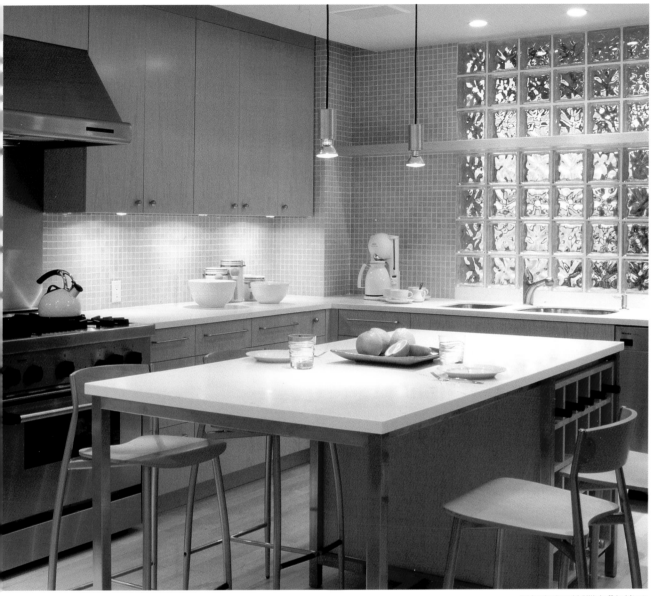

Design by Donald Billinkoff Architects
Photo © Elliot Kaufman Photography

Design by Eric Cobb
Photo © Paul Warchol

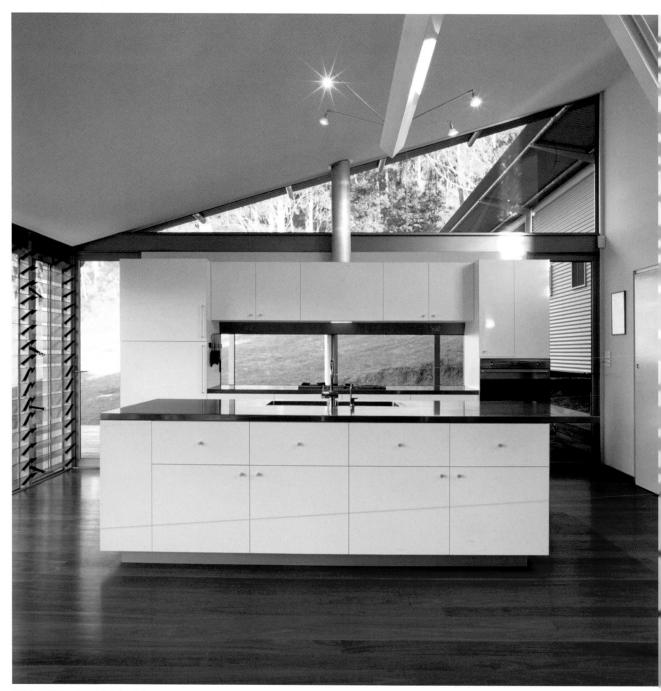

Design by Edward Szewczyk & Associates
Photo © Michael Saggus

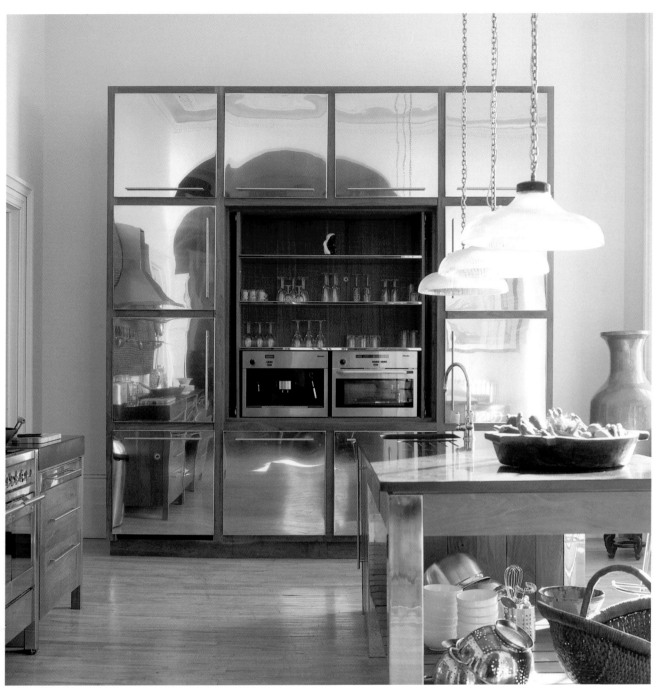

Design by Charles Style
Photo © Andreas von Einsiedel

Seamless surfaces

Design by BAAS Arquitectes
Photo © Eugeni Pons

Seamless surfaces, whether for flooring, worktops or cabinets, are created from such materials as acrylic resin laminates or stainless steel, and are particularly suited to creating neat, spacious volumes.

Fugenlose kontinuierliche Oberflächen am Boden, bei den Arbeitsflächen und den Möbeln können durch Materialien wie Kunstharze oder Edelstahl erreicht werden. Sie schaffen eine saubere, großzügige Atmosphäre.

Les surfaces continues, que ce soit au sol, sur les plans de travail ou sur le mobilier, sont réalisées en matériaux comme la résine ou l'acier, créant un effet soigné et une sensation d'espace.

Las superficies continuas, tanto en el suelo como en las encimeras y en el mobiliario, se logran con materiales como la resina o el acero y crean un efecto de espaciosidad y pulcritud.

Le superfici continue, sia a terra che nei piani di lavoro e nei mobili, si ottengono grazie a materiali come la resina o l'acciaio, e creano un effetto di spaziosità e di ordine.

Design by Jim Jennings
Photo © Roger Casas

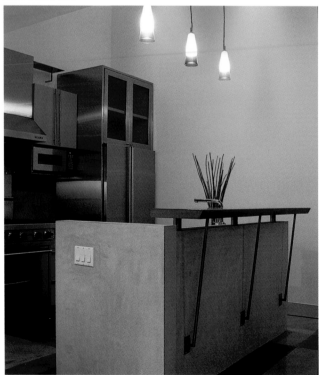

172

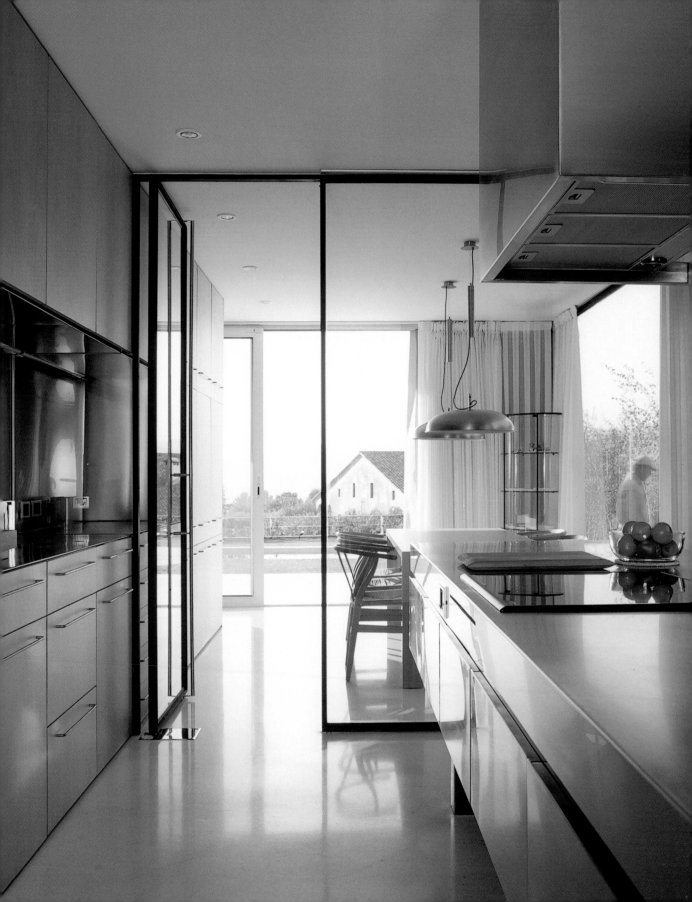

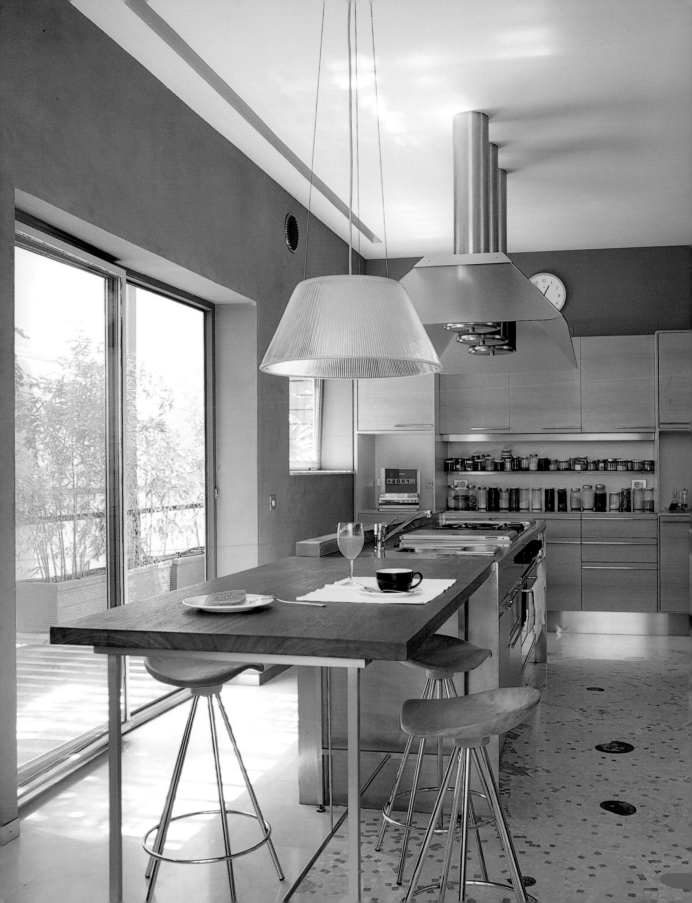

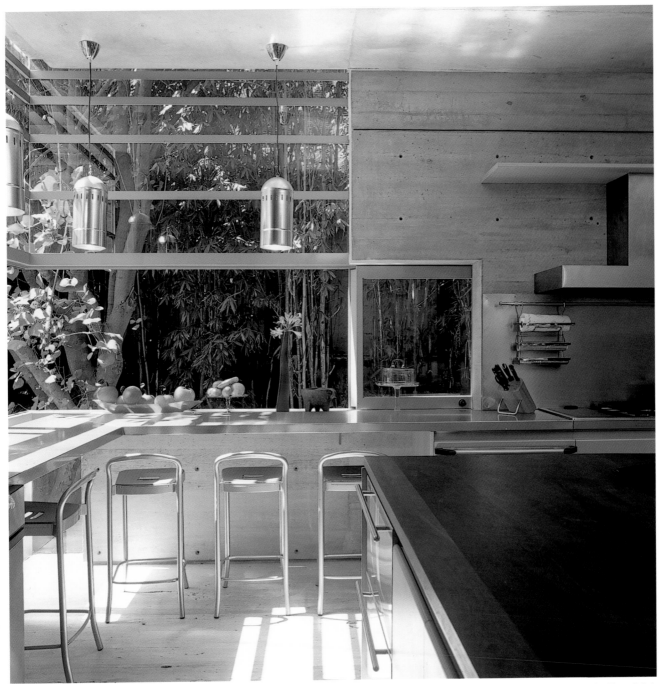

Design by Alberto Kalach
Photo © Undine Pröhl

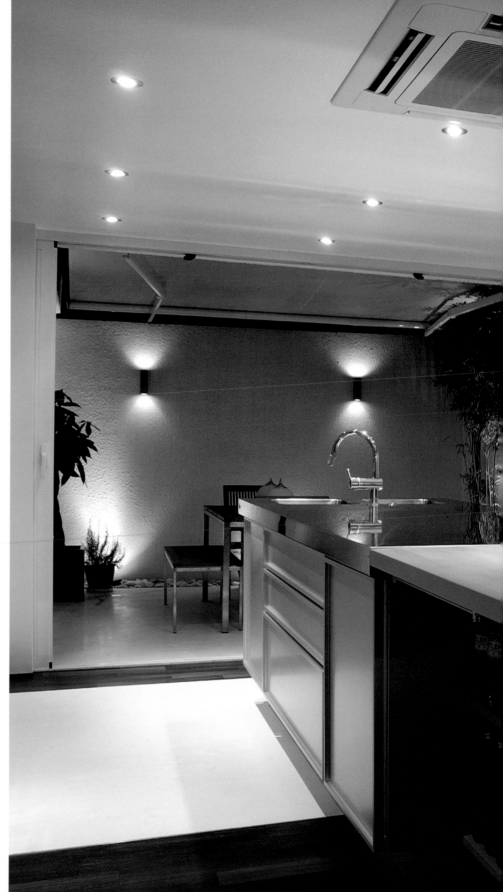

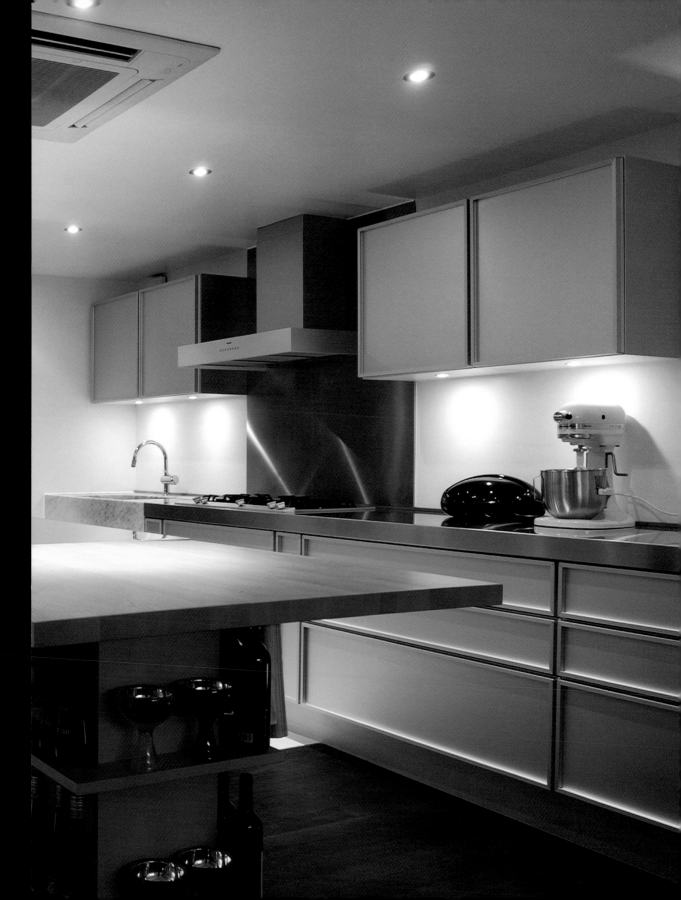

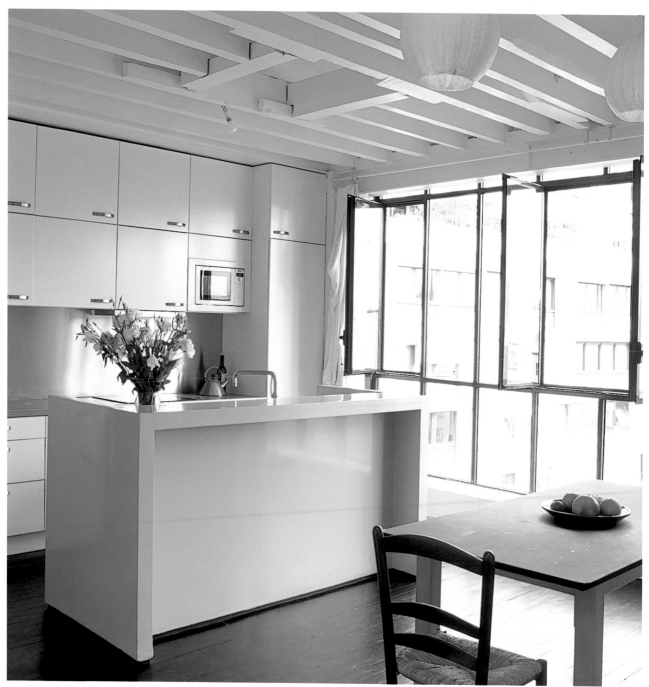

Design by Littow Architectes
Photo © Pekka Littow

Design by Attilio Stocchi
Photo © Andrea Martiradonna

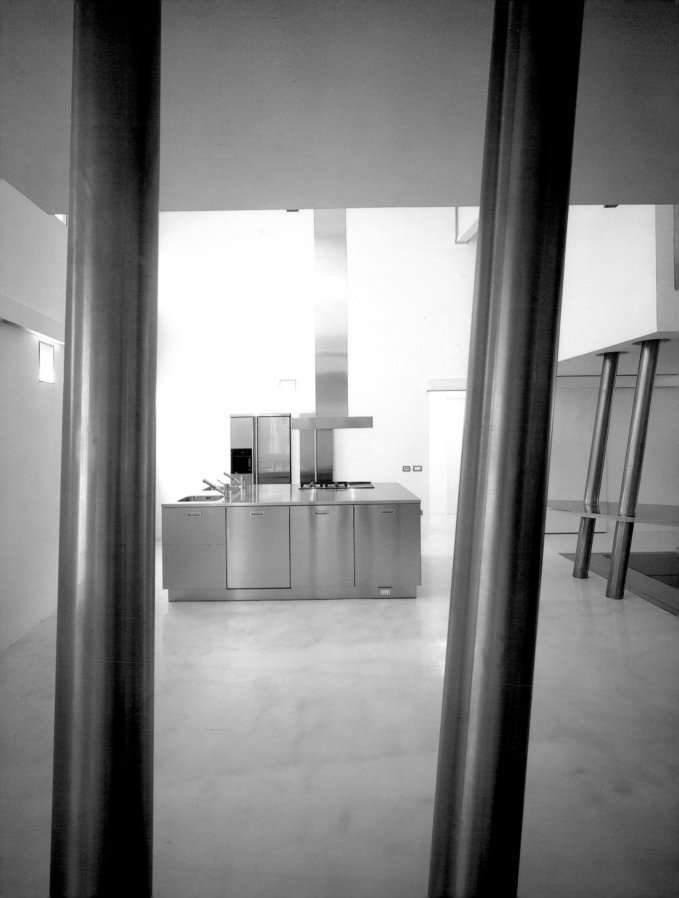

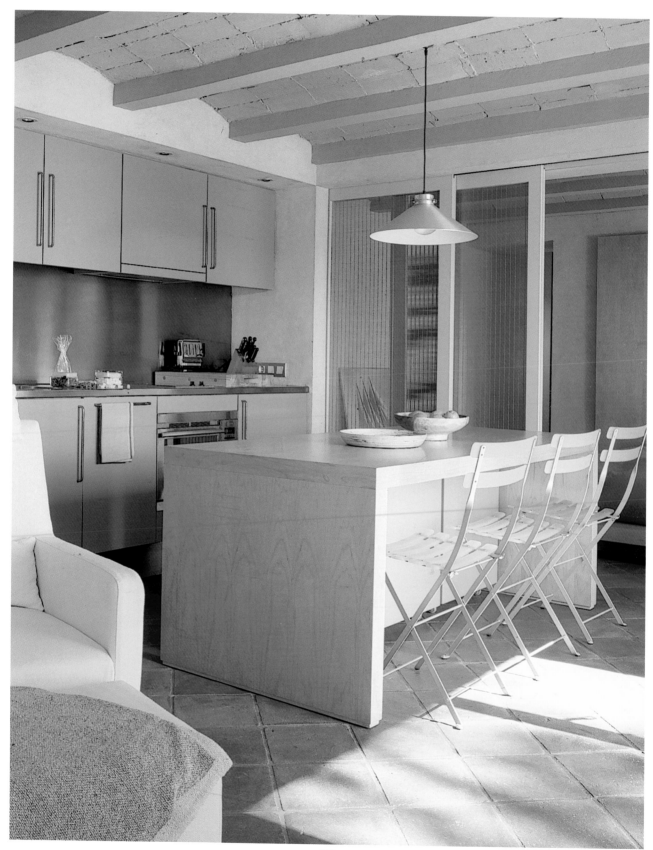

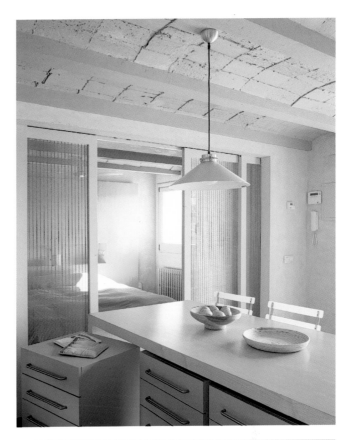

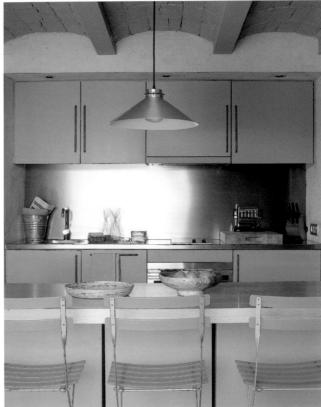

Both pages
Design by GCA Architects
Photo © Jose Luis Hausmann

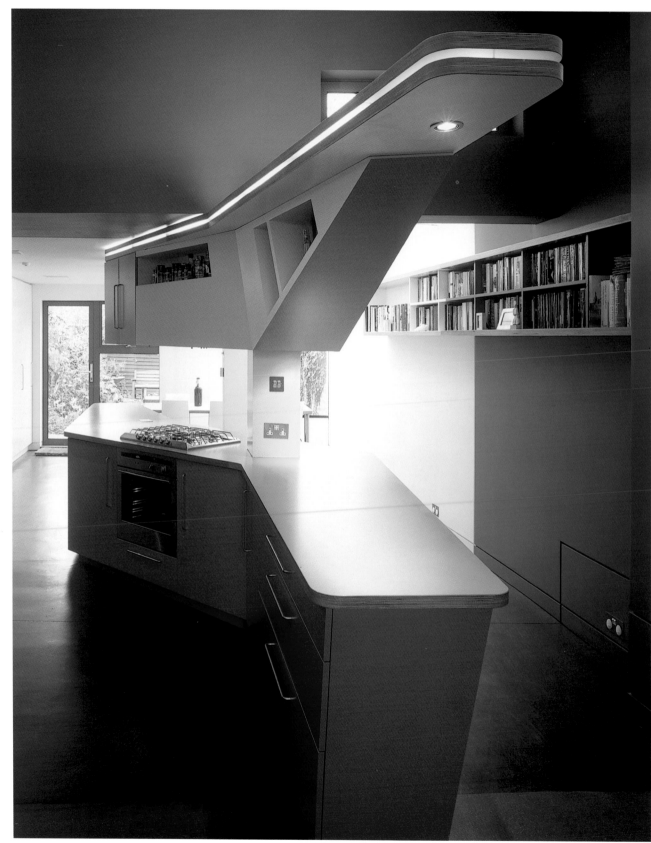

Both pages
Design by Surface Architects
Photo © Killian O'Sullivan

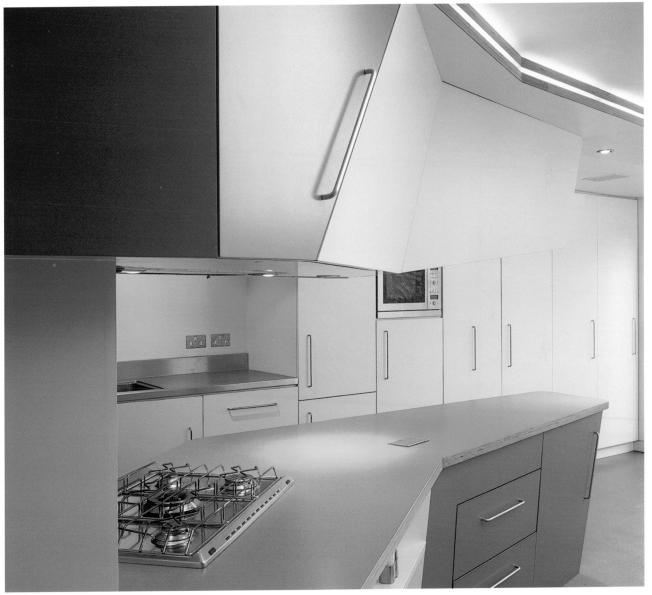

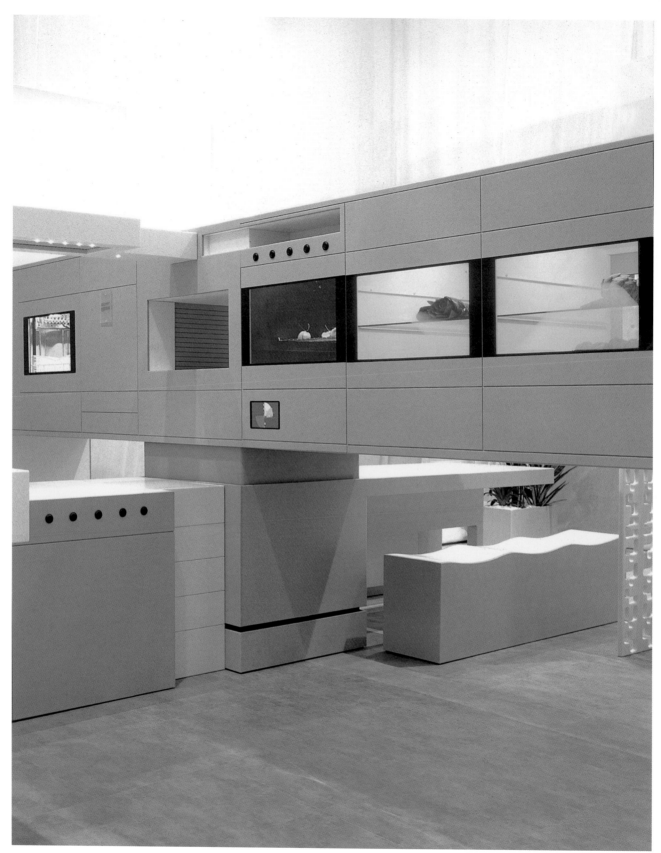

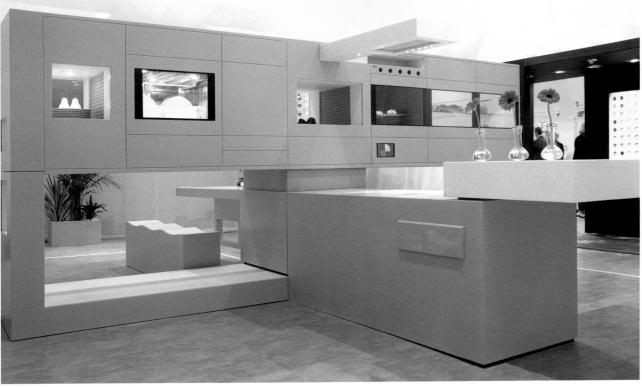

Both pages
Design by JAM Design & Co
Photo © Rob Carter

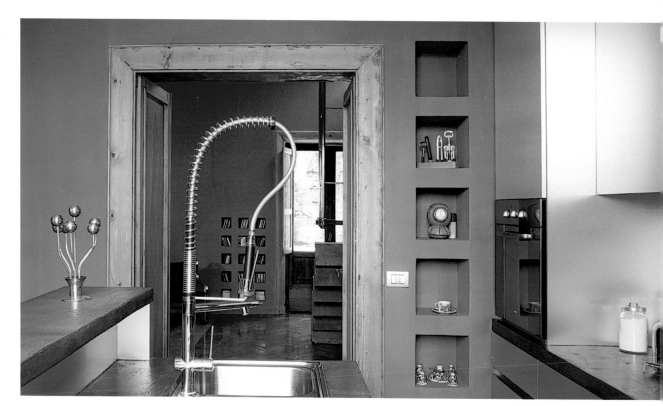

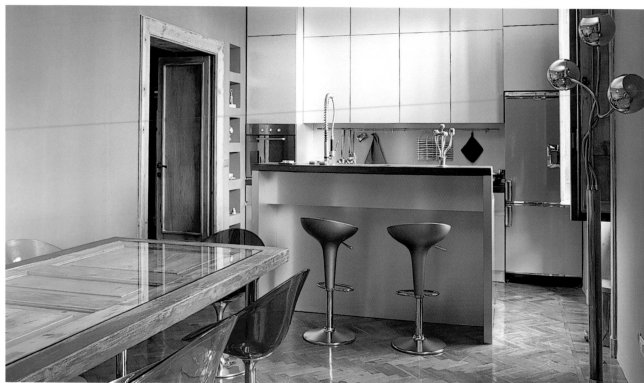

Both pages
Design by F. Bollati, E. M. Cicchetti
Photo © Gianni Franchelluci, M. Paolini

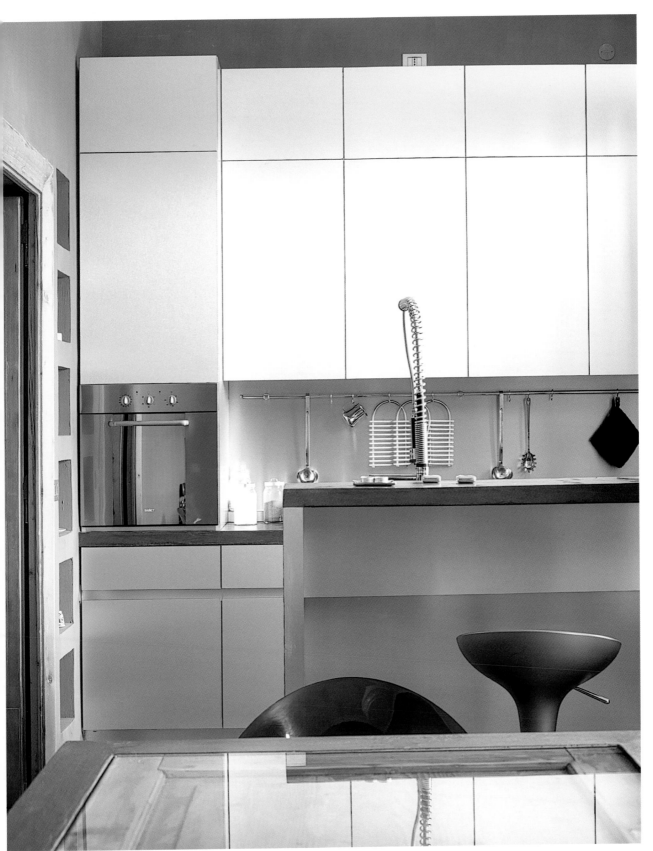

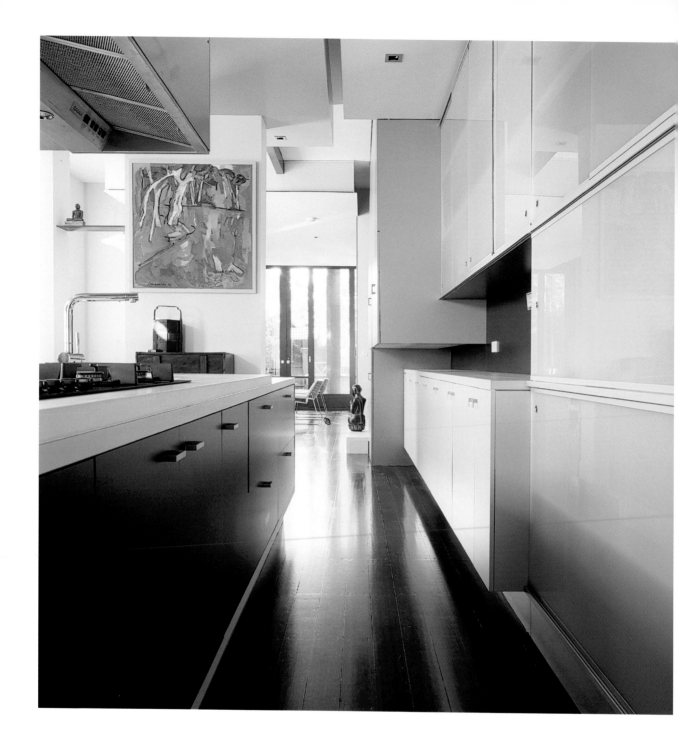

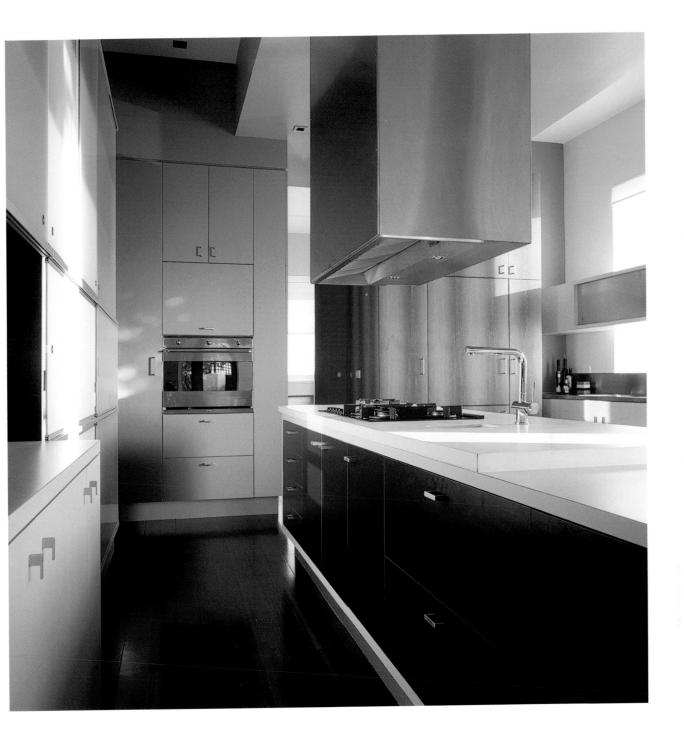

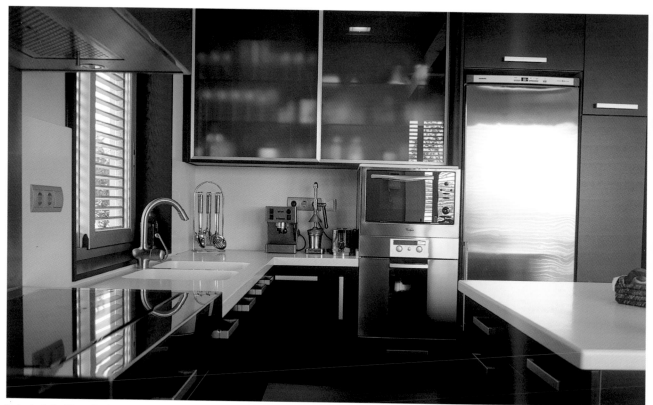

Design by Gorina i Farres Arquitectes
Photo © Miquel Tres

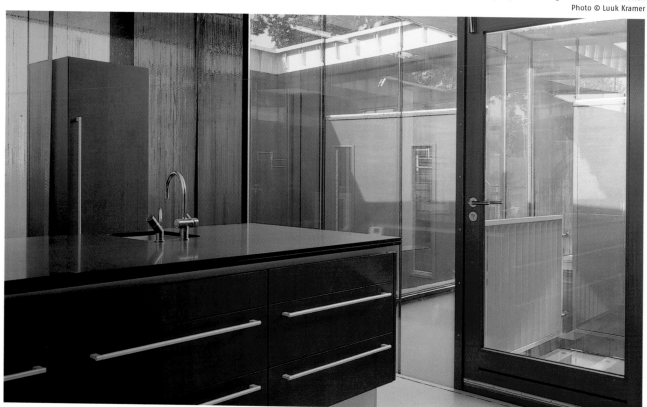

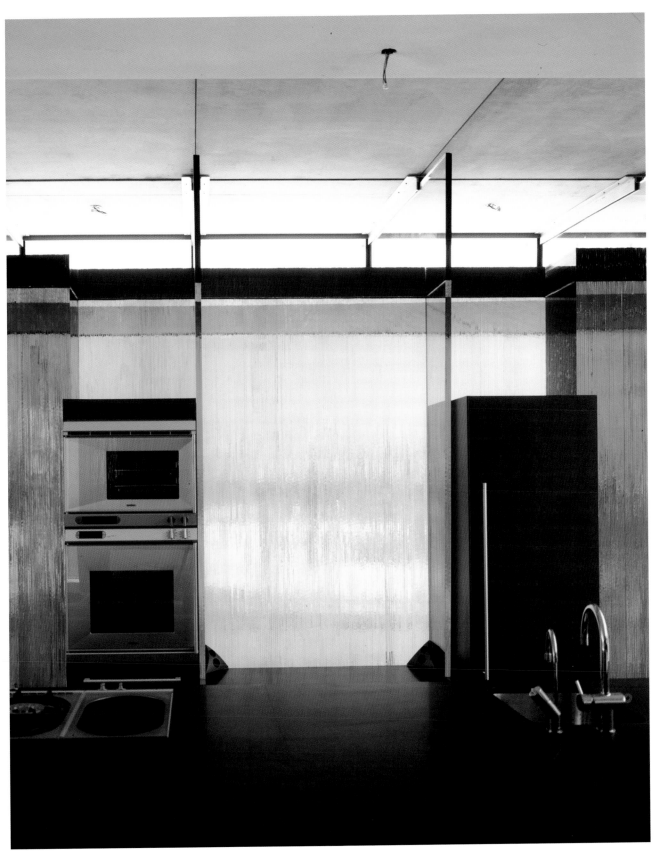

Wooden floors

Design by Jo Slade
Photo © Jordi Miralles

Wooden floorboards in an open kitchen suggest a warm atmosphere and reinforce a sense of unity with the rest of the house.

Der Boden aus Holzdielen in einer offenen Küche verleiht dem Raum Wärme und unterstreicht die Integration der Küche in den Rest der Wohnung.

Un parquet dans une cuisine ouverte, confère à la pièce un aspect chaleureux, et souligne son intégration à l'espace de vie.

El pavimento de listones de madera en una cocina abierta otorga calidez al espacio y enfatiza su integración con el resto de las estancias de la vivienda.

In una cucina aperta, il pavimento in legno a listoni dà una nota di calore allo spazio e sottolinea l'integrazione con il resto delle stanze dell'abitazione.

Design by Kar-Hwa Ho
Photo © Björg Photographer

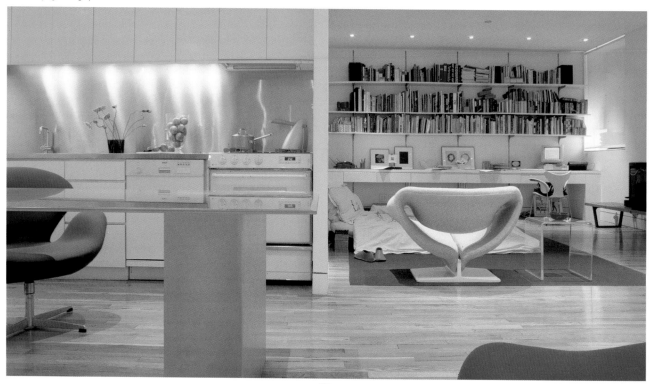

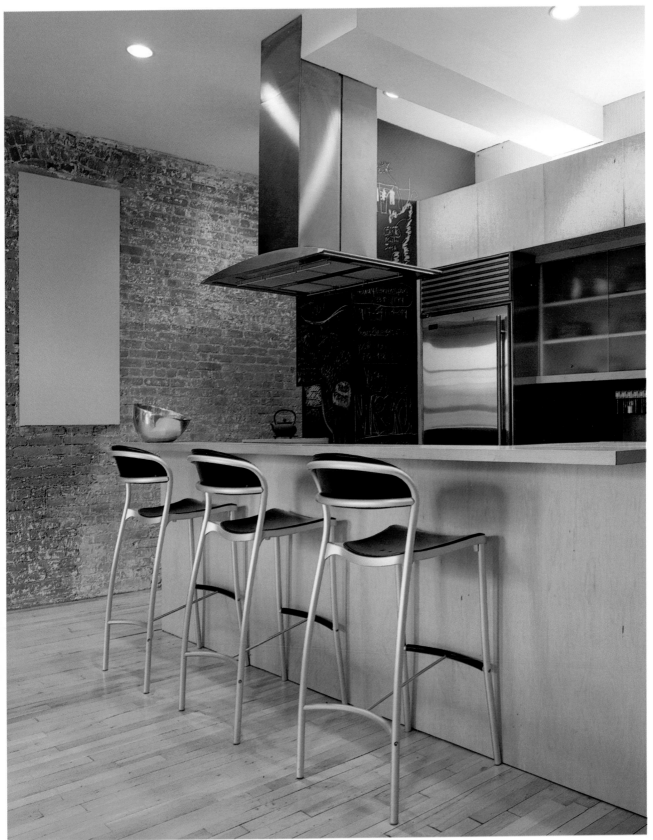

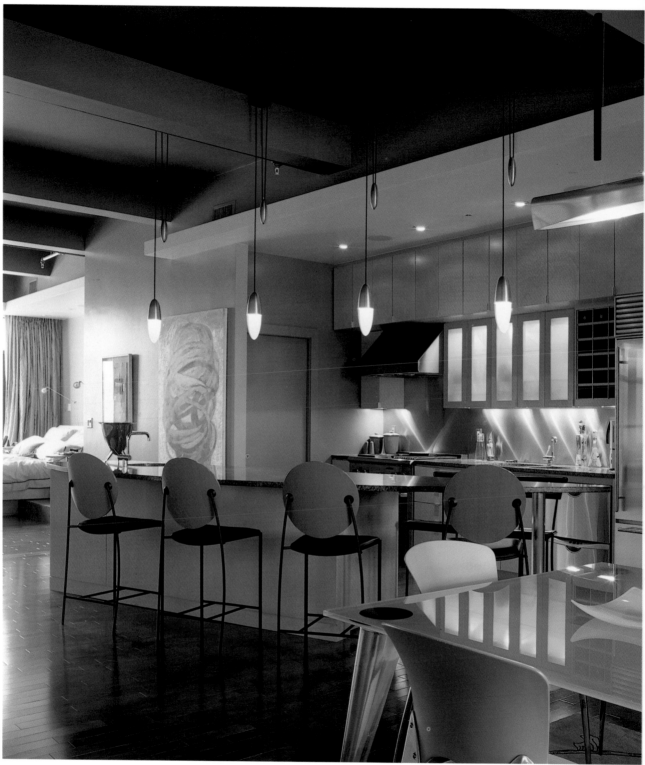

Design by Ruhl Walker Architects
Photo © Jordi Miralles

Design by A. Blanch & Elina Vila
Photo © Jose Luis Hausmann

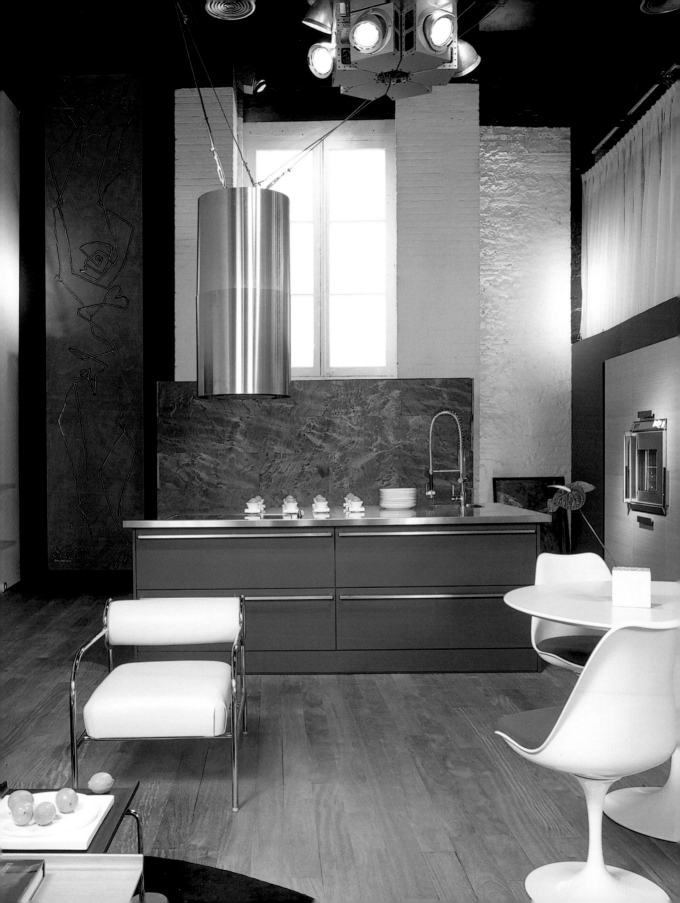

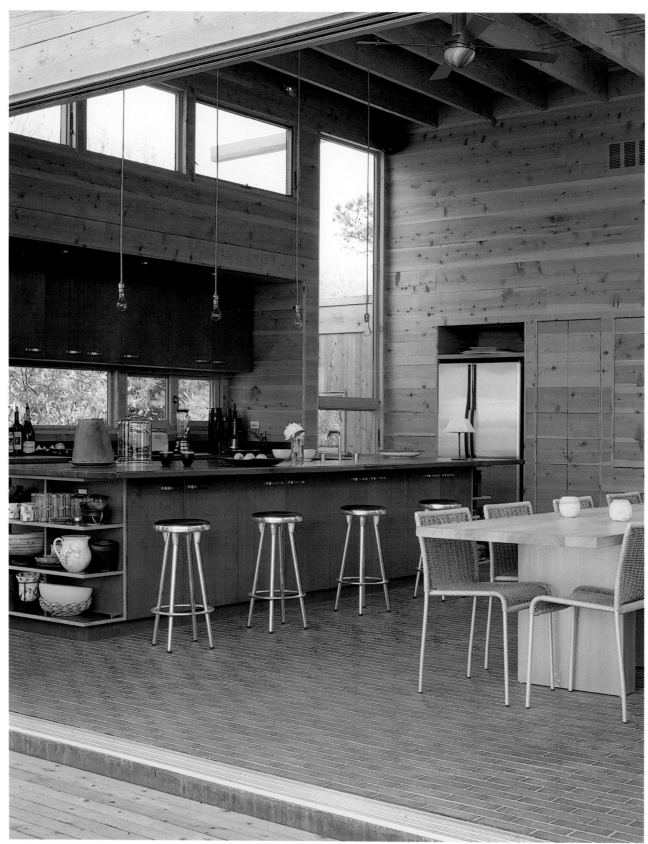

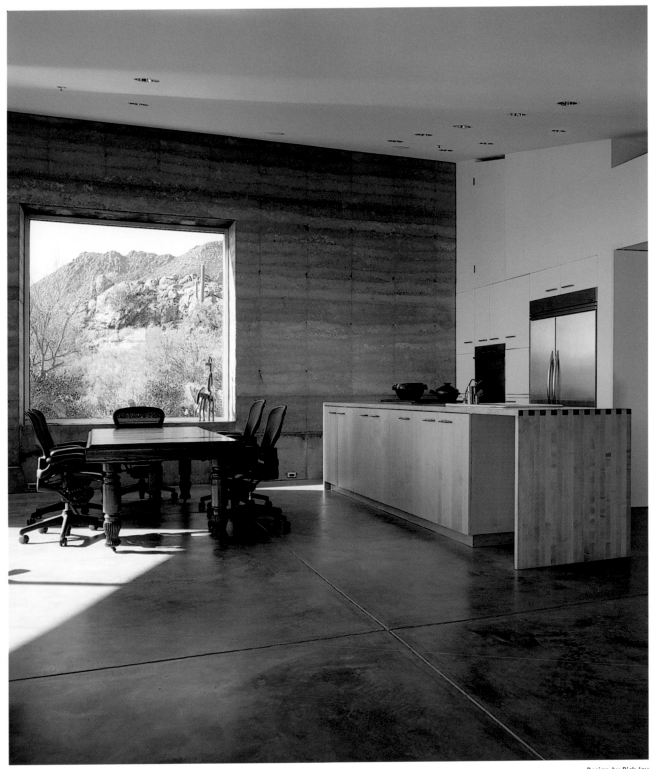

Design by Rick Joy
Photo © Undine Pröhl

Design by Bromley Caldari Architects
Photo © Jose Luis Hausmann

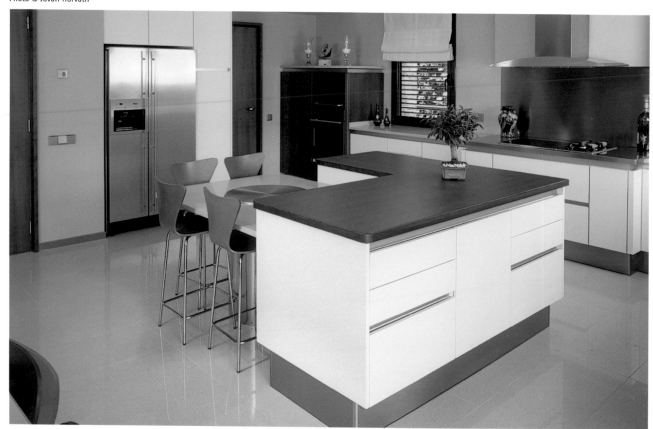

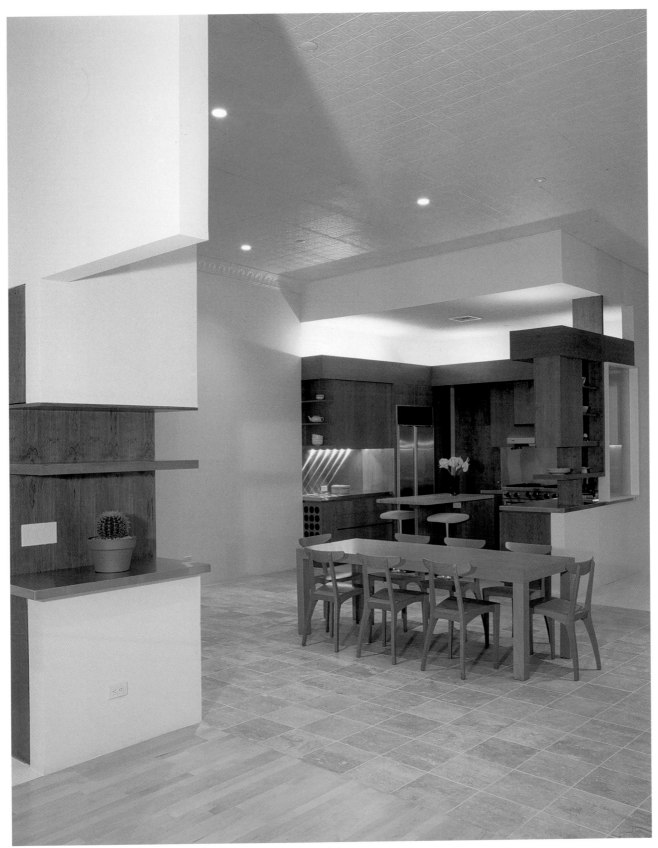

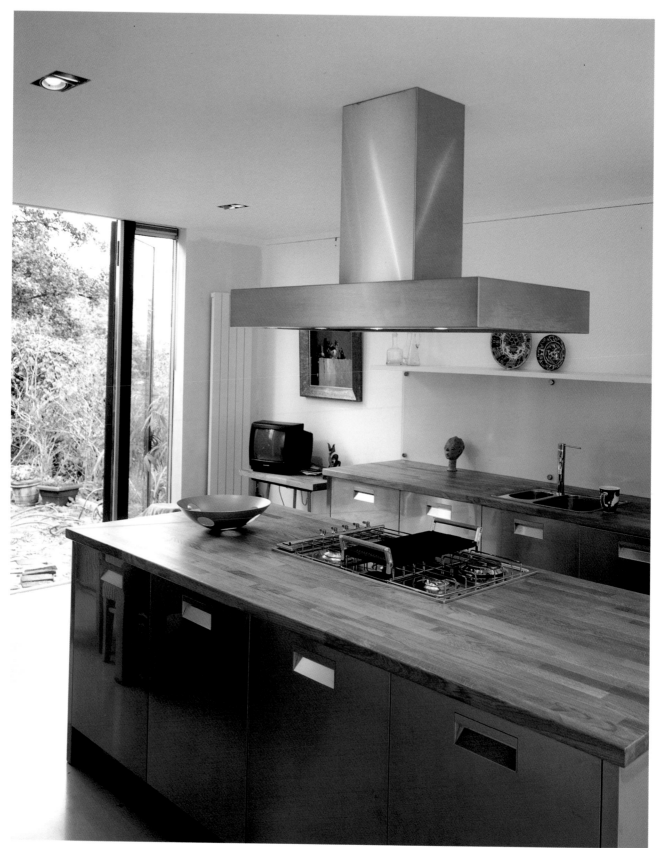

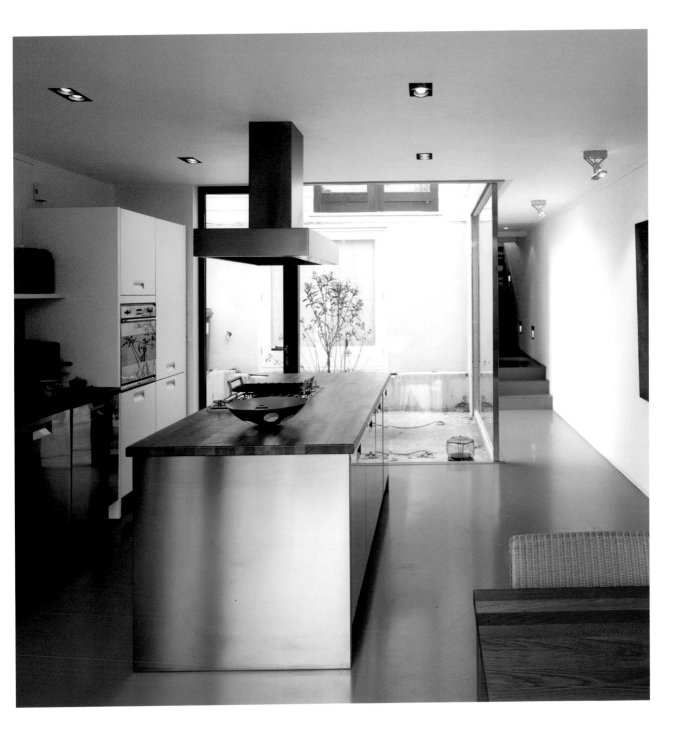

Both pages
Design by Moriko Kira
Photo © Luuk Kramer

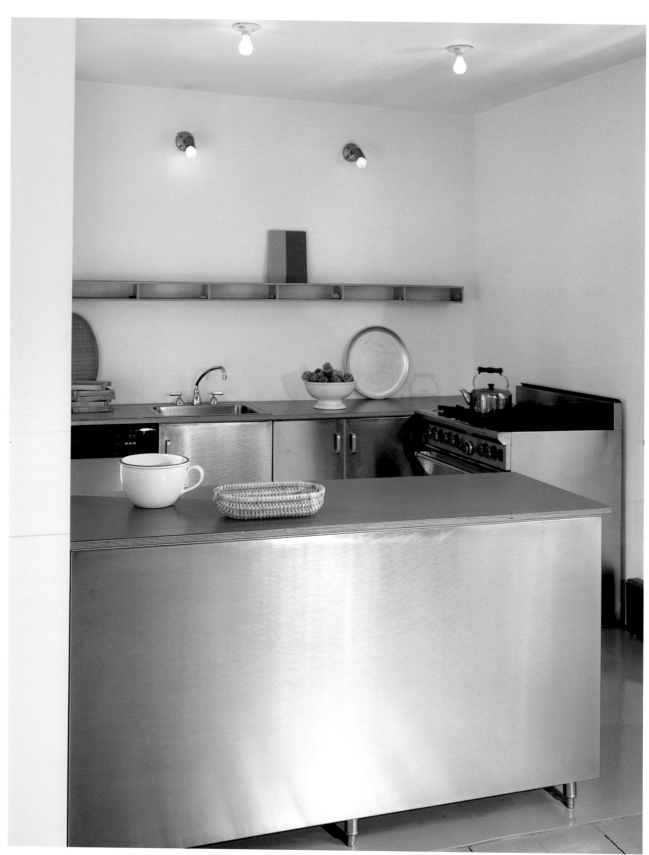

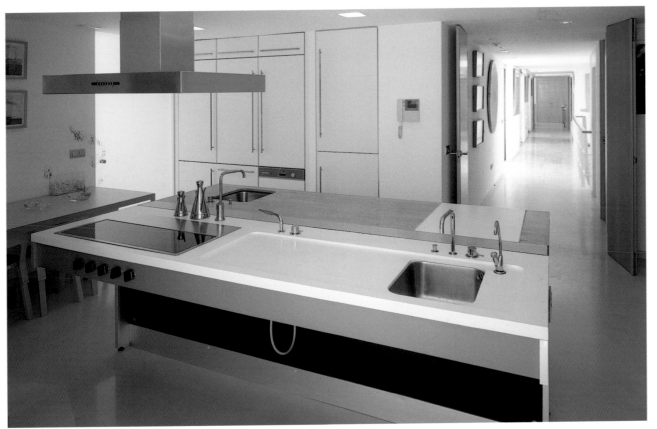

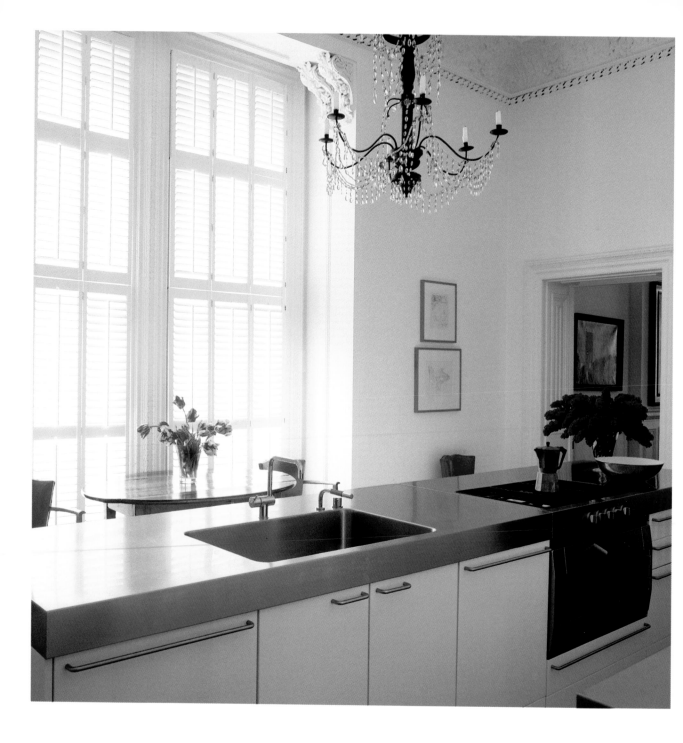

Both pages
Design by Jasper Conran
Photo © Andreas von Einsiedel

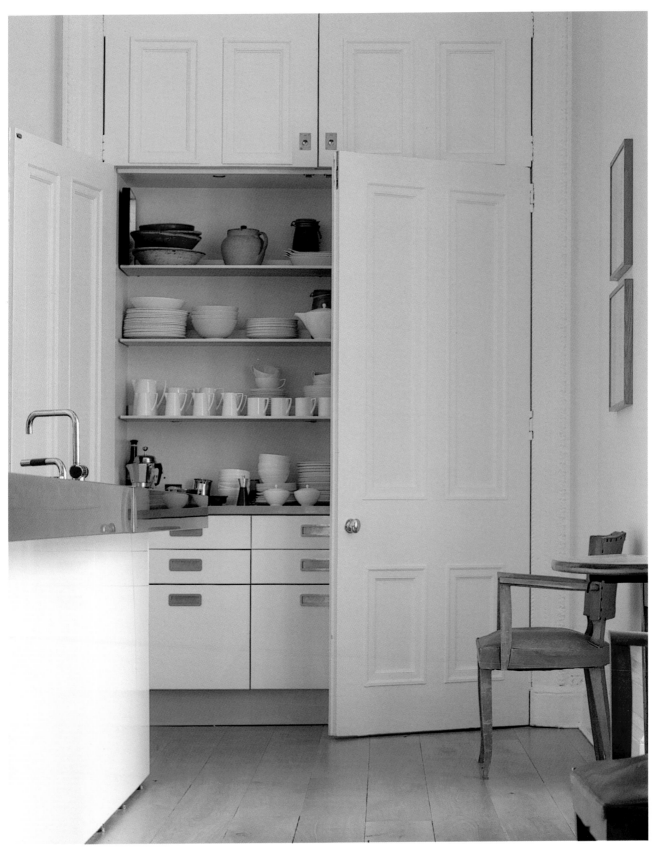

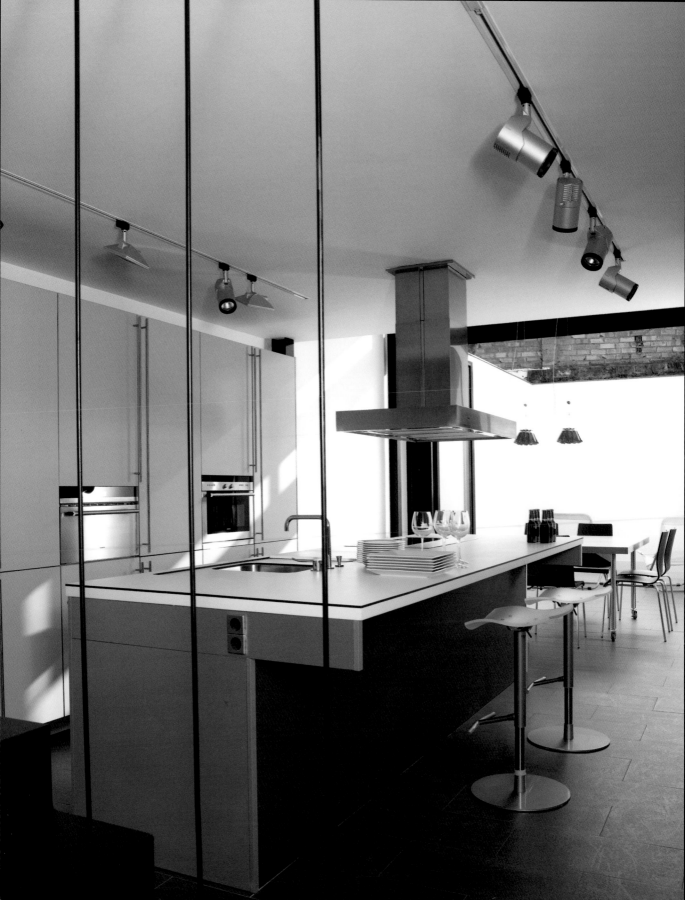

Both pages
Design by EXE Arquitectura
Photo © Eugeni Pons

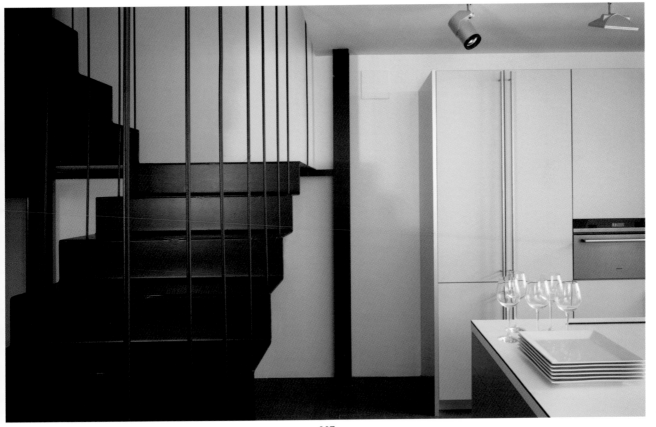

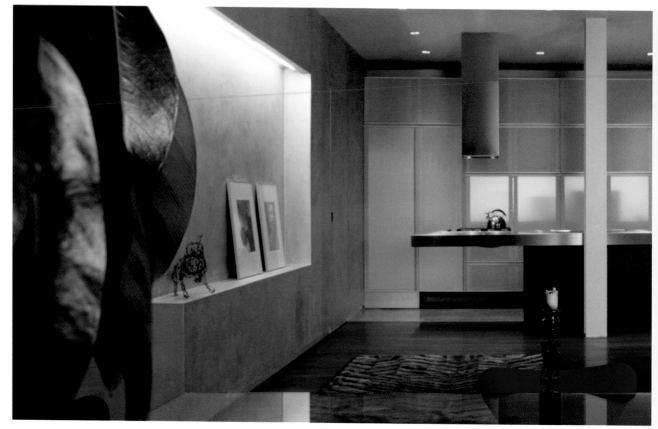

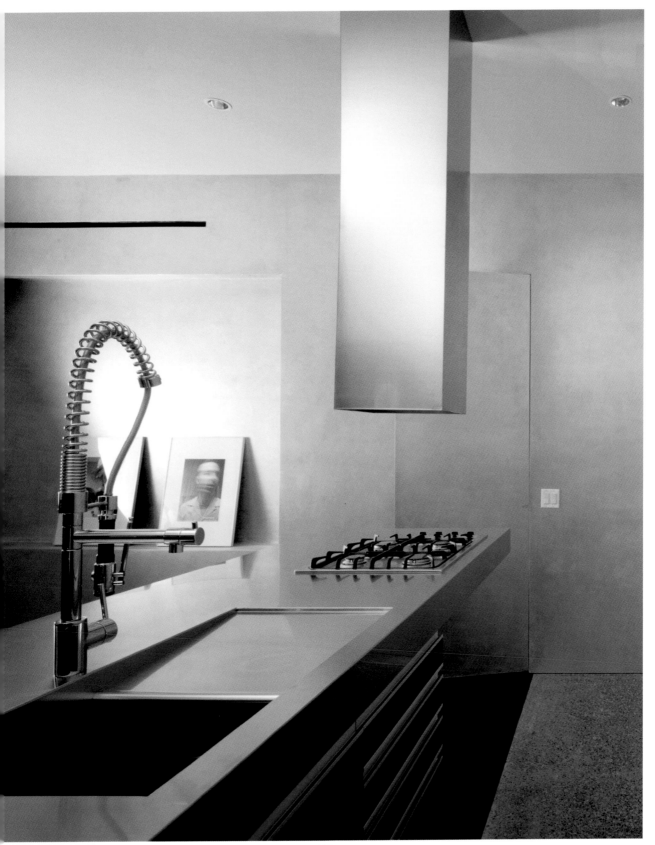

Country-style >>>>

This style, inspired by traditional rural kitchens, has not only become popular in
country houses, but also in city homes, thanks to the influence of contemporary
kitchens.

The country-style kitchen's main distinctive feature is that all utensils, appliances
and even the foodstuffs are clearly visible. Instead of flush-front cabinets, shelves
on the walls hold the bowls, dishes and jars which formerly had a functional
purpose but today also play a decorative role. The aesthetic of these elements on
view are backed up by careful choice of furniture for each part of the kitchen,
namely food preparation, cooking and washing up. To sum up, these are
extremely practical custom-made spaces, and therefore highly recommendable
for people who cook frequently.

Rustic materials determine the overall layout of the kitchen and contribute to giving
it greater definition. The most commonly used floor and wall coverings are tiles,
stone or brick, and these may be combined with painted surfaces and rough
finishes. Terracotta, stone or wooden flooring materials are ideal. The structure of
the building should be visible in the form of vaulted ceilings or wooden rafters,
where in many cases kitchen utensils may be displayed.

Solid wood furniture, white marble surfaces, cabinet doors faced with wire netting,
fittings built in situ or stone flags on the floors are staples. Recovered utensils or
devices of yesterday, such as a cast iron oven, an old kitchen table or antique
taps, add to the character of country-style kitchens. When added to the
particular selection of furniture and other elements in view, they help to create
unique, personalised kitchen spaces, fully adapted to the owners' requirements
and preferences.

> Inspired on traditional rural kitchens, this style has not only become popular in country houses, but in city homes too.

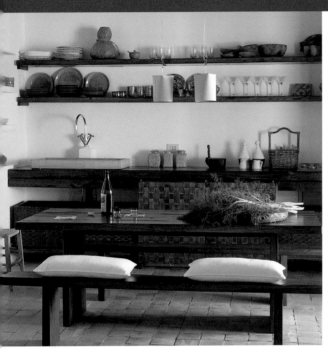

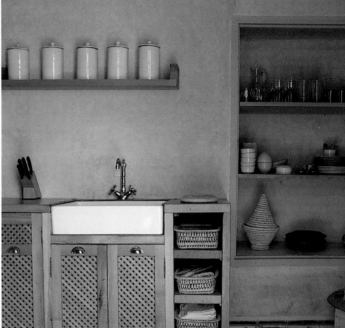

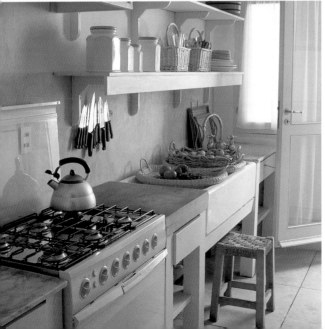

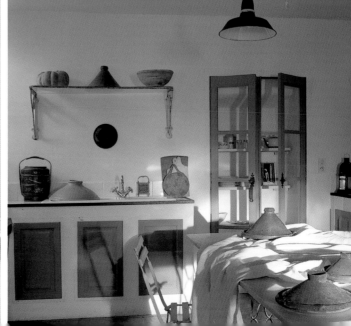

Rustikal

Der Einrichtungsstil dieser Küchen orientiert sich an den traditionellen Bauernküchen. Doch dank der zeitgenössischen Küchen ist diese Art von Kücheneinrichtung heute nicht nur im Landhaus zu finden, sondern auch in der Stadt.

Das wichtigste Merkmal der rustikalen Küche besteht darin, dass alle Geräte, Utensilien und Lebensmittel sichtbar sind. Es gibt keine Hängeschränke. Stattdessen nutzt man Regale für Schüsseln, Teller und Krüge, die so von Gebrauchsgegenständen zu Dekorationsobjekten werden. Die Wirkung der derart zur Schau gestellten Gegenstände wird von den sorgfältig ausgewählten Möbelstücken verstärkt, die den drei Arbeitsbereichen zugeordnet sind: Vorbereitung, Zubereitung und Abwasch. Die Küche im Landhausstil ist nach dem Geschmack der Besitzer und gleichzeitig überaus praktisch eingerichtet, daher ist sie besonders für Menschen geeignet, die gern und viel kochen.

Rustikale Materialien bestimmen das Gesamtbild der Küche und tragen zur Definition dieses Küchentyps bei: Die meisten Oberflächen sind gefliest oder in Naturstein oder Backstein gehalten. Dazu kommen farblich gestaltete Flächen mit eher rauer Struktur. Für den Boden bieten sich Terrakottafliesen, Natursteinplatten oder Holzdielen an. Bei der Deckengestaltung sollten bauliche Strukturelemente wie Balken oder Gewölbe erhalten bleiben. An den Balken lässt sich z.B. das Kochgeschirr aufhängen.

Am besten passen Massivholzmöbel oder gemauerte Schränke, Arbeitsflächen aus weißem Marmor, Schranktüren mit Gitternetz, Arbeitsmöbel und lose Steine auf dem Fußboden in diese Küche. Alte Haushalts- und Einrichtungsgegenstände erhalten einen Ehrenplatz in der rustikalen Küche: der gusseiserne Herd, der antike Küchentisch oder der klassische Wasserhahn. Im Einklang mit dem vielfältigen Mobiliar und den anderen Gebrauchsgegenständen verleihen diese Elemente jeder Küche ihren unverwechselbaren Charakter und passen sie den Vorlieben und Bedürfnissen der jeweiligen Besitzer an.

Both pages
Design by Miki Astori
Photo © Matteo Piazza

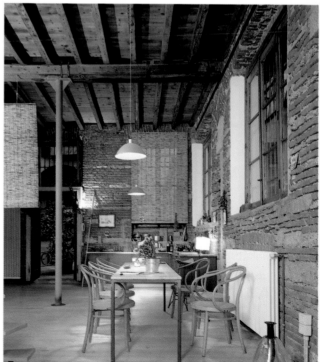

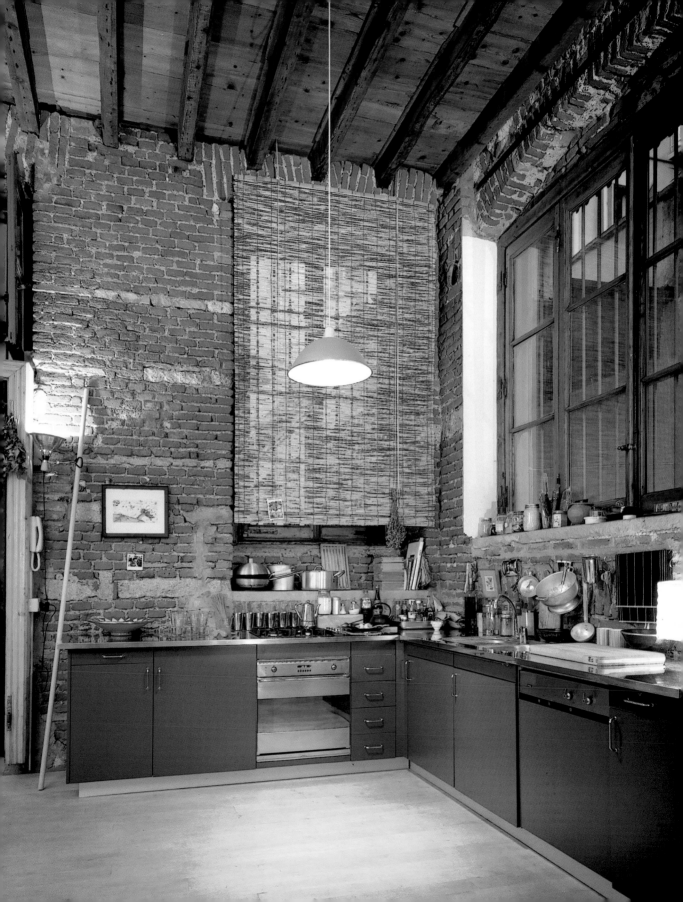

Rustiques

Ce style de cuisine, inspiré des maisons à la campagne et de la conception spatiale d'antan, a trouvé une place de choix dans la conception de cuisines contemporaines, non seulement à la campagne, mais aussi à la ville.

Ce qui caractérise la cuisine rustique, c'est le fait de laisser les appareils, les ustensiles et les aliments à portée de vue. Les armoires suspendues disparaissent, substituées par des étagères où l'on pose terrines, assiettes et flacons qui, outre leur qualité d'ustensiles, deviennent des objets décoratifs. L'esthétique des éléments exposés est renforcée par le choix de meubles divers selon les différentes zones de la cuisine : préparation, cuisson et vaisselle. Il s'agit, en somme, de cuisines sur mesure, recommandées pour les personnes qui cuisinent souvent.

Les matériaux rustiques, en plus de déterminer la configuration générale de la cuisine, contribuent aussi à la définir. Les revêtements les plus utilisés sont les carreaux de faïence, la pierre naturelle ou la brique, en alternance avec la peinture et des finis irréguliers. Pour le sol, l'idéal est d'utiliser un carrelage en terre cuite, en pierre naturelle ou un parquet. Quant au plafond, il est important de souligner la structure de la charpente, à l'instar de poutres ou de voûtes, qui, dans la plupart des cas, servent aussi de supports pour accrocher des ustensiles.

Les meubles les plus appropriés sont en bois massif, les plans de travail en marbre blanc, les portes des armoires dotées de grillage, les meubles ouvragés ou les revêtements en dalles de pierre. La récupération d'anciens appareils ou objets, tel un vieux four en fonte, une table de cuisine ou une robinetterie traditionnelle, est une caractéristique de la cuisine rustique. Ajoutés à la variété du mobilier et des objets apparents, ces éléments créent un type de cuisine unique et personnalisé, qui s'adapte aux goûts et aux besoins de leurs propriétaires.

Both pages
Design by Víctor Espósito
Photo © Pere Planells

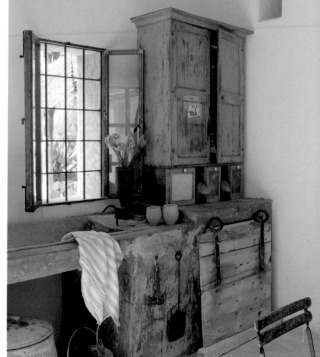

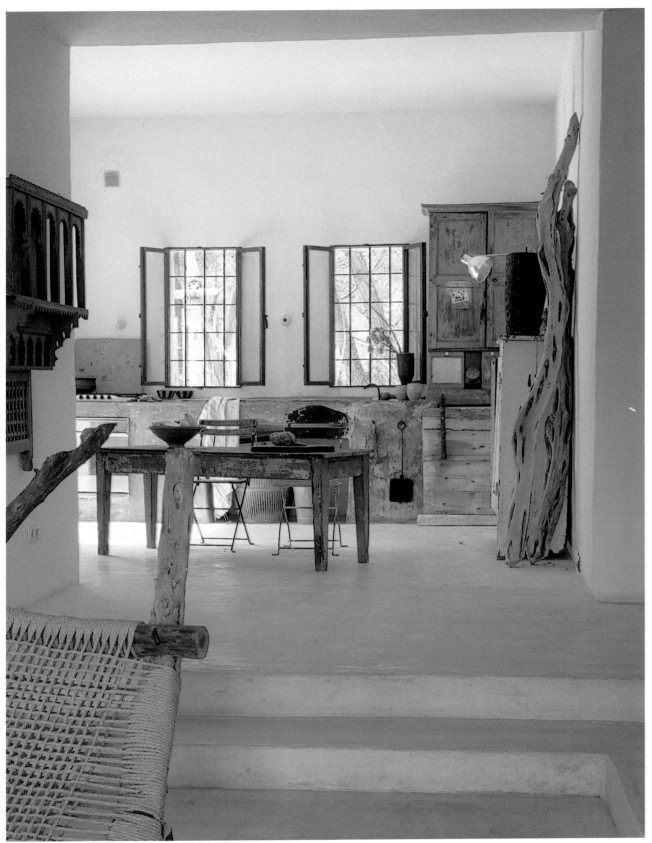

Rústicas

Este estilo de cocina, cuyos orígenes se remontan a las casas rurales, ha vuelto a estar de moda no solo en el campo sino también en la ciudad, gracias a la influencia de las cocinas contemporáneas.

La cocina rústica se caracteriza principalmente por dejar a la vista los aparatos, utensilios y alimentos. Los armarios colgados desaparecen y son sustituidos por estanterías donde se colocan cuencos, platos y frascos que, además de servir como utensilios, se convierten en objetos decorativos. La estética de los elementos expuestos se refuerza con la elección de muebles variados para las diferentes zonas de la cocina: la de preparación, la de cocción y la de fregado. Se trata, en suma, de cocinas hechas a la medida, muy prácticas e indicadas para personas que cocinan frecuentemente.

Los materiales rústicos, además de determinar la configuración general de la cocina, contribuyen también a su definición. Los revestimientos más empleados son los azulejos, la piedra natural y el ladrillo, que se pueden alternar con pintura y con acabados irregulares. Para el suelo es ideal un pavimento de barro cocido, de piedra natural o de madera; en cuanto al techo es importante resaltar la estructura de la edificación, como las vigas y las bóvedas, que en muchos casos actúan también como soportes para colgar utensilios.

Los muebles más adecuados son los de madera maciza, las encimeras de mármol blanco, las puertas de armarios con malla de gallinero, los muebles de obra y los revestidos con losas de piedra. La recuperación de aparatos y objetos antiguos, como un viejo horno de hierro, una mesa de trabajo o una grifería clásica, es un rasgo característico de la cocina rústica. Sumado a la variedad de mobiliario y a los elementos vistos, todo ello crea un tipo de cocina único y personalizado, que se adapta a los gustos y a las necesidades de sus propietarios.

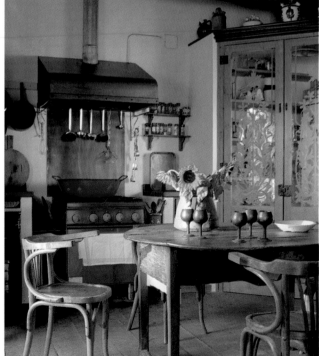

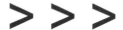

Rustiche

Questo stile di cucina, le cui origini affondano nelle case rurali di una volta e nel modo in cui anticamente si concepiva questo spazio, è tornato in auge influenzando il disegno di cucine contemporanee, sia in campagna che in città.

La cucina rustica si caratterizza principalmente in quanto lascia in vista le strutture, gli utensili e gli alimenti. Gli armadi pensili scompaiono lasciando il posto a scaffali e mensole dove vengono sistemati recipienti, ciotole e piatti che, oltre a servire da utensili, svolgono anche una funzione decorativa. L'estetica degli elementi esposti viene rafforzata dalla scelta di mobili e materiali diversi per le varie zone della cucina: superficie di lavoro, piano cottura e lavello. Si tratta, in definitiva, di cucine fatte su misura, molto pratiche e indicate per persone che cucinano con frequenza.

I materiali rustici, oltre a determinare la configurazione generale della cucina, contribuiscono anche alla sua definizione. I rivestimenti più utilizzati sono le piastrelle di maiolica, la pietra naturale o il mattone, che si possono alternare con la pittura e con finiture irregolari. A terra si è soliti optare per un pavimento in cotto, pietra naturale o in legno; nella zona alta si mettono in risalto alcuni elementi strutturali dell'edificio quali le travi o le volte del soffitto, che in molti casi servono pure come supporti dove appendere utensili.

I mobili più adeguati sono quelli in legno massiccio, i piani di lavoro in marmo bianco, le ante grigliate, i mobili in muratura o quelli rivestiti di lastre di pietra. Il recupero di oggetti e utensili antichi, come un vecchio forno in ferro, un tavolo di lavoro o una rubinetteria in stile classico, è un altro elemento caratteristico della cucina rustica. Tutti questi elementi, sommati alla varietà della mobilia, danno vita a un tipo di cucina unico e fortemente personalizzato, che si adatta ai gusti e alle esigenze dei loro proprietari.

Design by Martín Gómez
Photo © Ricardo Labougle

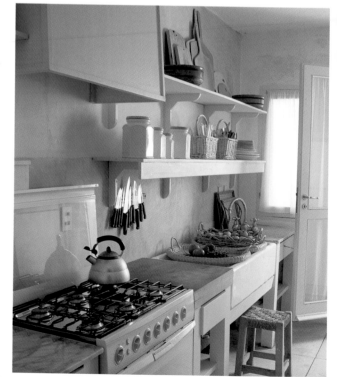

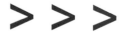

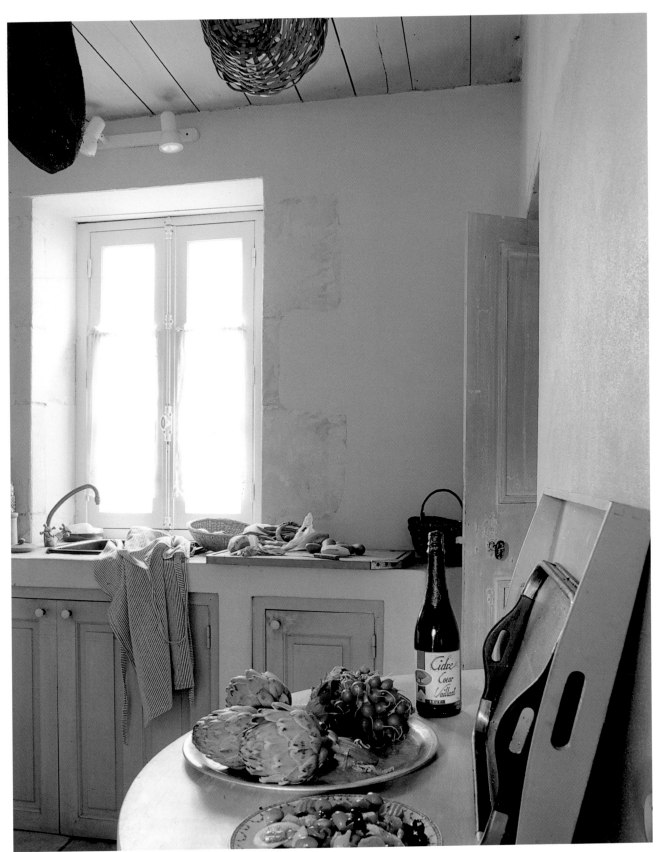

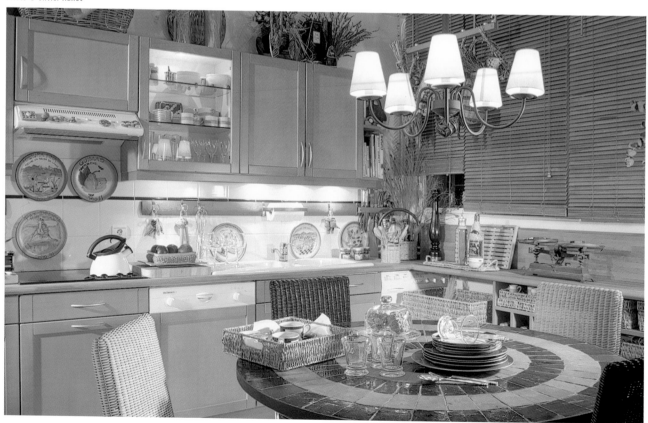

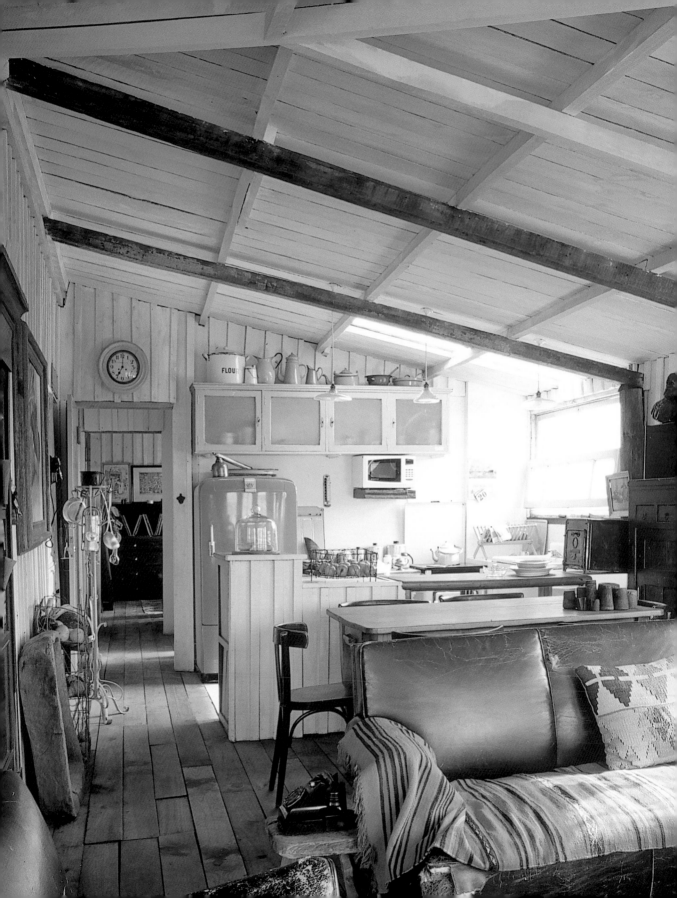

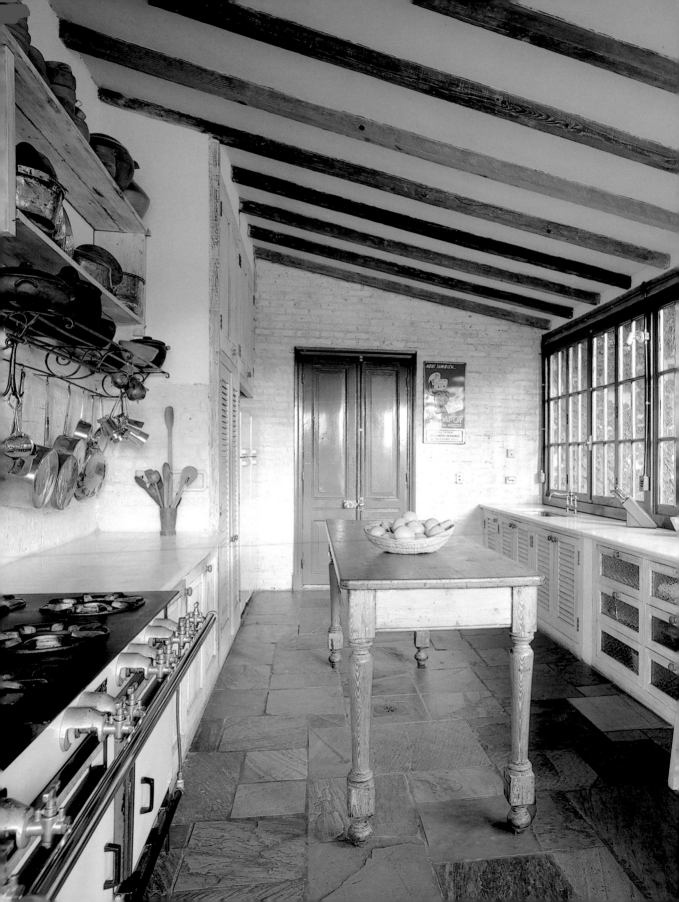

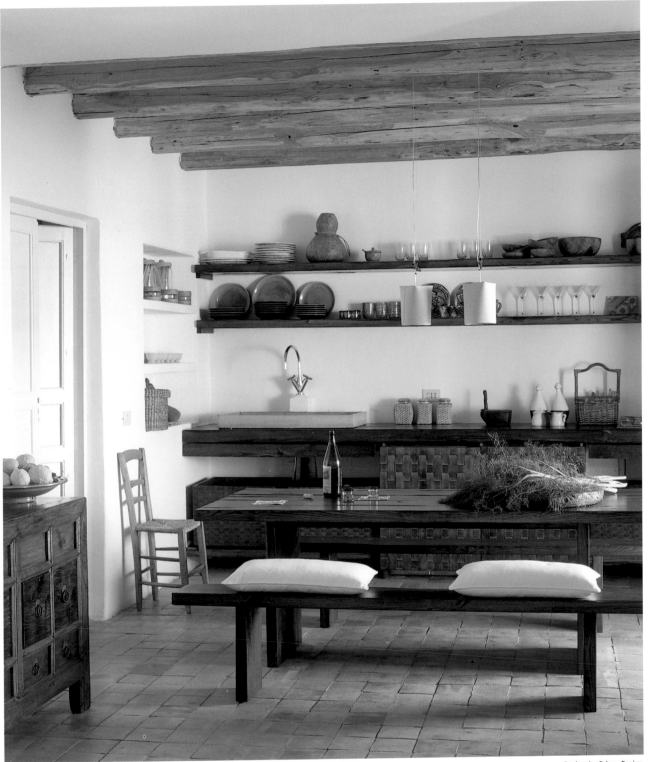

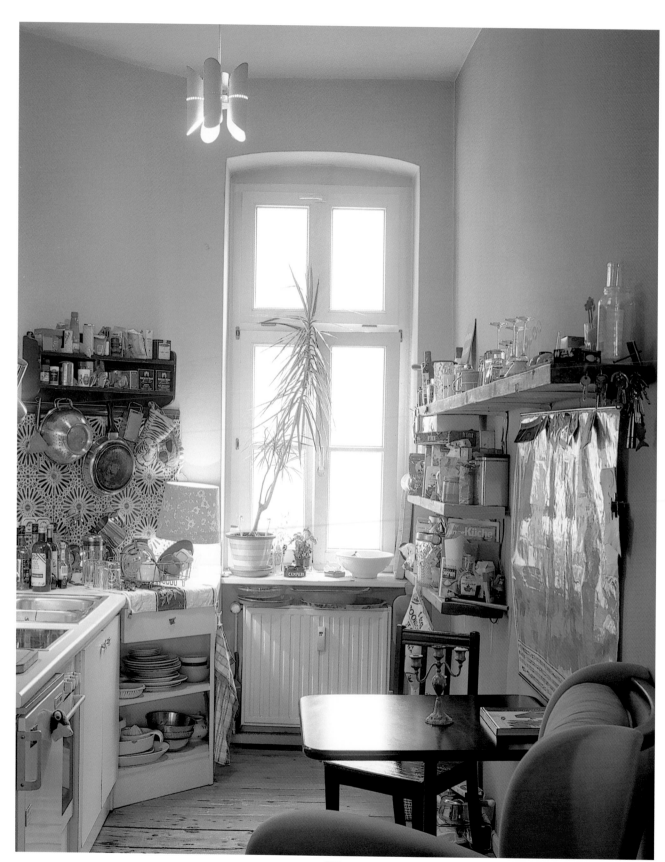

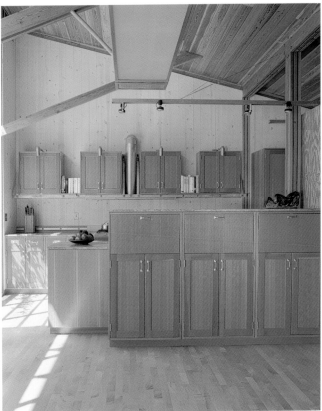

Old and new

Photo © Montse Garrriga

The rusticity of the original kitchen is evoked by an antique oven and the open brickwork on the wall. Modern electrical appliances and contrasting elements create an attractive, functional space.

Der rustikale Charakter der ursprünglichen Küche wird durch den alten Backofen und eine Natursteinwand hervorgerufen. Als Kontrast dazu schaffen die zeitgenössischen Elemente und Geräte ein funktionelles Ambiente.

Le caractère rustique de l'espace original, évoqué par la présence d'un vieux four et d'un mur en pierres apparentes, se mêle aux appareils et éléments contemporains pour créer une ambiance fonctionnelle.

El carácter rústico de la cocina original, evocado por la presencia de un viejo horno y una pared de piedra vista, se mezcla con aparatos y elementos contemporáneos para crear un espacio funcional.

Il carattere rustico dello spazio originale, evocato dalla presenza di un vecchio forno e di una parete a vista, si mescola ad apparecchiature ed elementi contemporanei per creare un ambiente funzionale.

Design by Giuseppe Caruso
Photo © Matteo Piazza

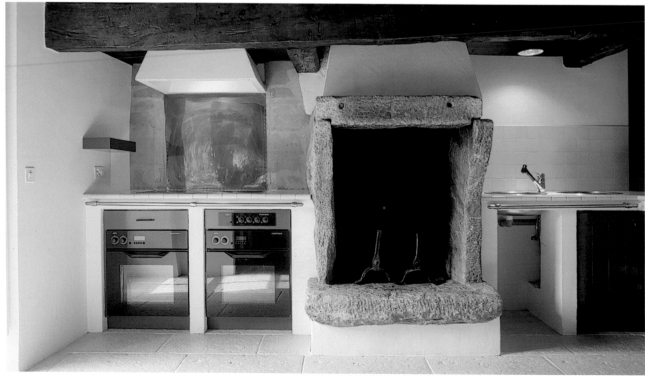

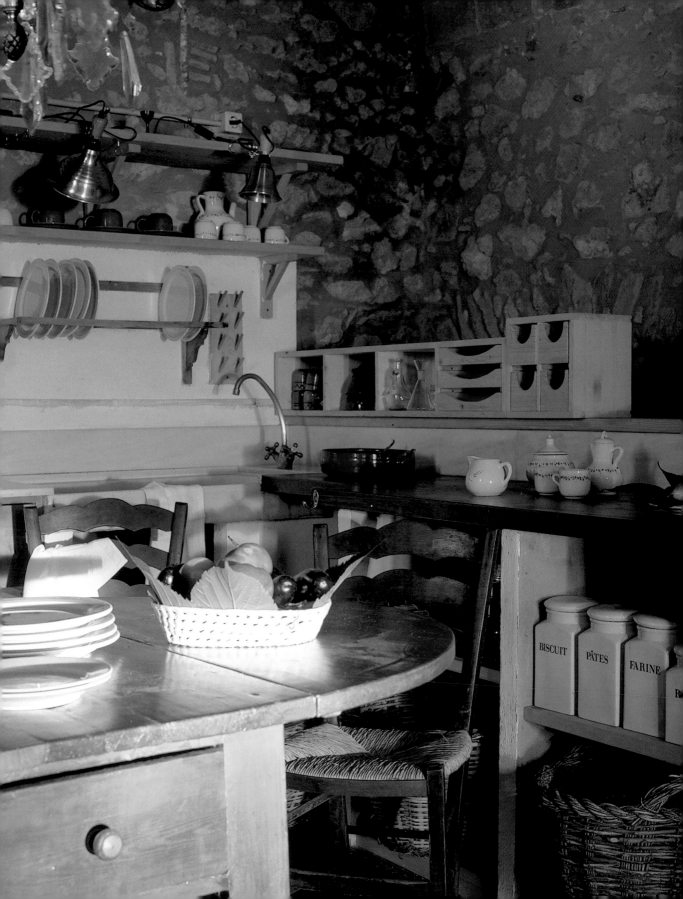

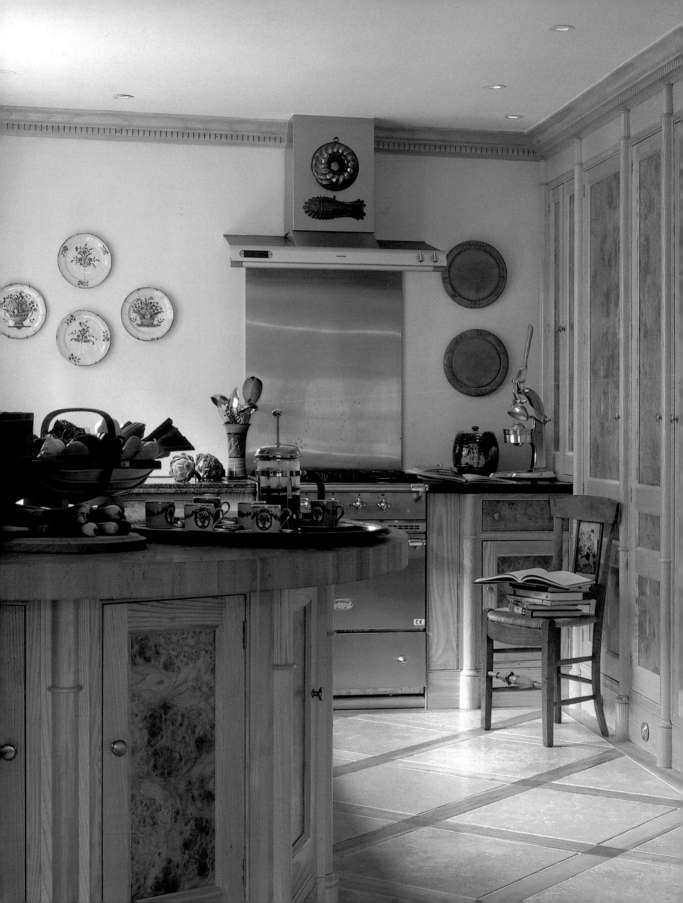

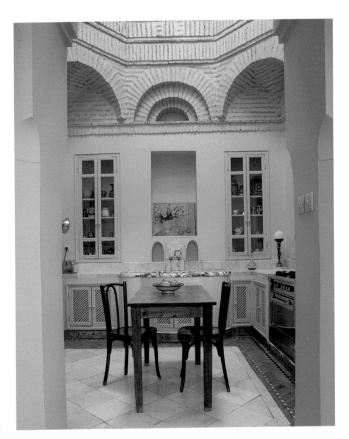

Design by Charles Boccara
Photo © Pere Planells

Design by Hugo Curletto
Photo © Ricardo Labougle

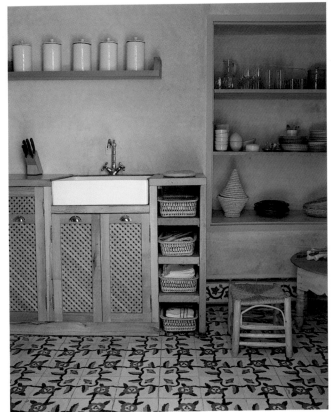

Design by Cecilia Neal
Photo © Andrew Wood

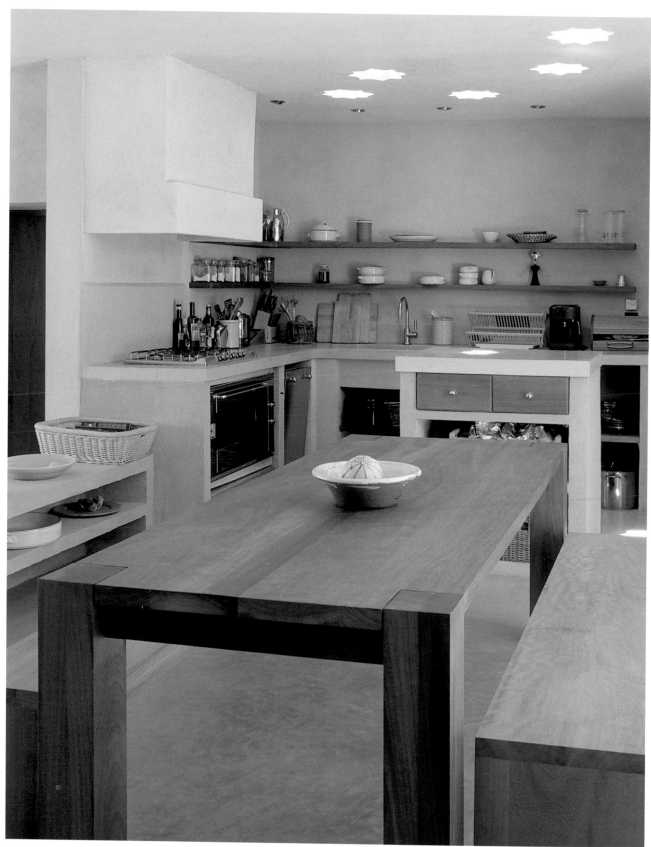

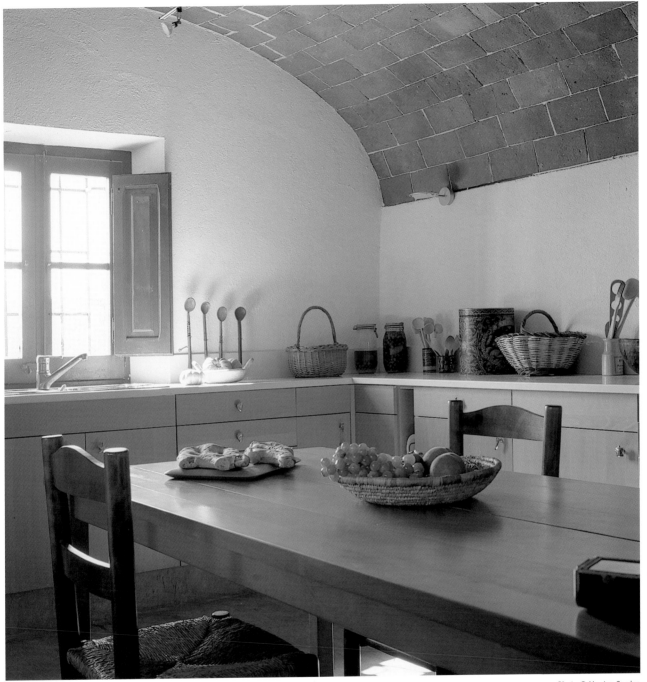

Photo © Montse Garriga

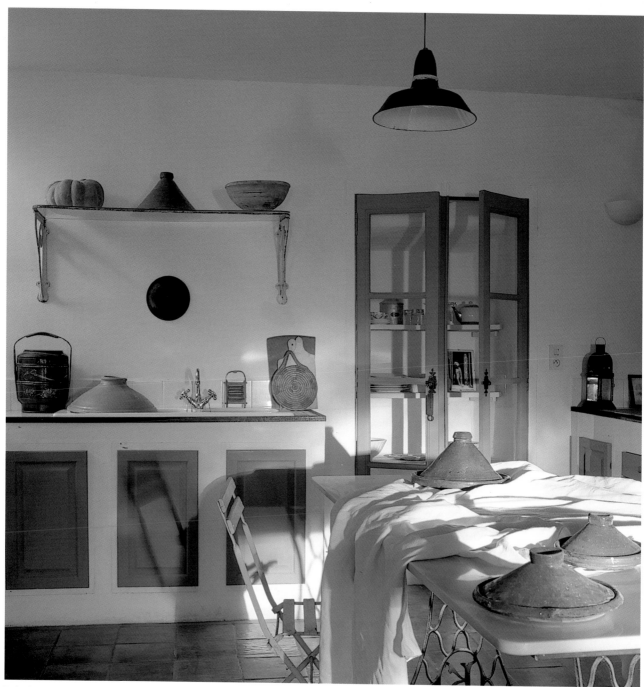

Design by Fabienne Baradot
Photo © Montse Garriga

Design by Lluís Auqué
Photo © Montse Garriga

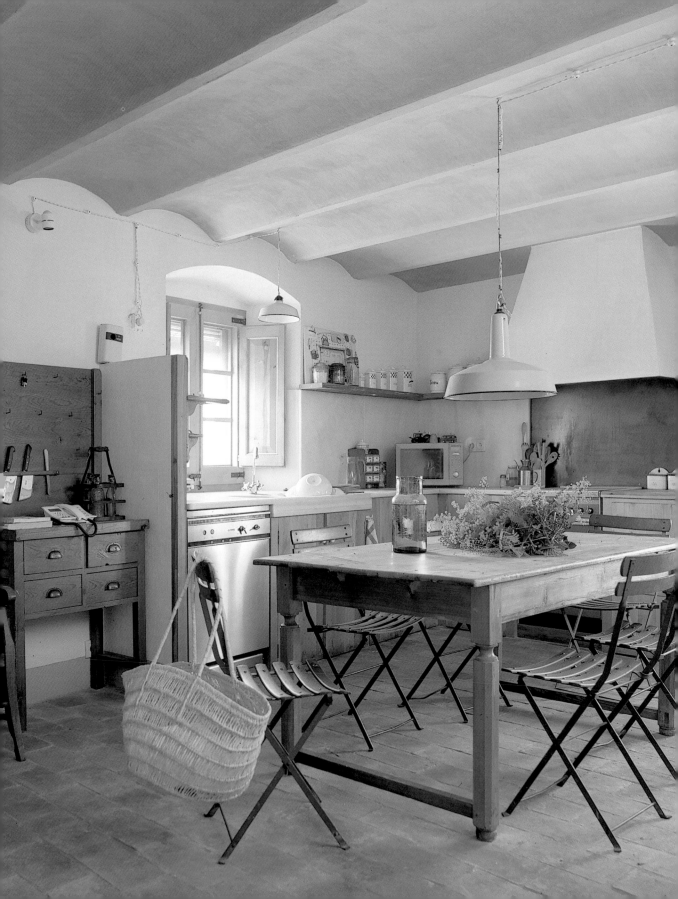

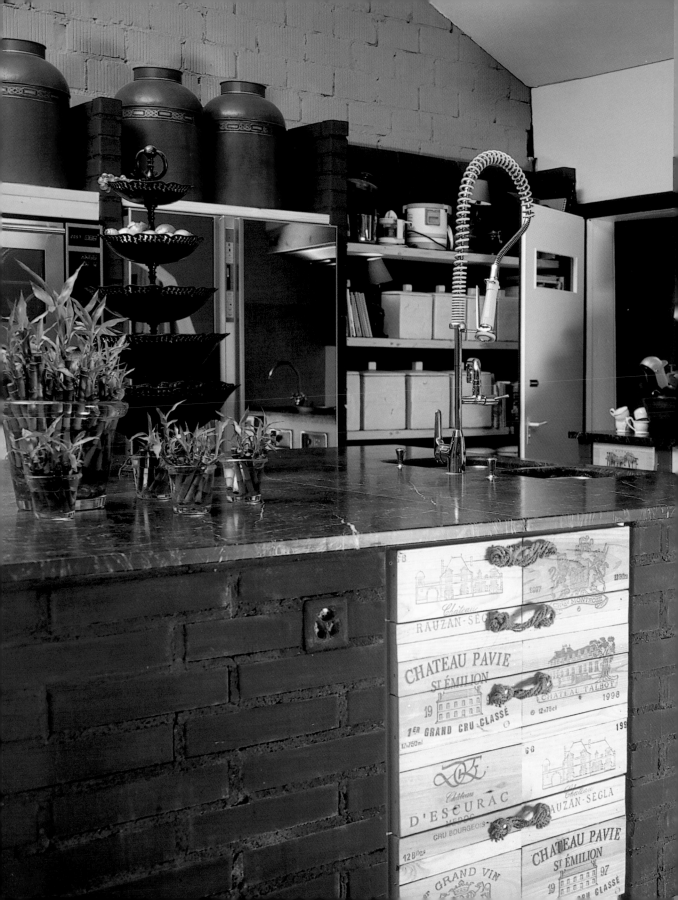

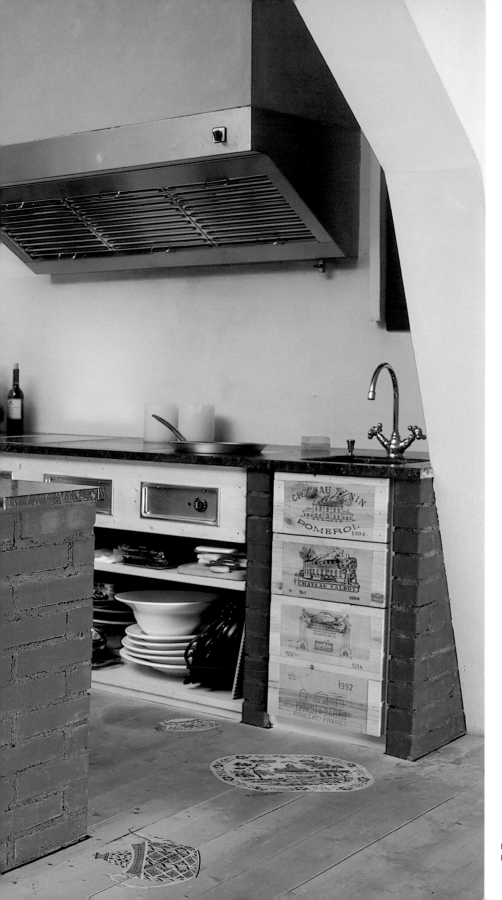

Design by Sue Rohrer
Photo © Zapaimages

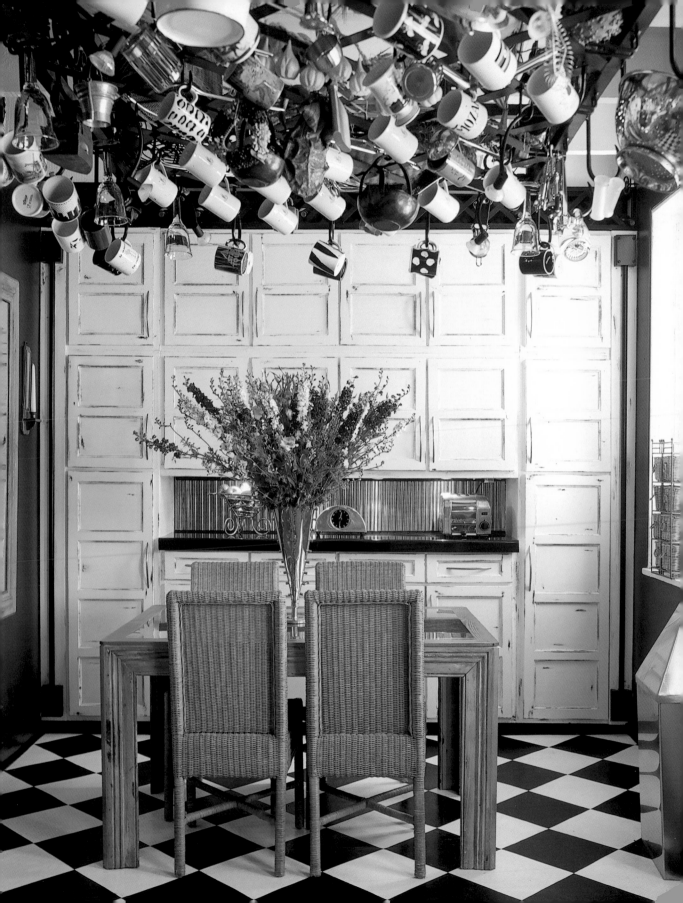

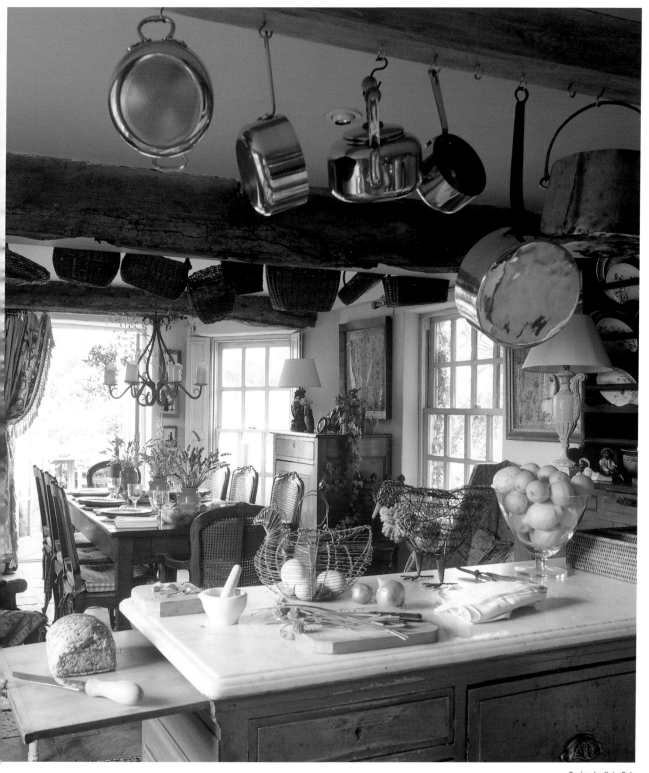

Design by Kate Pols
Photo © Andreas von Einsiedel

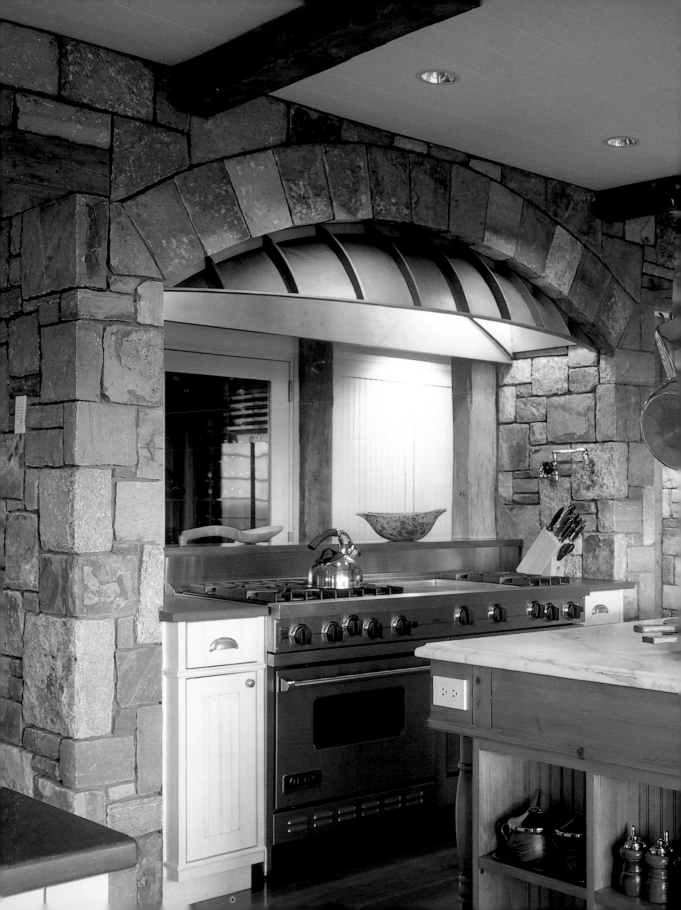

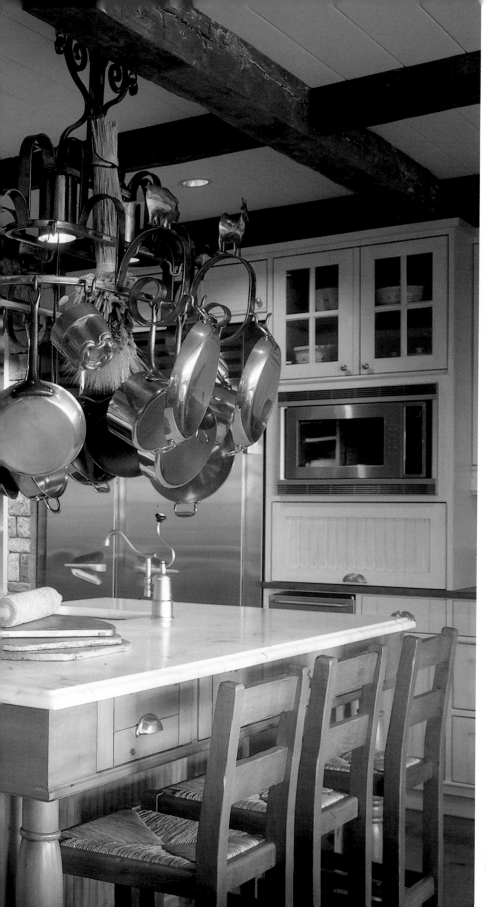

Design by Moro Stumper Associates
Photo © Scott Frances

Both pages
Design by René Rodríguez
Photo © Jose Luis Haussman

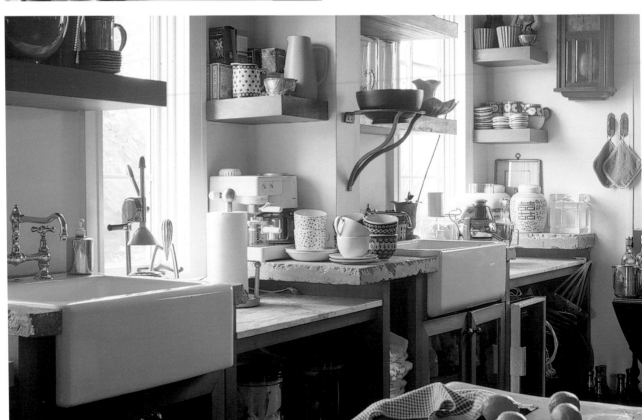

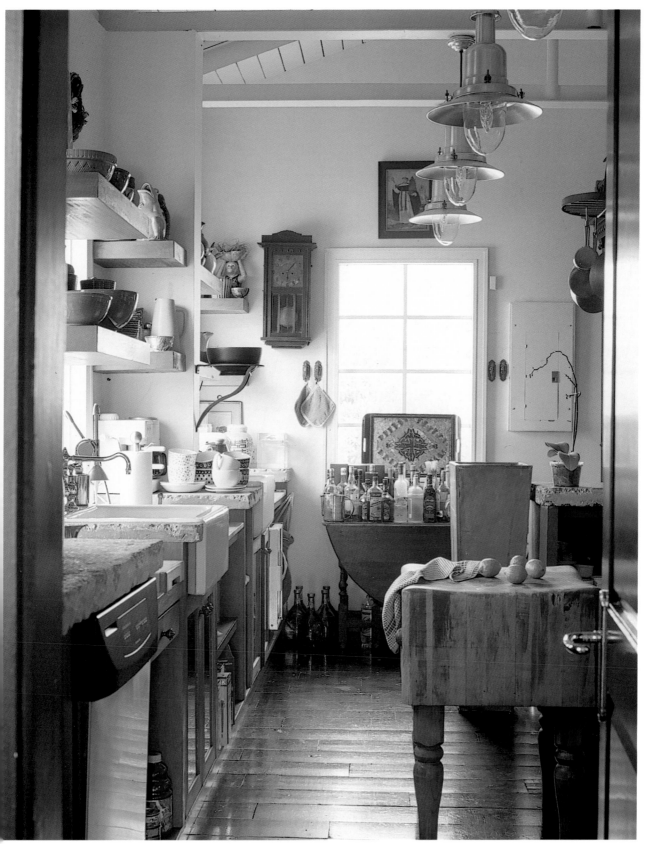

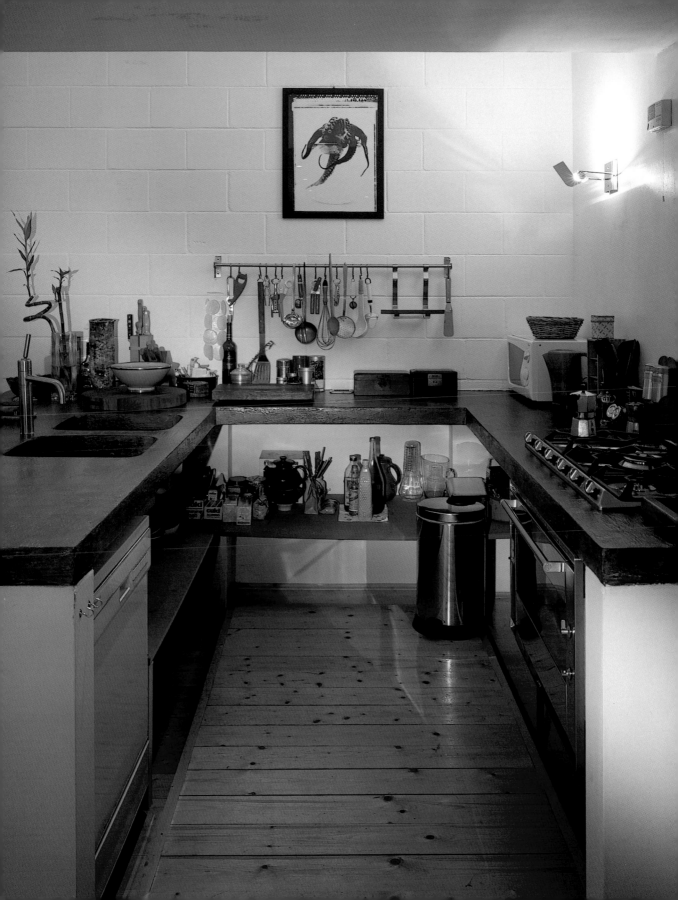

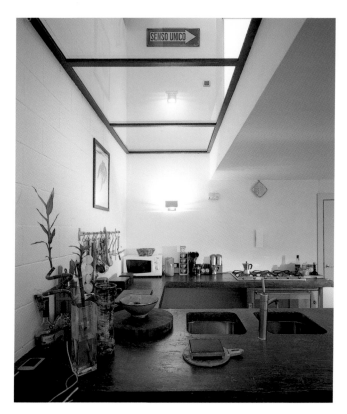

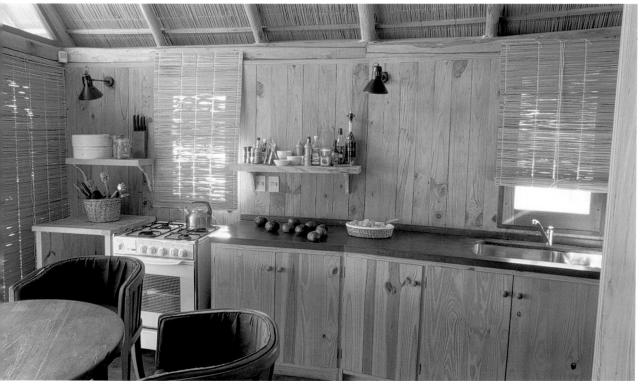

Mixed materials

Photo © E. Wenton

A combination of floor and wall coverings and the use of whites, blues and greens are a general characteristic of country-style kitchens.

Die Kombination verschiedener Materialien sowohl am Boden als auch an den Wänden und eine Farbpalette, die weiß, grün und blau umfasst, ist charakteristisch für die Landhaus-Küchen.

Le mélange de revêtements, tant sur les sols que sur les murs, conjugué à une gamme de couleurs déclinant le blanc, le vert et le bleu, caractérise les cuisines rustiques.

La mezcla de revestimientos, tanto en los suelos como en las paredes, y una gama de colores que comprende el blanco, el verde y el azul son características de las cocinas rústicas.

La mescolanza di rivestimenti, sia per i pavimenti che per le pareti, ed una gamma di colori che comprende il bianco, il verde e l'azzurro, sono caratteristici delle cucine rustiche.

Design by 1100 Architects
Photo © Michael Moran

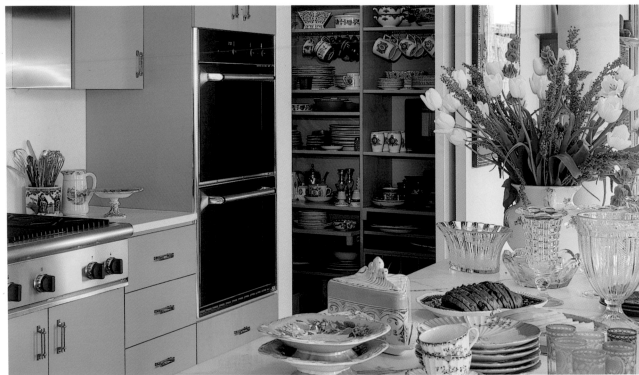

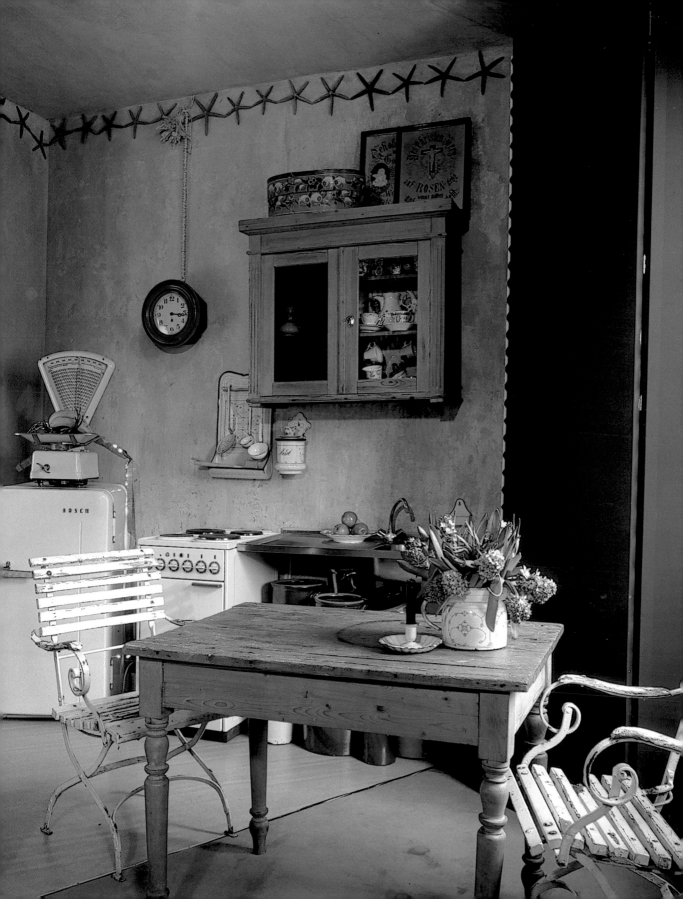

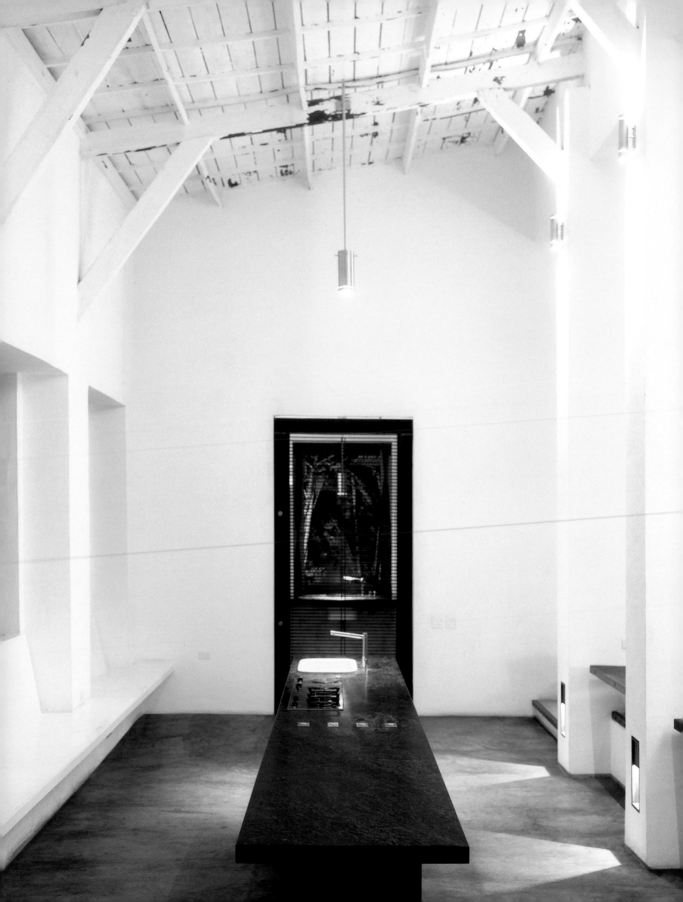

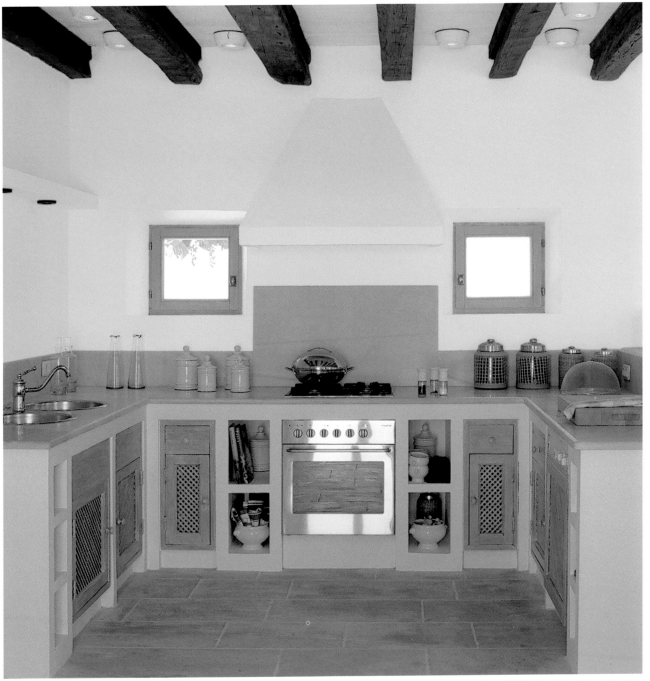

Design by B&B Estudio de Arquitectura S. Bastidas
Photo © Pere Planells

Design by Guillermo Arias, Luis Cuartas
Photo © Eduardo Consuegra

247

Design by Lluís Auqué
Photo © Montse Garriga

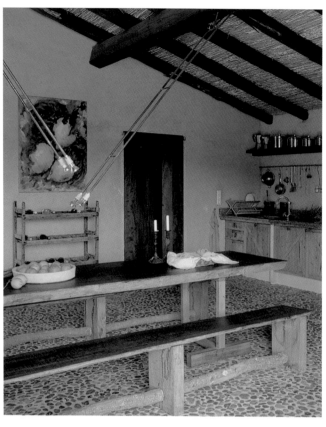

Both photos
Design by Thomas Wegner
Photo © Pere Planells

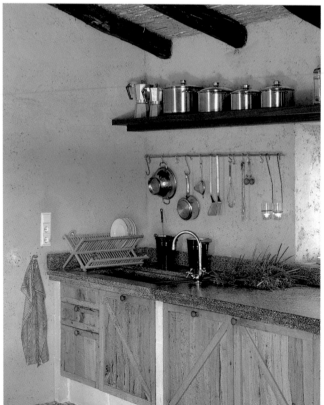

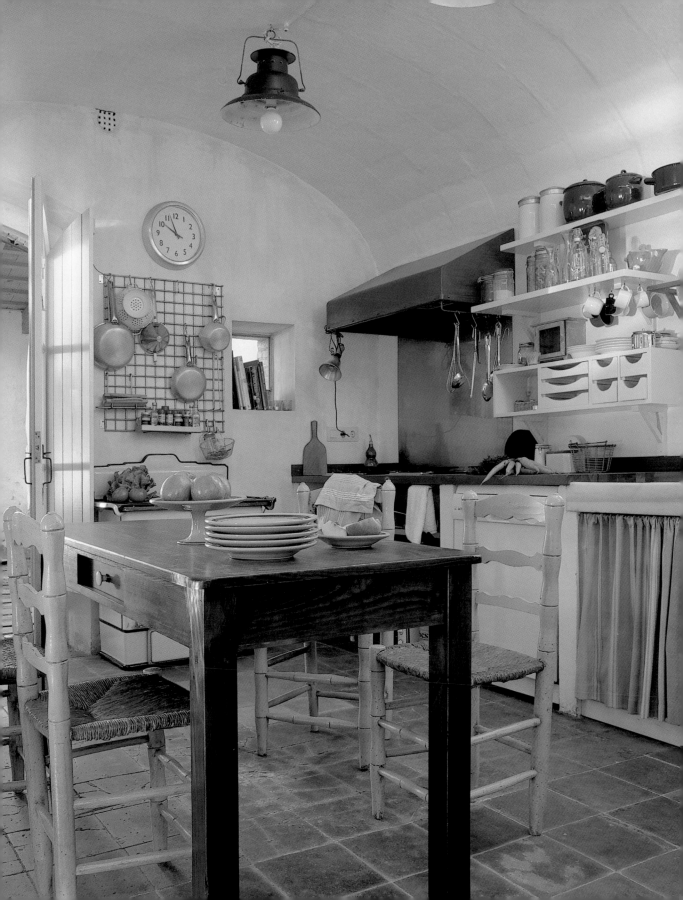

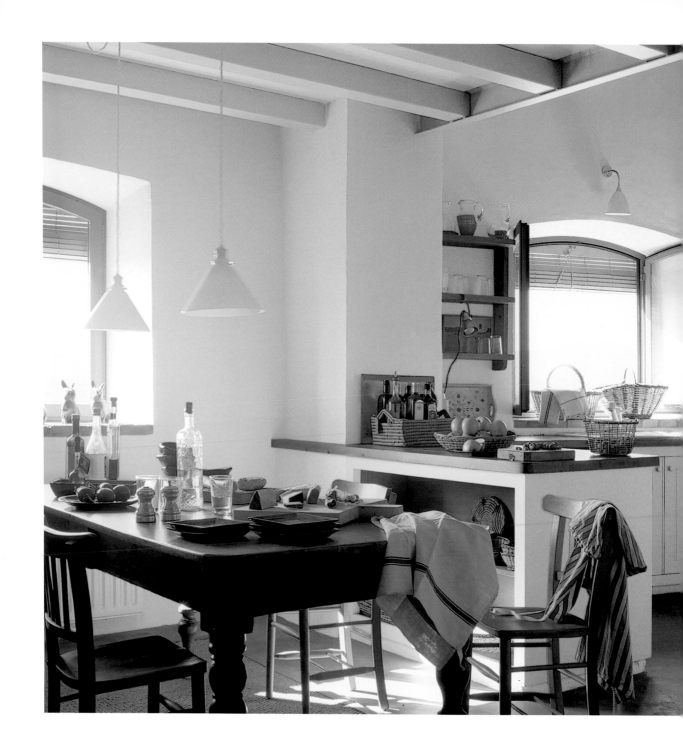

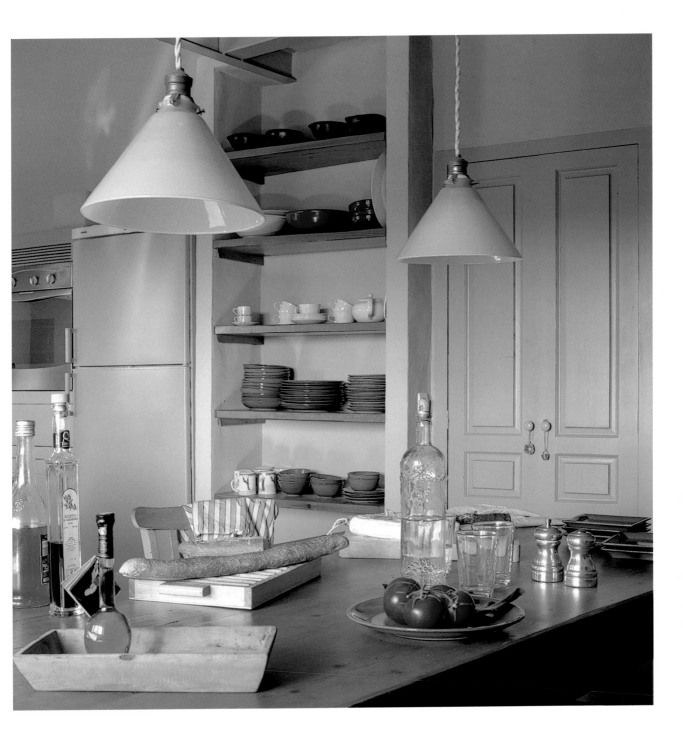

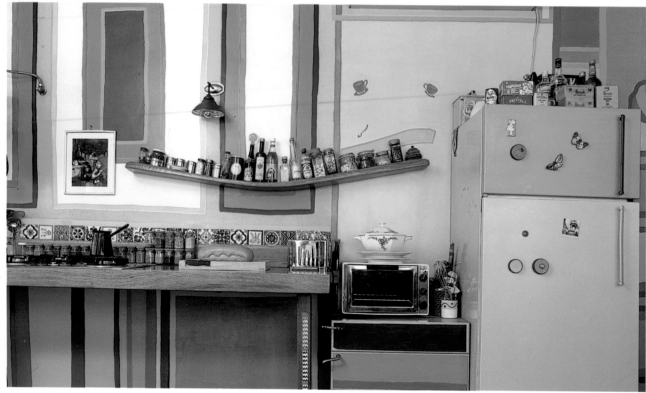

Both pages
Design by Nimrod Getter
Photo © Yael Pincus

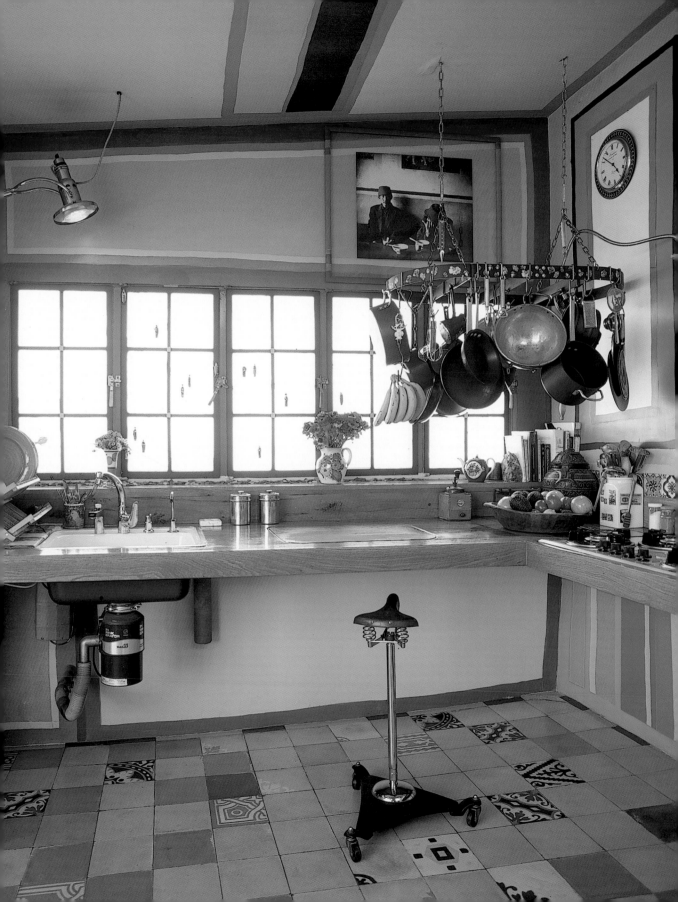

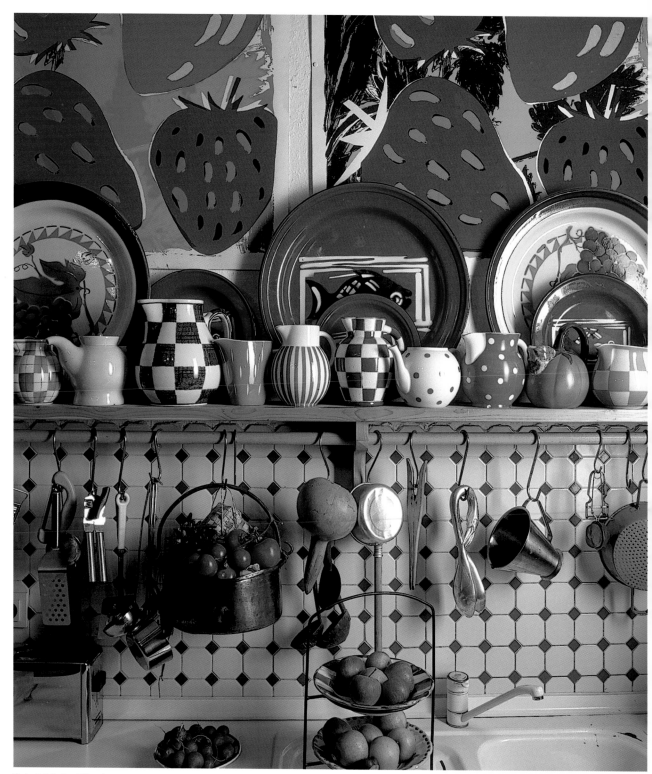

Photo © Reto Guntli/Zapaimages

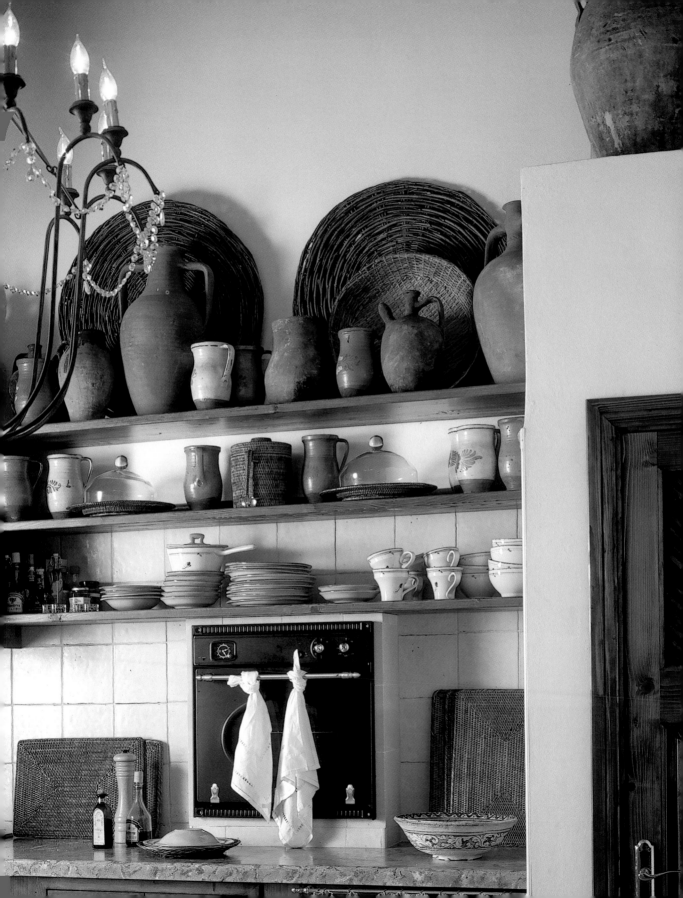

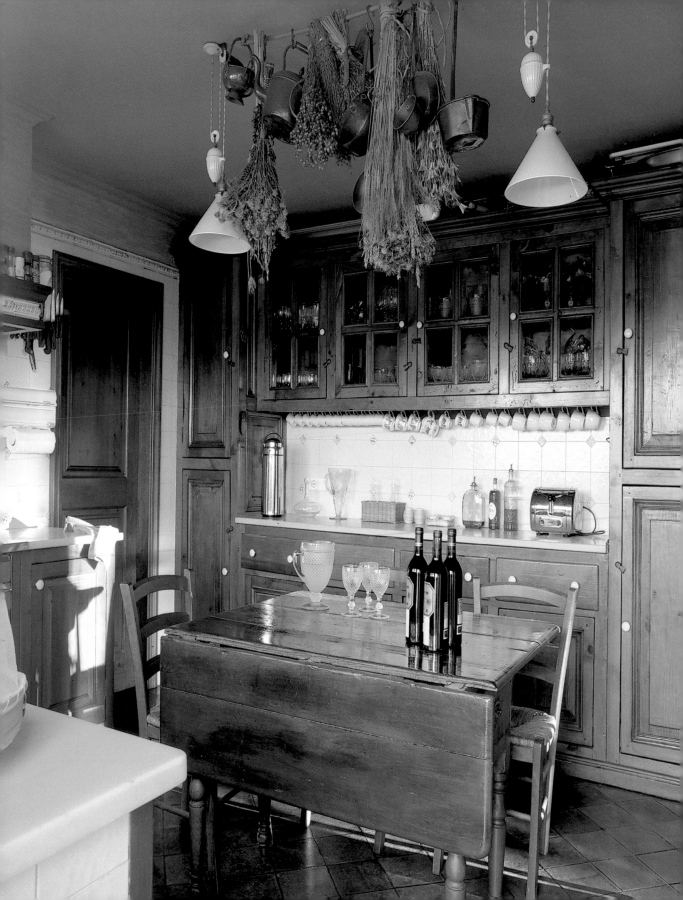

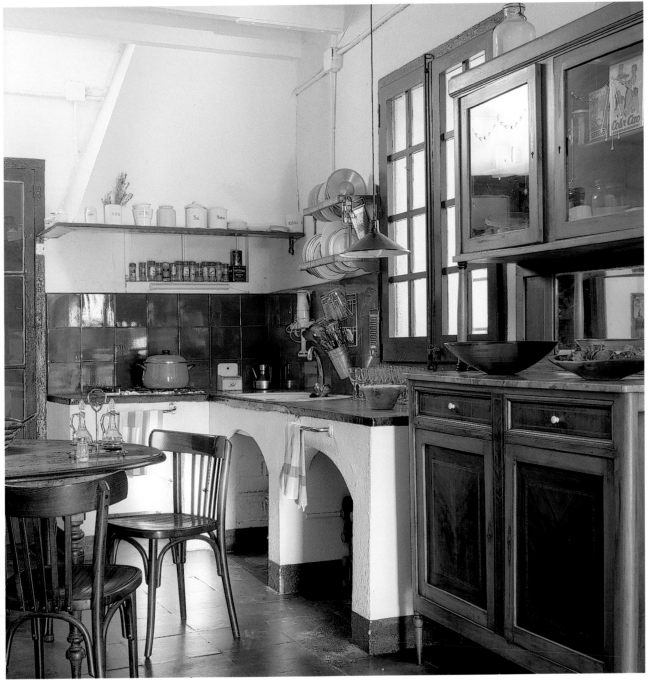

Design by Esperanza García
Photo © Montse Garriga

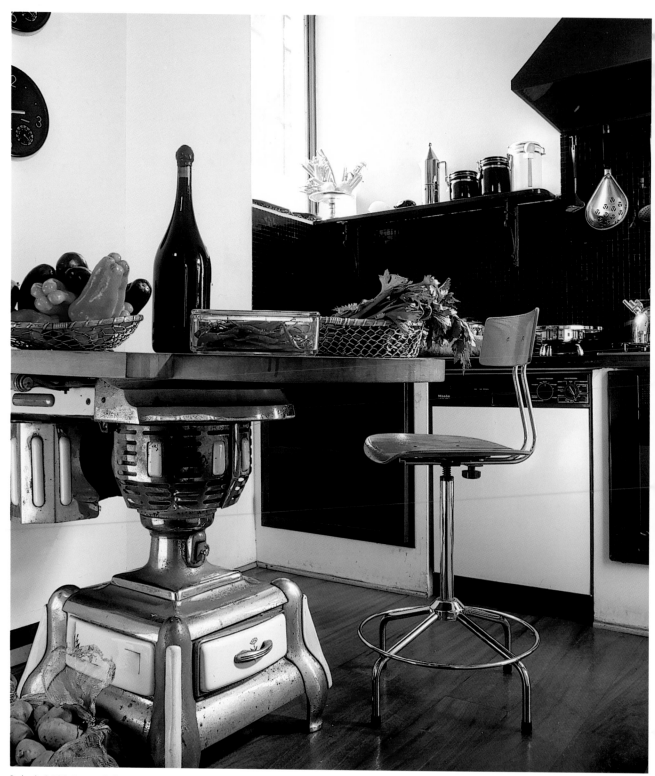

Design by Patrizio Romano Paris
Photo © Reto Guntli/Redcover

258

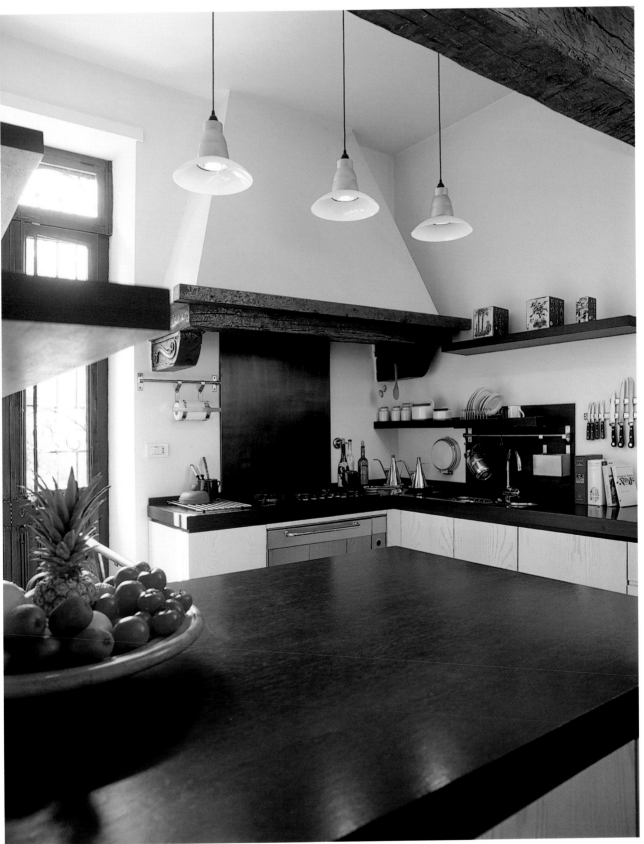

Decoration

Design by Barbara Jackson
Photo © Reto Guntli/Zapaimages

The scope for decorative elements in the country-style kitchen is huge, ranging from a single architectural feature such as a large fireplace, to any number of small items.

In der ländlichen Küche können die dekorativen Elemente stark variieren – vom einmaligen architektonischen Element über den imposanten Kamin bis hin zu kleinen Dekorationsobjekten.

Dans la cuisine rustique les éléments décoratifs peuvent être très variés, depuis un élément architectural unique, à l'instar d'une grande cheminée, jusqu'à une infinité de petits objets de décor.

En la cocina rústica los elementos decorativos pueden ser muy variados, desde una única pieza arquitectónica, como una gran chimenea, hasta un sinfín de pequeños objetos decorativos.

Nella cucina rustica gli elementi decorativi possono essere di vario genere, da un unico pezzo architettonico, come un gran camino, fino ad una serie illimitata di piccoli complementi di arredo.

Photo © Ken Hyden/Redcover

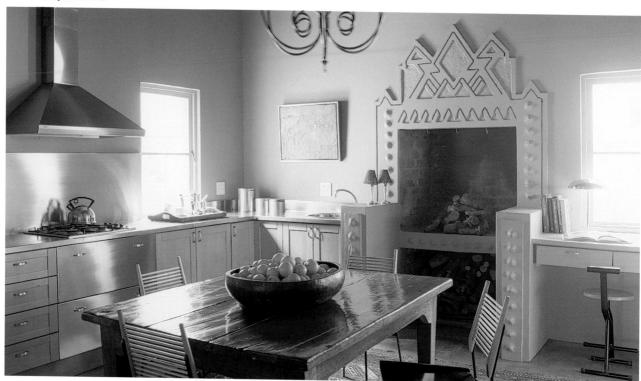

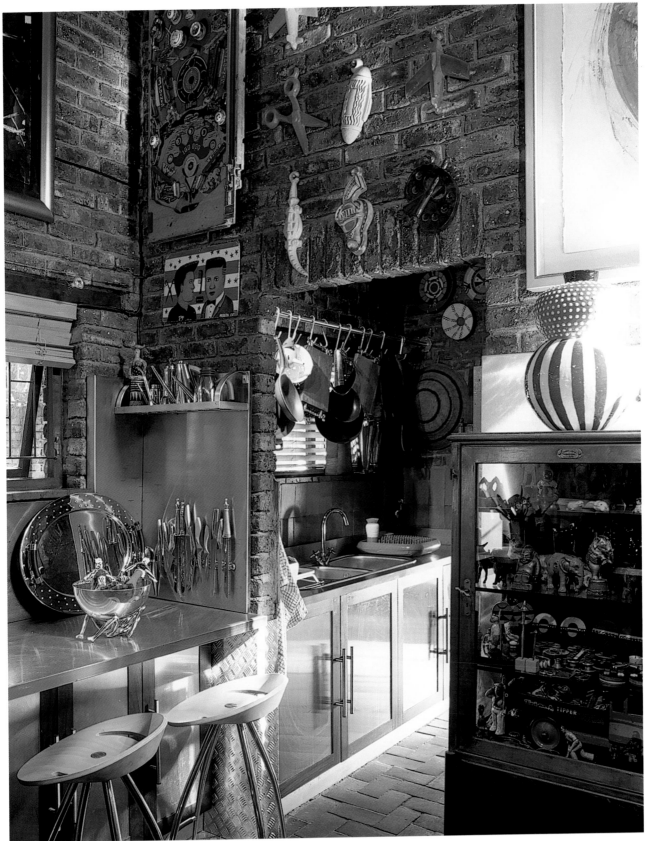

Photo © Montse Garriga

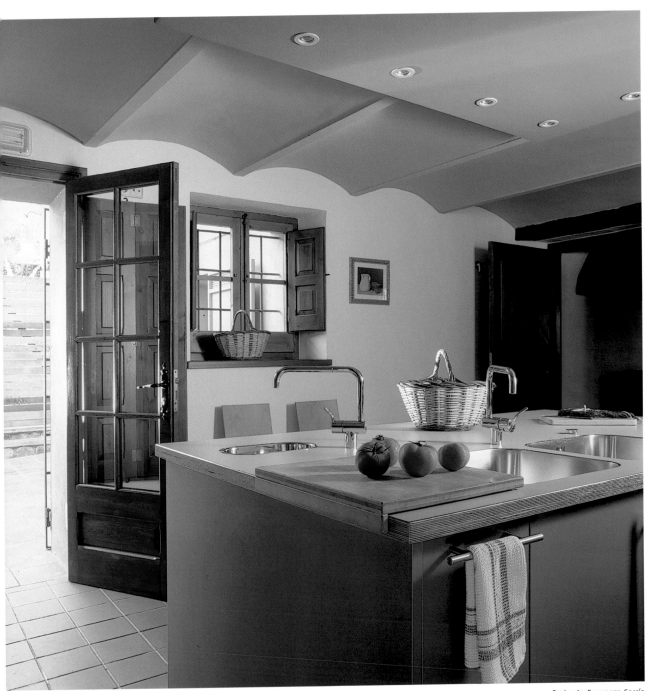

Design by Esperanza García
Photo © Montse Garriga

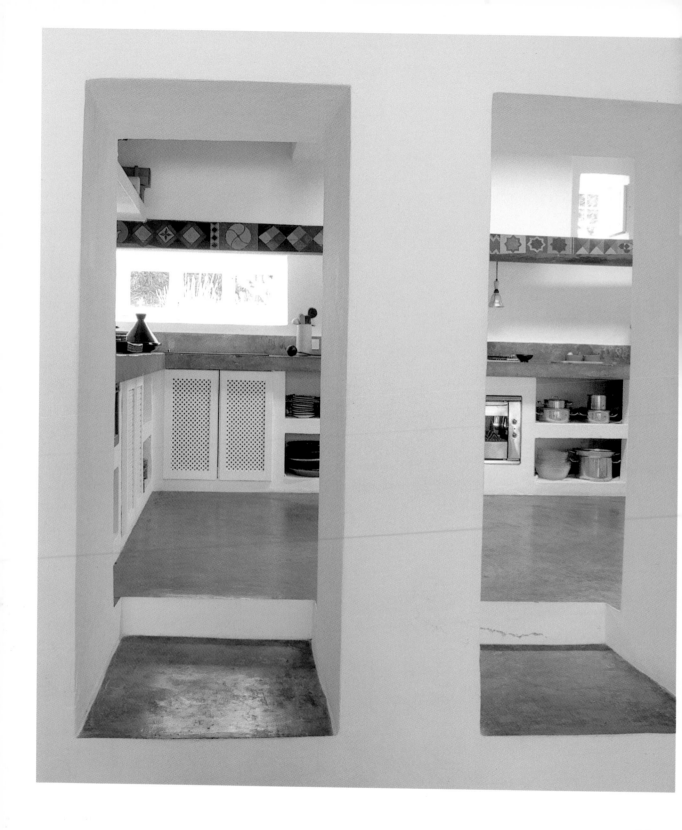

Both pages
Design by Nicolás Besset
Photo © Pere Planells

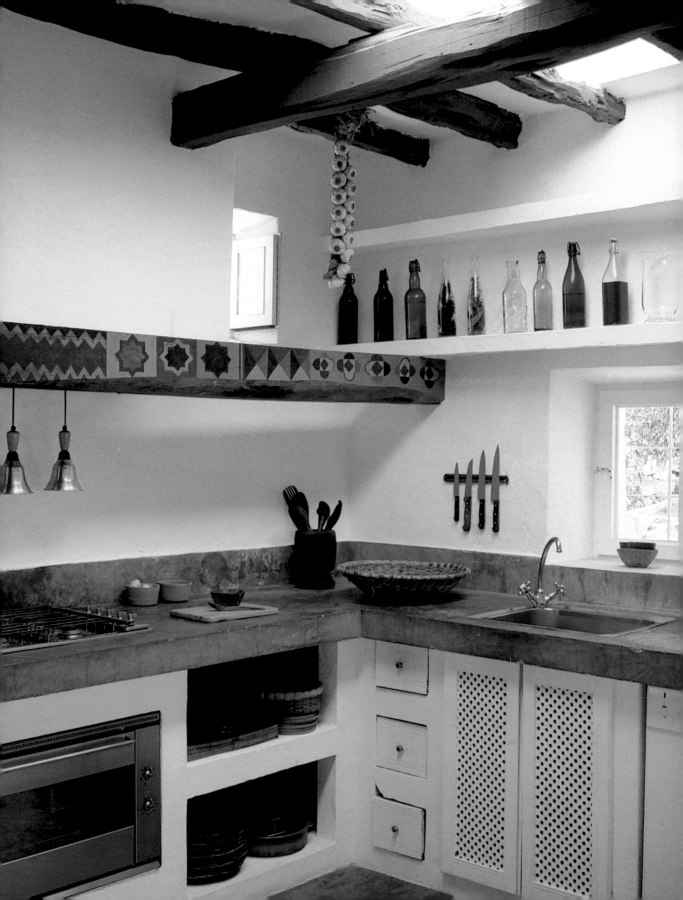

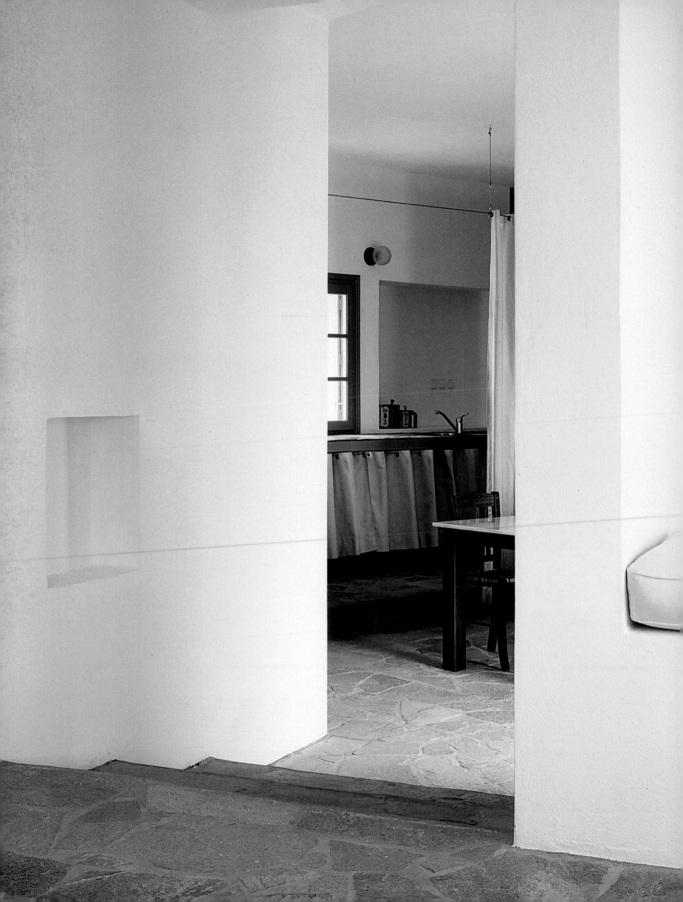

Both pages
Design by J. Bocabeille, I. Prego
Photo © Ken Hayden

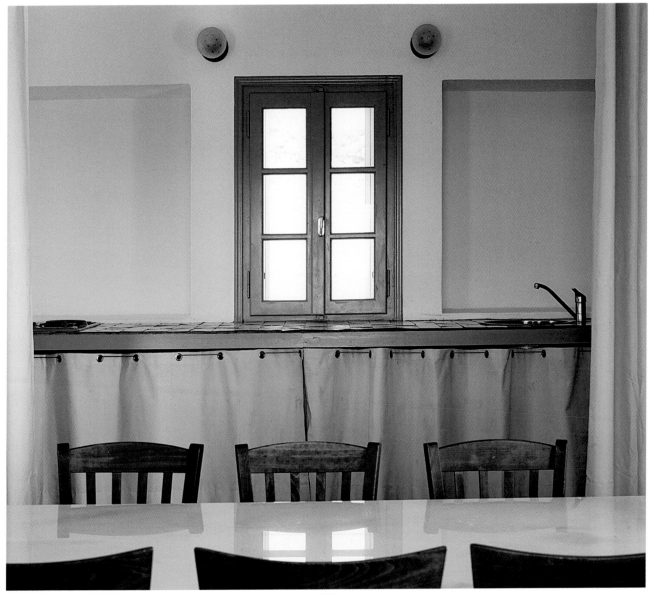

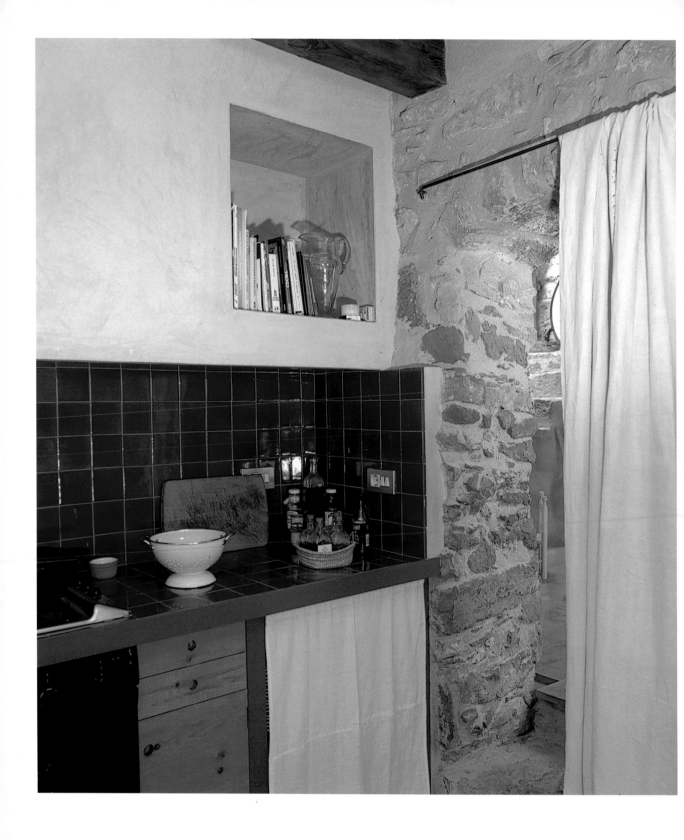

Both pages
Photo © Montse Garriga

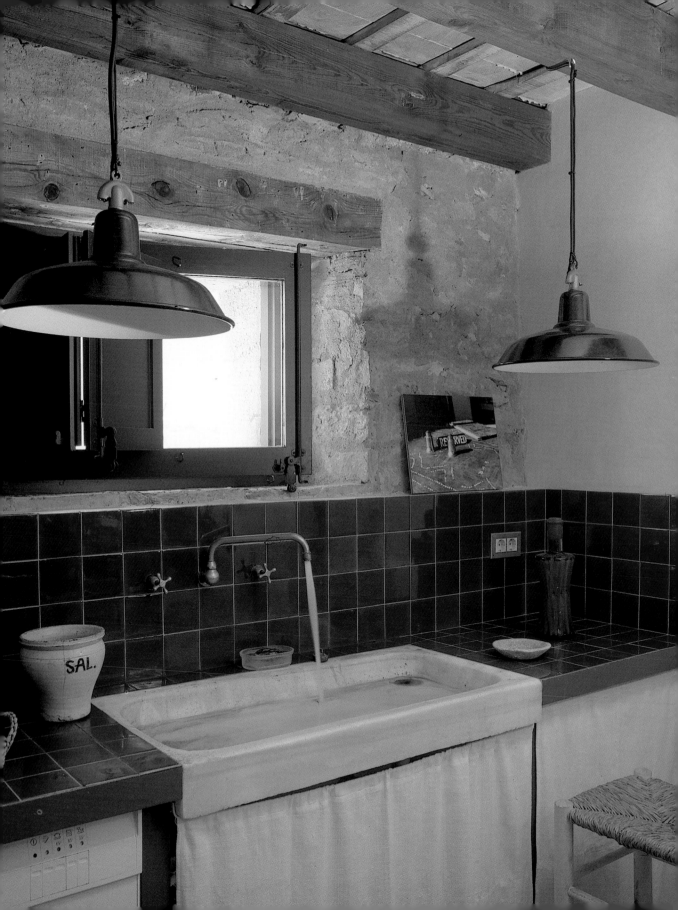

Photo © Concrete

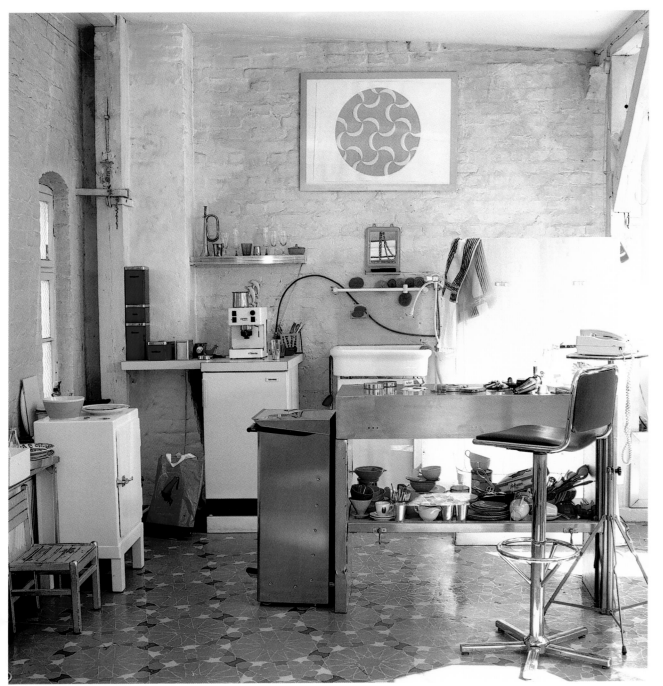

Photo © E. Wentorf

Minimalist >>>>>>

The minimalist style takes its name from the school of painting and sculpture that originated in the United States of America in the nineteen sixties, and has had a strong influence on the work of many outstanding architects over the last decades. Minimalism's growing popularity, along with the austerity its principles demand, is clearly visible in kitchen design where pure lines, the absence of decorative motifs, monochrome colour schemes and high tech solutions are applied to constructive techniques and to white goods alike. Regular outlines are decorative in their own right, and through the use of pure, clean forms, minimalist kitchens integrate naturally with the rest of the spaces in the home. Such rigidity of design, however, calls for a minute analysis of the future owners' needs since these spaces cannot be easily altered or enlarged.

The latest materials, such as high-density worktops and laminate products, are the most frequent choice in kitchens of this nature, and classical materials, such as stone or stainless steel, are only used sparsely. Materials that require joins between pieces, as in the case of ceramic tiles, are rejected and wherever joints are inevitable, they are reduced to a single seam in order to avoid the need for skirting boards or beading.

Minimalist furniture derives on the whole from modern kitchens, and consists of modular units which can be adapted to each individual space. However, minimalist kitchens are often entirely custom built. Since kitchen utensils are never exposed to view, the cabinetry needs to be capacious.

> The minimalist style takes its name from the school of painting and sculpture that originated in the United States of America in the nineteen sixties.

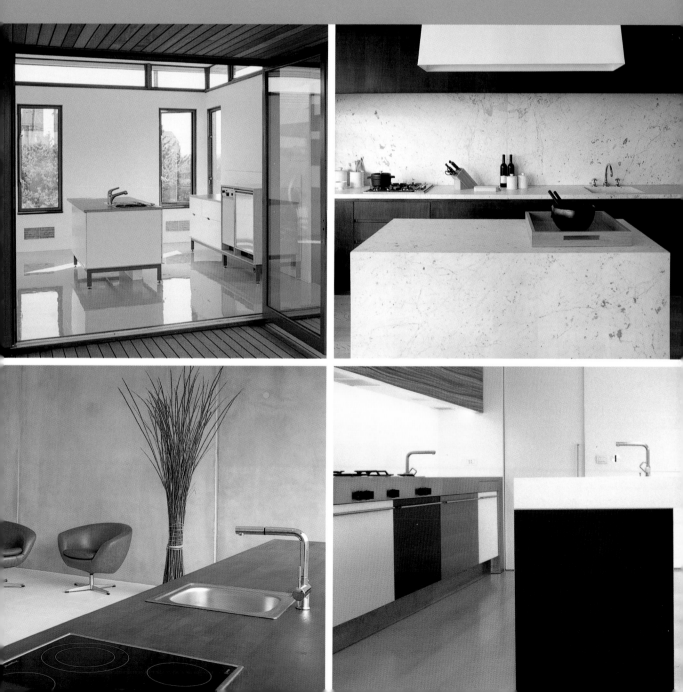

Minimalistisch

Der minimalistische Stil geht auf eine in den sechziger Jahren in den Vereinigten Staaten entstandene Kunstrichtung zurück, die von der Malerei und Bildhauerei ausgehend, in den letzten Jahrzehnten auch die Arbeit vieler Architekten beeinflusst hat. Dieser eher strenge Stil und die Konsequenz, die auch die Umsetzung der Ideen begleitet, findet auch im Küchendesign immer mehr Anhänger. Er zeichnet sich aus durch nüchterne, klare Linien, Verzicht auf schmückende Details, Einfarbigkeit und den Einsatz der neuesten technischen Errungenschaften sowohl im haushaltstechnischen wie auch im baulichen Bereich. Einfache, regelmäßige Formen werden als solche geschätzt und fügen sich dank des durchdachten Designs gut in den übrigen Wohnbereich ein. Ein derartig rigides Design macht aber auch eine genaue Analyse der Bedürfnisse der Nutzer vor der Einrichtung notwendig, da spätere Änderungen schwierig, wenn nicht gar unmöglich sind.

Bei der Einrichtung dieser Küchenart kommen in der Regel die modernsten Materialien zum Einsatz, wie etwa hochverdichtete Oberflächen im Arbeitsbereich oder furnierte Pressspanplatten. Seltener werden herkömmliche Materialien wie Naturstein, Holz oder Edelstahl verwendet, wobei immer darauf geachtet wird, möglichst wenig verschiedene Materialien miteinander zu kombinieren. Wegen der auftretenden Fugen werden Fliesen eher vermieden. Überhaupt sollte beim Aufeinandertreffen zweier Materialien nur eine feine Linie zu sehen sein, weshalb Sockelleisten oder Fugenabdeckungen verpönt sind.

Wie auch in den anderen modernen Küchen üblich, werden meist modulare Möbelsysteme genutzt, die sich an die jeweiligen räumlichen Gegebenheiten anpassen. Es gibt allerdings oft auch nach Maß gearbeitete minimalistische Küchen. Das Küchengerät bleibt dem Blick stets verborgen, sodass die Schränke viel Stauraum bieten müssen.

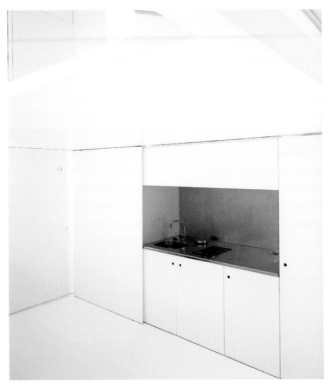

Both pages
Design by Manuel Ocaña
Photo © Luis Asín

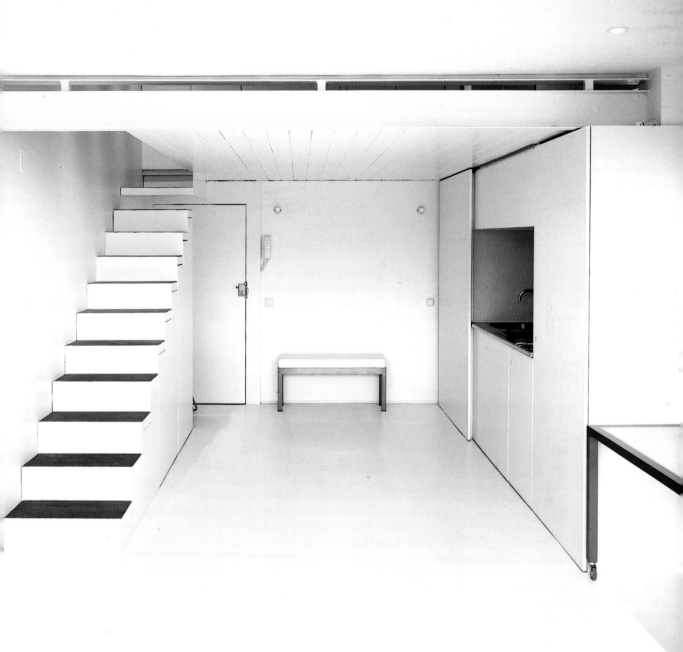

Minimalistes

Le style minimaliste, qui tire son nom du courant de peinture et sculpture surgit aux Etats-Unis dans les années soixante, a influencé, au cours des dernières décennies, le style de plusieurs architectes. L'essor de ce style et la rigueur qui accompagne sa réalisation, se reflète clairement dans la conception des cuisines, caractérisées par un design épuré, l'absence de détails décoratifs, une tendance monochromatique et la technologie de pointe employée tant dans l'électroménager que dans les détails constructifs. Les formes régulières sont des pièces décoratives par elles-mêmes. Grâce à leur design clair, les cuisines minimalistes s'intègrent facilement à l'espace de vie. De par la rigueur du design, il est toutefois nécessaire, de procéder à une analyse détaillée des exigences des futurs utilisateurs, car il est difficile d'effectuer des agrandissements ou transformations ultérieures.

Le dernier cri sur le plan des matériaux − comme les surfaces compensées pour les plans de travail et les contreplaqués de bois − est très fréquemment employé dans ce genre de cuisine : les matériaux classiques − à l'instar de la pierre naturelle, du bois ou de l'acier inoxydable − sont également utilisés, en évitant, toutefois, l'abus de mélanges. On évite les matériaux, qui, une fois installés, créent des joints − comme les carreaux de faïence − en essayant de réduire la jointure entre les différents matériaux à une ligne, éliminant, ainsi, socles et couvre-joints.

Le mobilier, hérité des cuisines modernes, est constitué, en général, de modules adaptables aux différentes conditions spatiales. Cependant, il est fréquent d'avoir des cuisines minimalistes entièrement dessinées et construites sur mesure. Les ustensiles n'étant jamais apparents, il est donc indispensable que les placards disposent d'une grande capacité de rangement.

Both pages
Design by Simon Conder Associates
Photo © Peter Warren

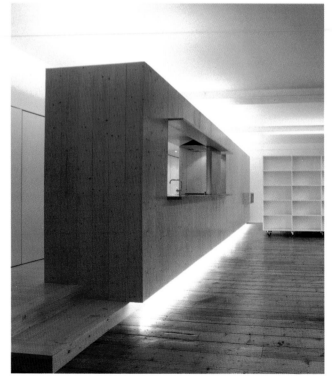

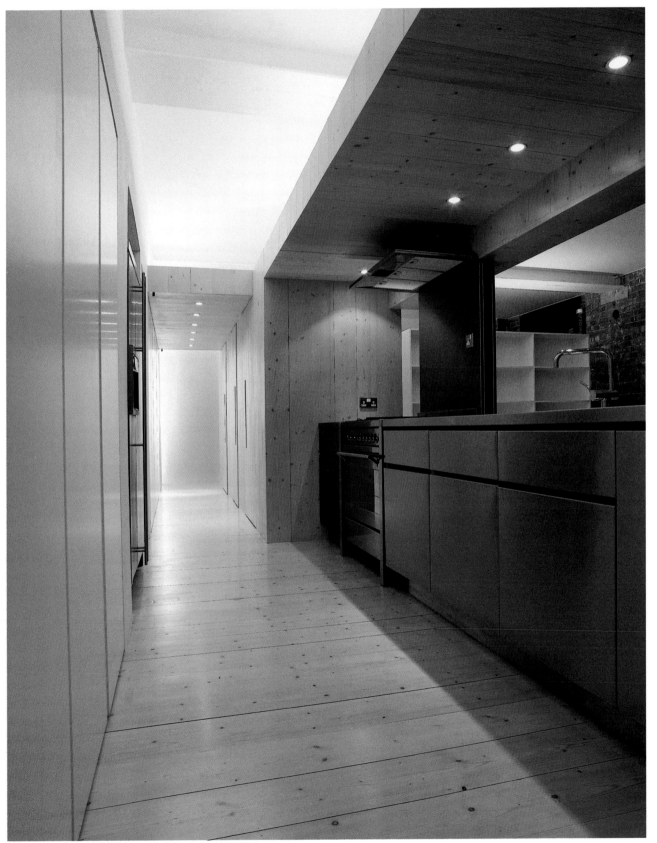

Minimalistas

El estilo minimalista, que toma su nombre de la corriente pictórica y escultórica surgida en Estados Unidos en los años sesenta, ha influido, en las últimas décadas, sobre el estilo de diversos arquitectos. El auge de este estilo y el rigor que conlleva su realización se refleja claramente en el diseño de las cocinas, que se caracteriza por unas líneas depuradas, por la ausencia de detalles decorativos, por una propuesta monocromática y por la alta tecnología, presente tanto en los electrodomésticos como en los detalles constructivos. Las formas regulares son un decorado en sí mismas y, gracias a su diseño limpio, las cocinas minimalistas se integran con facilidad en el espacio de la vivienda. A causa de la rigidez del diseño, es necesario, sin embargo, un análisis detenido de los requerimientos de los futuros usuarios, ya que no son posibles muchas de las ampliaciones y adaptaciones posteriores.

Suele ser habitual que este tipo de cocinas incorpore lo último en materiales, como las superficies de alta densidad para las encimeras y los contrachapados de madera. También emplea materiales clásicos, como la piedra natural, la madera y el acero inoxidable, cuidando siempre de no combinar muchos. Se prescinde de los materiales que, al colocarse, producen juntas –como los azulejos– y se procura que el encuentro entre materiales diferentes se reduzca a una línea, con lo que se evita, de este modo, el empleo de zócalos y tapajuntas.

El mobiliario, heredado de las cocinas modernas, consiste por lo general en módulos que pueden adaptarse a las condiciones de cada espacio. Sin embargo, es frecuente encontrar cocinas minimalistas enteramente diseñadas y construidas a medida. Los utensilios nunca están a la vista y, por lo tanto, es necesario que los armarios posean una buena capacidad de almacenaje.

Both pages
Design by i29 Office for Spatial Design
Photo © Joroen Dellensen

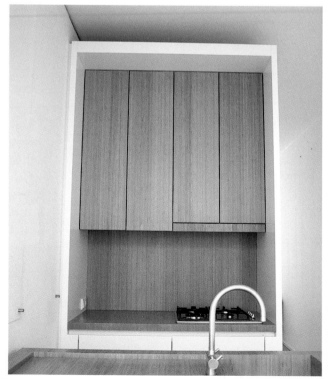

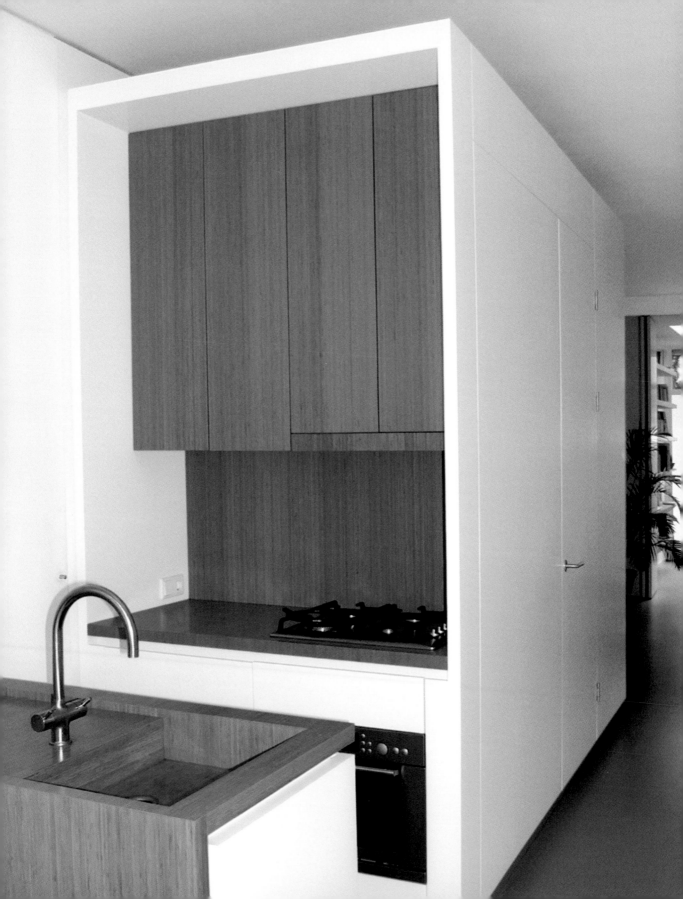

Minimaliste

Negli ultimi anni lo stile minimalista, che deve il suo nome alla corrente pittorica e scultorea sorta negli Stati Uniti negli anni sessanta, ha esercitato una notevole influenza sullo stile di diversi architetti. Il recupero di questo stile e il rigore insito nella sua realizzazione vengono rispecchiati chiaramente nelle linee delle cucine, sobrie ed essenziali, caratterizzate dall'assenza di particolari decorativi, da proposte monocromatiche e dall'uso dell'alta tecnologia, presente sia negli elettrodomestici che nei dettagli costruttivi. Le forme regolari delle cucine minimaliste presentano di per sé un grande effetto scenico e grazie a uno stile scarno e pulito, si integrano con facilità nello spazio dell'abitazione; ciò nonostante, a causa della rigidità del disegno, è necessario analizzare attentamente le esigenze dei futuri utenti, visto che non è possibile effettuare molte modifiche o adattamenti posteriori.

In questo tipo di cucine è molto frequente l'uso dei materiali più in voga, come le superfici ad alta densità per i piani di lavoro e il compensato in legno. Ciò non esclude, però, l'uso dei materiali classici – come la pietra naturale, il legno o l'acciaio inossidabile – che preferibilmente vengono adoperati singolarmente, facendo attenzione a non combinarli in eccesso. Si evita l'uso di materiali la cui collocazione dia origine a giunture – come per le piastrelle smaltate – e si fa in modo che l'incontro tra materiali diversi si riduca ad una linea, evitando così, l'uso di battiscopa e coprifilo.

La mobilia, ereditata dalle cucine moderne, generalmente consiste in moduli che si possono adattare alle condizioni di ogni singolo spazio. Ciò nonostante, è frequente trovare cucine minimaliste interamente disegnate e realizzate su misura. Gli utensili non vengono lasciati mai in vista, pertanto è necessario che gli armadi siano abbastanza capienti.

Both pages
Design by Chroma AD
Photo © David M. Joseph

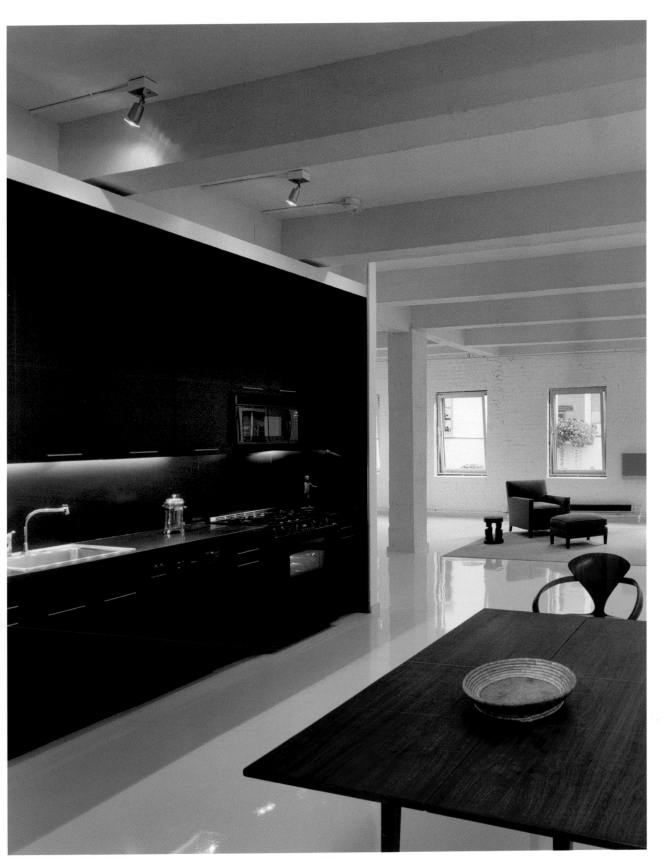

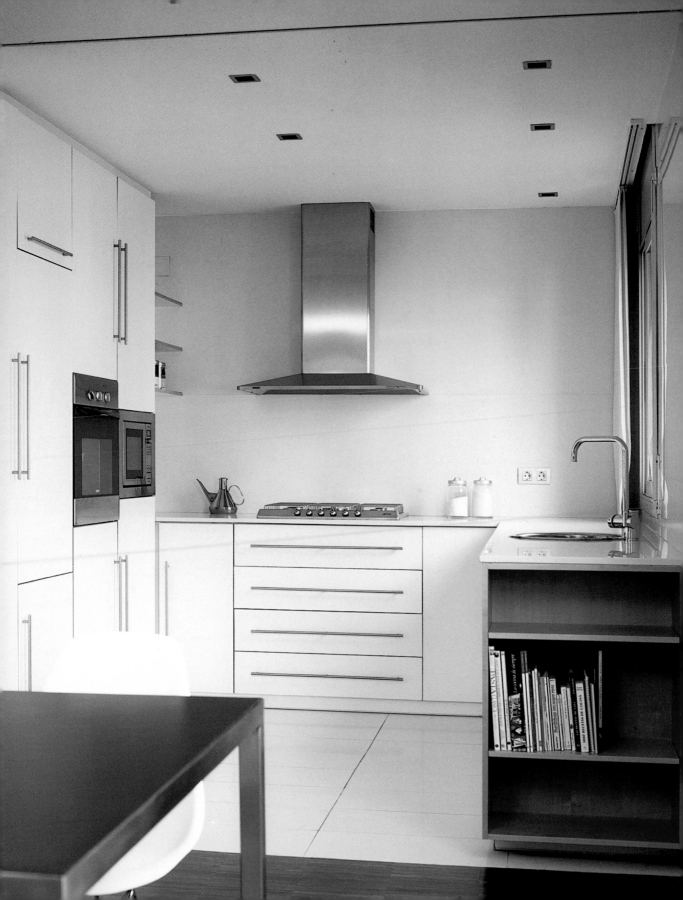

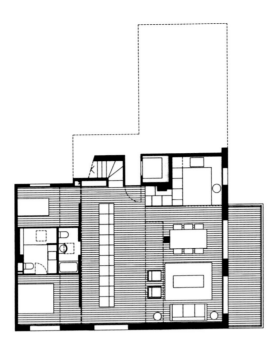

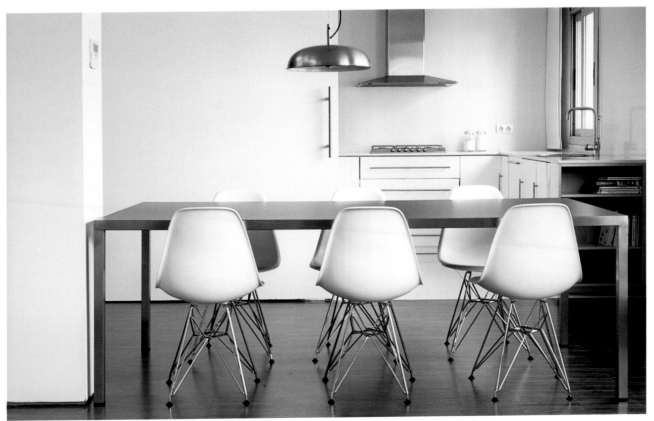

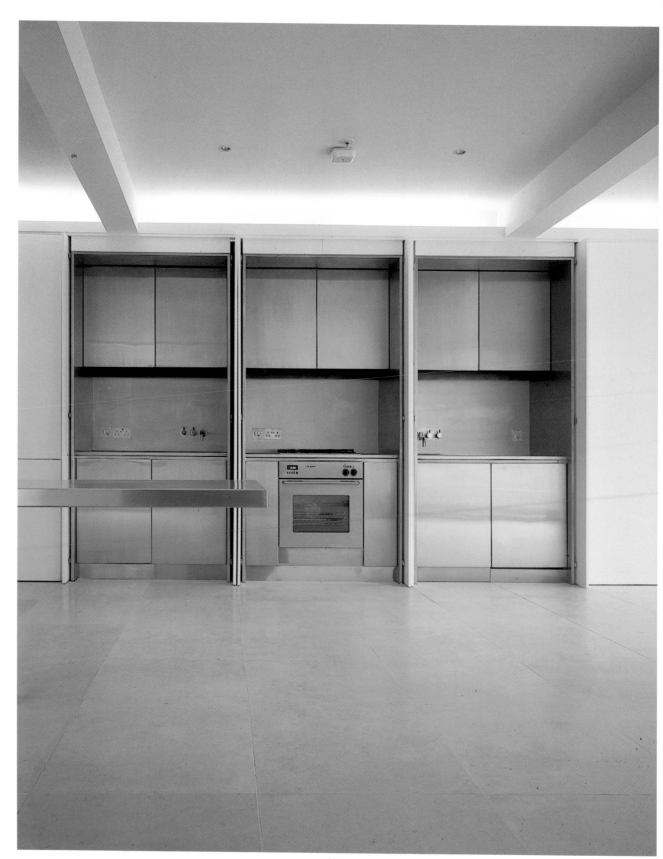

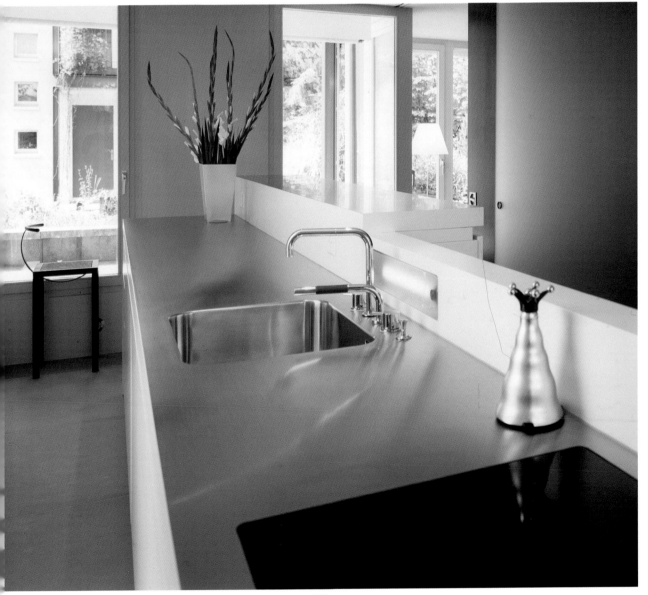

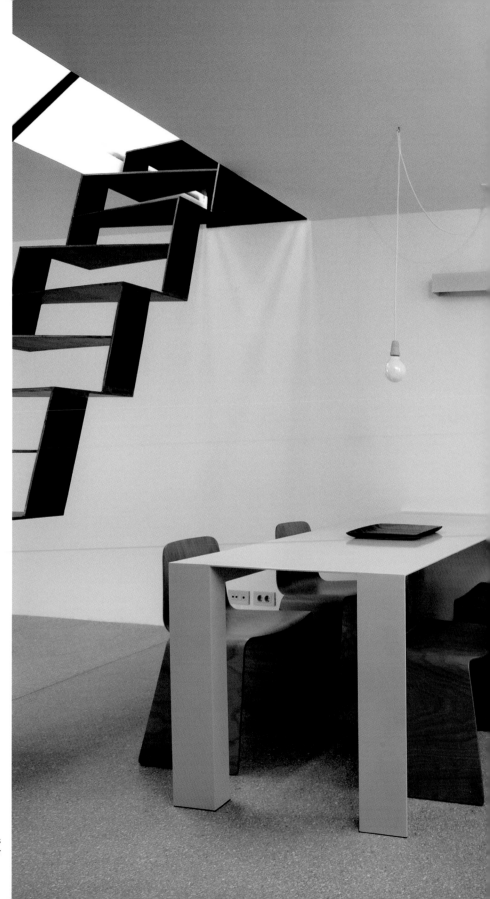

Design by Dekleva Gregoric Architects
Photo © Matevz Paternoster

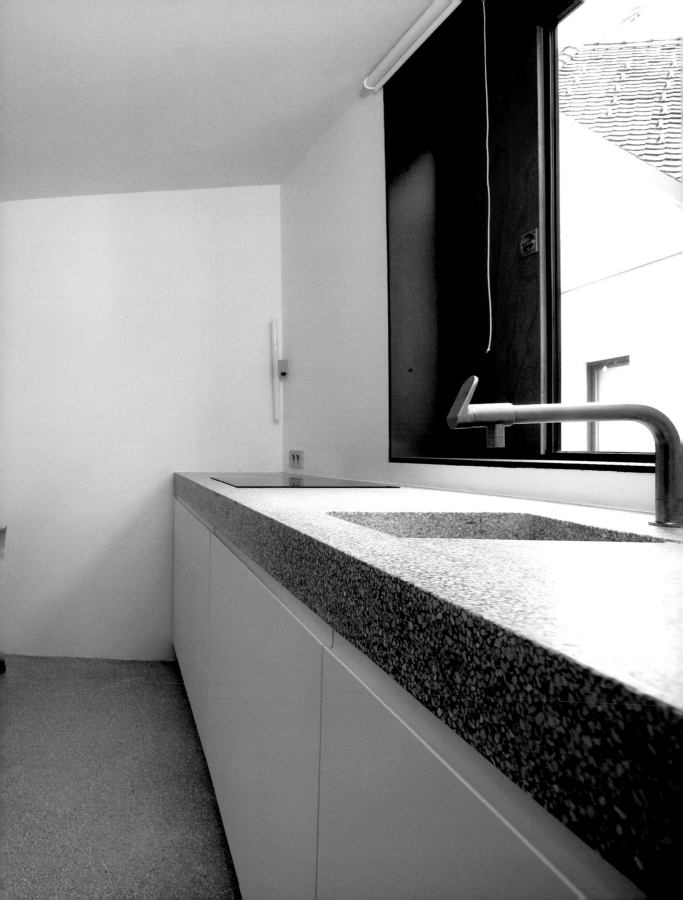

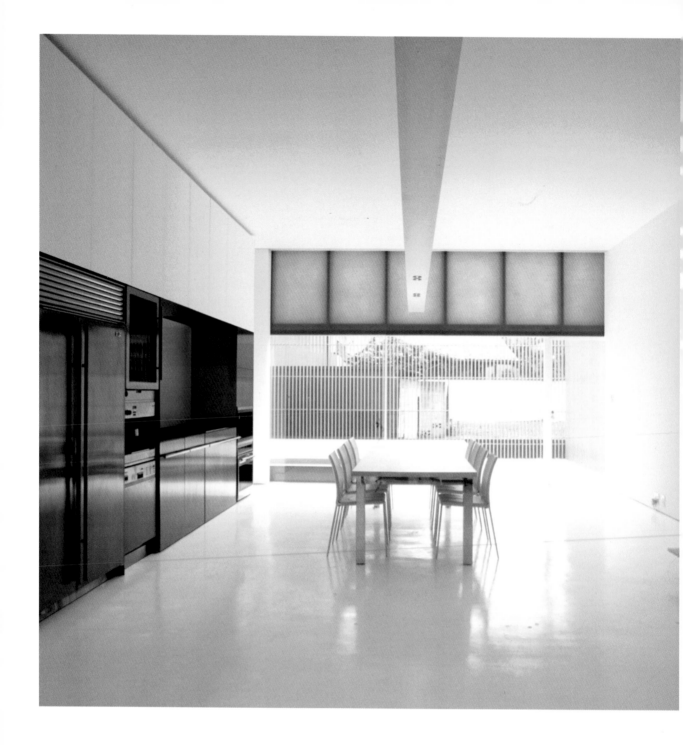

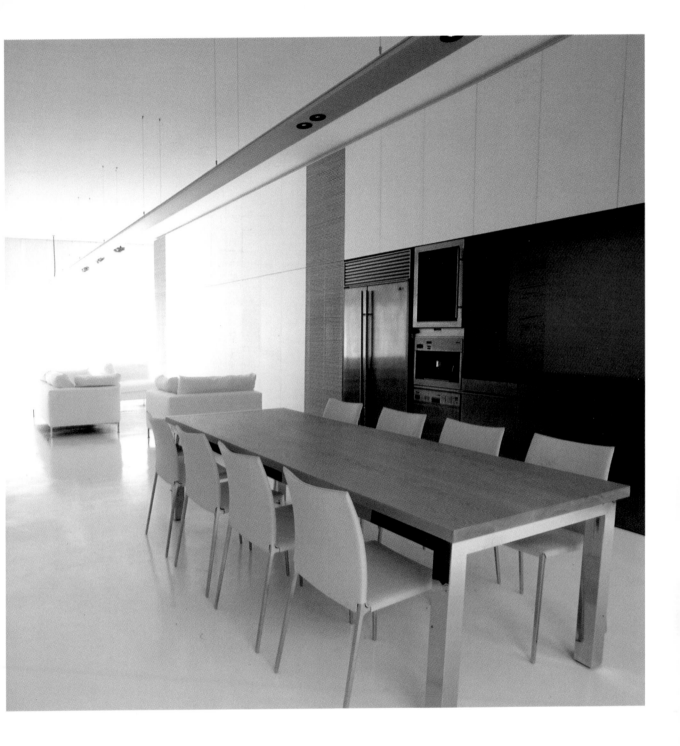

Both pages
Design by Kengo Kuma
Photo © Mitsumasa Fujitsuka

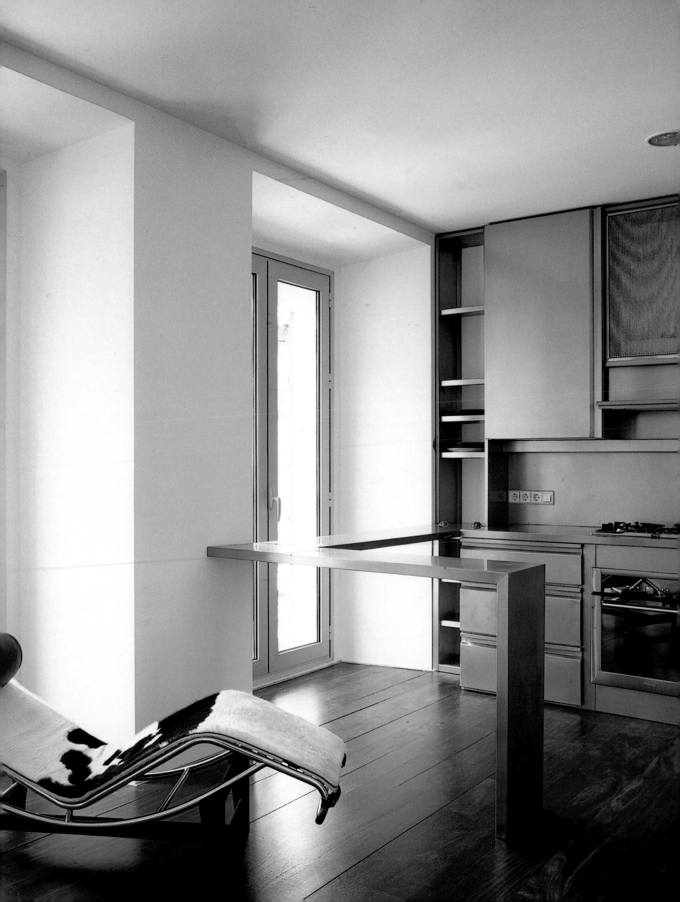

Both pages
Design by Manuel Ocaña
Photo © Alfonso Postigo

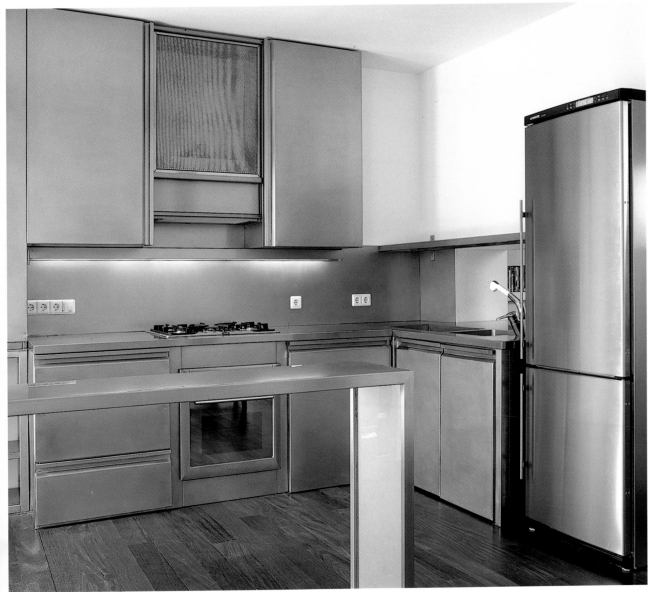

Mixed materials

Design by Uda Architects
Photo © Emilio Conti

The combination of stainless steel on worktops and laminate pan-
elling for cabinets creates a warm atmosphere, ruling out the 'indus-
trial kitchen' feeling.

Indem der Edelstahl der Arbeitsflächen mit laminierten Spanplatten
kombiniert wird, kann eine zu industrielle Erscheinung vermieden
und eine angenehme Atmosphäre geschaffen werden.

En combinant l'acier inoxydable, utilisé sur les plans de travail, au
laminé de contreplaqué, utilisé dans les placards, on évite l'aspect
industriel tout en créant une ambiance chaleureuse.

Al combinar el acero inoxidable, que se emplea en las encimeras,
con el contrachapado laminar de los armarios, se evita una apa-
riencia industrial y se logra un ambiente cálido.

Abbinando l'acciaio inossidabile, usato per i piani di lavoro, al com-
pensato lamellare, adoperato per gli armadi, si evita di conferire un
aspetto prettamente industriale ottenendo così un ambiente grade-
vole e accogliente.

Design by Reg Lark
Photo © Sharrin Rees

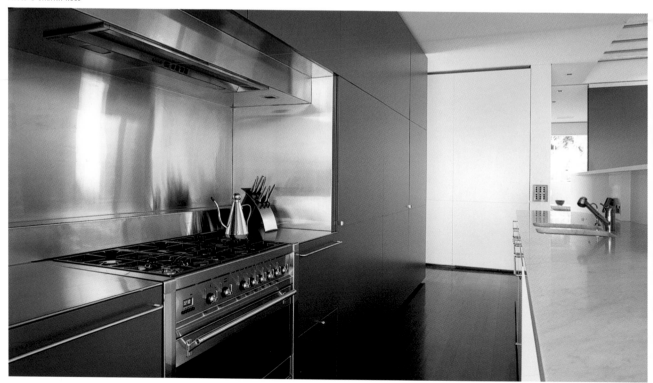

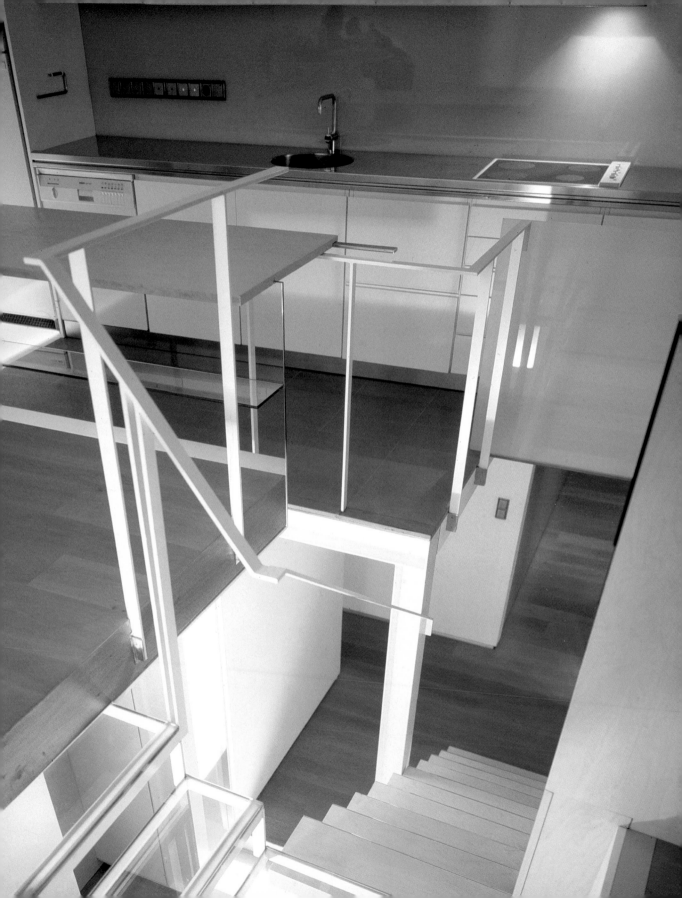

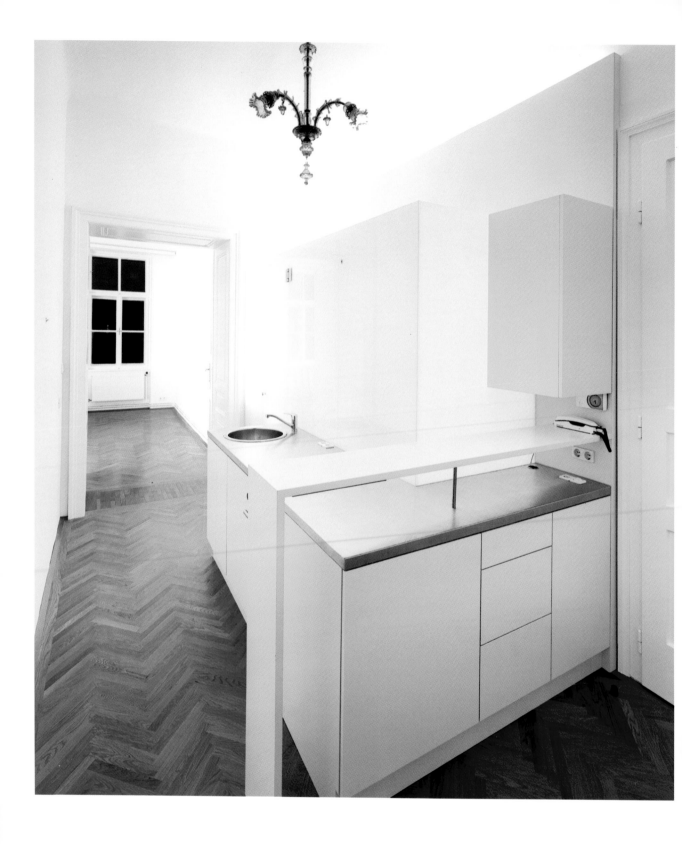

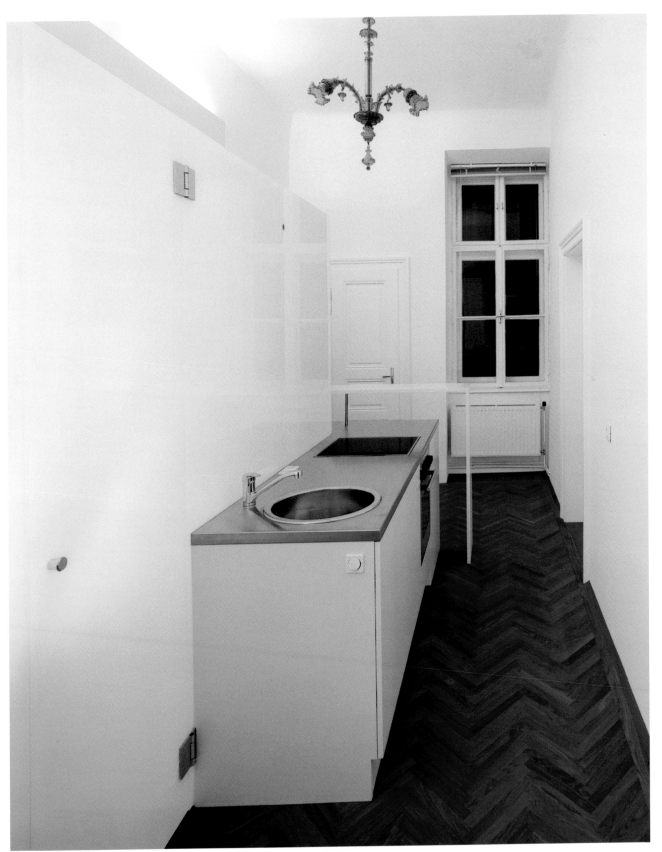

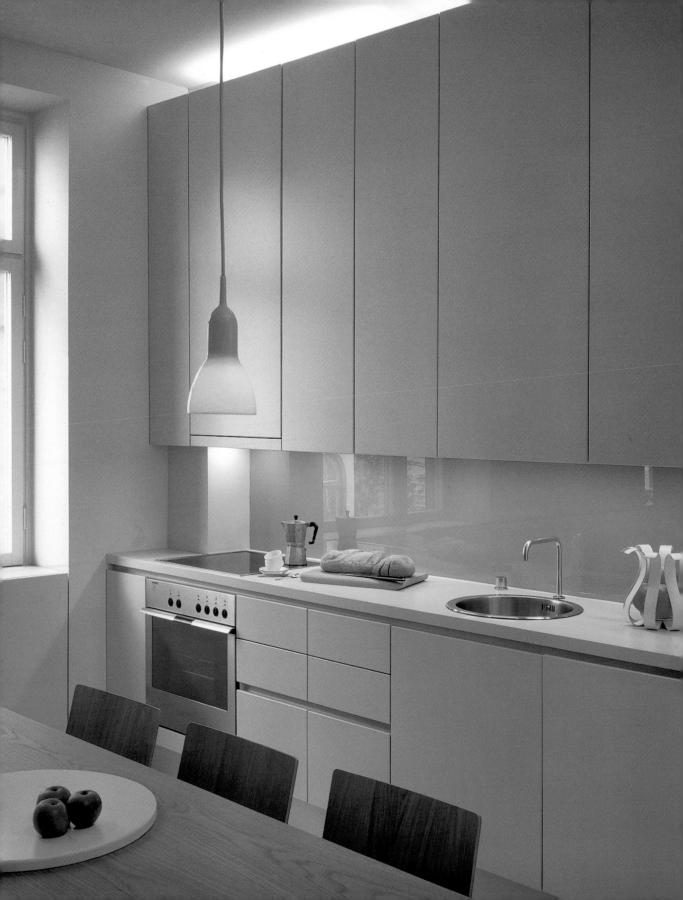

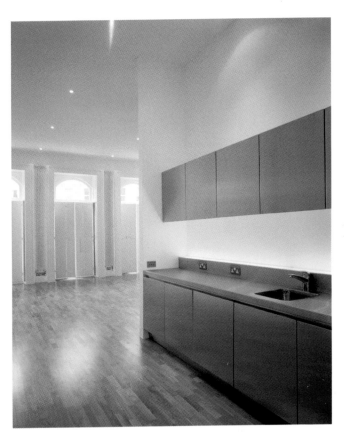

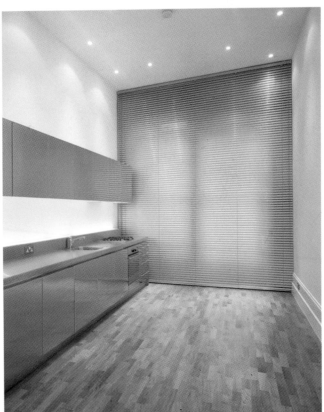

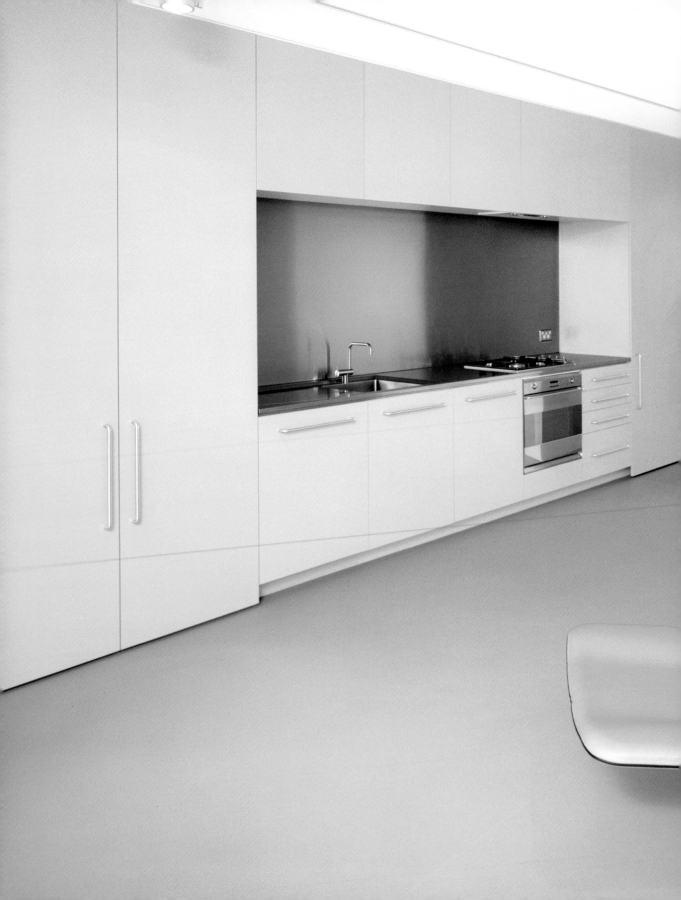

Design by Engelen Moore
Photo © Ross Honeysett

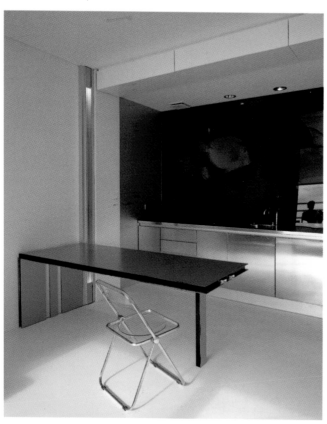

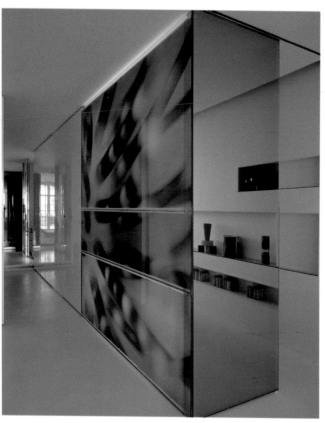

Both pages
Design by Uda Architects
Photo © Hervè Abbadie

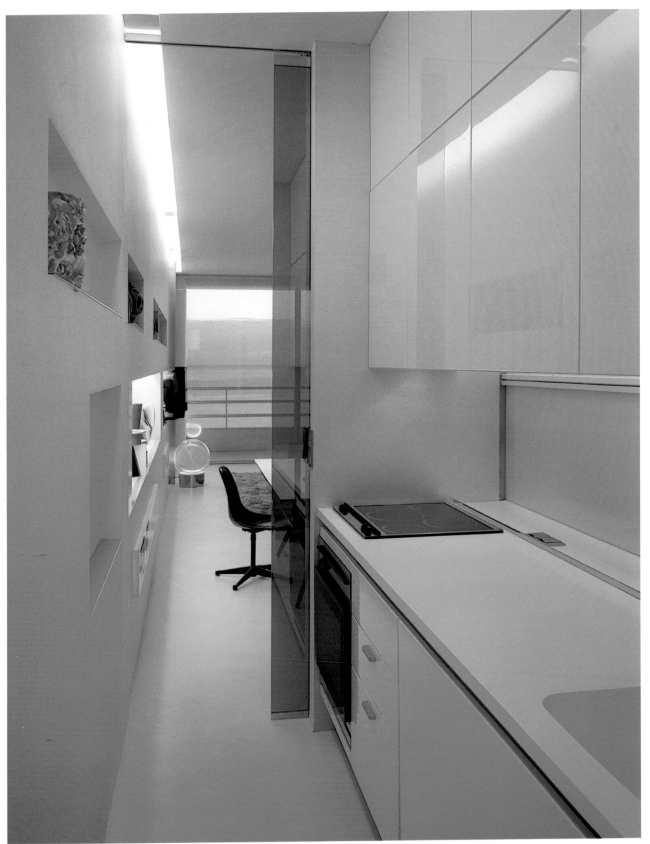

Lighting

Design by Mutsue Hayakusa/Cell Space Architects
Photo © Hiroshi Ueda

Both natural and artificial lighting are key to minimalist kitchen design, bringing out its essential contours.

Die Beleuchtung mit natürlichem oder künstlichem Licht ist bei der Gestaltung der minimalistischen Küche von entscheidender Bedeutung, denn sie unterstreicht die klare Formgebung.

L'éclairage, naturel ou artificiel, est un aspect déterminant dans le design d'une cuisine minimaliste, car il contribue à en exalter les lignes.

La iluminación, tanto natural como artificial, es un aspecto determinante en el diseño de una cocina minimalista, ya que contribuye a destacar sus líneas.

In fase di progettazione, l'illuminazione, sia naturale che artificiale, è un aspetto determinante da tenere in considerazione, in quanto contribuisce a mettere in risalto le linee della cucina.

Design by Filippo Bombace
Photo © Luigi Filetici

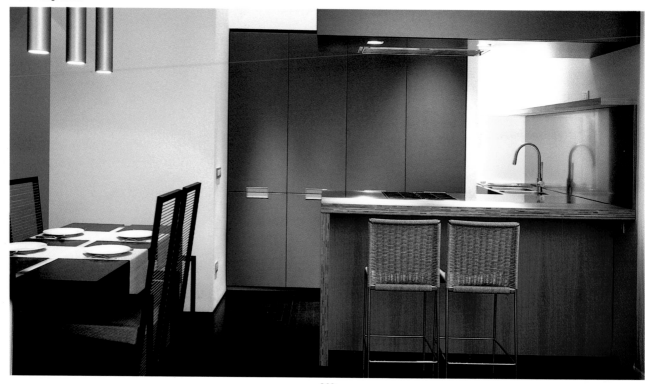

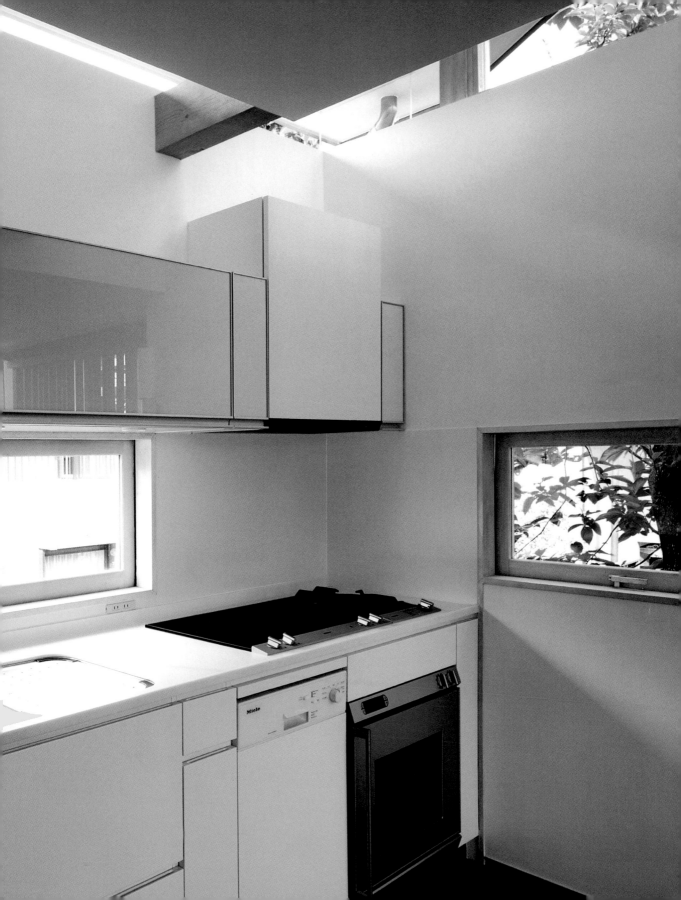

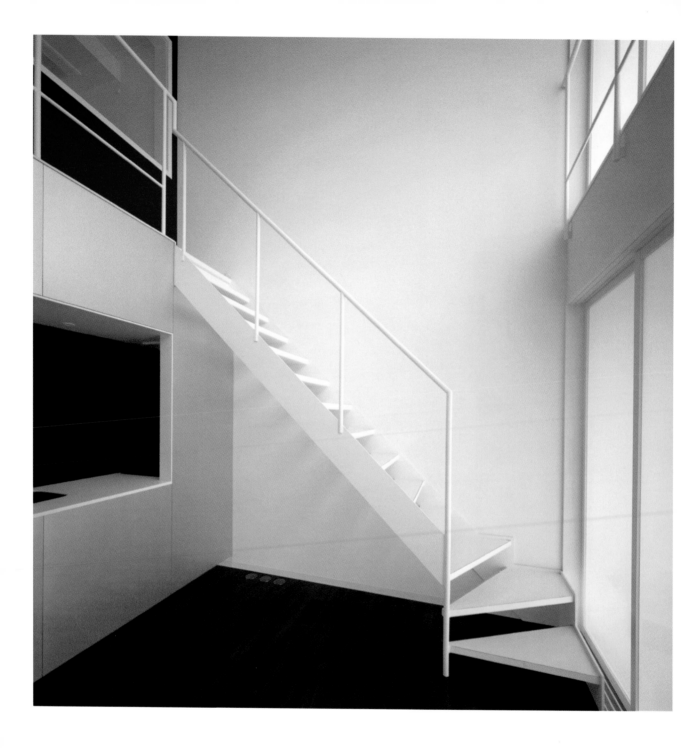

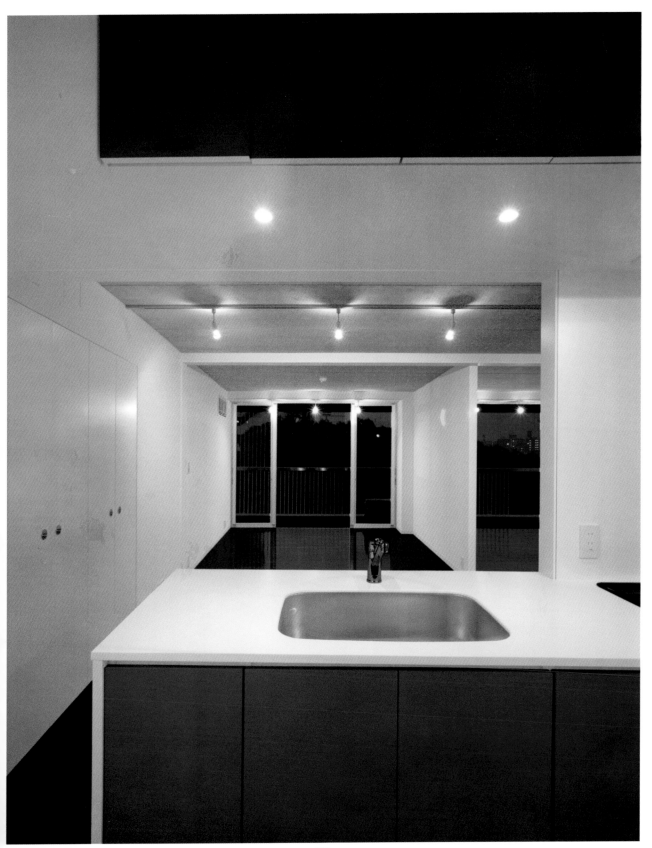

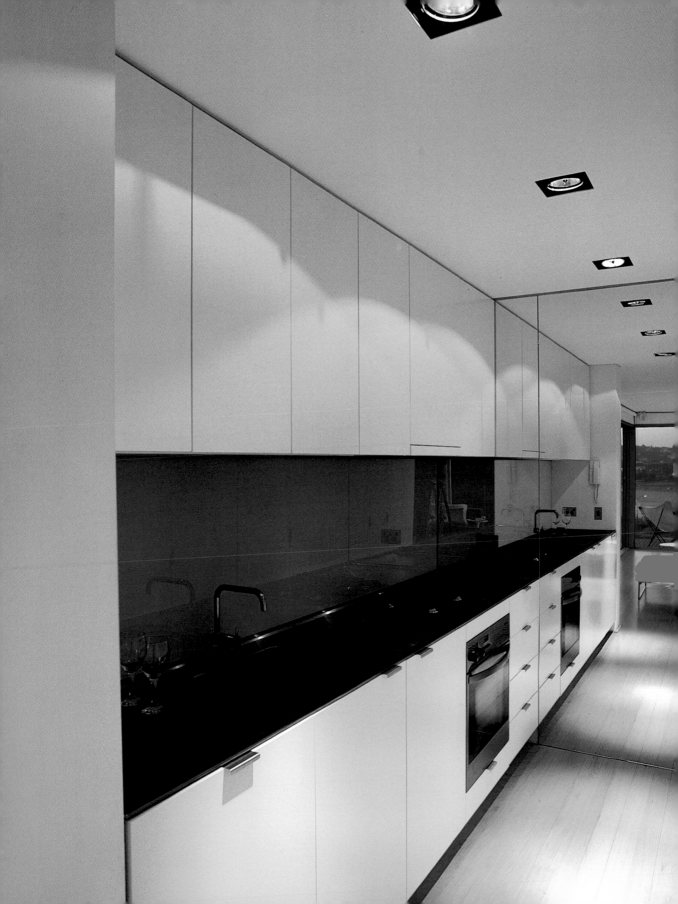

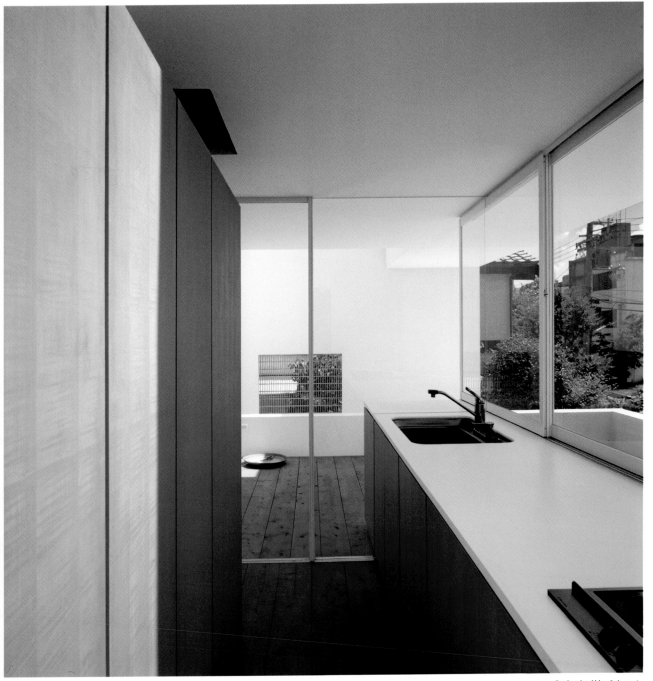

Design by Akira Sakamoto
Photo © Nacása & Partners

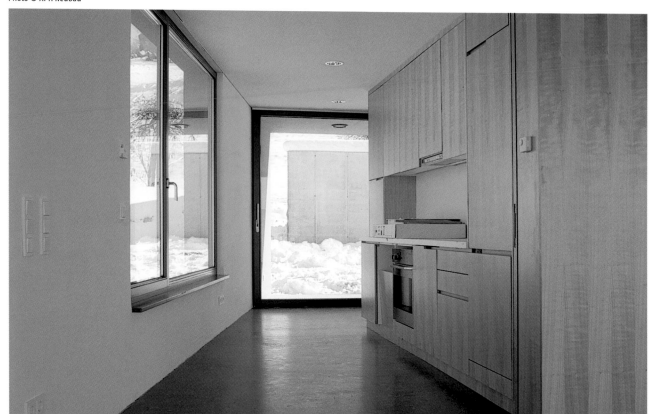

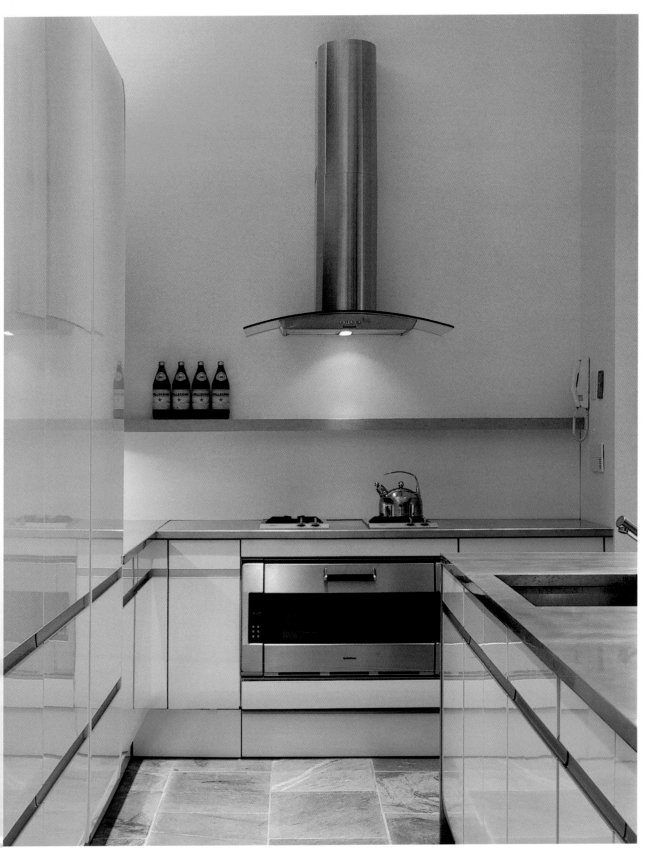

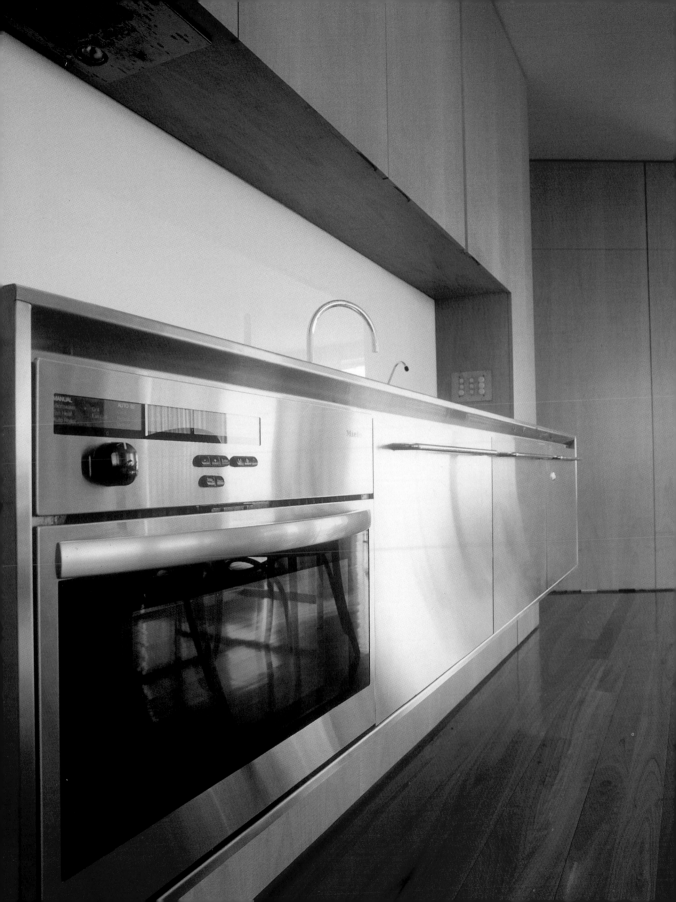

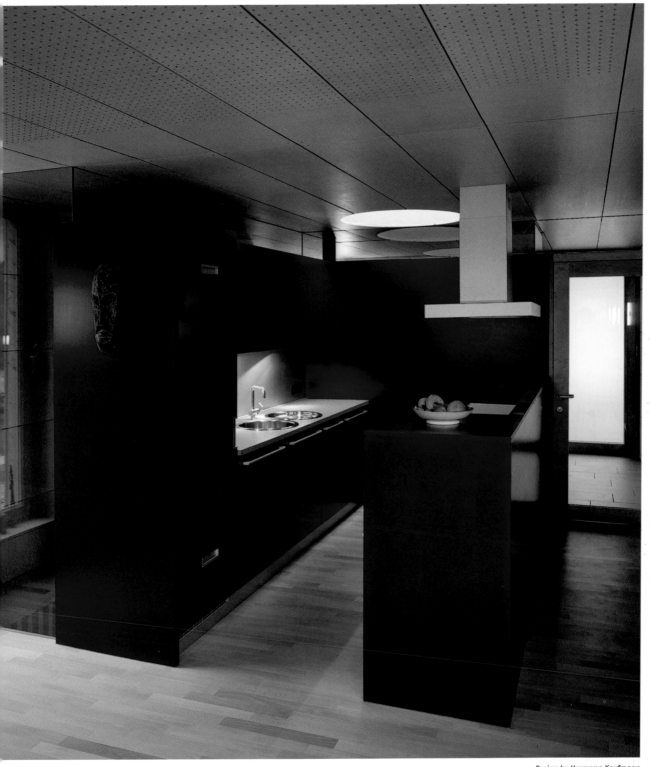

Design by Hermann Kaufmann
Photo © Ignacio Martínez

esign by Richard Francis Jones/MGT
hoto © Brett Boardman

Wood

Design by BEHF Architekten
Photo © Rupert Stainer

Using diverse types and combinations of wood, many different effects can be gained, ranging from the energy-giving reddish tones of natural wood to the gentle textures of stained wood finishes.

Durch die Kombination unterschiedlicher Holzarten lassen sich die vielfältigsten Effekte erzielen: Natürliches, rötliches Holz vermittelt Energie, während getönte Holzflächen eher geschmeidige Gelassenheit ausstrahlen.

En utilisant différents types et associations de bois, on obtient des effets très divers, allant de l'énergie transmise par le bois naturel rougeâtre à la douceur des textures du bois teint.

Mediante diferentes tipos y combinaciones de madera, se pueden lograr efectos muy diversos, que van desde la energía que transmite la madera natural rojiza hasta la suavidad de las texturas de la madera teñida.

Utilizzando diversi tipi e combinazioni di legno, si possono ottenere i più svariati effetti. Il legno naturale rossiccio trasmette, ad esempio, molta energia, mentre le varie texture e tonalità del legno tinto suggeriscono una leggera morbidezza.

Design by Janson Goldstein
Photo © Paul Warchol

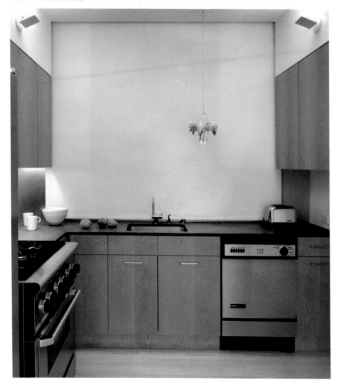

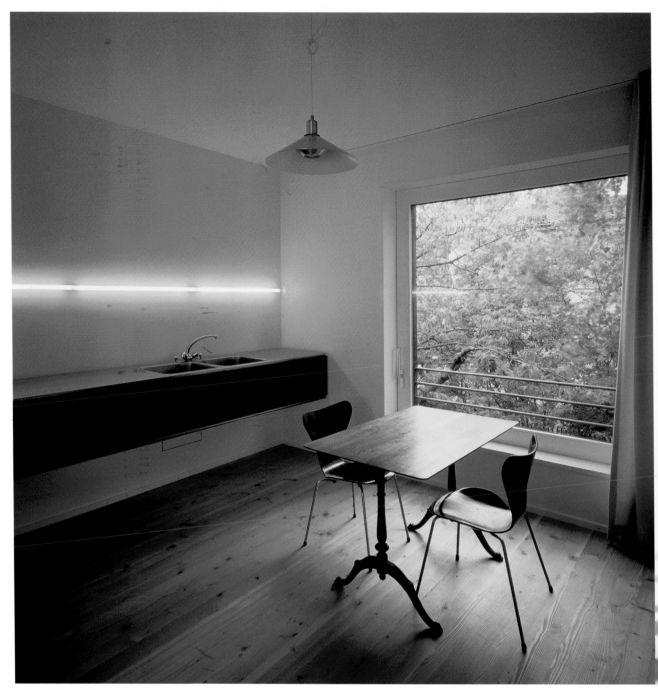

Design by Harry Gugger
Photo © Margherita Spiluttini

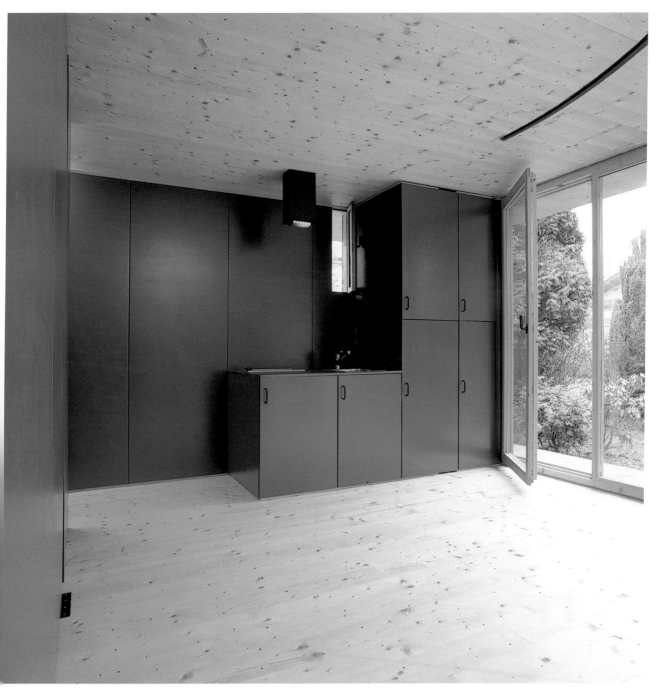

Design by Ivan Kroupa
Photo © Matteo Piazza

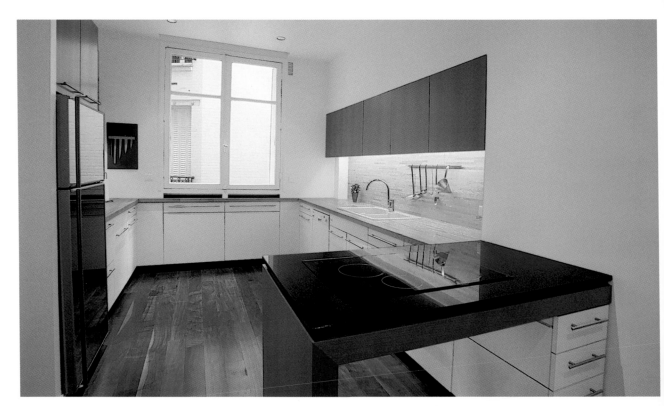

Both photos
Design by Guilhem Roustan
Photo © Patrick Müller

Design by Uda Architect
Photo © Heiko Semeye

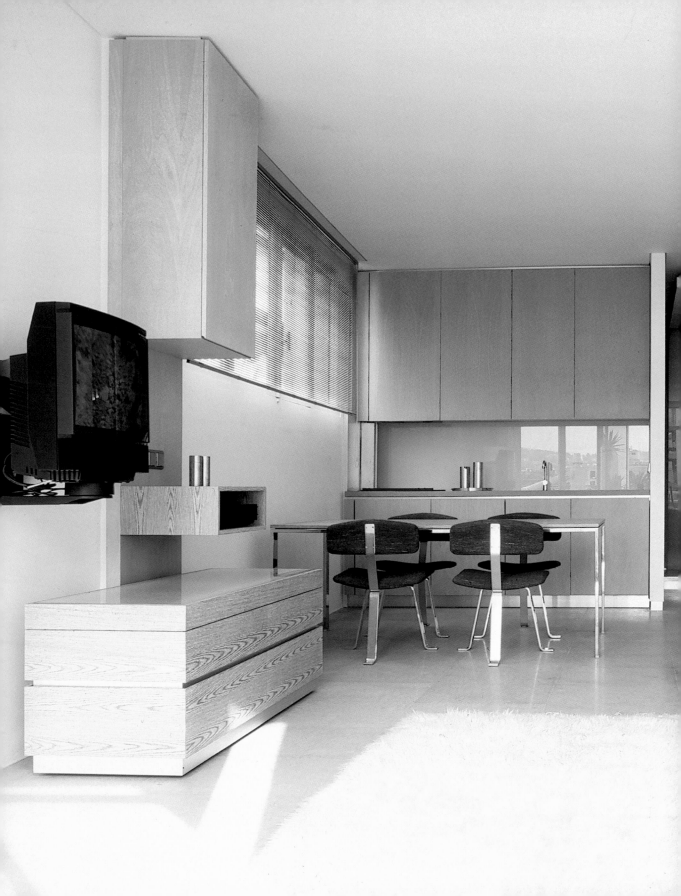

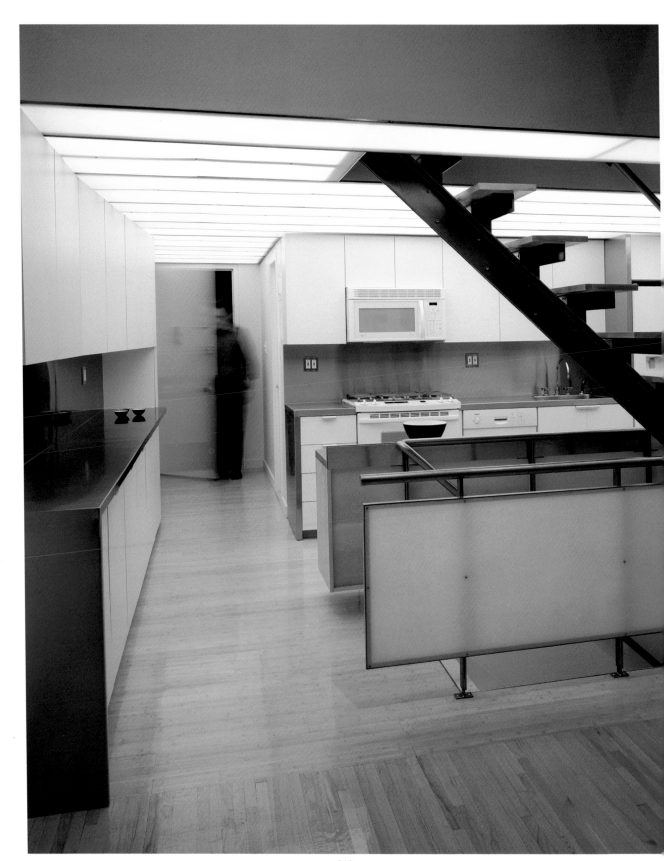

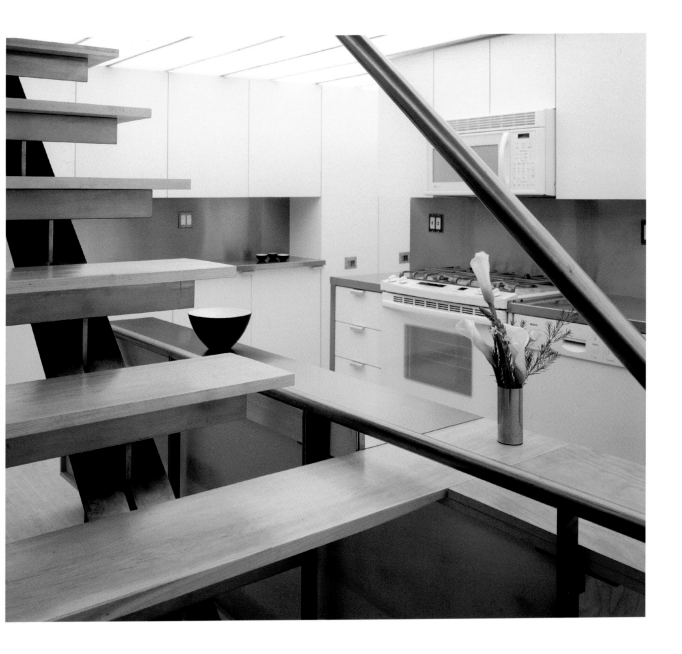

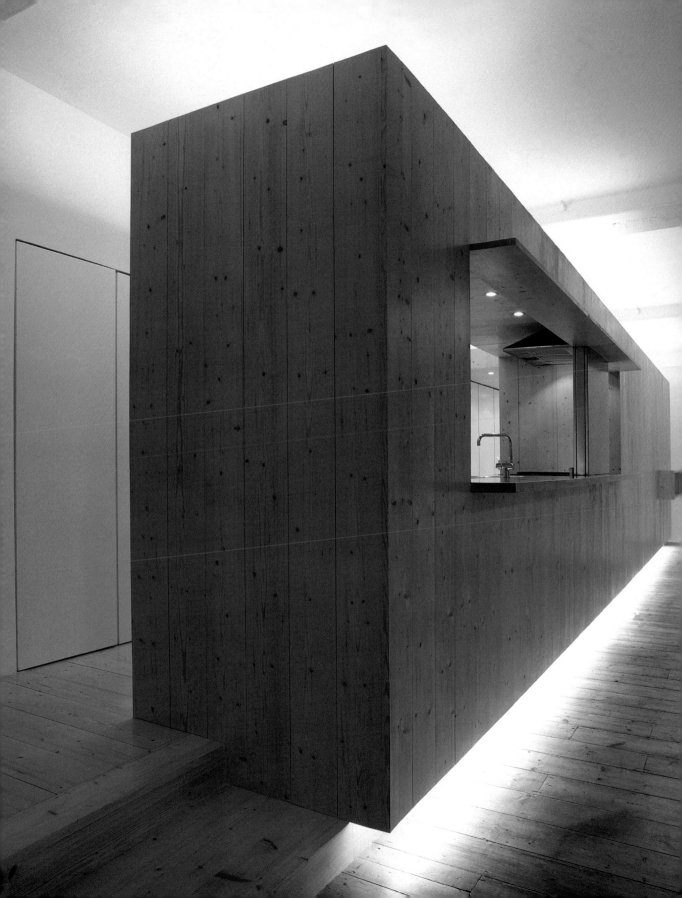

Design by Simon Conder Associates
Photo © Peter Warren

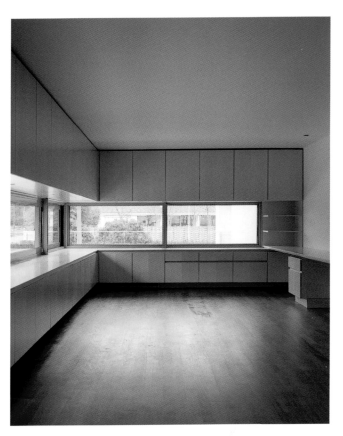

Both photos
Design by Jo Coenen & Co
Photo © Christian Richters

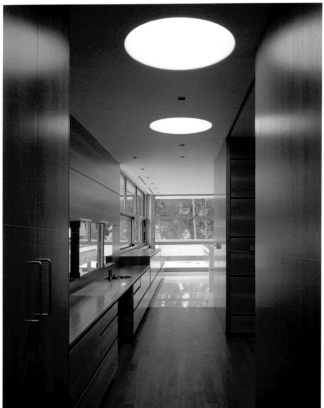

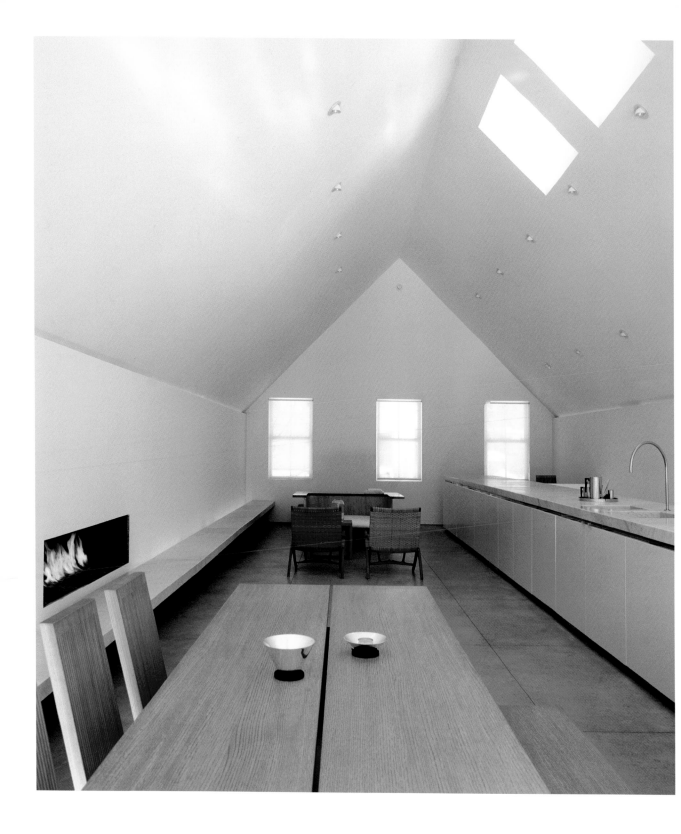

Both pages
Design by John Pawson
Photo © Undine Pröhl

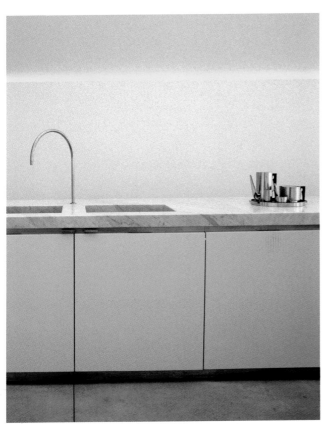

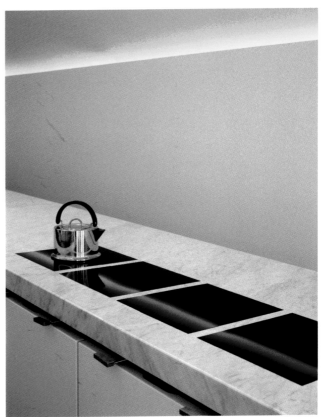

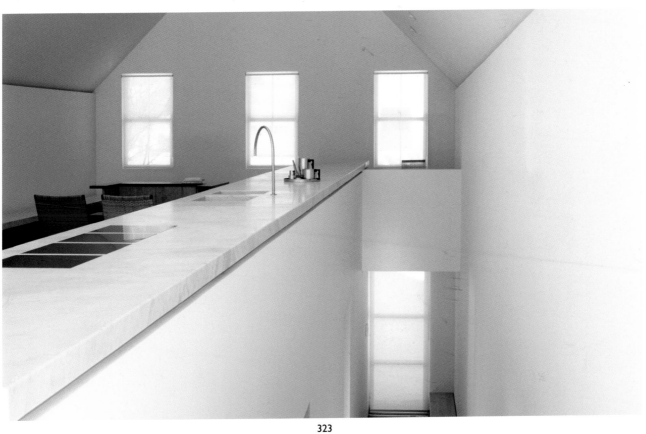

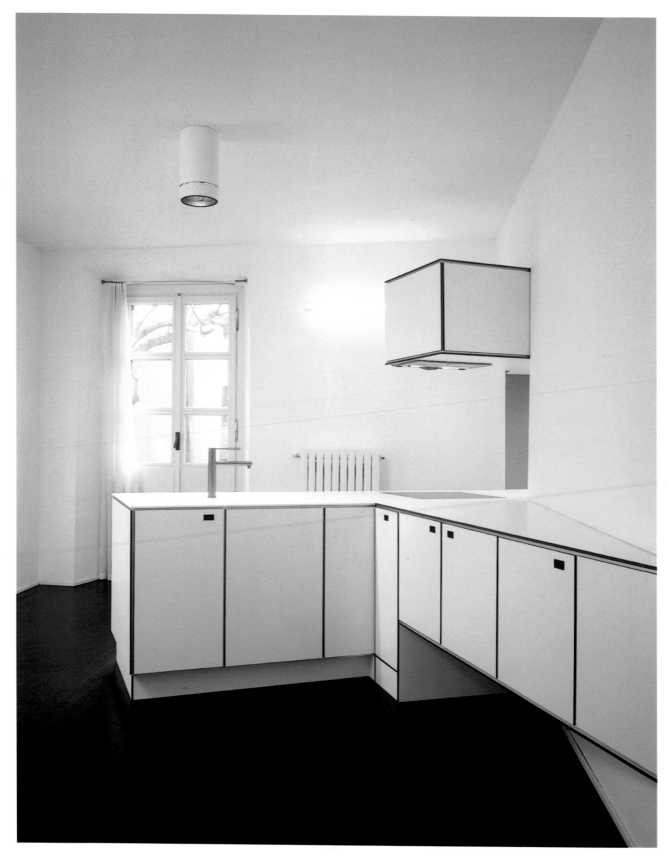

Both pages
Design by Fabrizio Leoni
Photo © Dessì e Monari

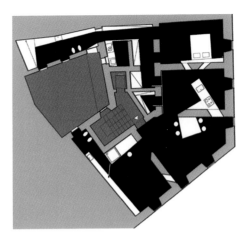

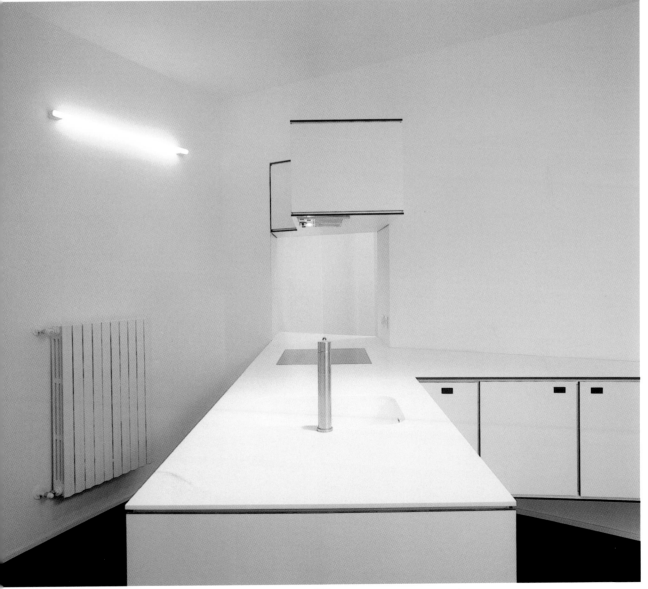

Colors

Design by Koen van Velse
Photo © Christian Richter

The palette of colors applicable to the minimalist kitchen contains very subtle tones such as white, grey, black and brown. Some projects, however, successfully introduce more colorful designs.

Die Farbpalette der minimalistischen Küche umfasst bevorzugt zurückhaltende Töne, wie weiß, grau, schwarz oder braun. Trotzdem finden sich zuweilen Beispiele lebhafterer Farbgebung.

La palette de couleurs employée dans le design d'une cuisine minimaliste se décline dans les tons neutres, comme le blanc, le gris, le noir et le marron. Il y a toutefois des exemples réussis utilisant des couleurs plus vives.

La paleta de colores empleada en el diseño de una cocina minimalista tiende a los tonos apagados, como el blanco, el gris, el negro y el marrón; aunque hay ejemplos logrados donde se utilizan colores más vivos.

La palette dei colori usata per il disegno di una cucina minimalista propende per delle tonalità spente, come il bianco, il grigio, il nero e il marrone; non si escludono però esempi molto riusciti con colori molto più vivi.

Design by Julie Snow Architects
Photo © Don Wong

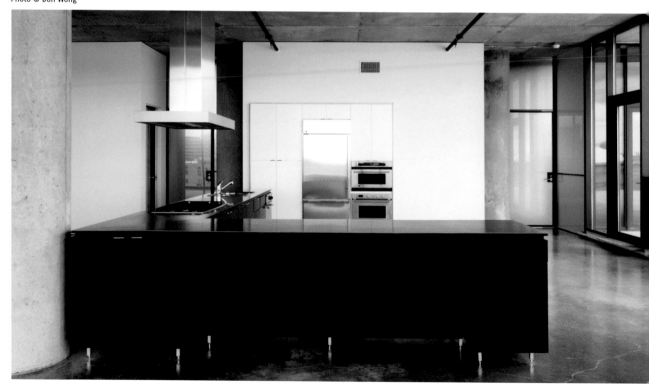

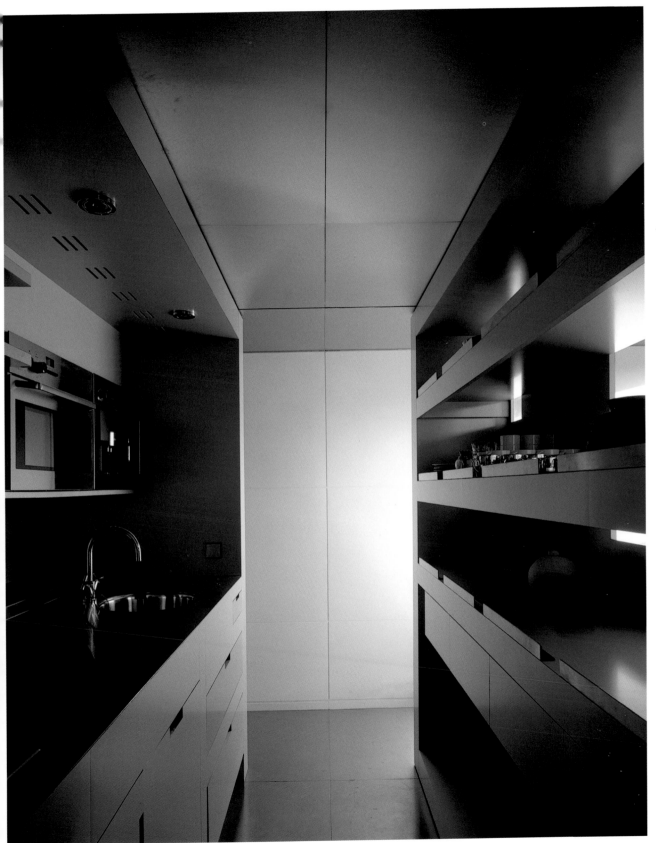

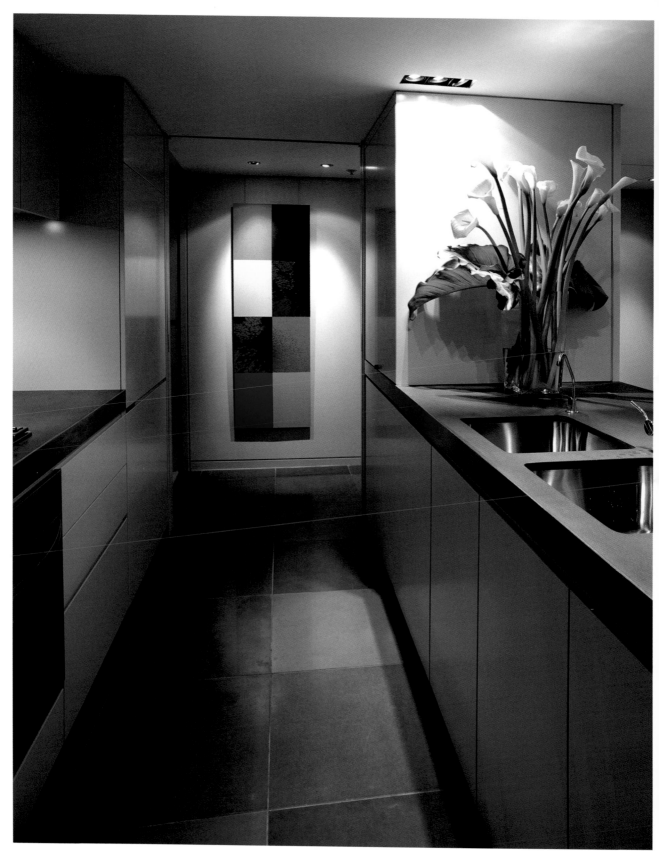

Both pages
Design by Smart Design Studio
Photo © Sharrin Rees

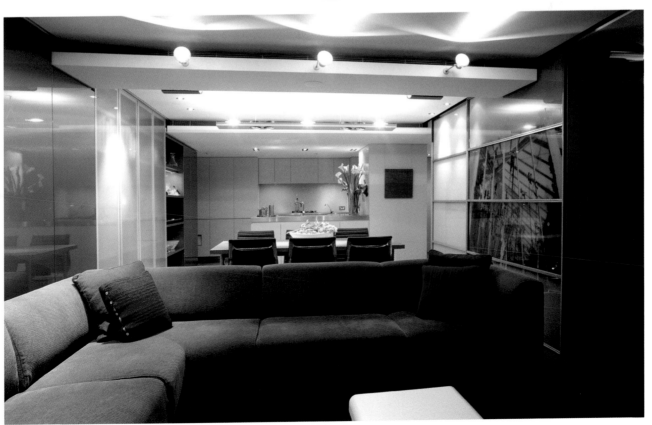

Design by C. Lazzarini & C. Pickering
Photo © Matteo Piazza

Design by Abelow Conners Sherman
Photo © Michael Moran

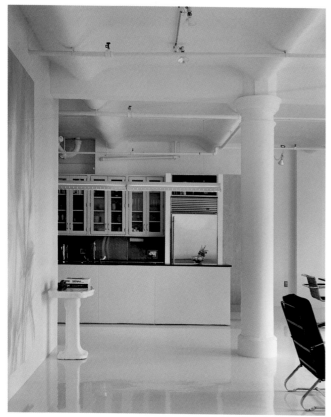

Design by Simon Ungers
Photo © Eduard Hueber/Archphoto

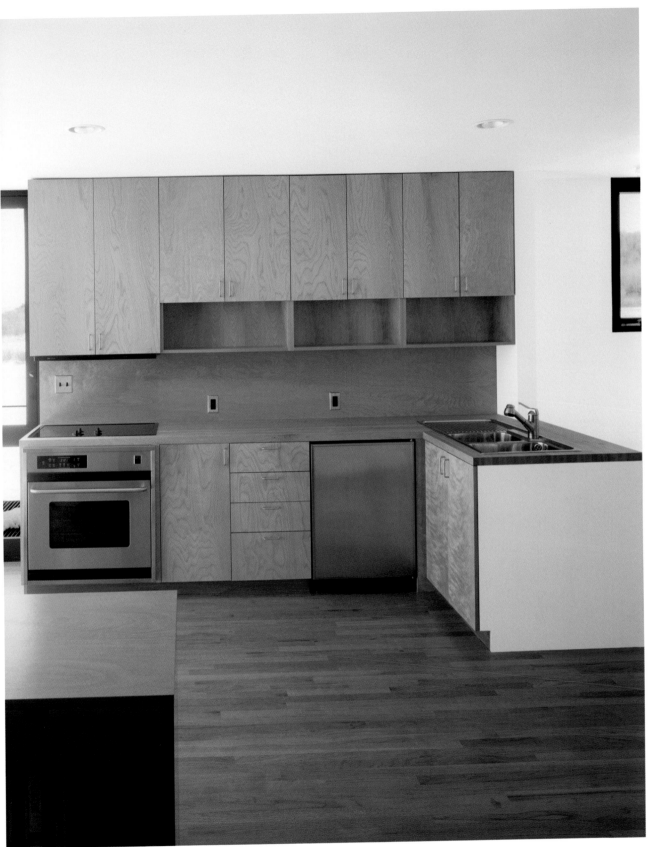

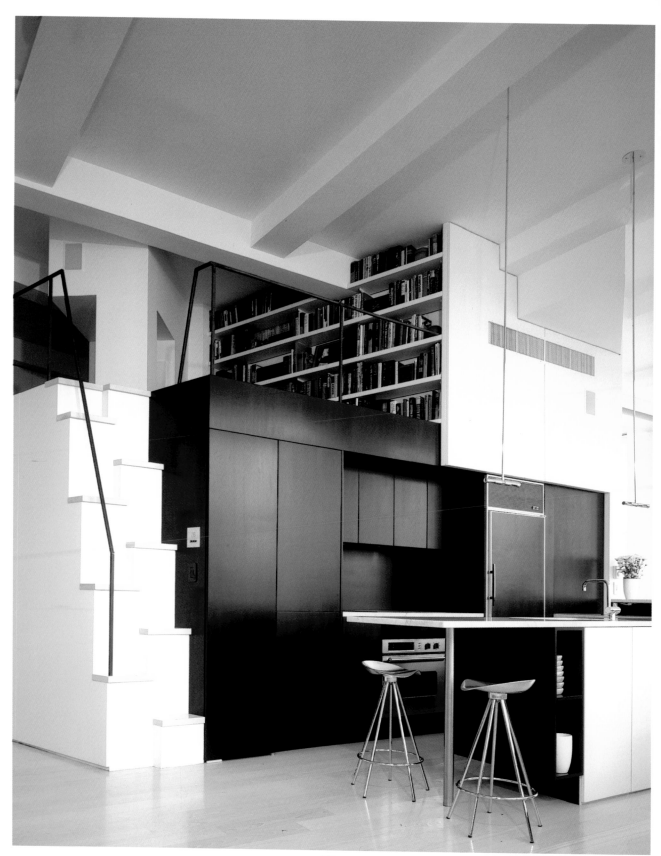

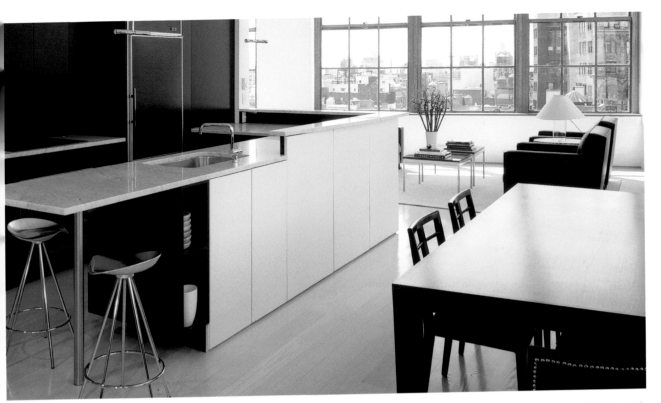

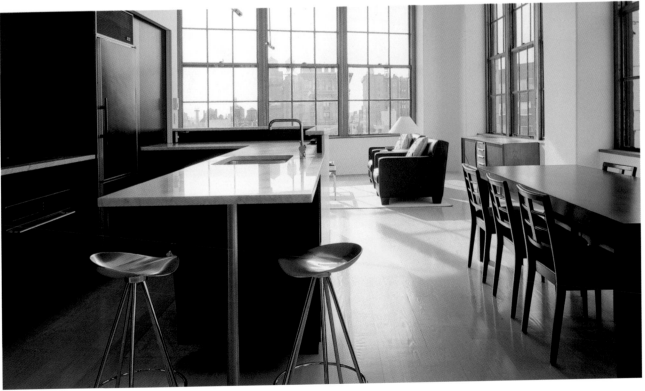

Both pages
Design by James Dart
Photo © Catherine Tighe

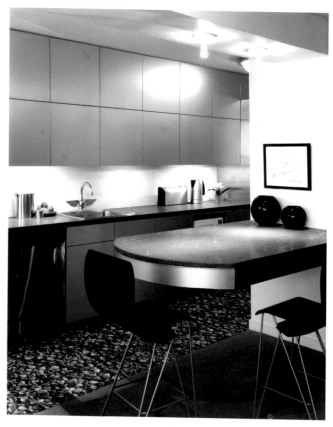

Both pages
Design by Ronette Riley Architect
Photo © Dub Rogers

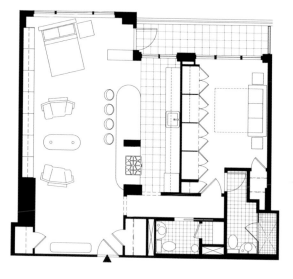

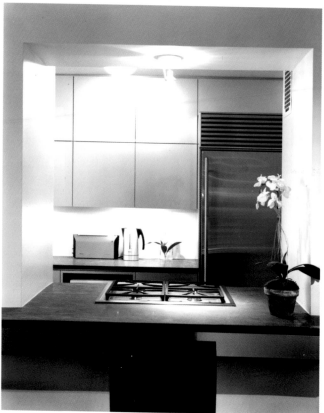

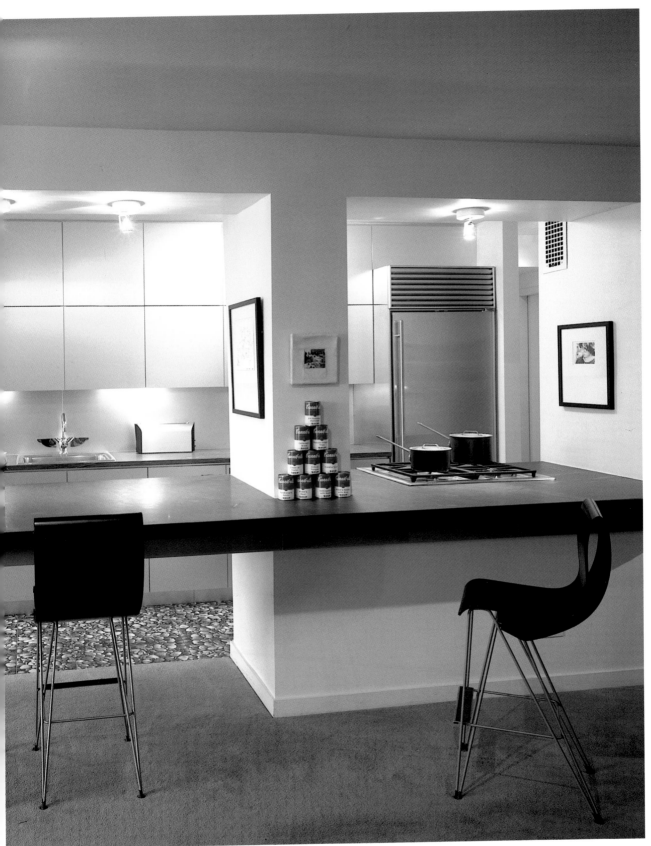

Minimalist island

Design by Gabellini Associate
Photo © Paul Warchc

The minimalist kitchen's sculptural dimension is greatly set off by an island in the centre of the floor space, thus placing its pure forms and finishes on display.

Der skulpturale Charakter einer minimalistischen Küche wird besonders durch die Mittelinsel betont. Die hervorragende Verarbeitung, kommt so voll zur Geltung.

Le caractère sculptural d'une cuisine minimaliste est mis en valeur par la disposition autour de l'îlot central : la pureté de ses finitions se révèle, alors, dans toute sa splendeur.

La disposición con isla central resalta el carácter escultórico de una cocina minimalista: la limpieza de sus acabados se aprecia, pues, en todo su esplendor.

Il carattere scultoreo di una cucina minimalista viene risaltato dalla disposizione dell'isola centrale: così la raffinatezza delle sue finiture si apprezza in tutto il suo splendore.

Design by Studiointernationale
Photo © Martin van der Wal

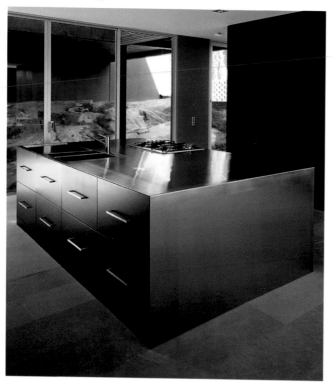

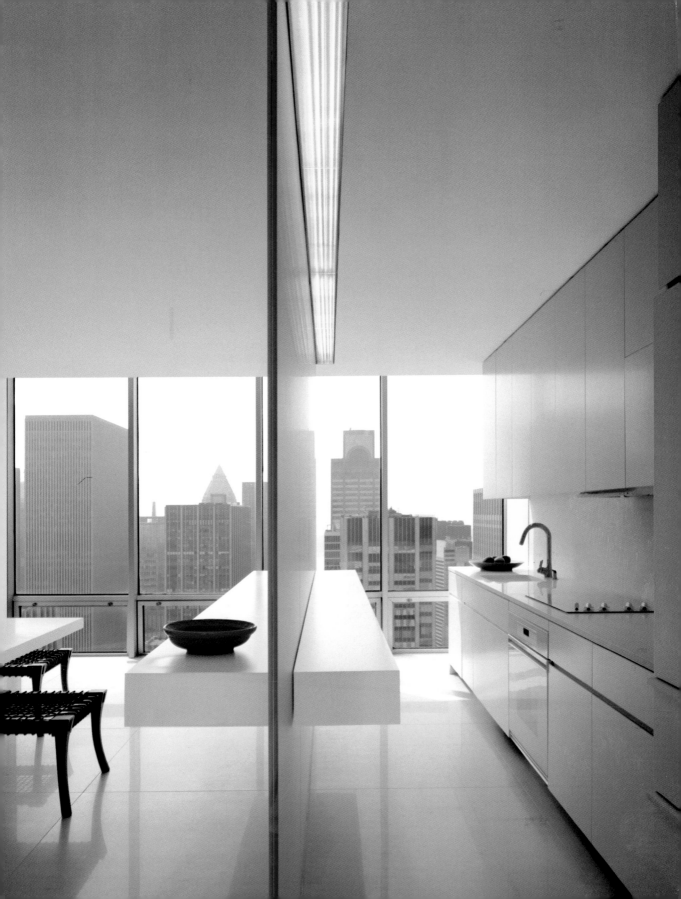

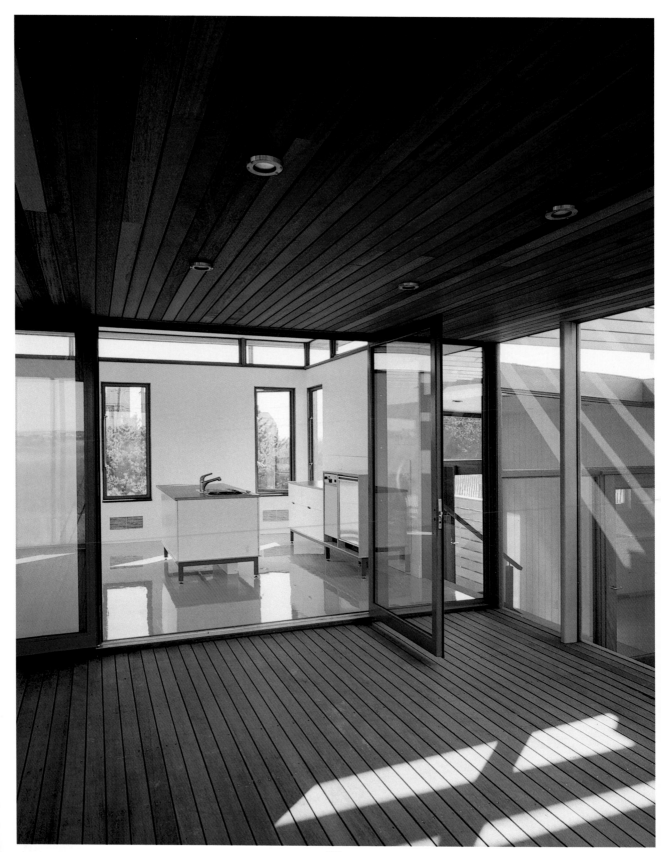

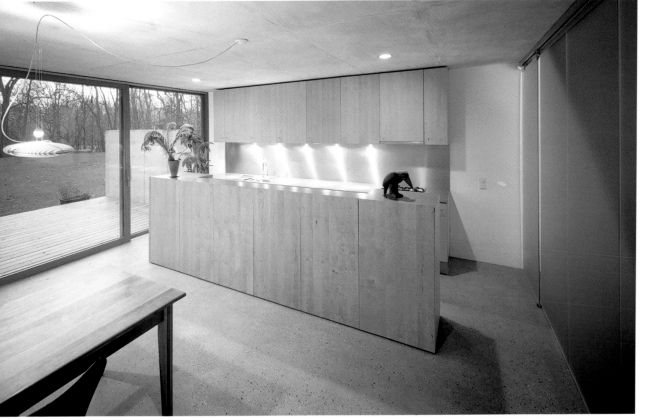

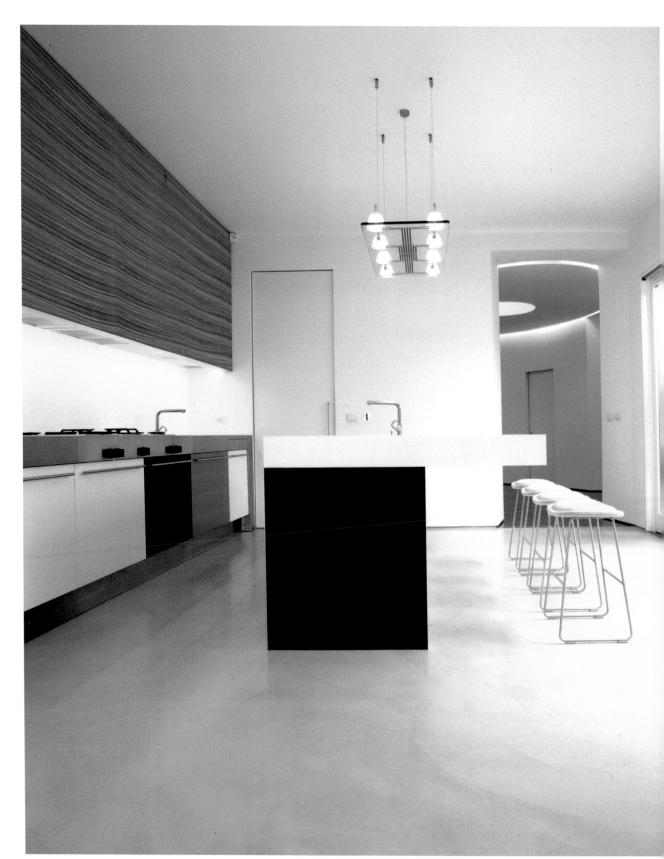

Both pages
Design by Carlo Donati
Photo © Matteo Piazza

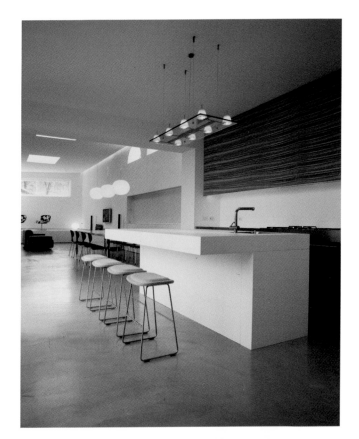

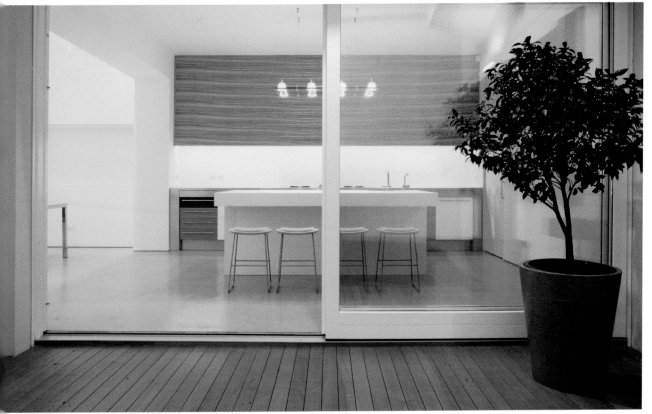

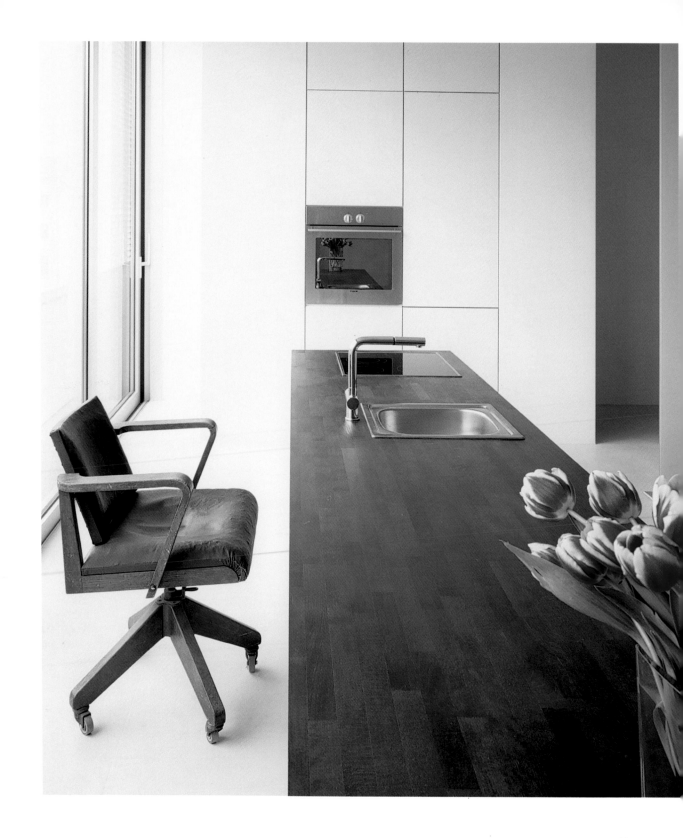

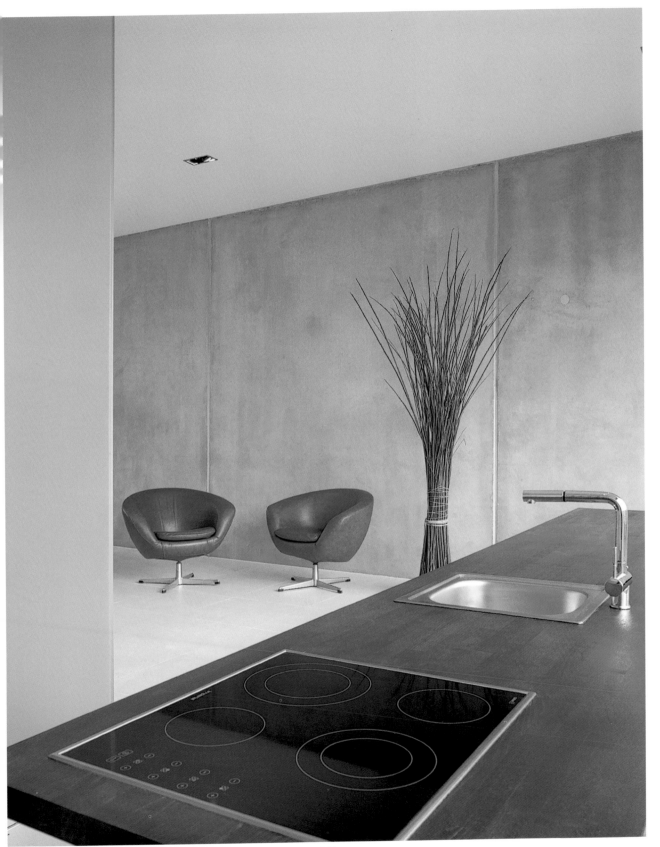

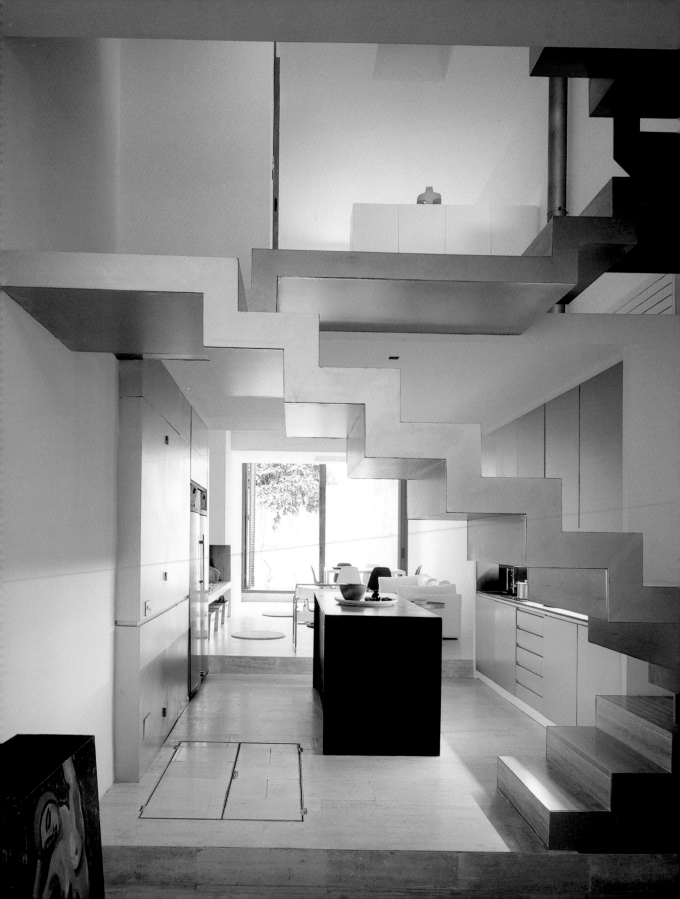

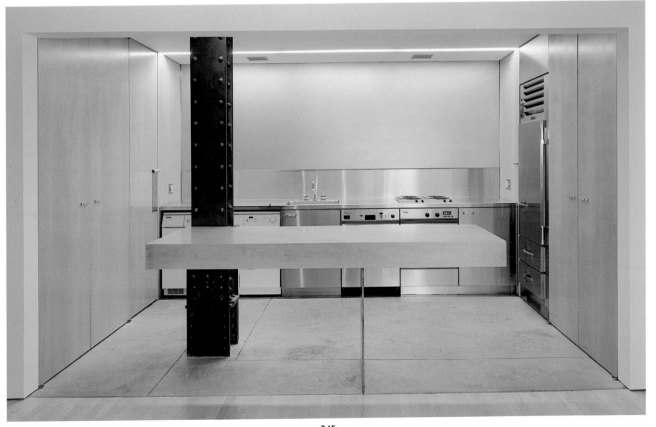

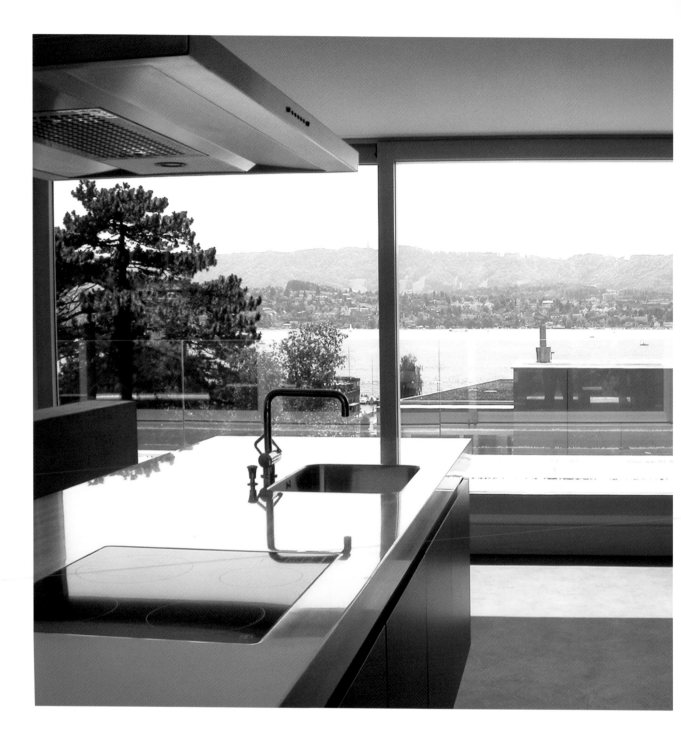

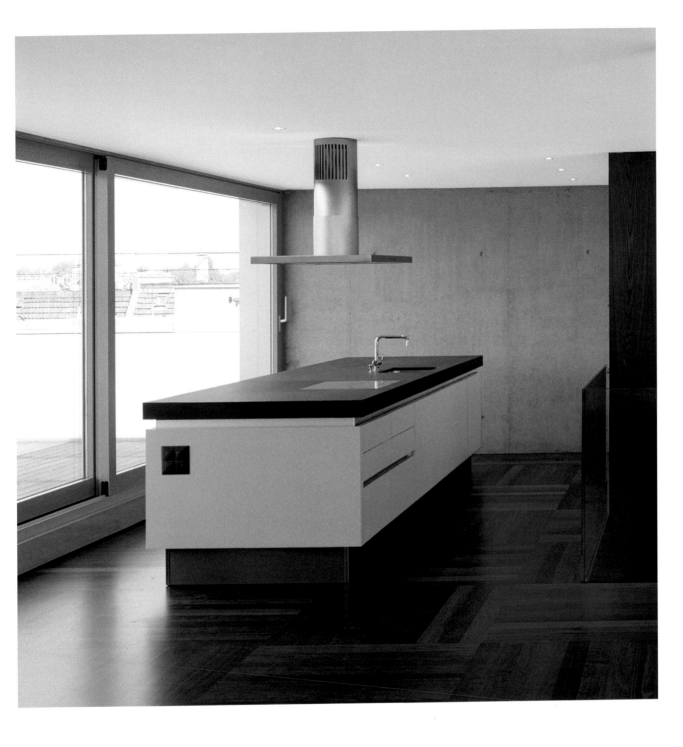

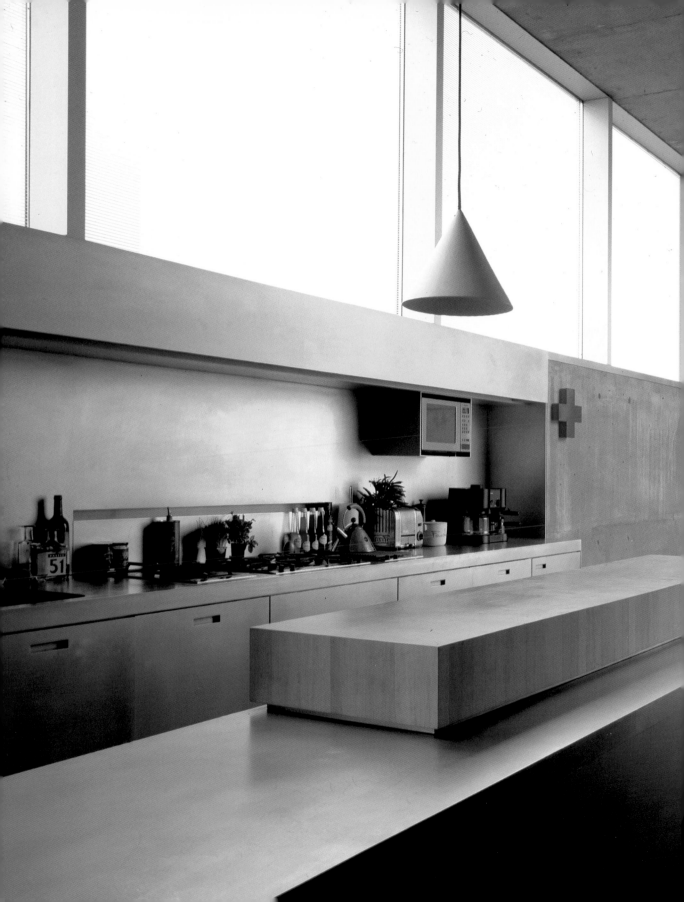

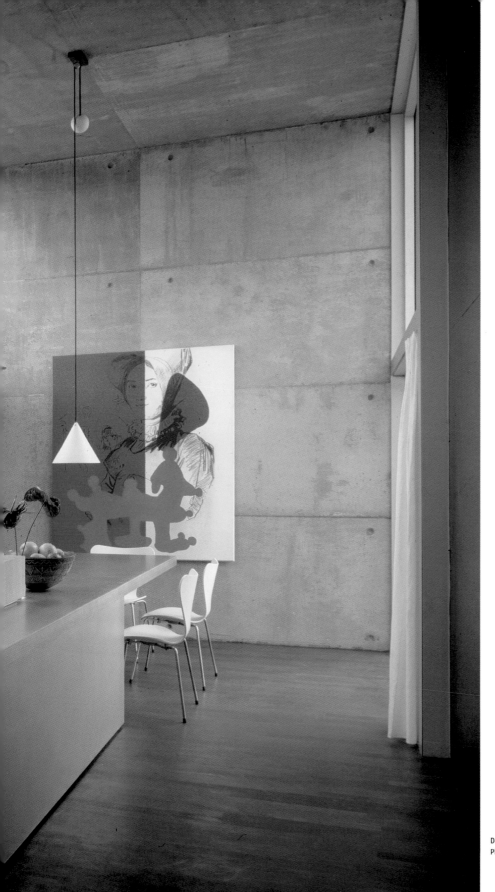

Design by Jo Crepain Architects
Photo © Jan Verlinde

White

White is the color par excellence for the minimalist kitchen, since it affords a sense of space and light no other color can.

Weiß ist eindeutig die am besten geeignete Farbe bei der Gestaltung der minimalistischen Küche, weil sie das Gefühl von Weite und Helligkeit noch verstärkt.

Cette couleur convient le mieux à une cuisine minimaliste, car elle lui confère une sensation d'ampleur et de luminosité accrues.

Este color resulta el más apropiado para el diseño de una cocina minimalista, ya que aumenta la sensación de amplitud y luminosidad.

Questo colore risulta quello più appropriato per il disegno di una cucina minimalista visto che dà una sensazione di maggiore ampiezza e luminosità.

Both page
Design by Norisada Maed
Photo © Nacása & Partne

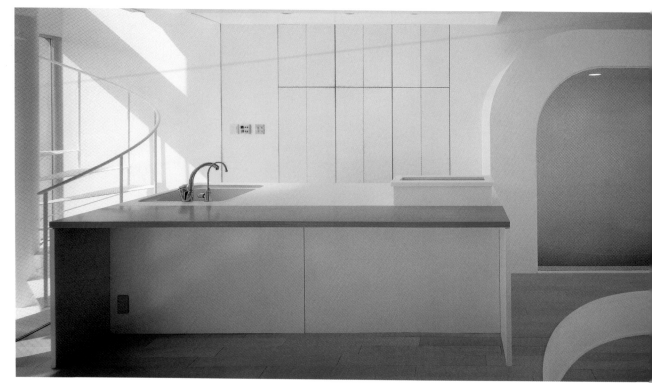

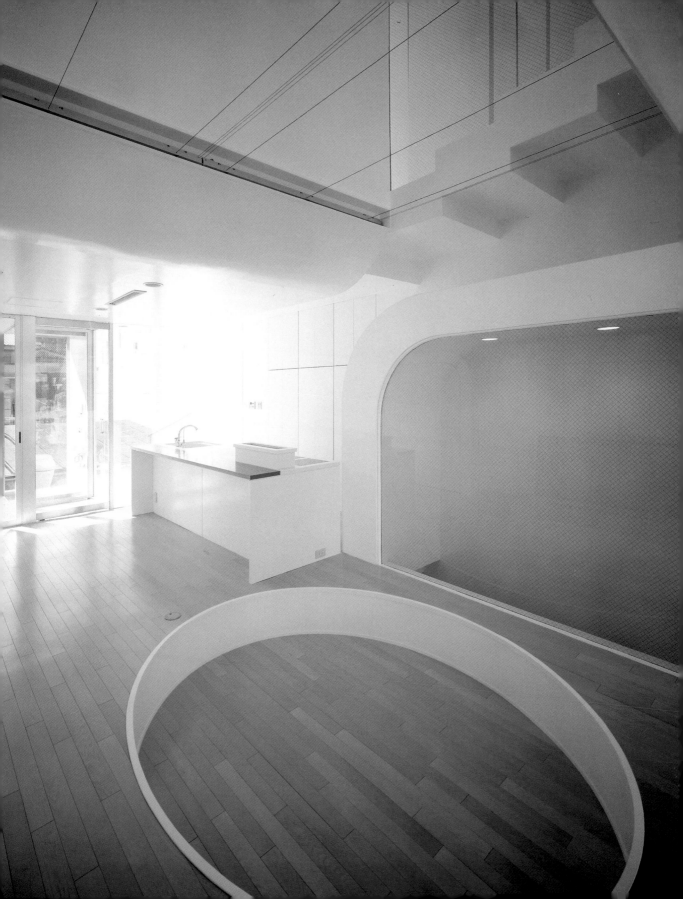

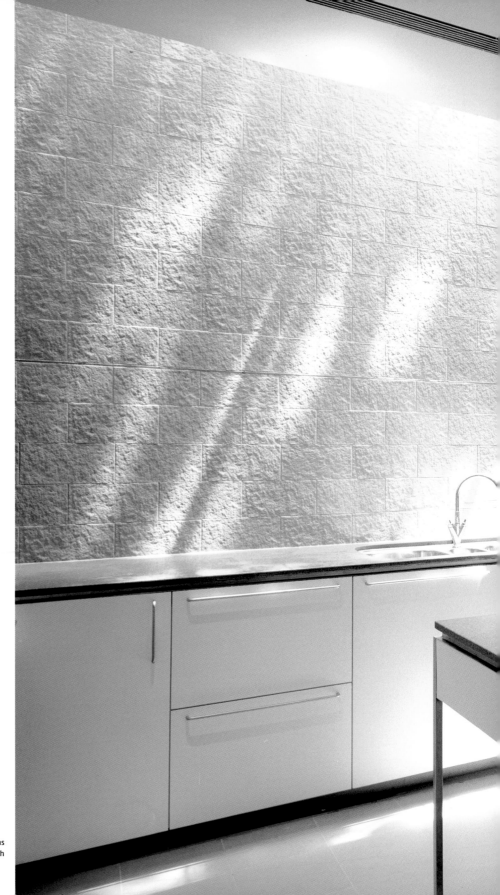

Design by Woha Designs
Photo © Tim Griffith

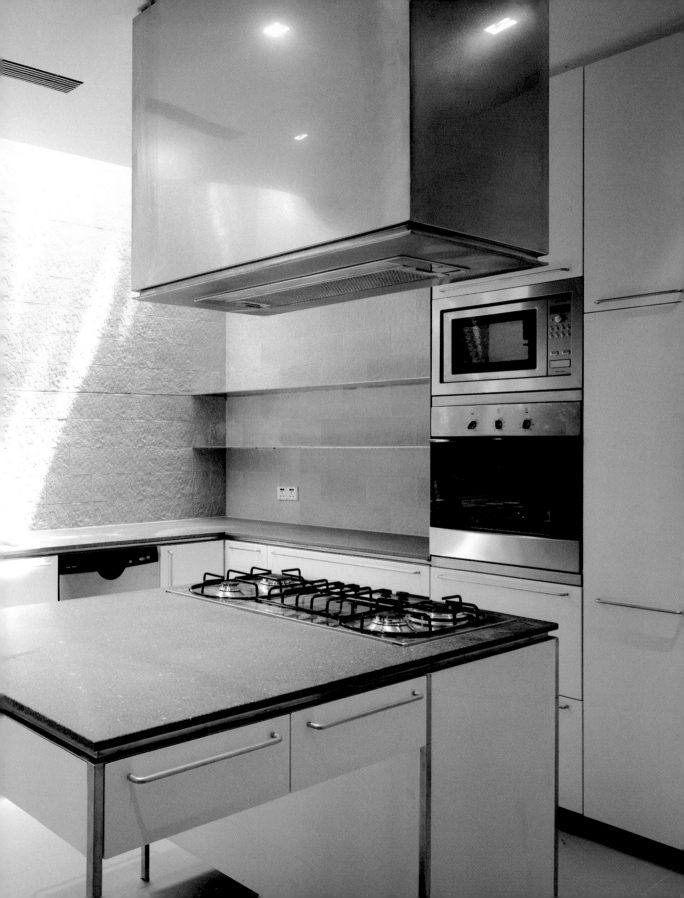

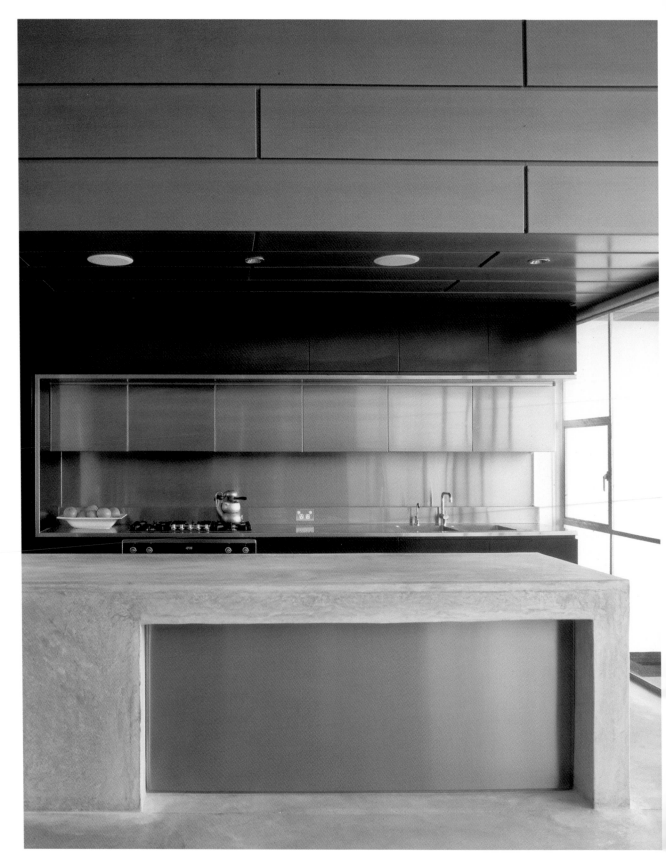

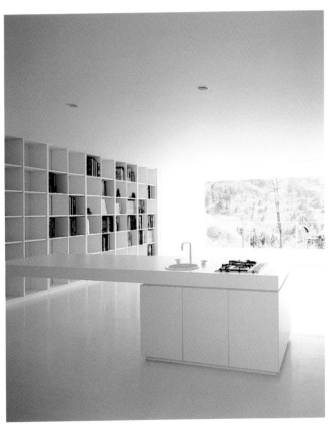

Both photos
Design by Shigeru Ban
Photo © Hiroyuki Hirai

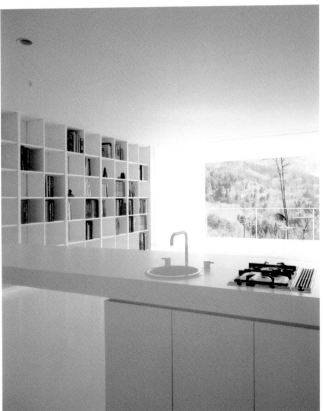

Design by Marsh Cashman Architects
Photo © Willem Rethmeier

355

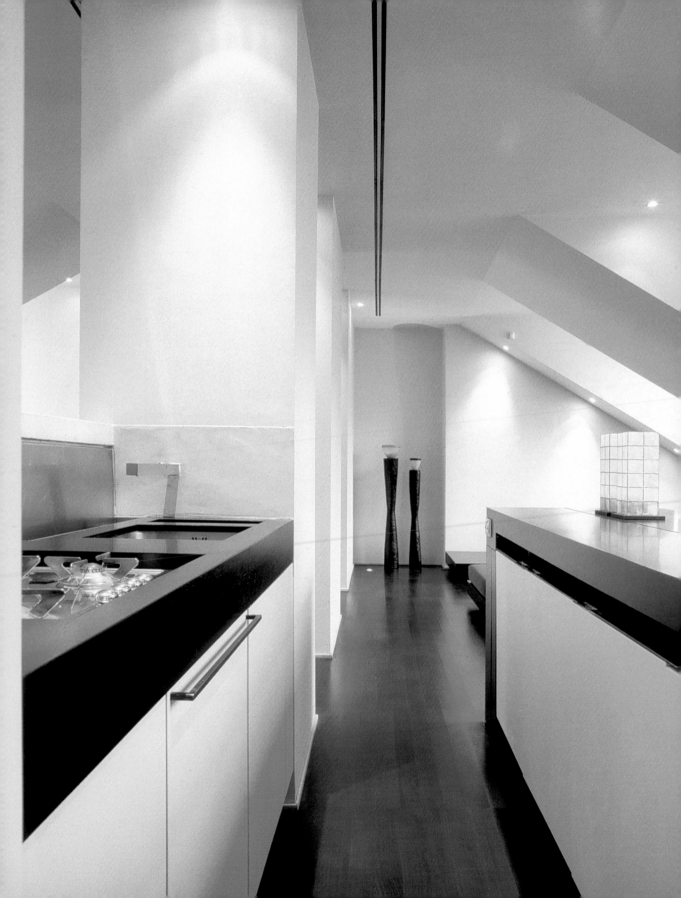

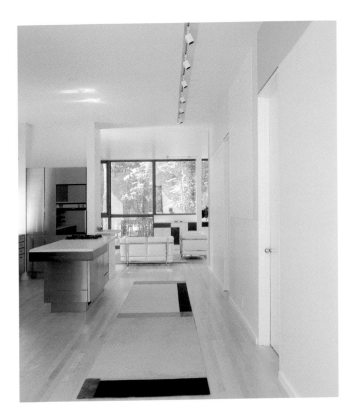

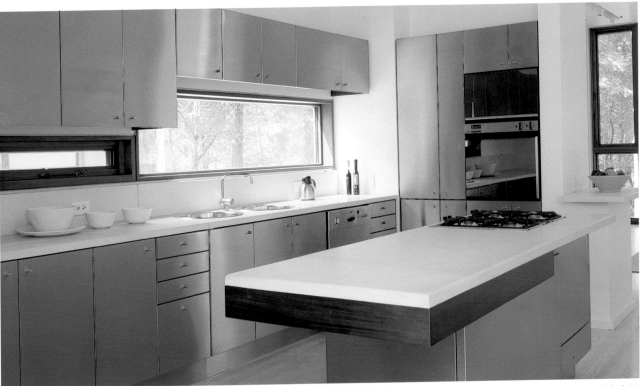

Both photos
Design by Price Harrison
Photo © Catherine Tighe

Design by Marco Savorelli
Photo © Matteo Piazza

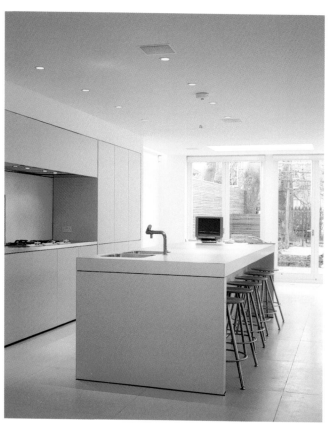

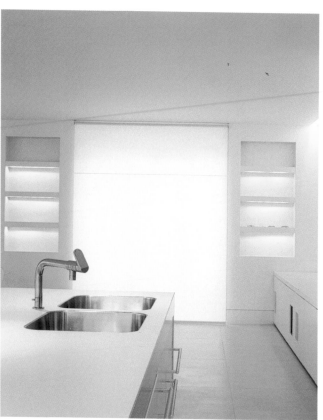

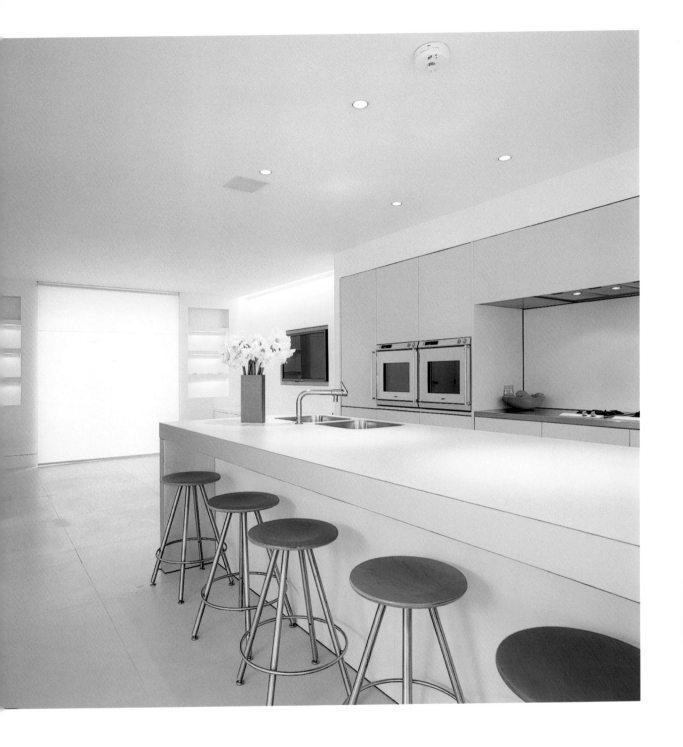

Both pages
Design by Michaelis Boyd Associates
Photo © Gunnar Knechtel

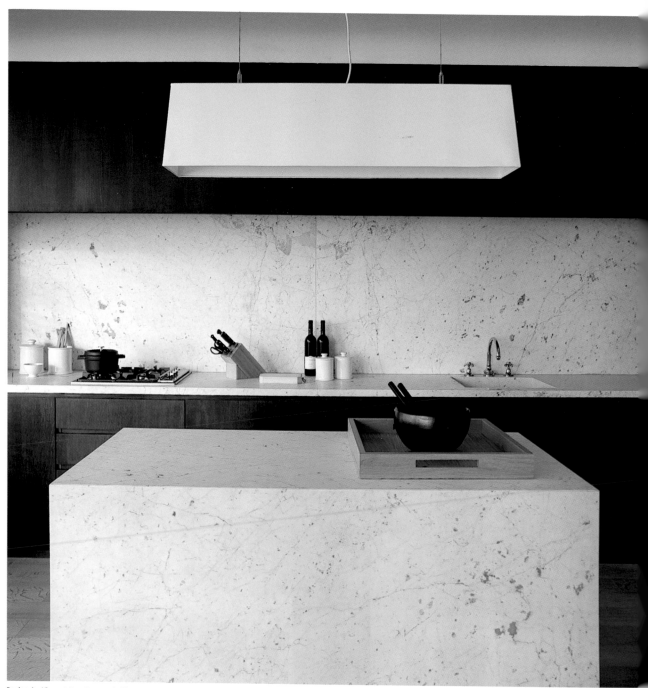

Design by Vincent Van Duysen Architects
Photo © Jan Verlinde

Design by Aires Mate
Photo © D. Malhao, J. P. Silva, F. Mate

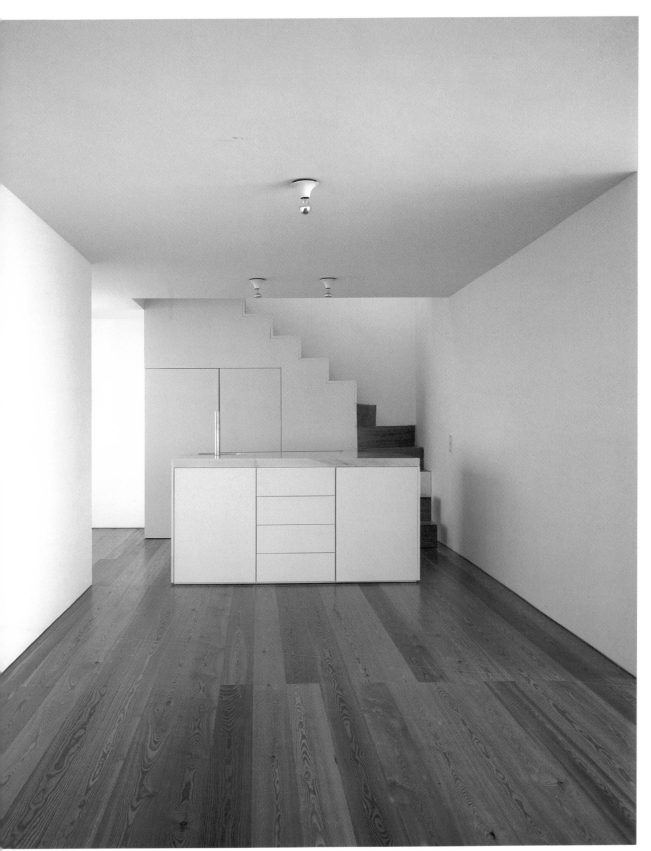

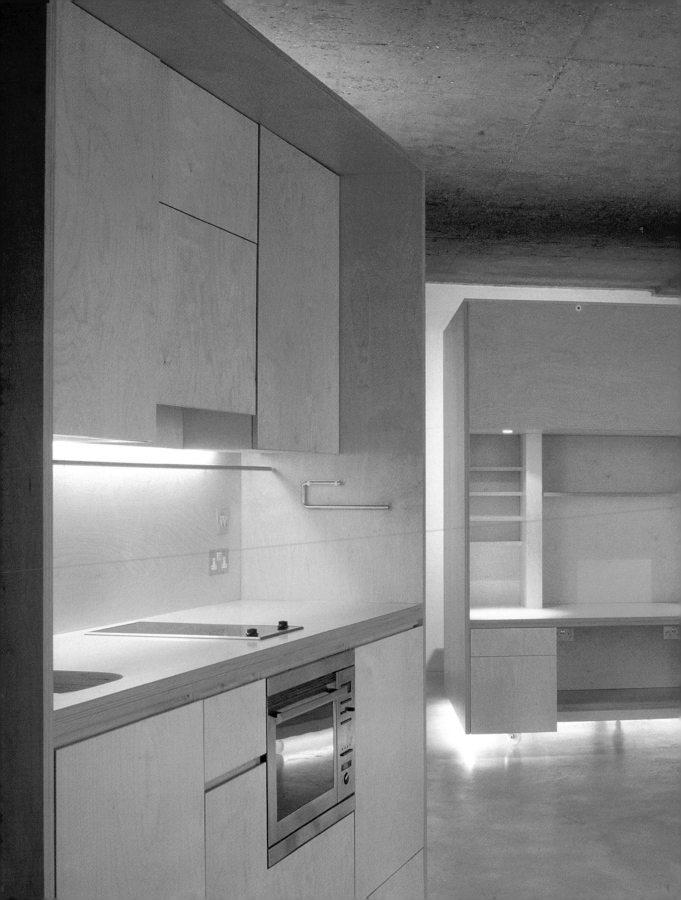

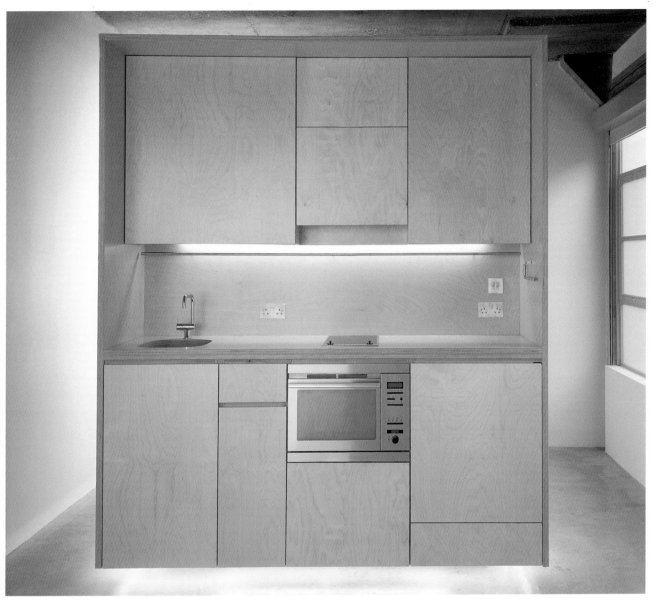

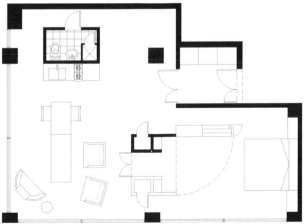

Both pages
Design by Simon Conder Associates
Photo © Jose Lasheras

Dark

Design by ODR
Photo © Derek Swalwell

Dark colors create stark contrasts, intimate ambiences and elegant surroundings. On the whole, dark hues are achieved through the presence of wood, resin laminates or stone.

Dunkle Farben schaffen starke Kontraste, ein intimeres Ambiente und einen betont eleganten Gesamteindruck. Meist werden hierzu dunkle Hölzer, Kunstharze oder Naturstein verwendet.

Les couleurs sombres engendrent des contrastes très forts, une atmosphère plus recueillie et une élégance accrue. On les obtient en général, en utilisant des bois foncés, des résines ou de la pierre naturelle.

Los colores oscuros generan contrastes fuertes, una atmósfera más recogida y un aspecto muy elegante. Generalmente, éstos se logran con maderas oscuras, con resinas y con piedra natural.

I colori scuri generano contrasti molto forti, un'atmosfera più raccolta e un ambiente più elegante. Generalmente si ottengono mediante l'uso di legni scuri, con resina o con pietra naturale.

Design by Suppose Design Office
Photo © Nacása & Partners

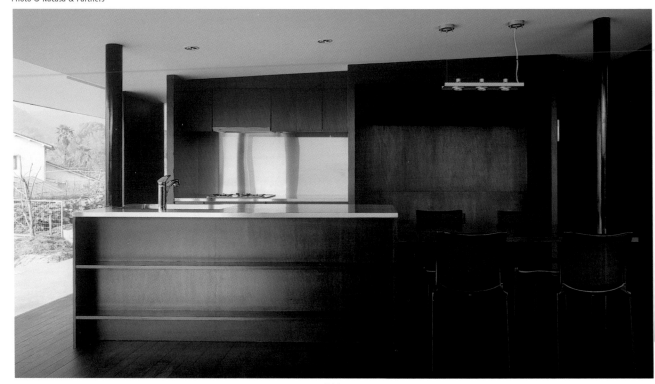

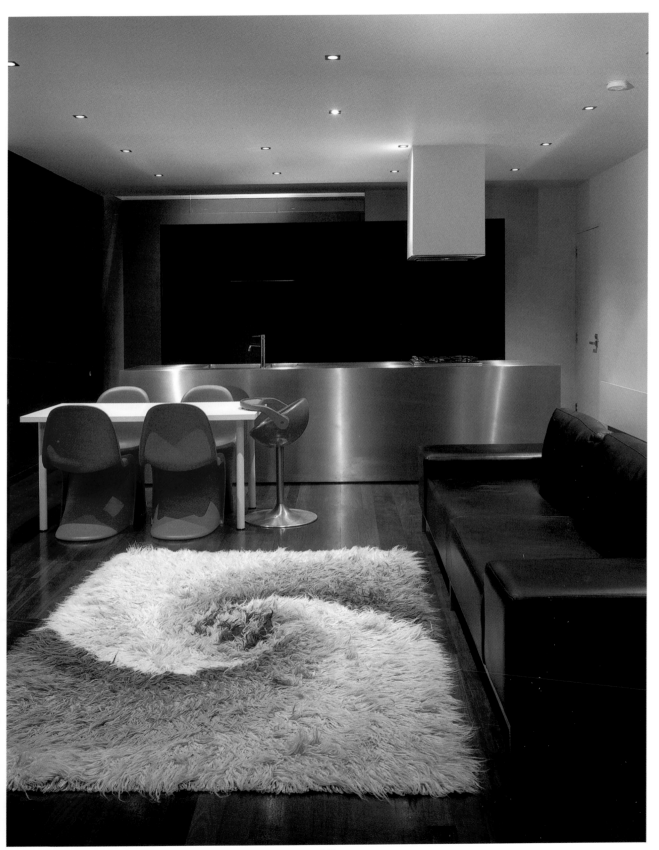

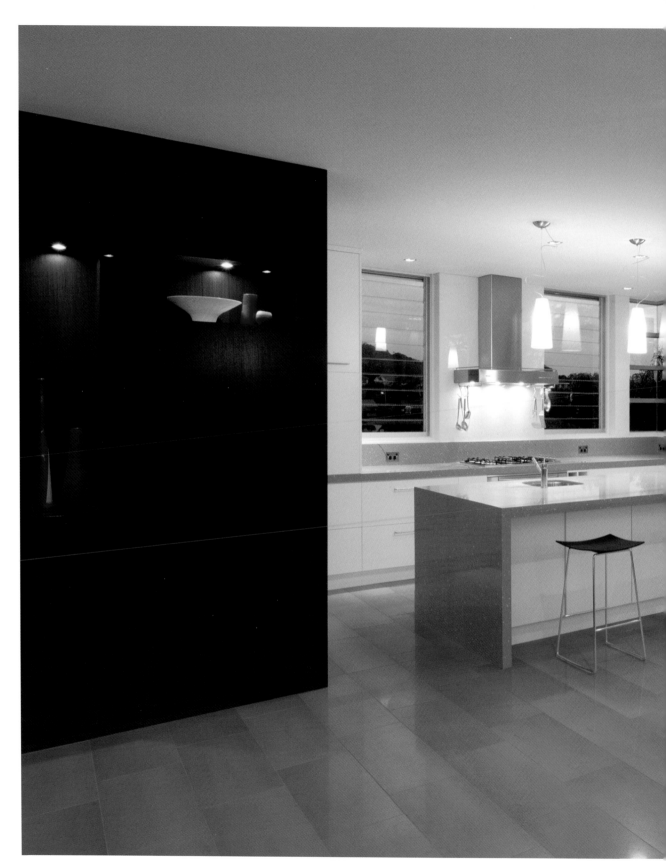

Design by Molnar Freeman Architects
Photo © Murray Fredericks

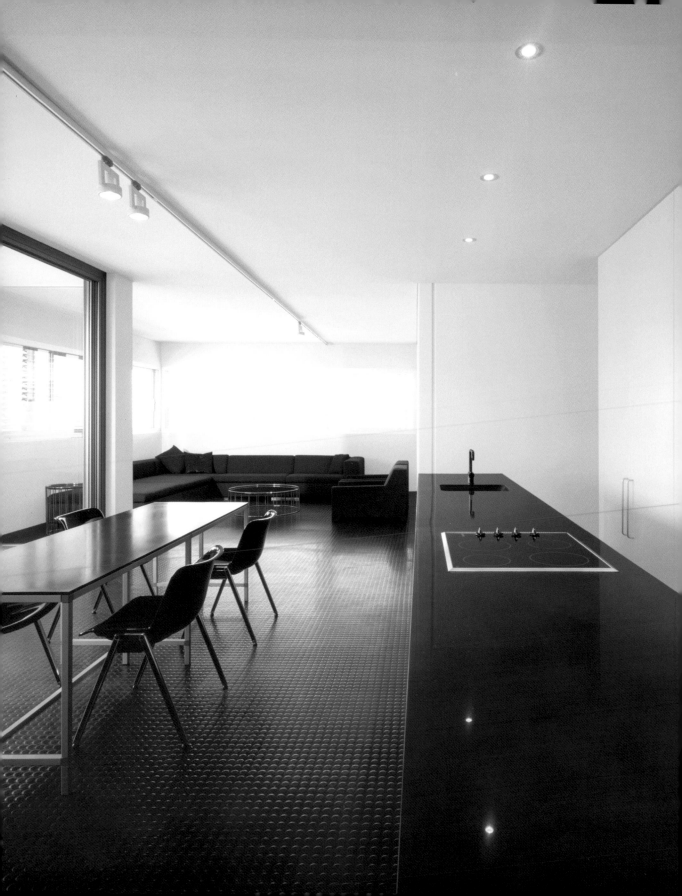

Both pages
Design by Engelen Moore
Photo © Ross Honeysett

Design by Abcarius & Burns
Photo © Ludger Paffrath

Design by Claesson Koivisto Rune
Photo © Patrik Engquist

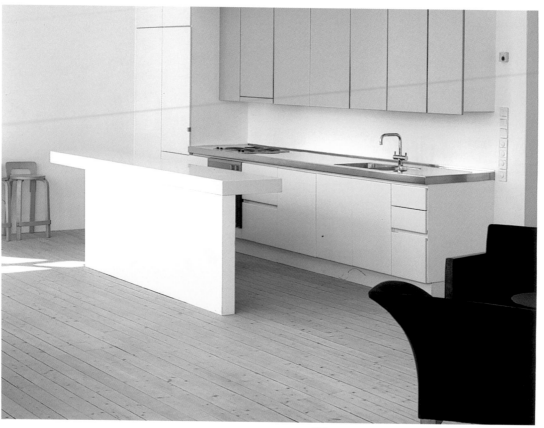

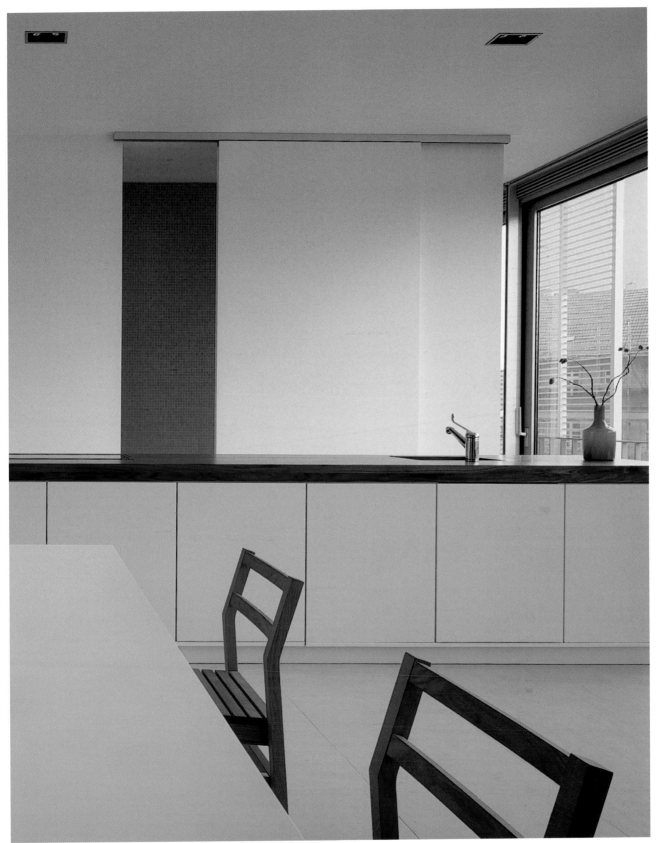

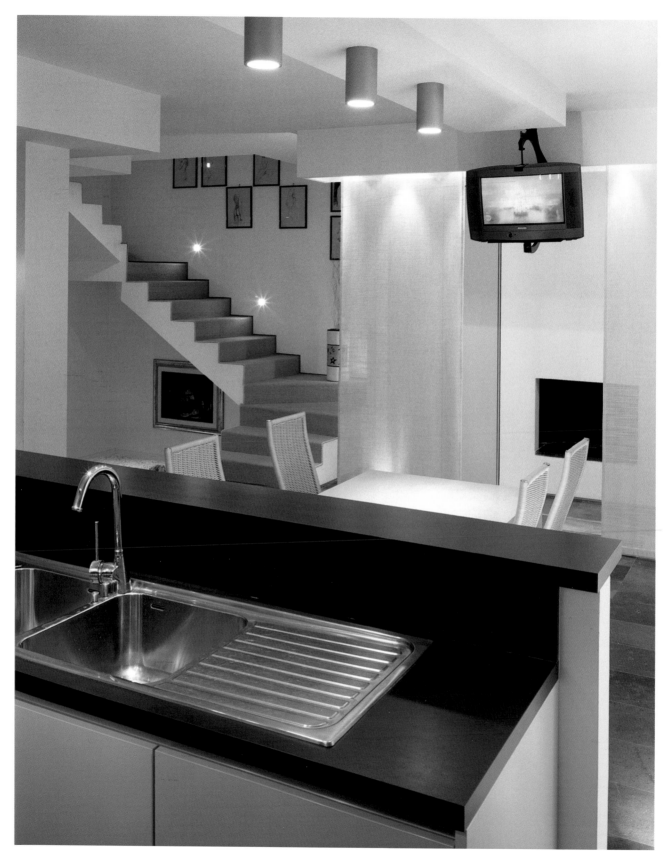

Both pages
Design by Filippo Bombace
Photo © Luigi Filetici

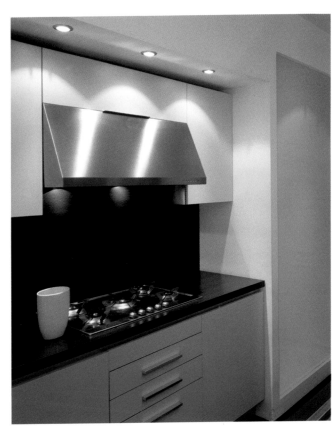

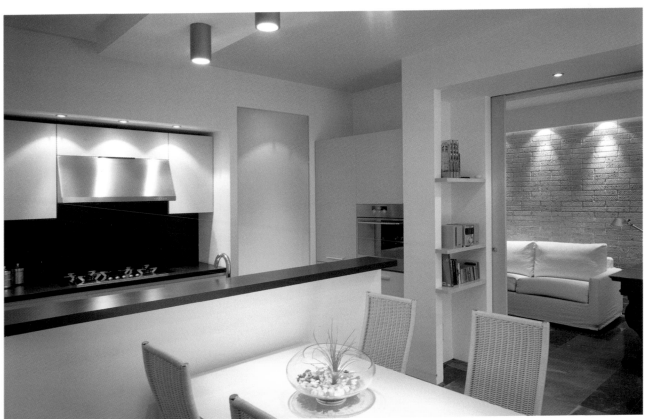

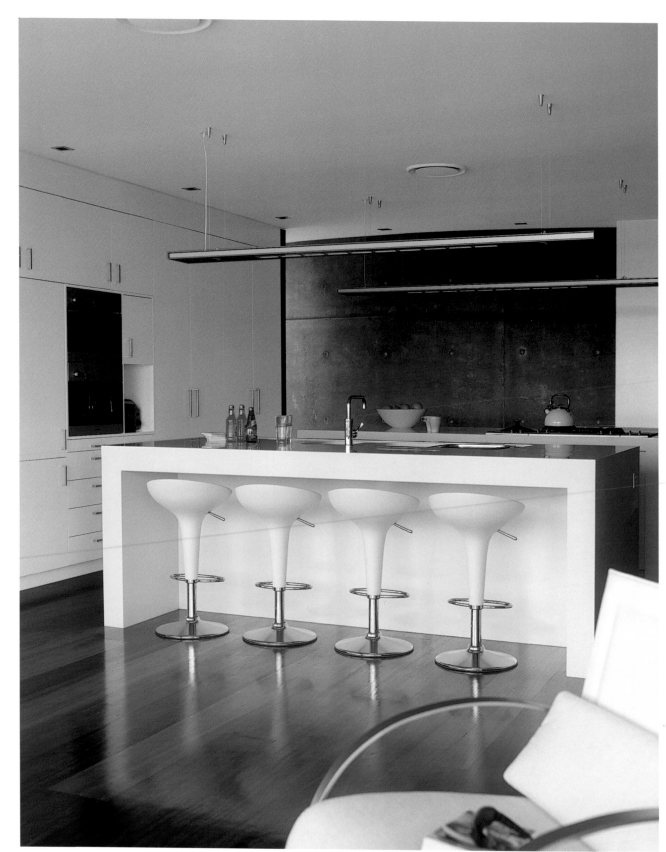

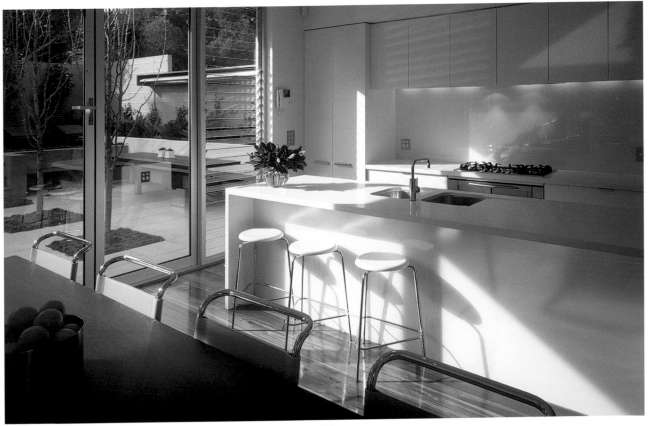

Double function

Design by Joachim Wendt
Photo © Jörg Hempel

An island can be very versatile and serve not only as an auxiliary work surface, but also as a mobile kitchen unit or a table for the dining room.

Die Mittelinsel bietet zusätzliche Arbeitsfläche, kann als Tisch dienen oder sogar als bewegliches Modul gestaltet sein und ins Esszimmer gebracht werden.

L'îlot central, offrant une surface de plan de travail supplémentaire, peut également servir de table auxiliaire ou de module amovible, transportable vers la salle à manger.

La isla central, además de cumplir la función de superficie de trabajo adicional, puede servir de mesa auxiliar o de módulo móvil y llevarse hasta el comedor.

L'isola centrale, oltre a svolgere la funzione di superficie di lavoro supplementare, può servire come tavolo aggiuntivo o modulo mobile, che può essere portato fino alla sala da pranzo.

Design by Connor & Solomon Architects
Photo © Peter Scott

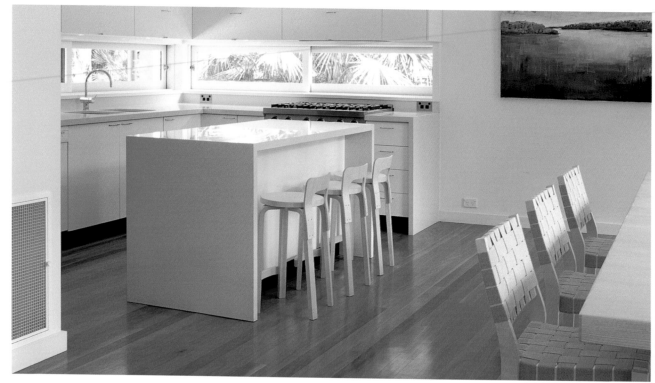

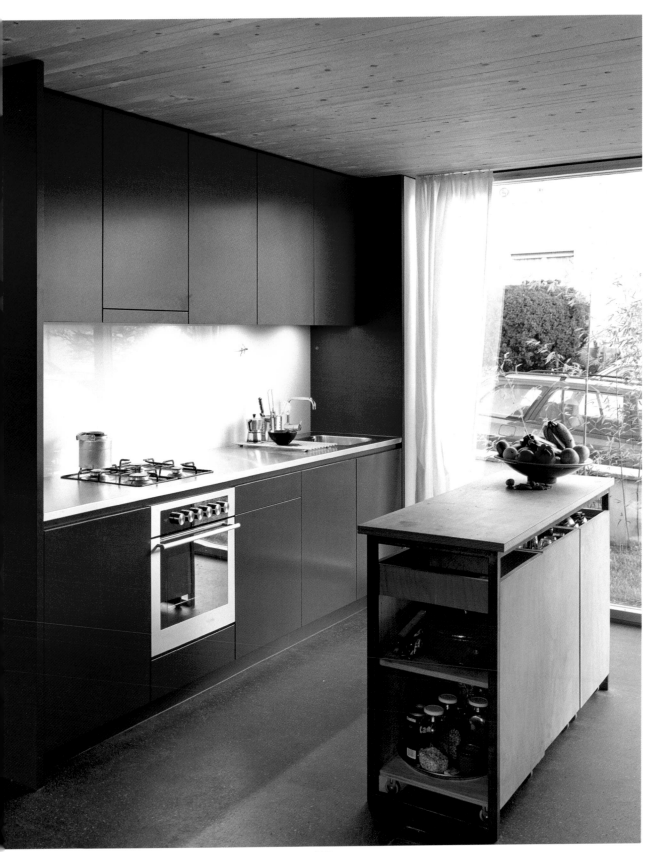

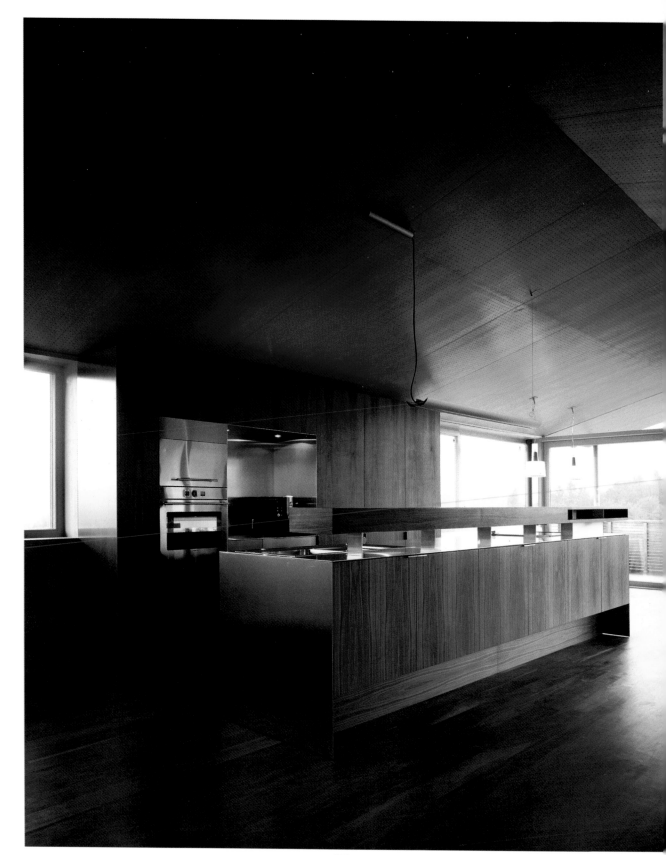

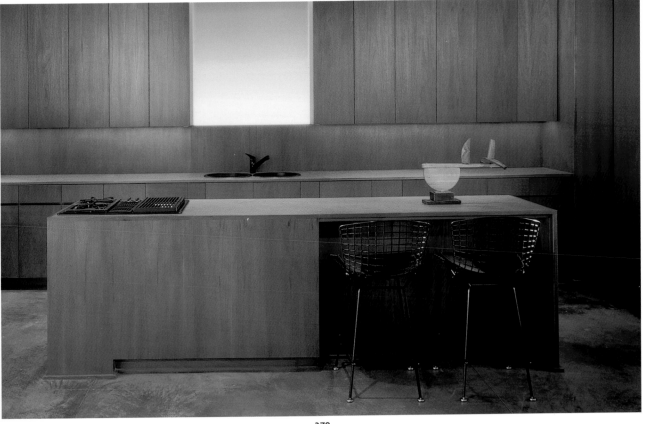

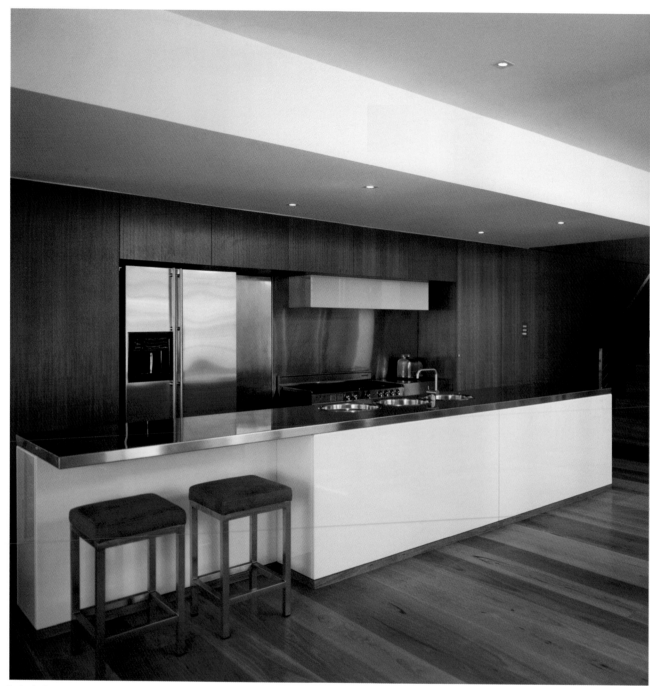

Design by Buzacott Associates Architects
Photo © John Fotiadis

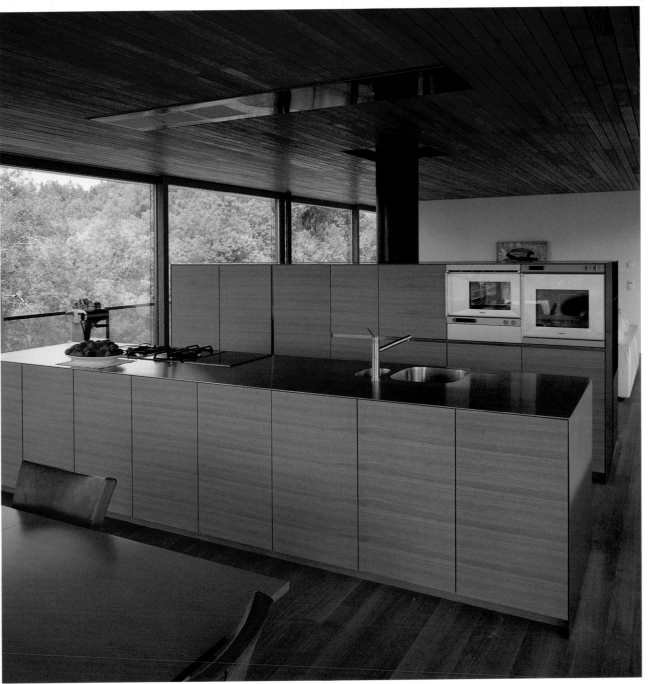

Design by Dietrich/Untertrifaller
Photo © Ignacio Martínez

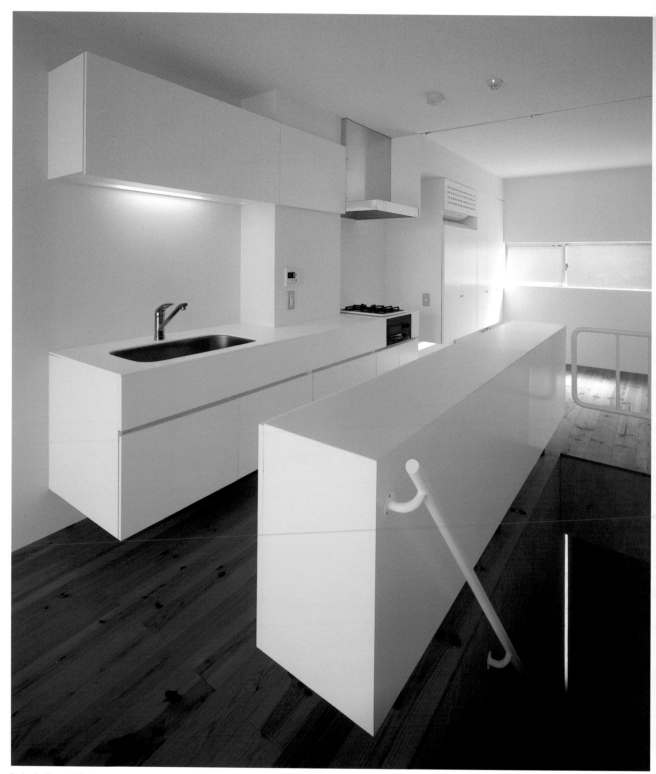

Design by Naya Architects
Photo © Nacasa & Partners

Design by Dietrich/Untertrifaller
Photo © Ignacio Martínez

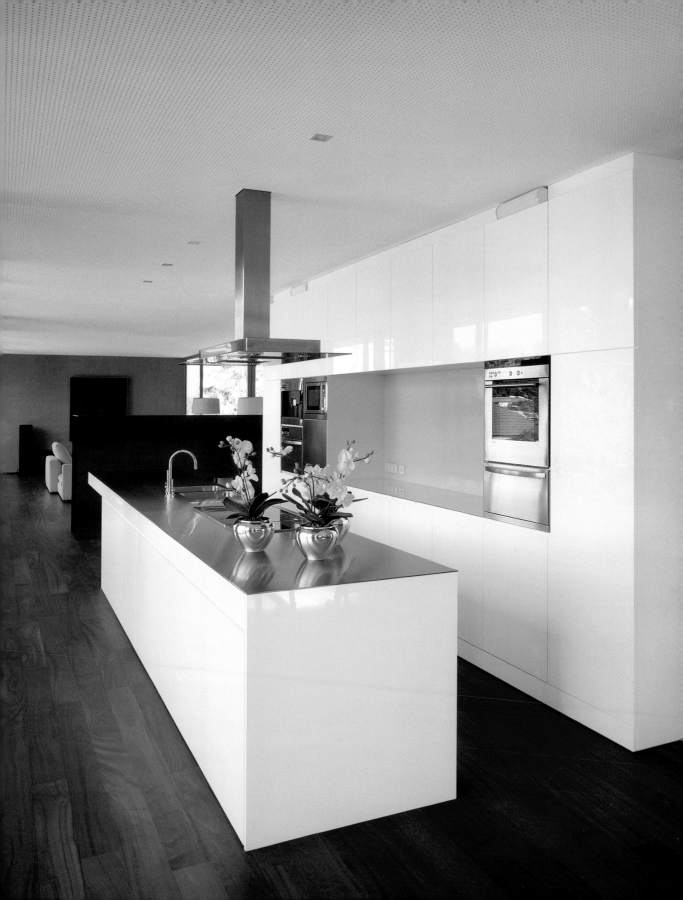

Both pages
Design by Lynx Architecture
Photo © Andreas J. Focke

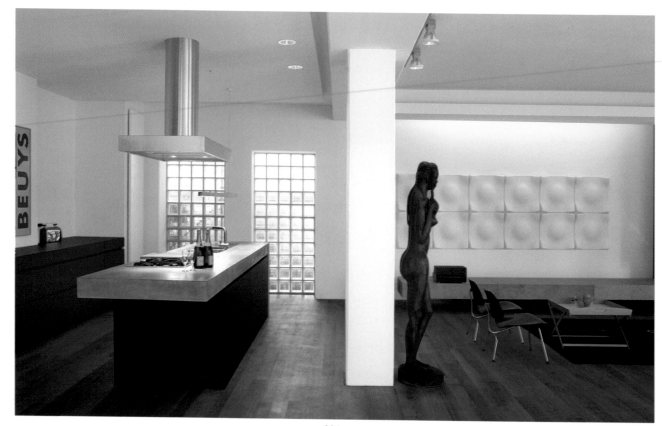

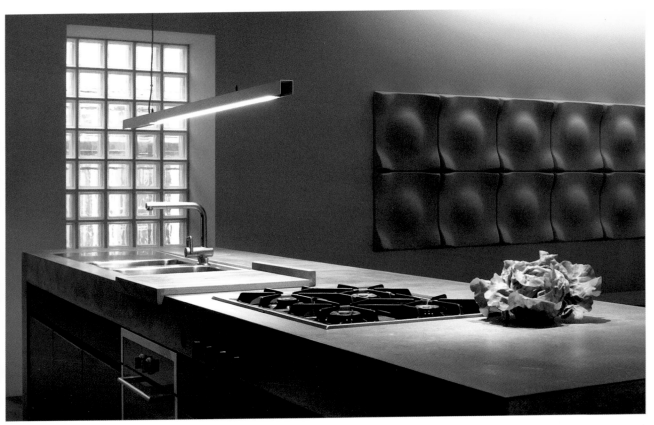

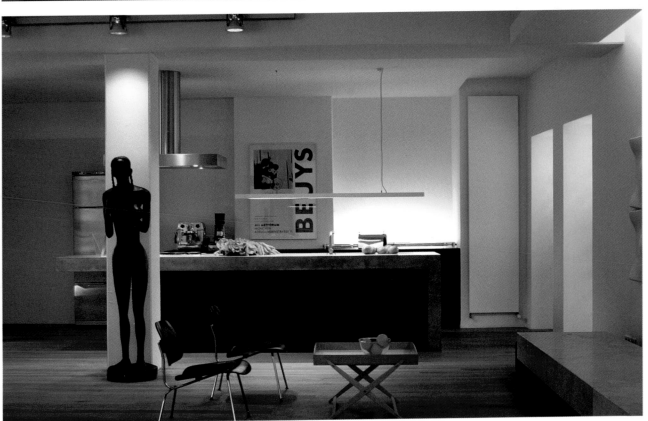

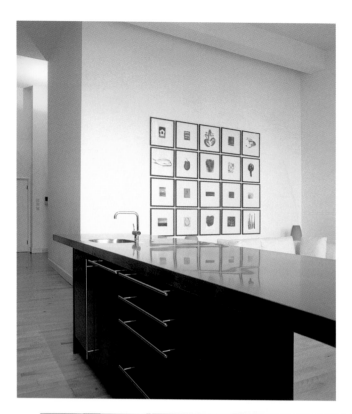

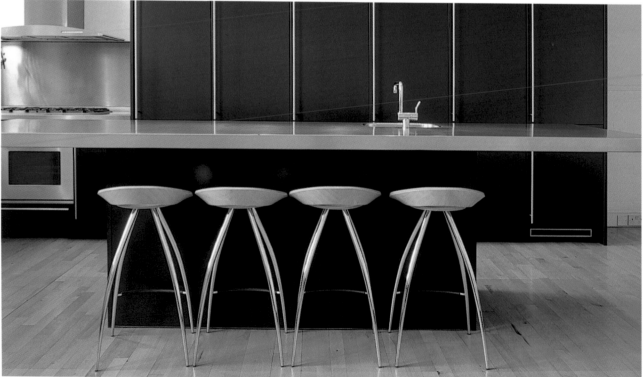

Both photos
Design by Brian Ma Siy
Photo © Jordi Miralles

Design by Moneo Brock
Photo © Jordi Miralles

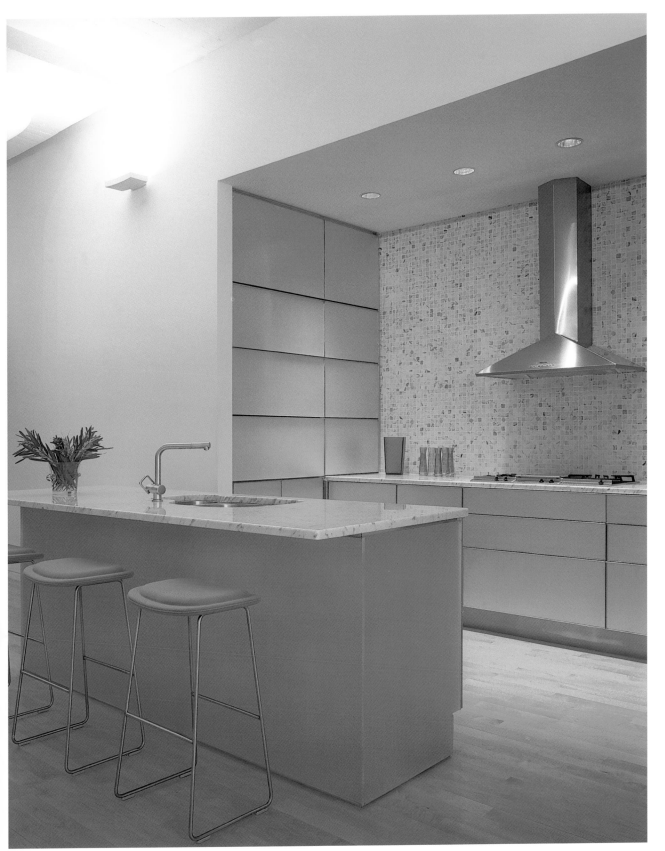

Miniature >>>>>>>

Today's lifestyles have created densely populated cities where people live in
increasingly smaller homes.

The miniature kitchen is a result of this tendency and has evolved with a nature of
its own thanks to the need to apply ingenious design to solving the problem of
space.

The strategies deployed in designing kitchens in small spaces are their most
prominent feature. Movable panels to conceal the kitchen as though it were a
cupboard; drawers to make use of every last scrap of available space; specially
built appliances that take up a minimum of space: all these are typically present
in this type of kitchen, a consequence of city life but popular too in country
residences or larger homes.

The preferred materials for small kitchens are manifold, but in most cases these
follow suit with the rest of the house. Some kitchens are built on a modular
basis, or of laminate panels that are compatible with the overall kitchen design.
Nevertheless, custom built kitchens are undoubtedly the best option from the
point of view of making the most of space. Wood, stainless steel, and in some
cases, stone, are the most widely used materials. Ceramic tiles are seldom
preferred because the joins generally convey a sense of reduced space, which is
contrary to the desired effect.

> Today's lifestyles have created densely populated cities where people live in increasingly smaller homes.

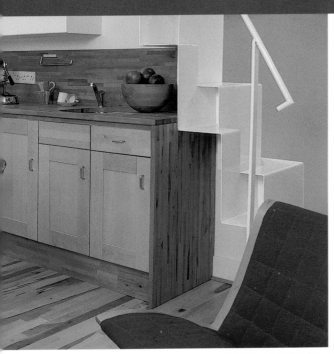

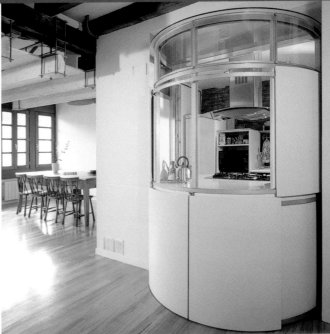

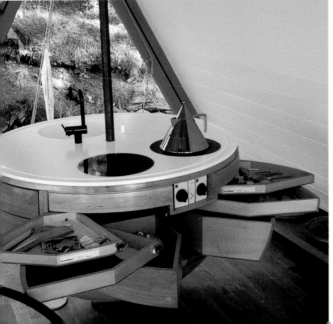

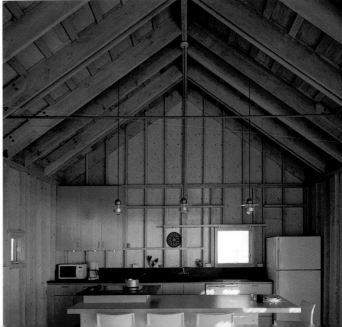

Klein

Unser heutiger Lebensstil hat zu dicht bevölkerten Innenstädten geführt, in denen die Wohnungen immer kleiner werden.

Die kleine Küche, ein Produkt dieses Phänomens, hat sich als eigene Kategorie herausgebildet. Es gilt, aus der Not eine Tugend zu machen und das Problem des engen Raums mit einfallsreichem Design zu lösen.

Der nur beschränkt zur Verfügung stehende Raum bestimmt die Strategien bei der Gestaltung einer kleinen Küche: Bewegliche Paneele verbergen die Küche wie einen Schrank, alle möglichen Arten von Schubläden nutzen auch noch den letzten Winkel, die Küchengeräte sollen so klein wie möglich sein – kurz, der Platz muss optimal genutzt werden. Obwohl diese Art von Küche ursprünglich aus der Raumnot in kleinen Stadtwohnungen entstand, findet man sie inzwischen auch in Häusern auf dem Land oder in größeren Wohnungen.

In kleinen Küchen kommen die unterschiedlichsten Materialien zur Anwendung, sie sollten allerdings immer mit der Einrichtung der anderen Wohnräume harmonieren. Es gibt zwar Einbauküchenmodule aus furnierten oder laminierten Spanplatten, die sich dem zur Verfügung stehenden Raum anpassen. Trotzdem ist eine nach Maß entworfene und gebaute Küche zweifellos die beste Lösung, um den Raum optimal zu nutzen. Verwendet werden meist Holz, Edelstahl und zuweilen Naturstein. Wandfliesen werden nach Möglichkeit vermieden, weil ihre Kleinteiligkeit und die Fugen den begrenzten Raum noch kleiner erscheinen lassen würden, als er in Wirklichkeit ist.

Both pages
Design by Guillermo Arias
Photo © Pablo Rojas

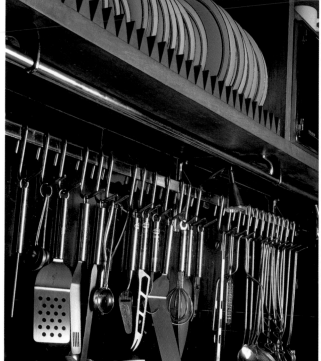

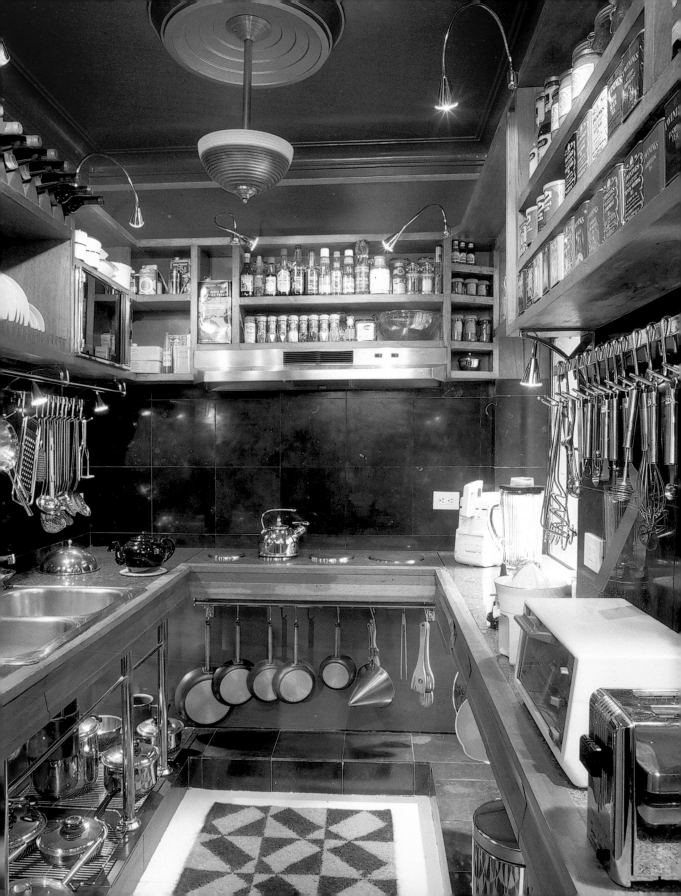

Petites

Le style de vie contemporain a engendré des villes à forte densité de population où la taille des habitations diminue de plus en plus.

La petite cuisine, issue de ce phénomène, a développé son propre style, fruit d'un design ingénieux nécessaire à la résolution des problèmes d'espace.

Les stratégies utilisées pour résoudre l'agencement d'une cuisine aux dimensions réduites en sont la caractéristique essentielle : panneaux amovibles masquant la cuisine à l'instar d'un placard, tiroirs multiples utilisant les moindres recoins et appareils aux dimensions minimalistes sont quelques unes des particularités propre à ce type de cuisine. Tout en étant un modèle né du manque d'espace dans les grandes villes, ce genre de cuisine est également installé dans les maisons de campagne ou dans les résidences plus grandes.

Les matériaux utilisés dans une petite cuisine peuvent être très variés. Dans la plupart des cas, son aspect esthétique est à l'image du reste de la maison. Il y a des cuisines modulaires, construites en aggloméré ou en contreplaqué de bois, qui, en général, s'adaptent à la pièce destinée à la cuisine. Toutefois, une cuisine conçue et construite sur mesure semble être la meilleure façon d'optimaliser l'espace. Bois, acier inoxydable et dans certains cas, pierre naturelle, sont les matériaux les plus employés. Pour les revêtements, on n'utilise guère les carreaux de faïence, car l'effet produit par les joints entre les carreaux donne la sensation de rapetisser l'espace par rapport à la réalité.

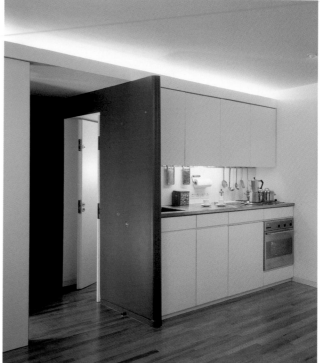

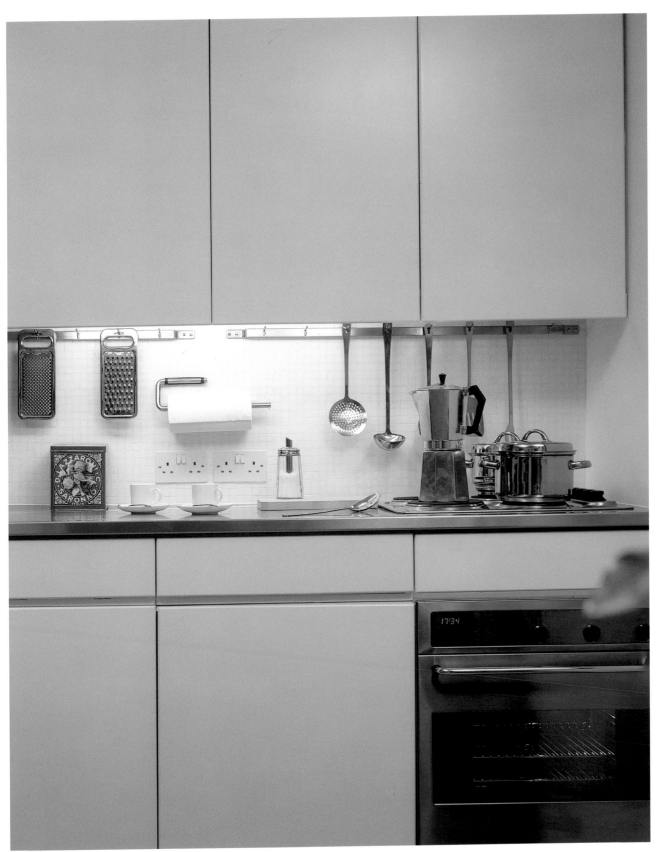

Pequeñas

El estilo de vida contemporáneo ha dado lugar a ciudades densamente pobladas donde el tamaño de las viviendas es cada vez más reducido.

La cocina pequeña, producto de este fenómeno, ha desarrollado un estilo propio, a causa del ingenioso diseño necesario para resolver los problemas de espacio.

Las estrategias a las que se recurre para solucionar la disposición de una cocina de reducidas proporciones constituyen su característica esencial: paneles móviles que esconden la cocina como si fuese un armario, múltiples cajones que aprovechan hasta el último rincón y aparatos de dimensiones mínimas son algunas de las peculiaridades propias de este tipo de cocinas. Aunque se trata de un modelo que surgió como consecuencia de la falta de espacio en las grandes ciudades, es posible encontrar también estas cocinas en casas de campo y residencias de mayor tamaño.

Los materiales que se utilizan en una cocina pequeña pueden ser muy diversos; en la mayoría de los casos, su aspecto sigue la estética del resto de la casa. Existen cocinas modulares, construidas con aglomerados y con contrachapados de madera que, por lo general, se adaptan a la estancia asignada a la cocina; sin embargo, una cocina diseñada y construida a medida resulta la mejor opción para aprovechar el espacio. Madera, acero inoxidable y, en algunos casos, piedra natural, son los materiales más empleados. Para los revestimientos se utilizan poco los azulejos, ya que el efecto que producen las juntas entre las piezas hace que el espacio parezca más reducido de lo que es en realidad.

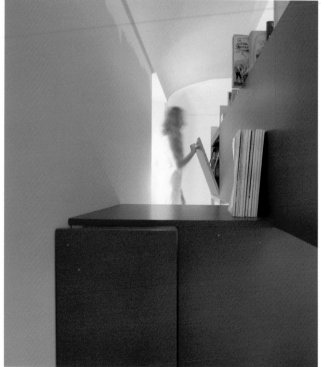

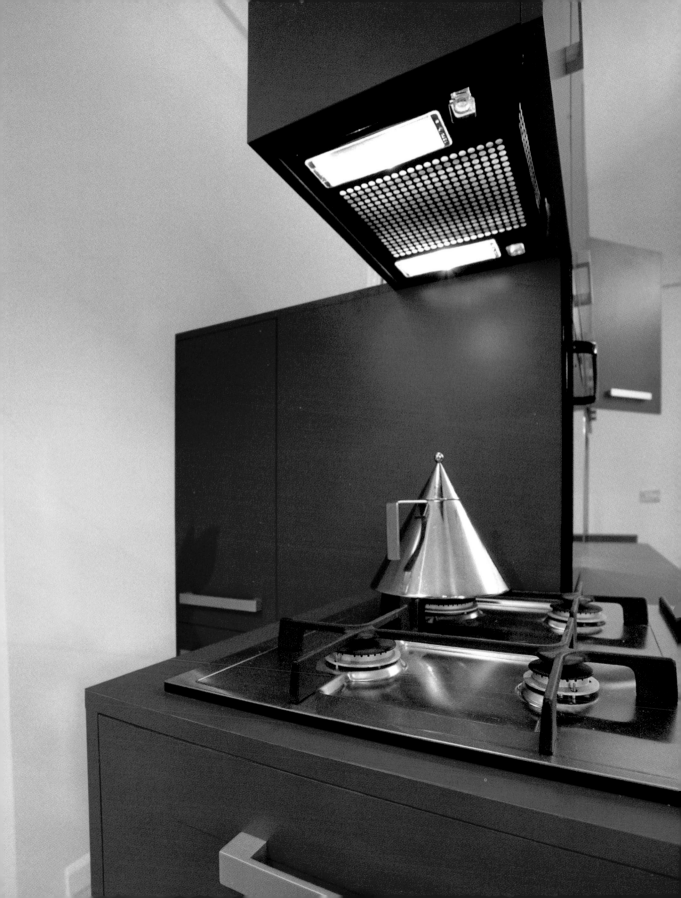

Piccole

Lo stile di vita contemporaneo ha dato vita a città densamente popolate in cui le dimensioni delle abitazioni sono sempre più ridotte.

Le cucine piccole, frutto di questo fenomeno, hanno sviluppato uno stile proprio per via dell'ingegnoso disegno necessario per risolvere i problemi di spazio.

Le strategie alle quali si ricorre per disporre nel migliore dei modi una cucina di dimensioni ridotte costituiscono la sua caratteristica essenziale: pannelli mobili che nascondono la cucina come se si trattasse di un armadio, cassetti multipli che sfruttano lo spazio fino all'ultimo centimetro e apparecchiature di piccole dimensioni. Queste sono alcune delle peculiarità che caratterizzano questo tipo di cucine. Sebbene si tratti di un modello sorto come conseguenza della mancanza di spazio nelle grandi città, è possibile trovare esempi di questo tipo di cucine anche in abitazioni di campagna o residenze di grandi dimensioni.

I materiali che si utilizzano in una cucina piccola possono essere di vario tipo; nella maggior parte dei casi, il loro aspetto segue l'estetica del resto della casa. Esistono cucine modulari, costruite con truciolati o compensati in legno che, in genere, si adattano all'ambiente riservato alla cucina; la migliore opzione per sfruttare al meglio lo spazio disponibile resta, comunque, una cucina progettata e costruita su misura. Legno, acciaio inossidabile e, in alcuni casi, pietra naturale, sono i materiali più utilizzati. Per i rivestimenti, scarso è l'utilizzo di piastrelle smaltate, visto che l'effetto prodotto dalle fughe tra una piastrella e l'altra fa sì che lo spazio sembri ancora più ridotto di quello che è in realtà.

Both pages
Design by William Smart Architects
Photo © Gene Raymond Ross

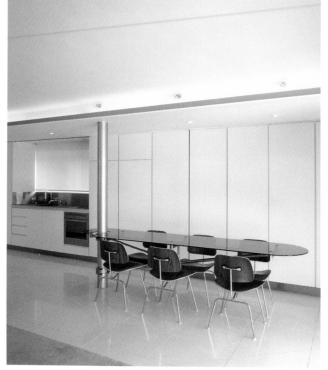

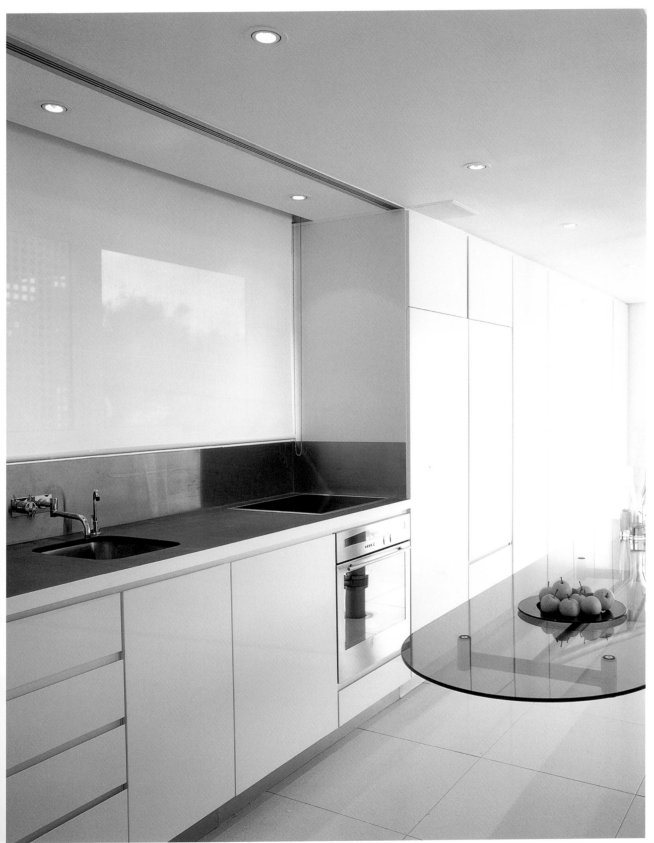

Both pages
Design by Manzano, Flavia
Photo © Eugeni Pons

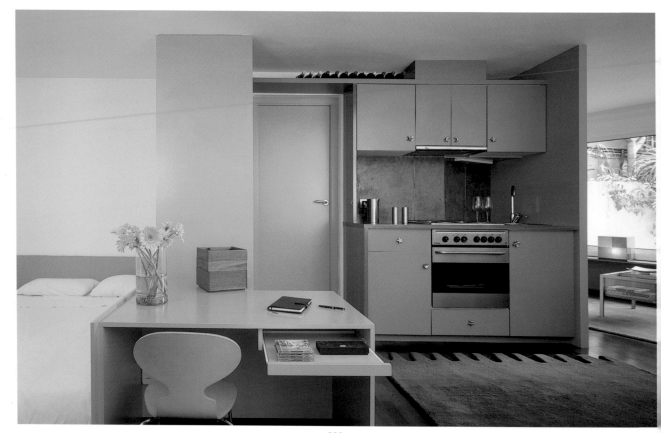

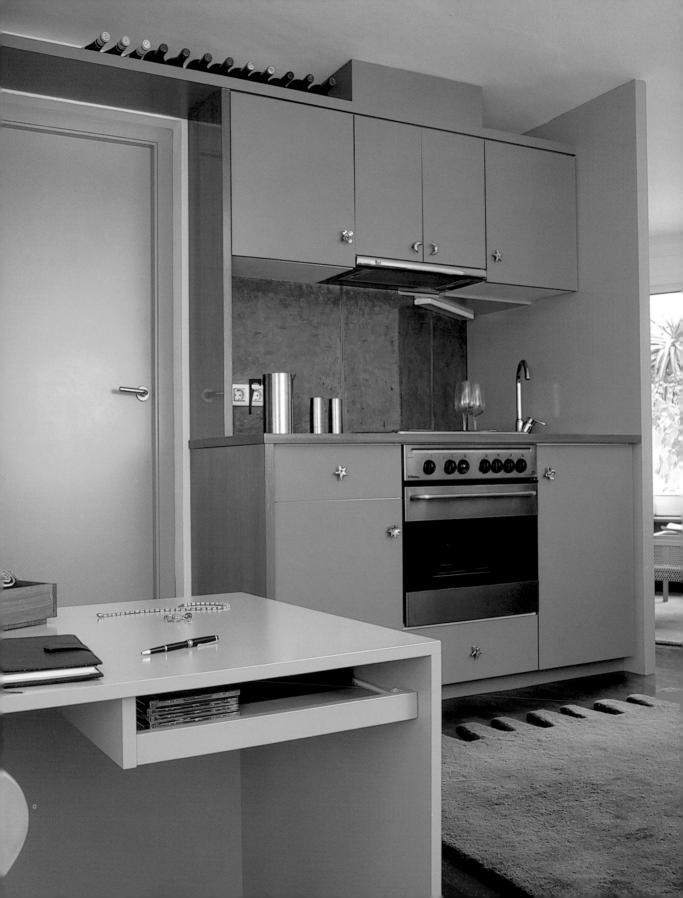

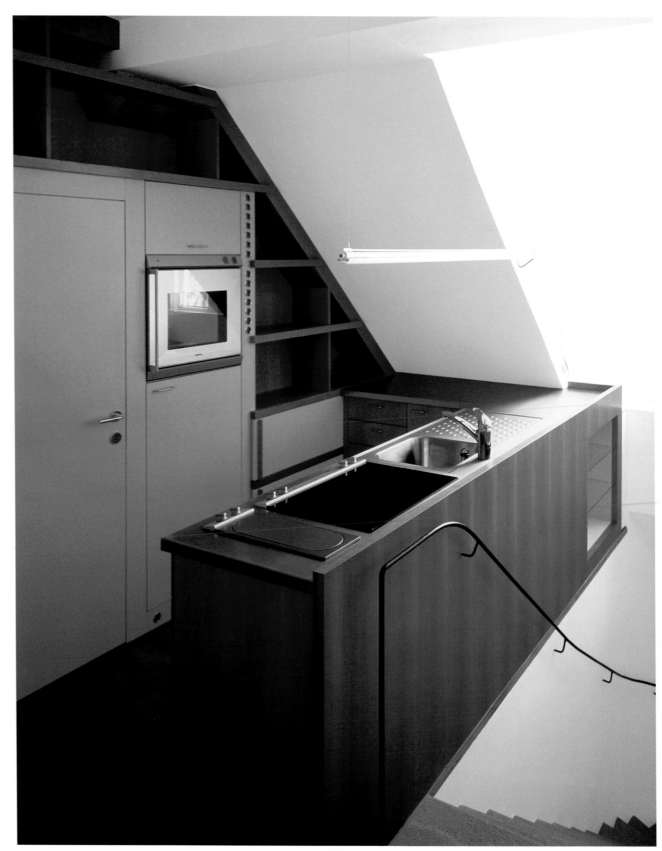

both pages
Design by Juerg Meister
Photo © Pez Hejduk

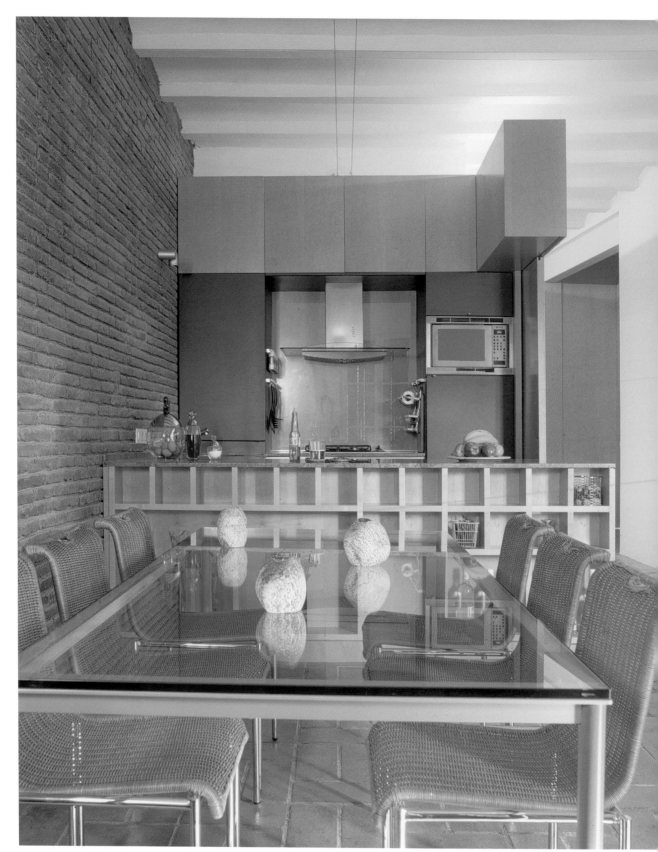

Both pages
Design by Simon Platt and Rob Dubois
Photo © Eugeni Pons

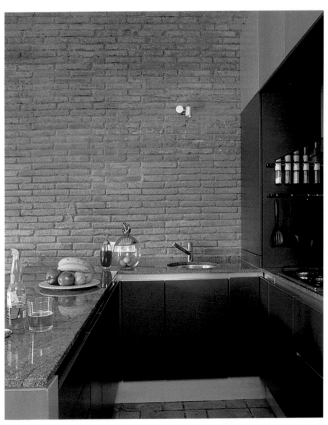

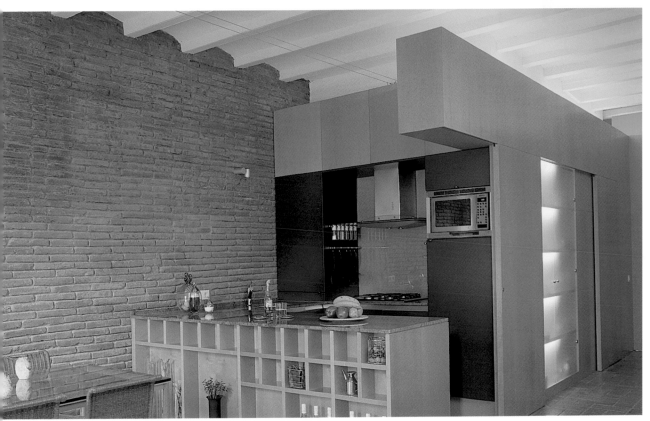

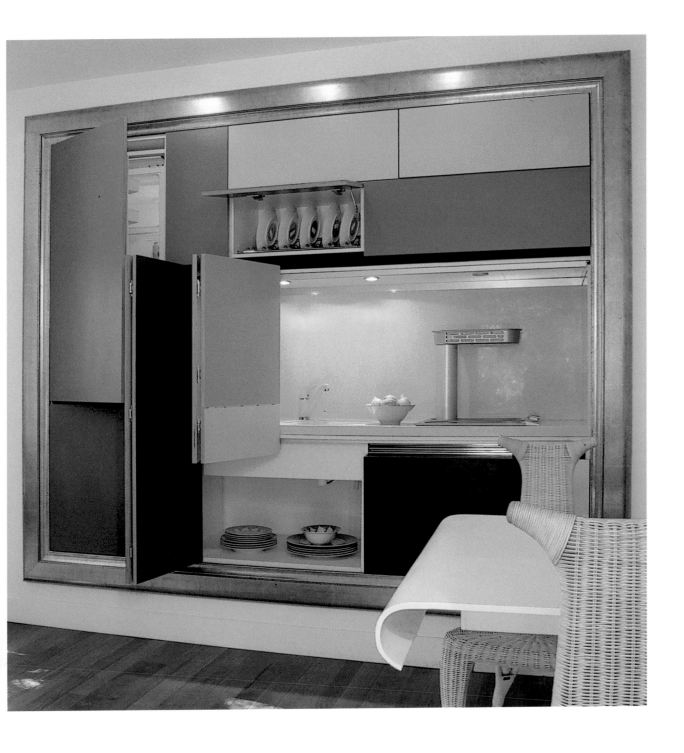

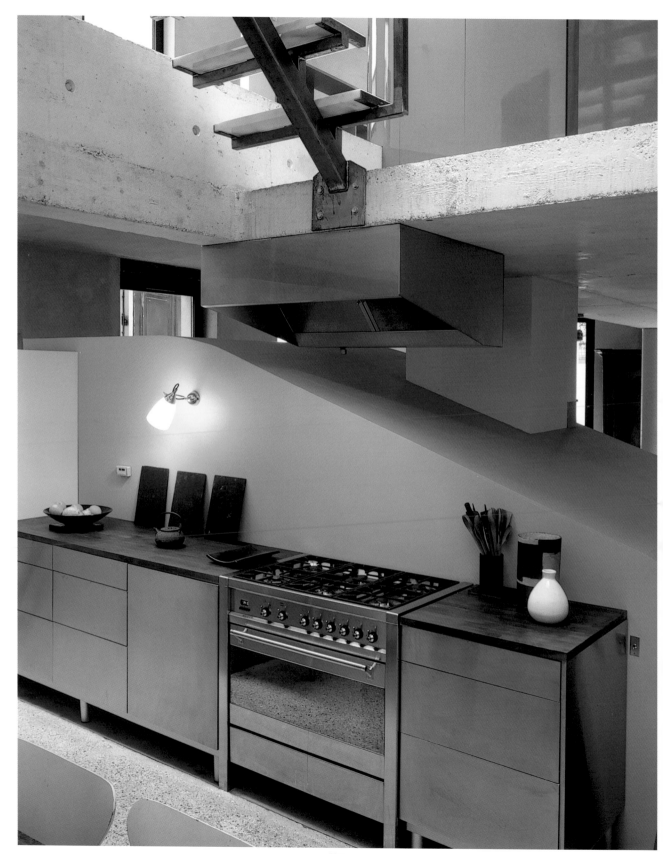

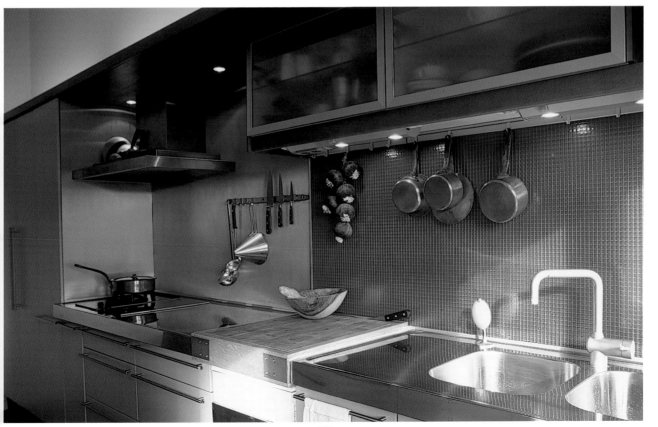

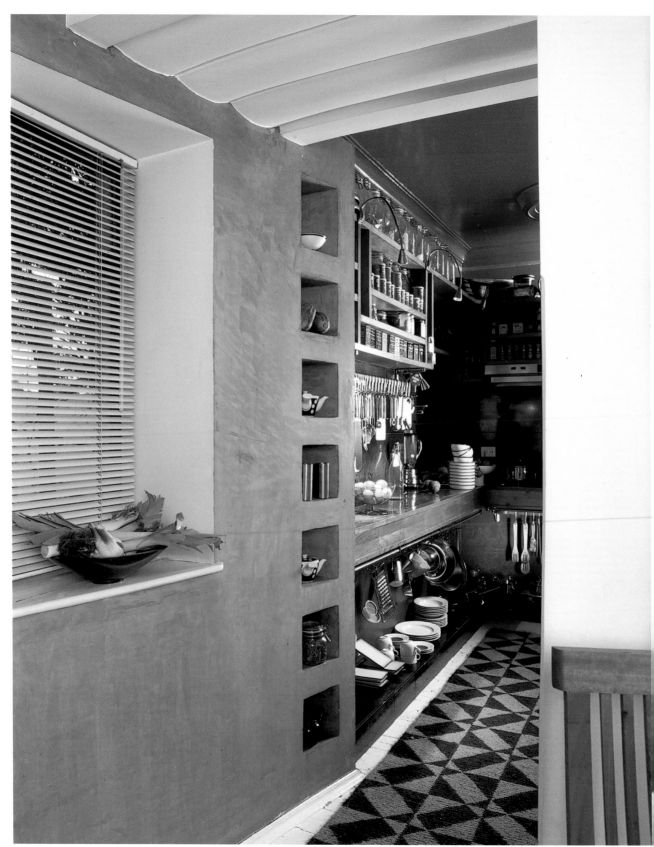

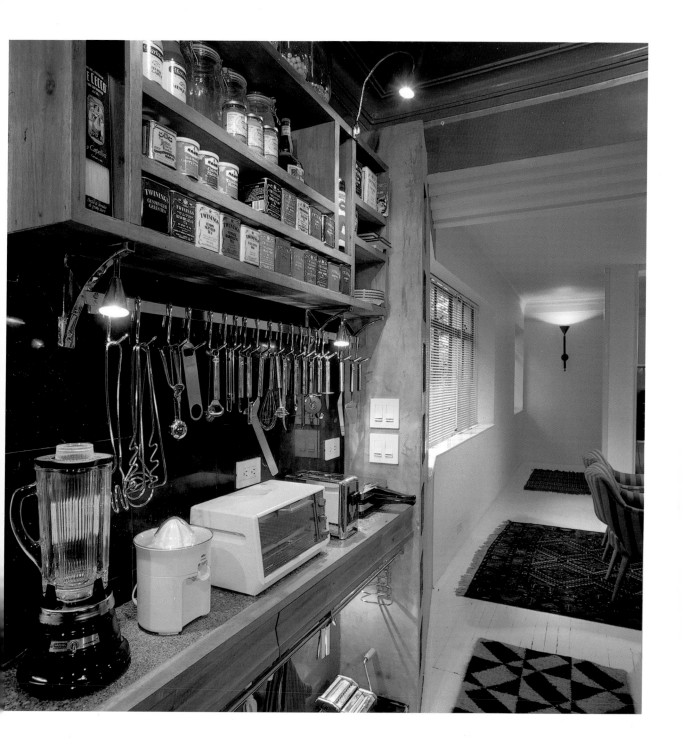

Both pages
Design by Guillermo Arias
Photo © Pablo Rojas

Both pages
Design by Michele Bonino
Photo © Beppe Giardino

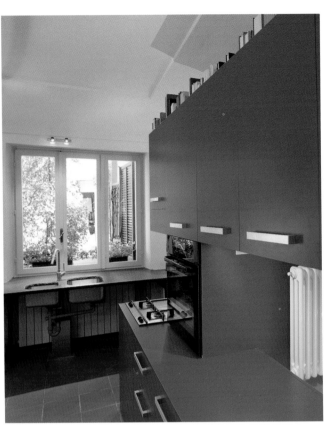

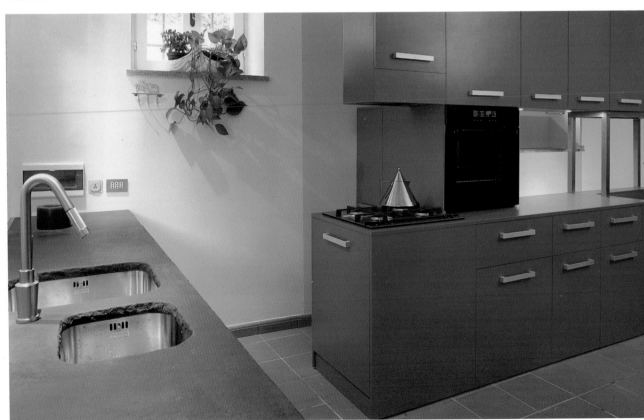

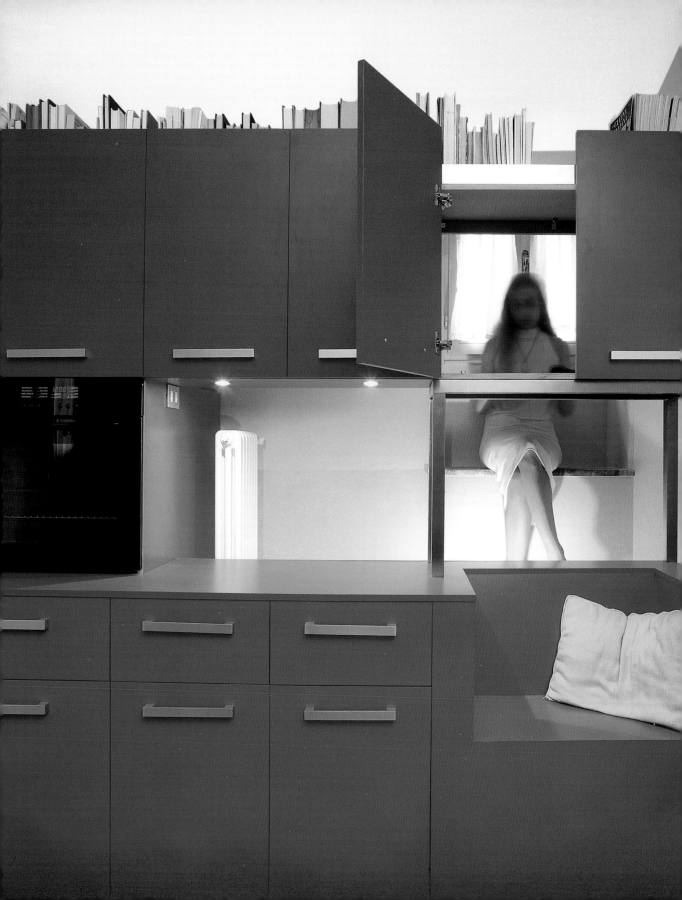

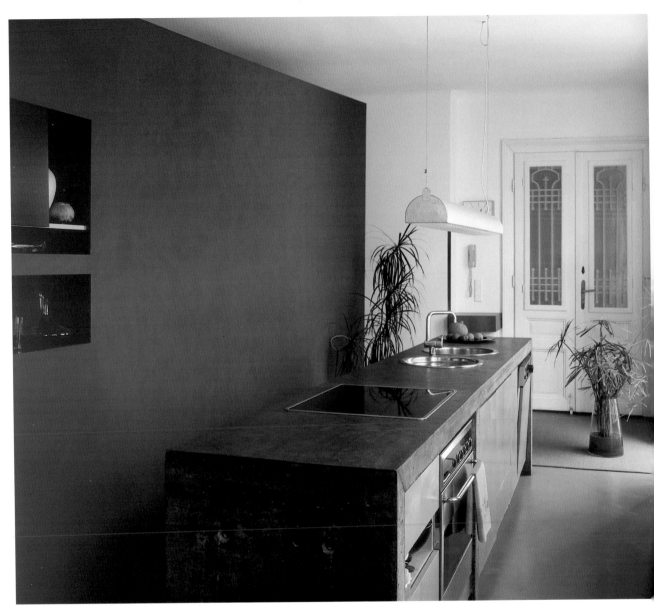

Design by Lakonis Architekten
Photo © Margherita Spiluttini

Design by Propeller
Photo © Margherita Spilutti

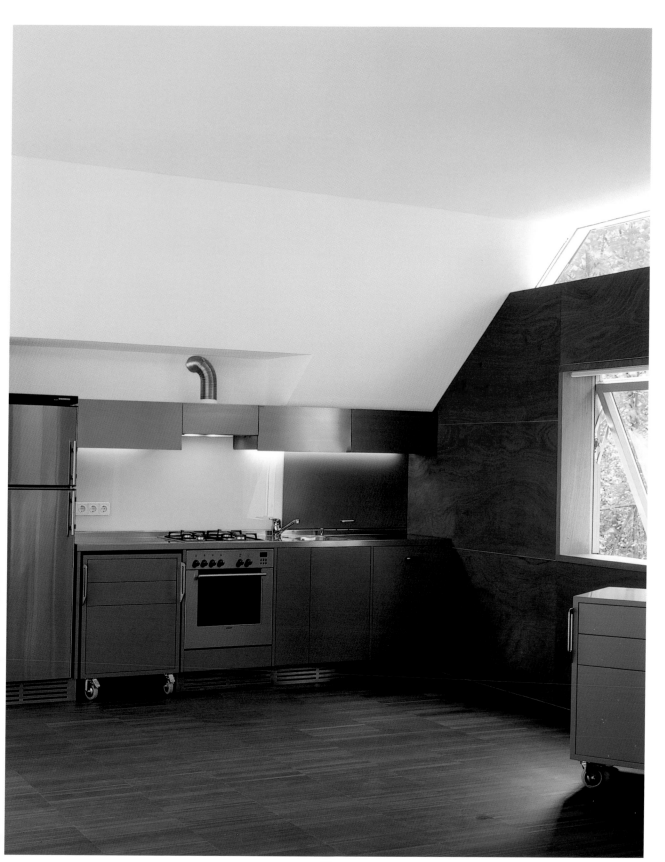

Island

Design by Della Valle + Bernheimer Design
Photo © Richard Barnes

Islands are an ideal solution for tiny kitchens requiring optimum use of circulations, or when the kitchen needs to be integrated with the rest of the surrounding spaces.

Einzeln stehende Module stellen die Ideallösung einer kleinen Küche dar, wenn es darum geht, Bewegungsfreiheit zu wahren und die Küche in den Rest der Wohnung zu integrieren.

Les modules isolés sont une solution idéale pour les petites cuisines quand il s'agit d'optimiser le passage ou d'intégrer la cuisine au reste de l'espace.

Los módulos aislados constituyen una solución ideal para cocinas pequeñas cuando se trata de aprovechar la circulación o integrar la cocina en el resto del espacio.

I moduli ad isola rappresentano un'ottima soluzione per cucine piccole quando si vuole sfruttare appieno lo spazio attorno o integrare la cucina al resto dell'ambiente.

Design by Graser Architekten
Photo © Lilli Kehl

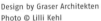

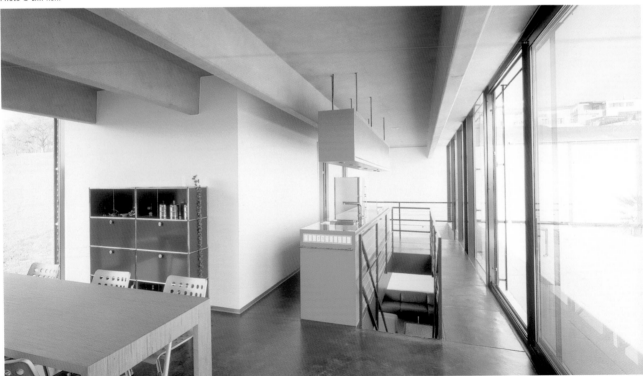

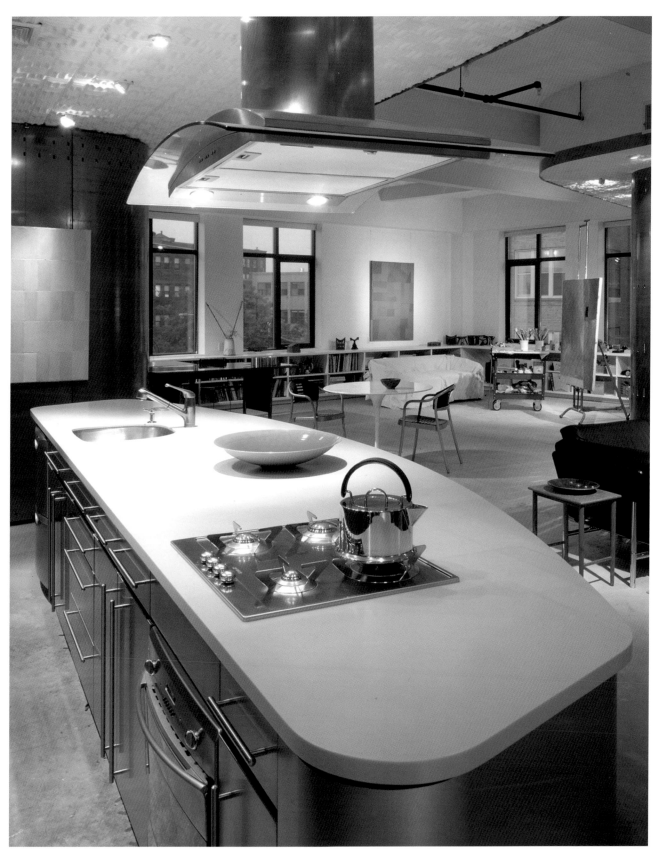

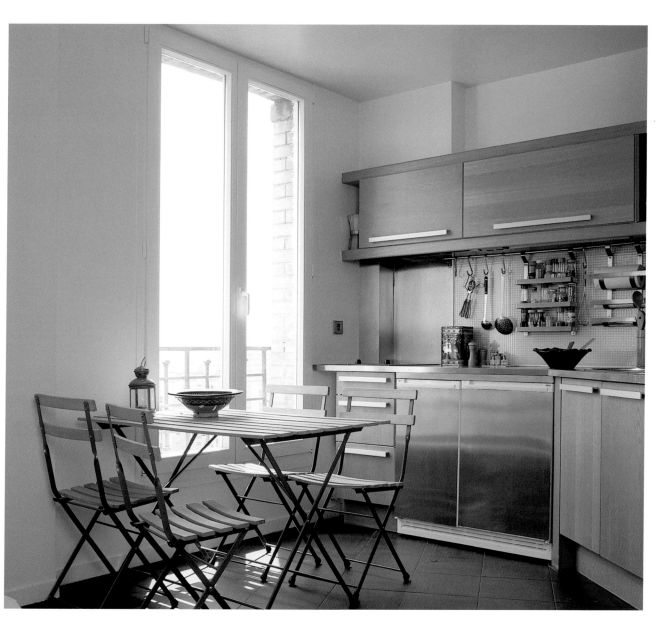

Both pages
Design by Damien Brambilla
Photo © Antonio Duarte

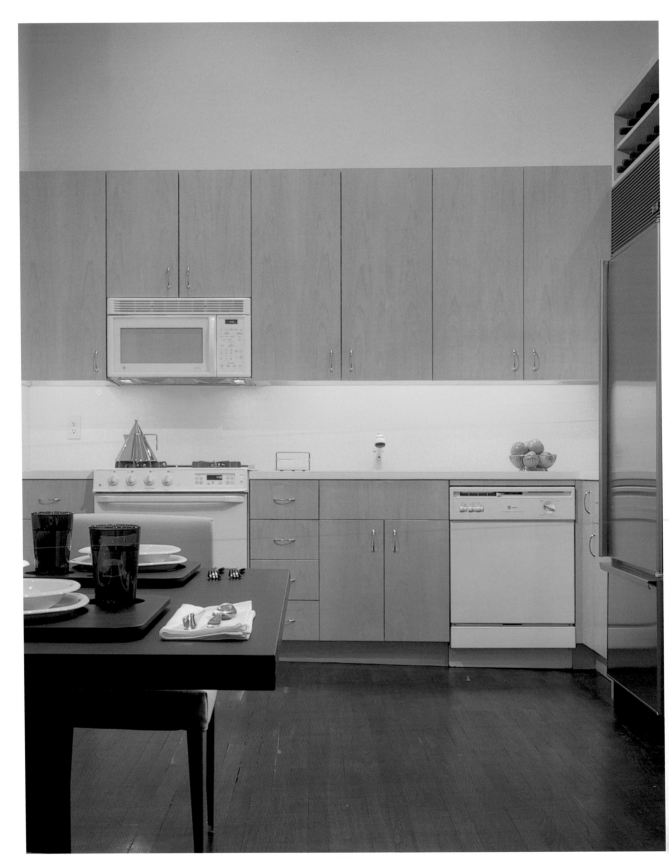

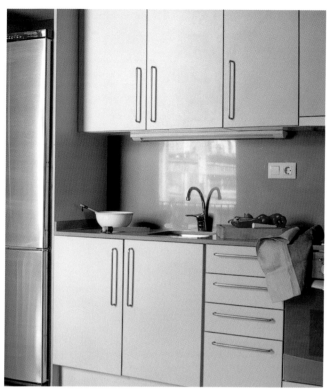

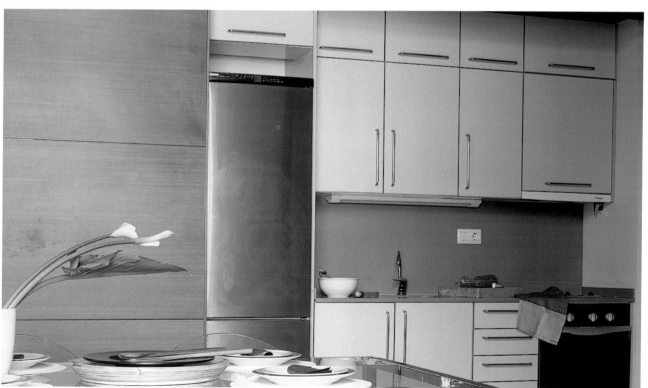

Design by Harry Elson
Photo © Paul Warchol

Both photos
Design by Bárbara Salas
Photos © Montse Garriga

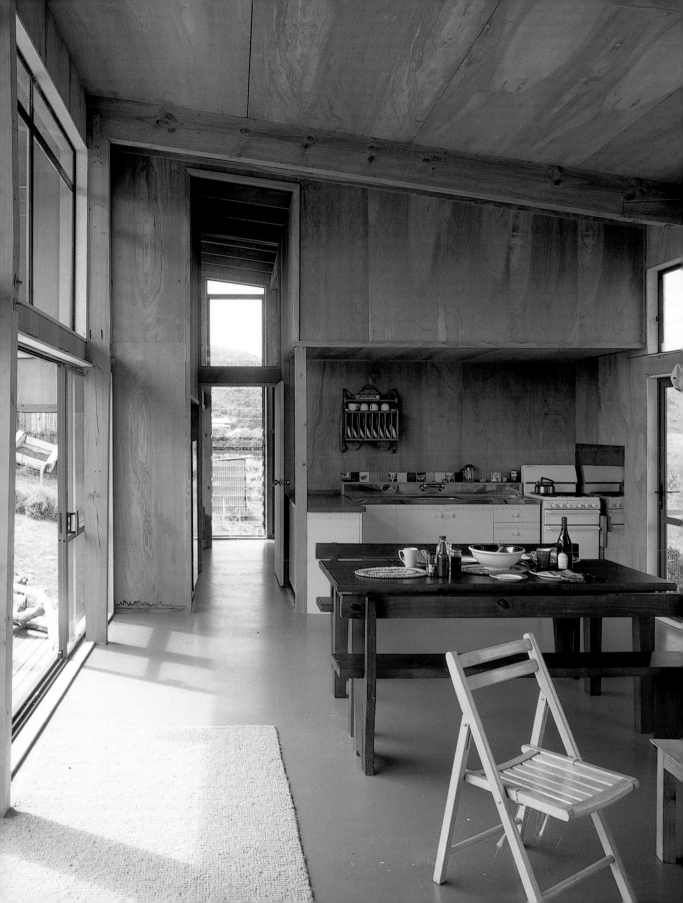

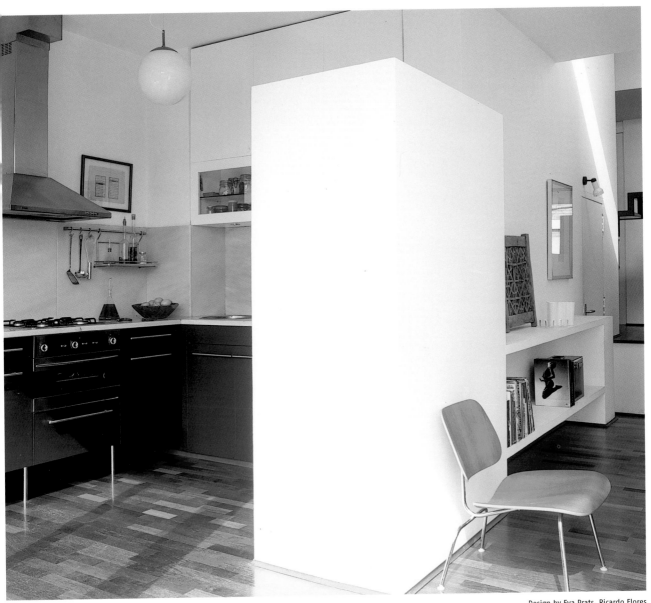

Design by Eva Prats, Ricardo Flores
Photo © Eugeni Pons

Design by Arquitectus
Photo © Patrick Reynolds

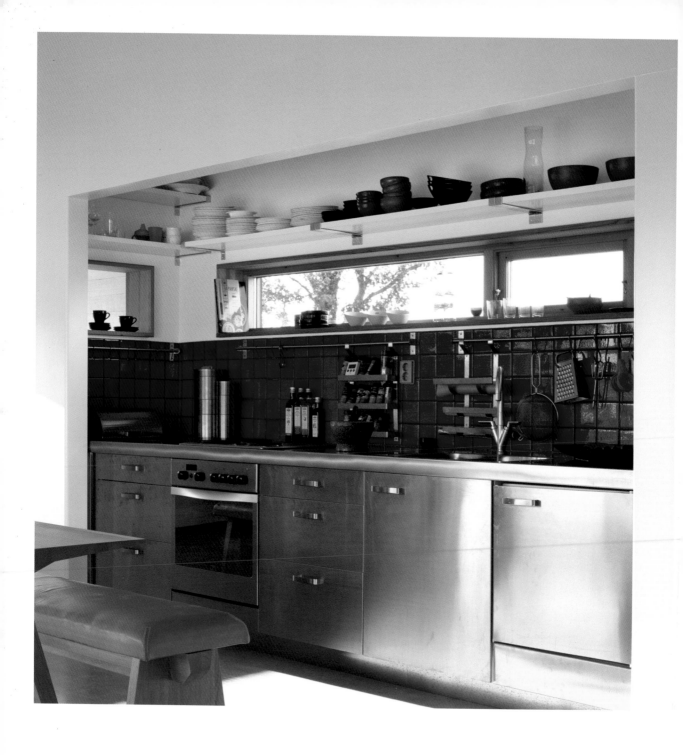

Both pages
Design by Peter Hulting/Meter Arkitektur
Photo © James Silverman

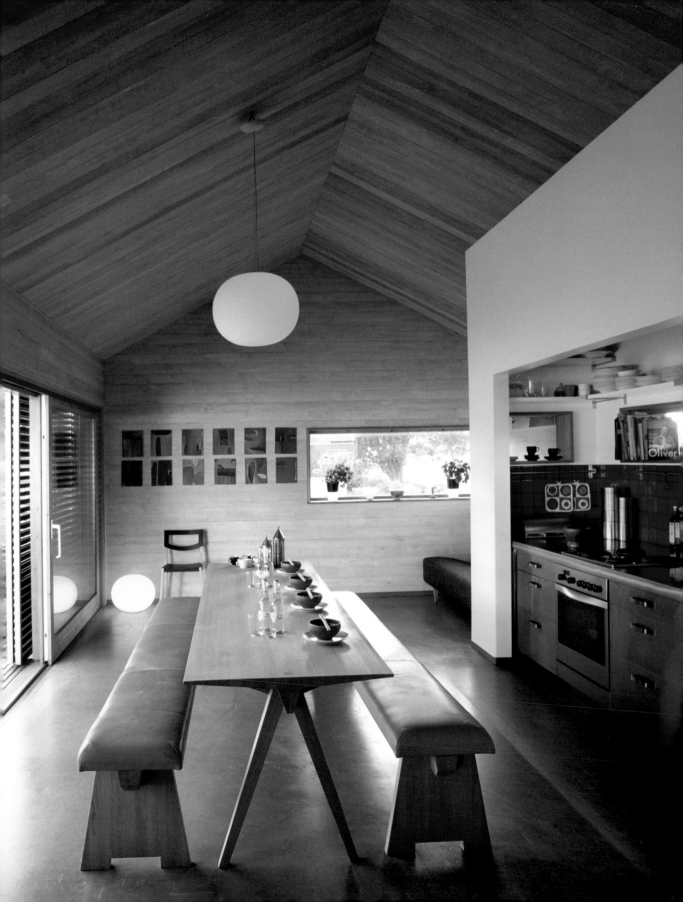

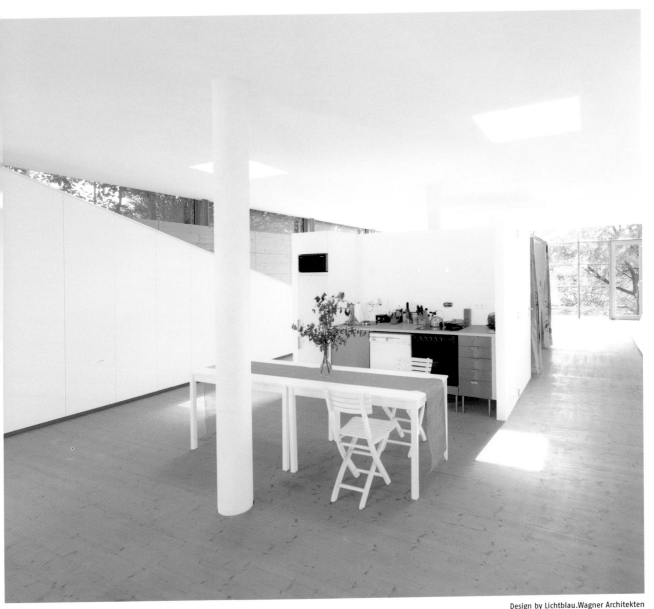

Design by Lichtblau.Wagner Architekten
Photo © Bruno Klomfar

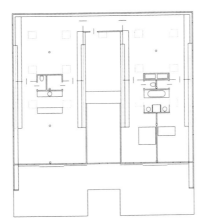

Design by Studio Rodighiero Associati
Photo © Antonio de Luca, Alessandro Lui

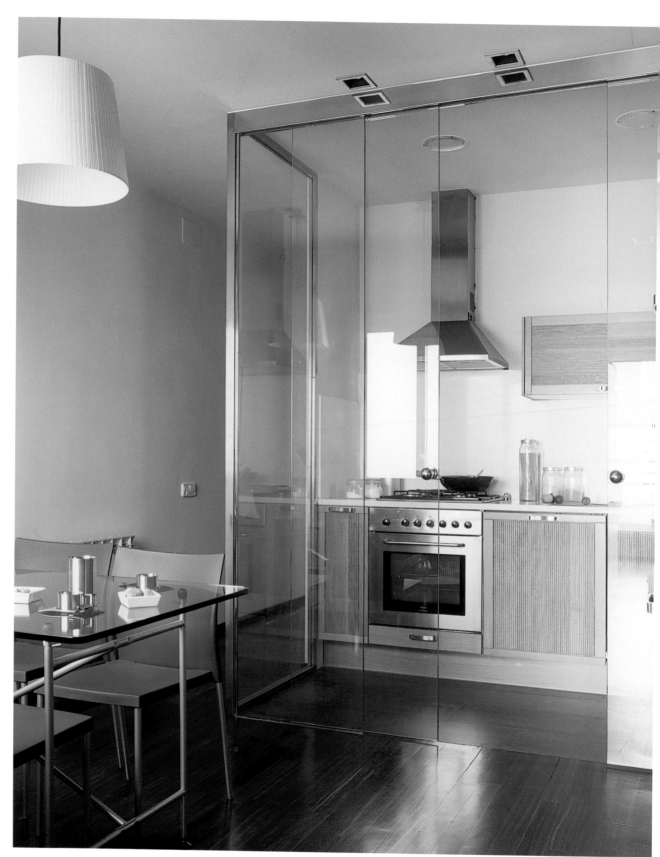

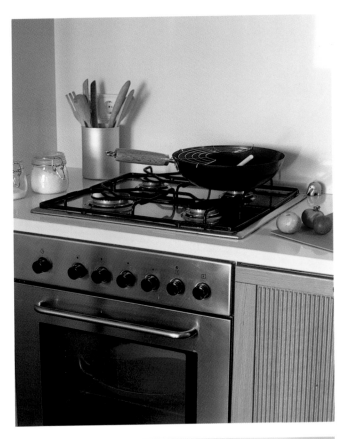

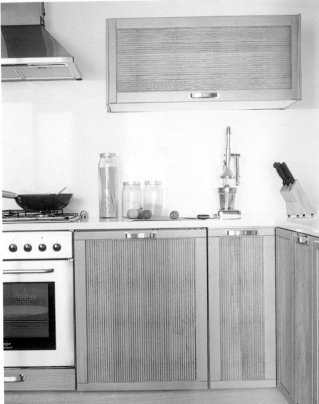

Both pages
Design by Ares Fernández
Photo © Jose Luis Hausmann

Glass walls

Design by Dick van Gameren
Photo © Christian Richters

Glass wall coverings are another extremely effective way to generate a sense of depth and clean-cut lines, when combined with the appropriate lighting schemes.

Gläserne Oberflächen und eine gut durchdachte Ausleuchtung sind eine hervorragende Lösung, um den Eindruck von räumlicher Tiefe und Aufgeräumtheit zu erzielen.

Le revêtement de verre des surfaces, agrémenté d'un éclairage correct, est assez efficace pour créer un effet de profondeur et de propreté.

El revestimiento de cristal de las superficies, acompañado de una correcta iluminación, resulta muy eficaz para lograr un efecto de profundidad y limpieza.

Il rivestimento in vetro delle superfici, corredato da una corretta illuminazione, risulta molto efficace al fine di ottenere un effetto di profondità ed ordine.

Design by Desai/Chia Studio
Photo © Joshua McHug

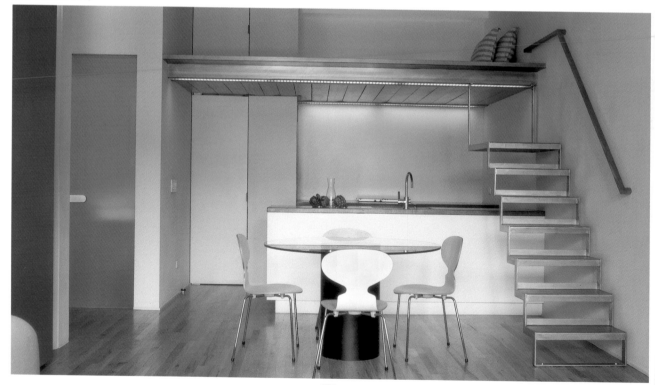

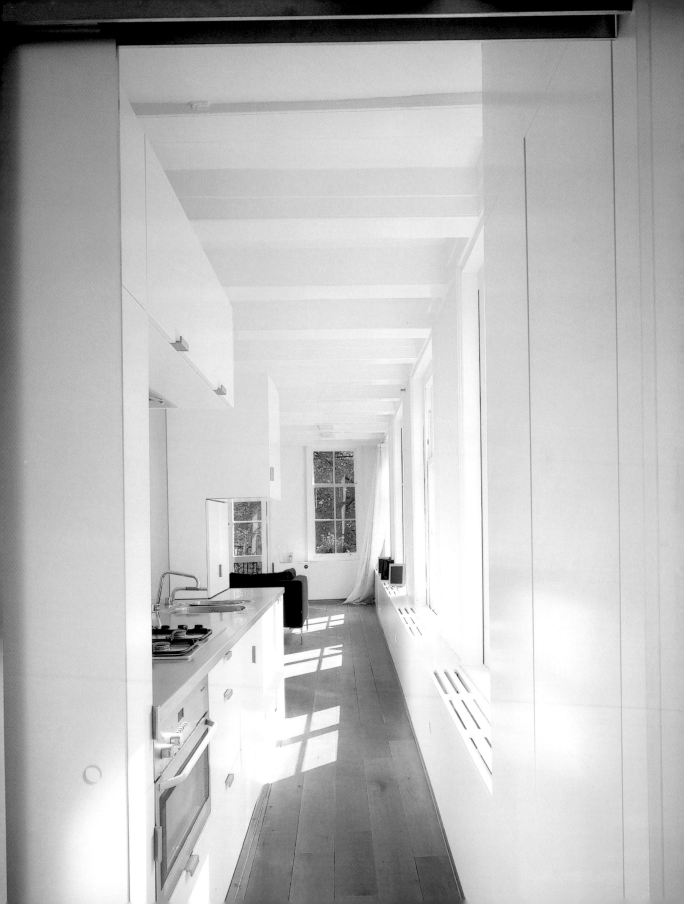

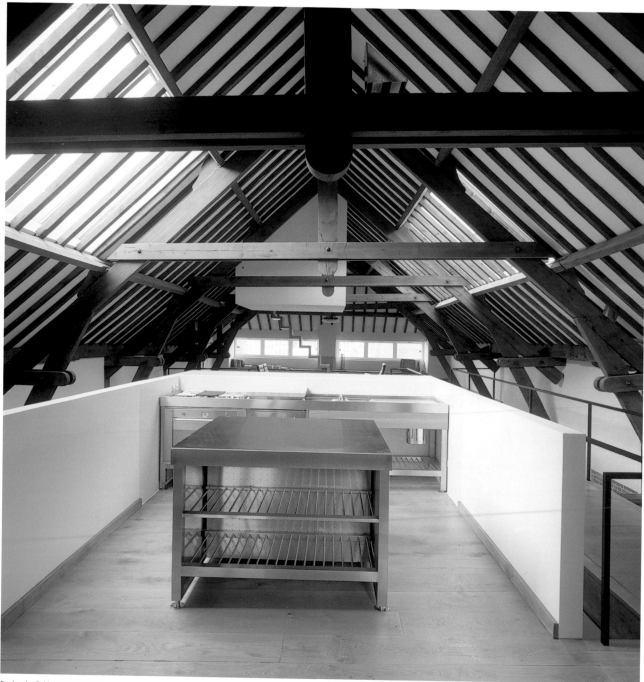

Design by Fokkema Architekten
Photo © Christian Richters

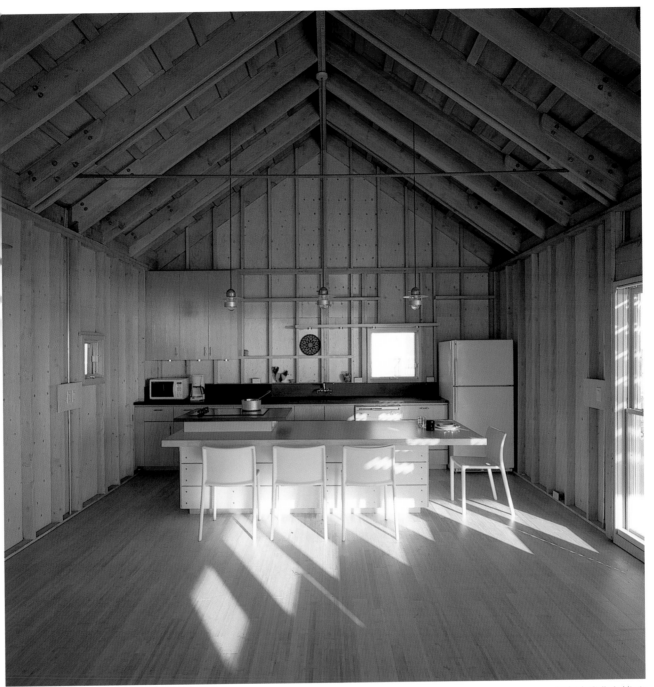

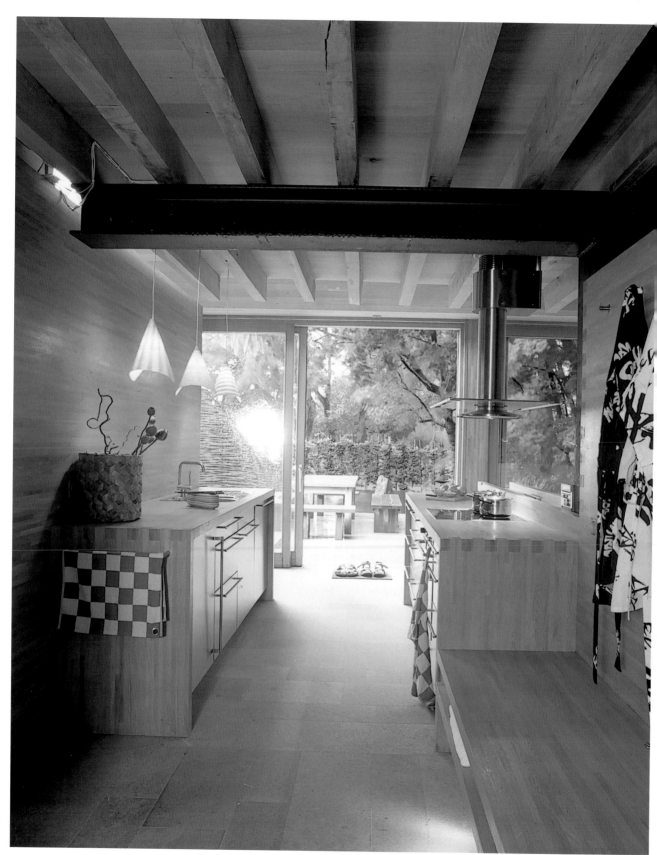

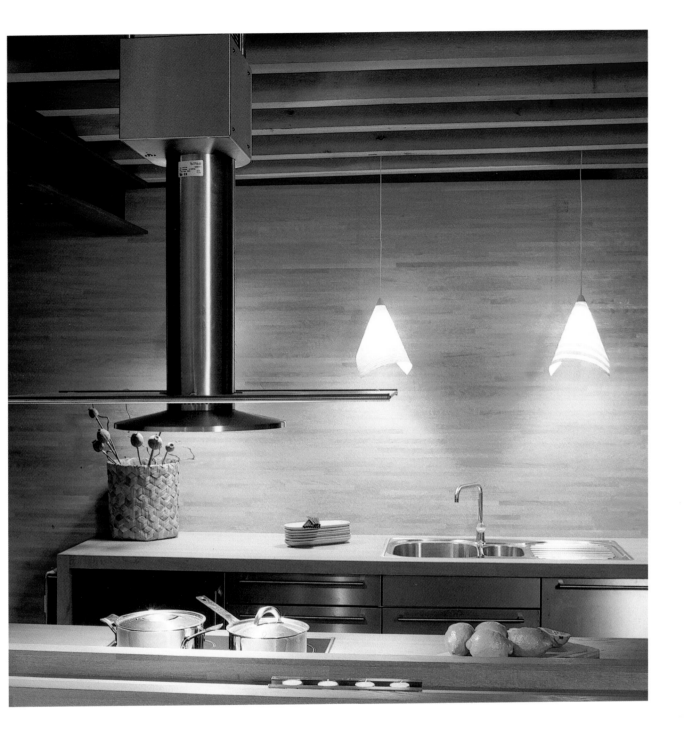

Both pages
Design by Wingardh Arkitektkontor
Photo © James Silverman

433

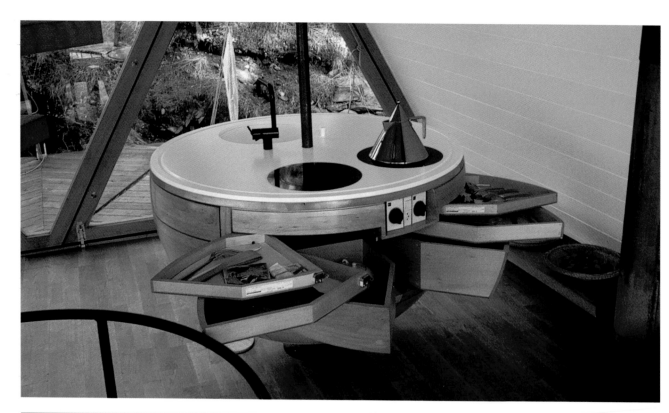

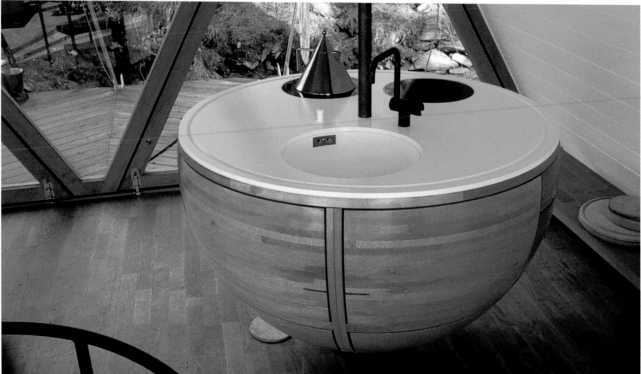

Both photos
Design by Heidi & Peter Wenger
Photo © Peter Wenger

Design by Stephen Atkinson
Photo © Chipper Hatter

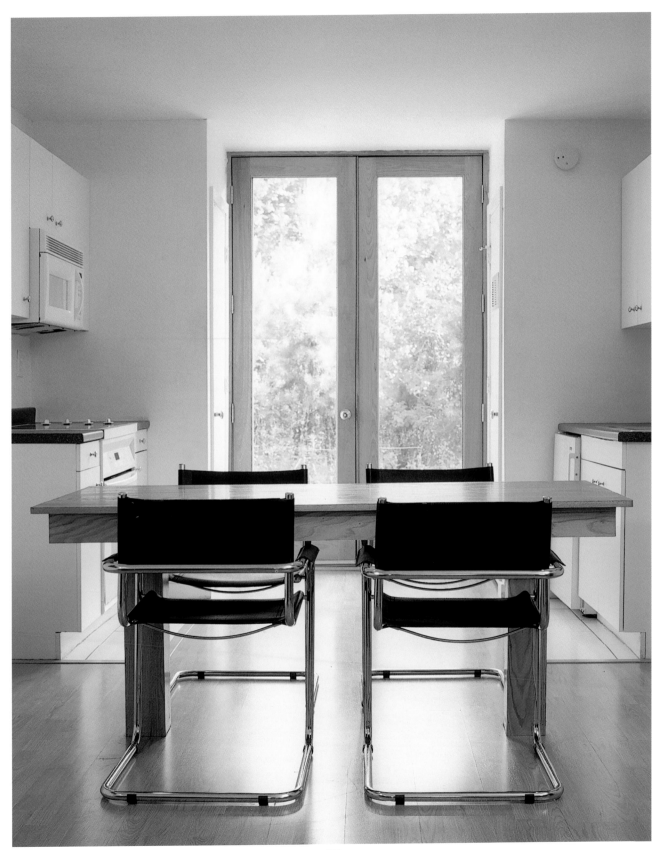

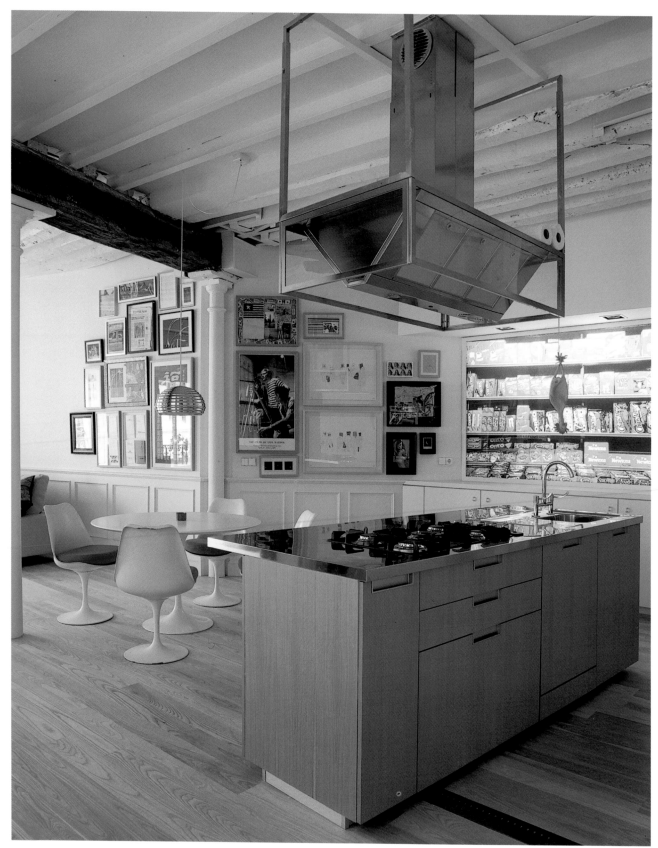

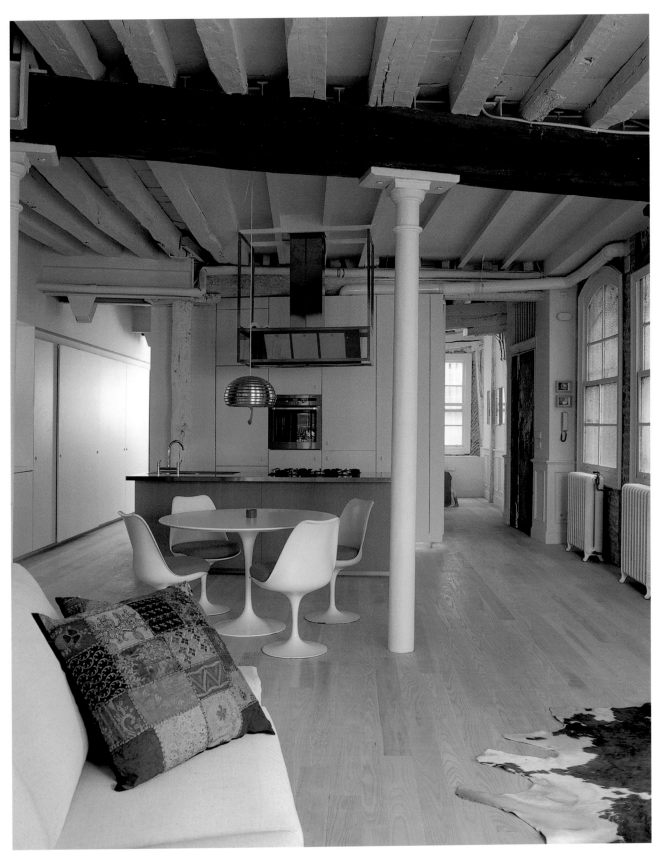

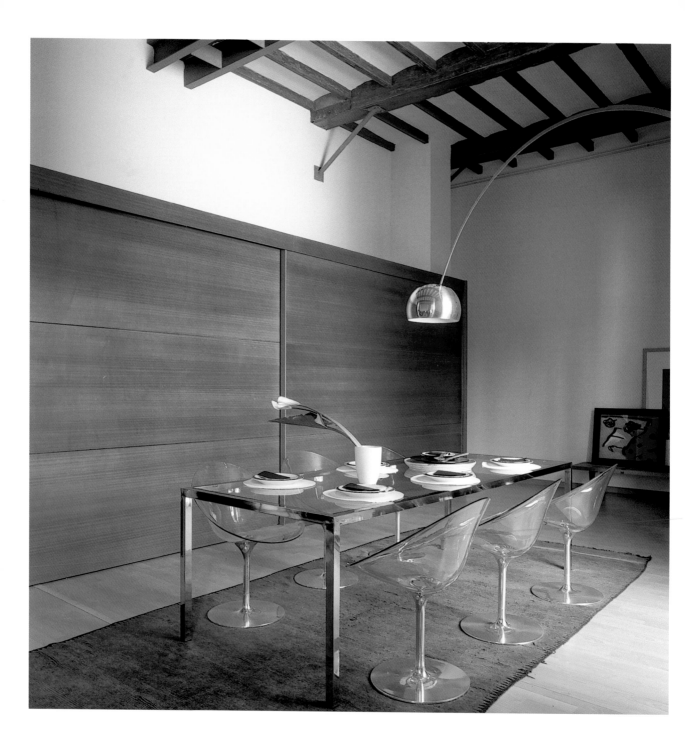

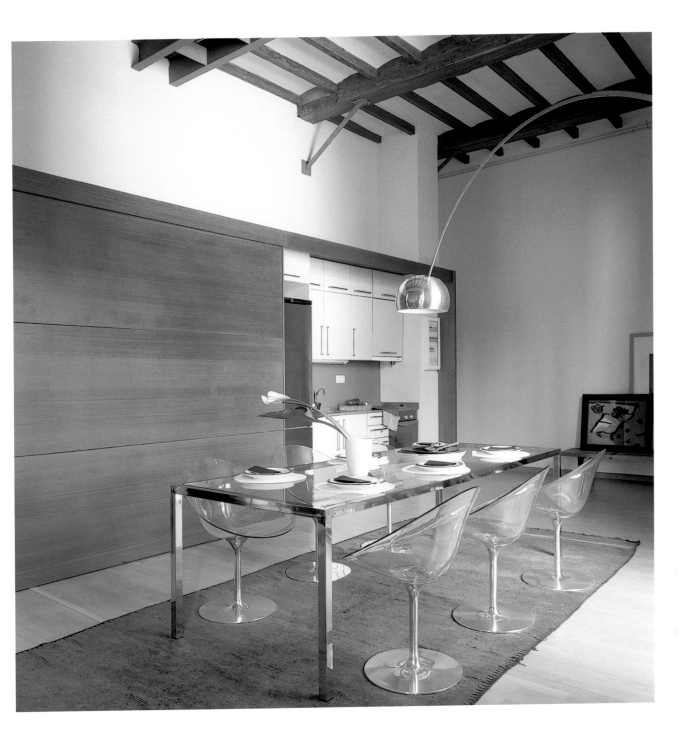

Both pages
Design by Bárbara Salas
Photo © Montse Garriga

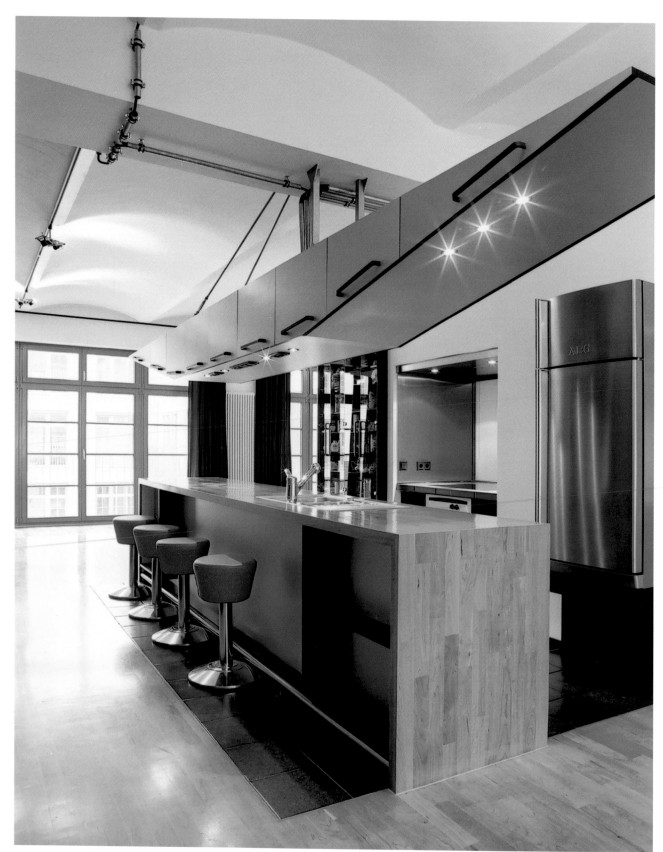

Design by Peanutz Architects
Photo © Thomas Bruns

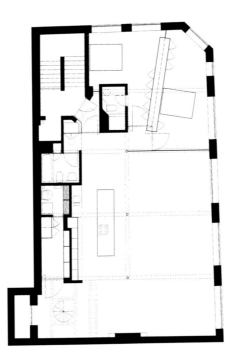

Design by AEM
Photo © Alan Williams

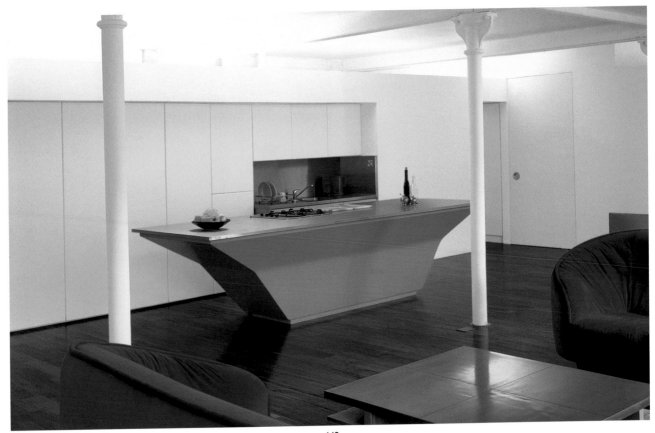

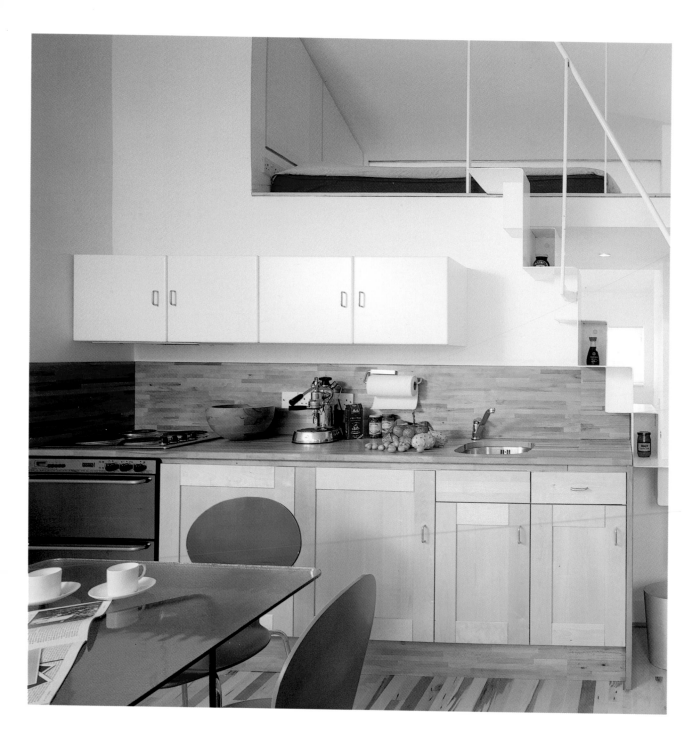

Both pages
Design by AEM
Photo © Alan Williams

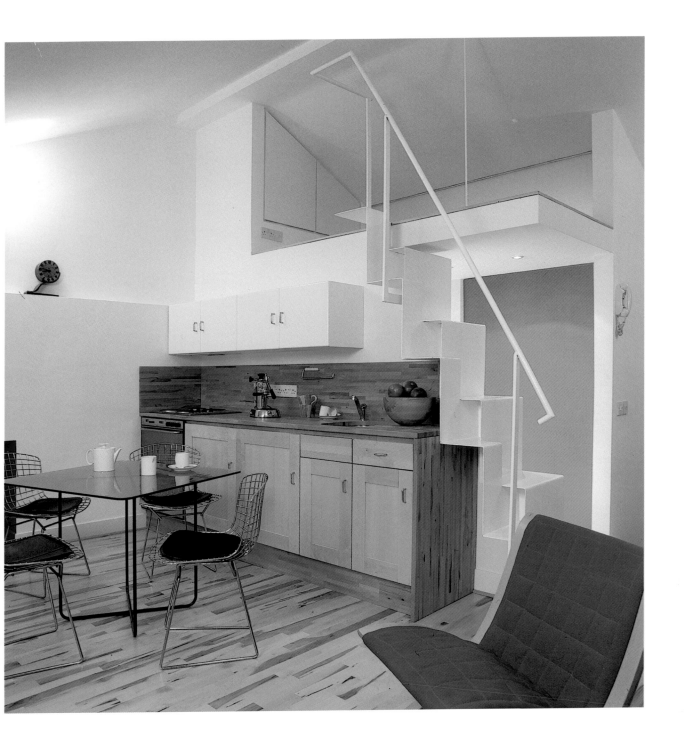

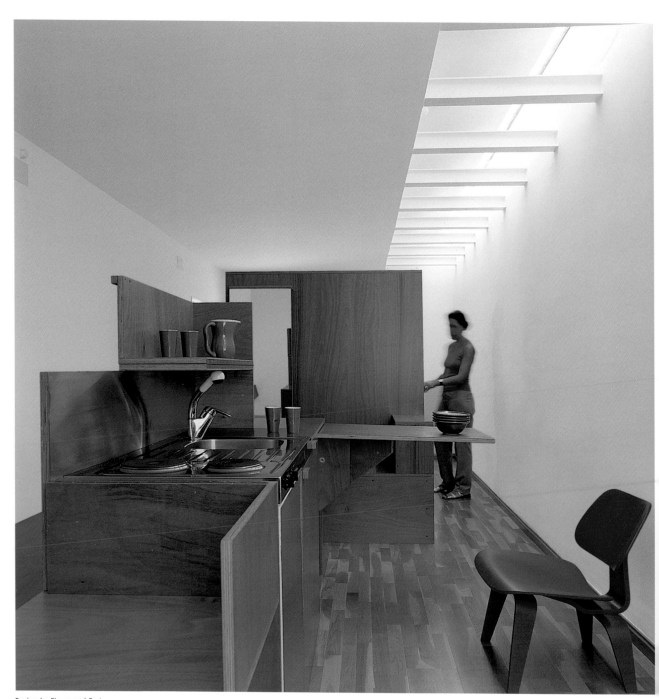

Design by Flores and Prats
Photo © Eugeni Pons

Design by White Architects/AB White Design
Photo © Bert Leandersonn

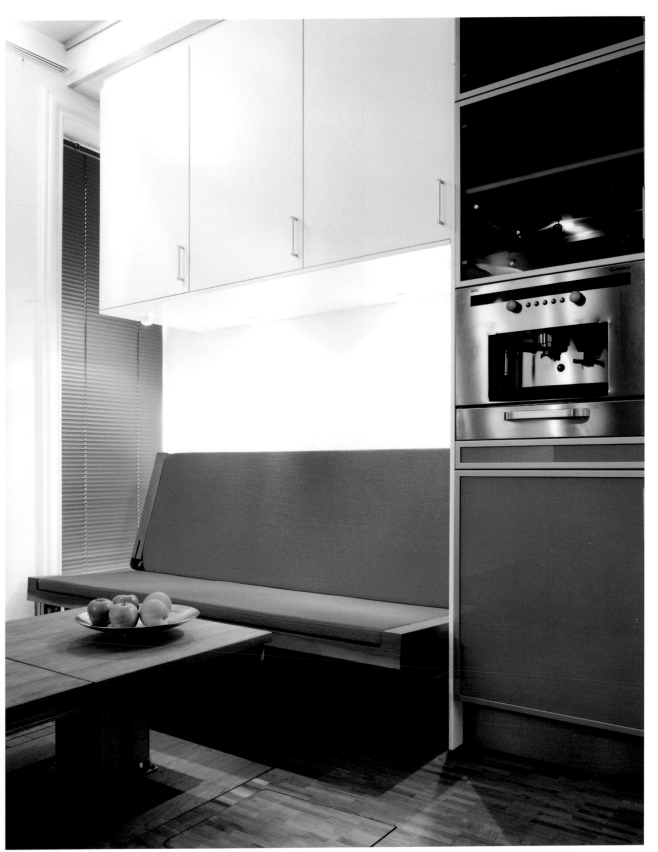

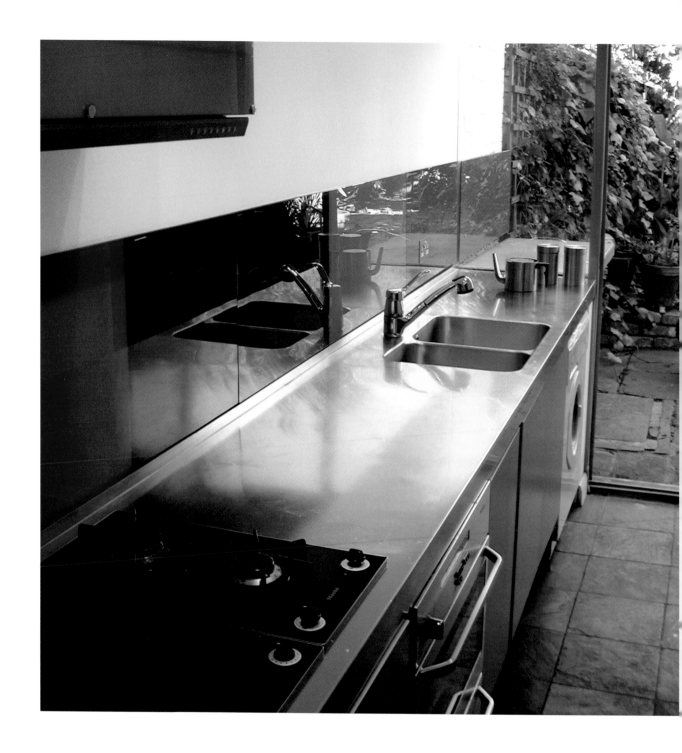

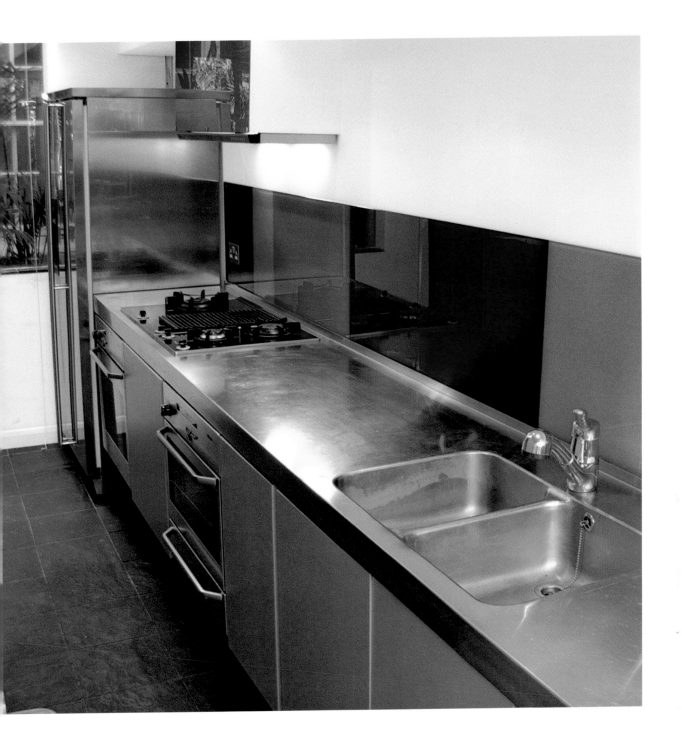

Natural light

Both pages
Design by Eichinger oder Knecht
Photo © Margherita Spiluttini

Kitchen cabinets should be carefully placed to make the most of any windows, which will provide natural ventilation and improve lighting conditions.

Bei der Einrichtung der Küche sollten die Fensteröffnungen mit einbezogen werden, um eine gute Durchlüftung zu erreichen und das Tageslicht zu nutzen.

Dans l'emplacement des meubles de cuisine, il convient de tirer parti de la disposition des fenêtres pour favoriser la ventilation naturelle et obtenir un meilleur éclairage.

En la ubicación de los muebles de la cocina la disposición de las ventanas se aprovecha para favorecer la ventilación natural y lograr una mejor iluminación.

Quando si pensa all'ubicazione dei mobili della cucina, bisogna saper sfruttare la disposizione delle finestre per agevolare una ventilazione naturale ed ottenere una buona illuminazione.

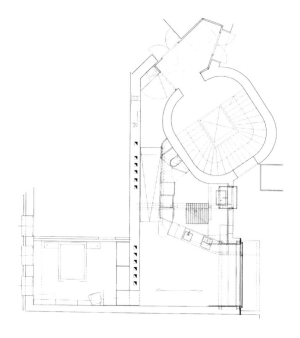

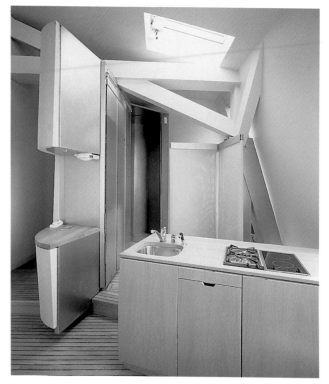

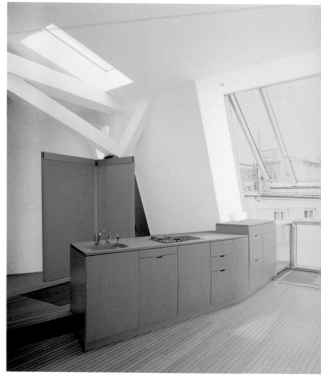

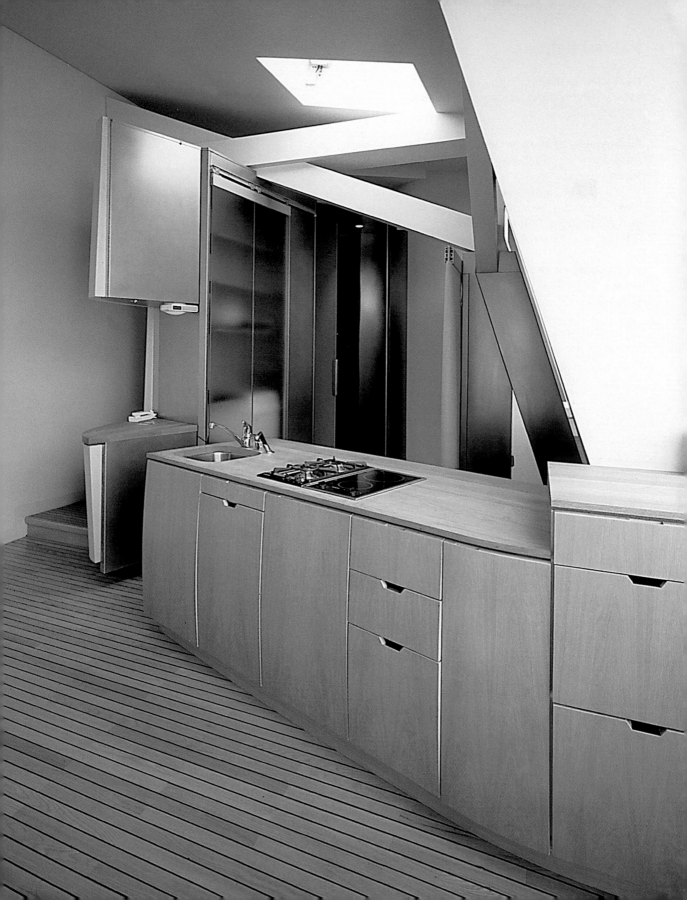

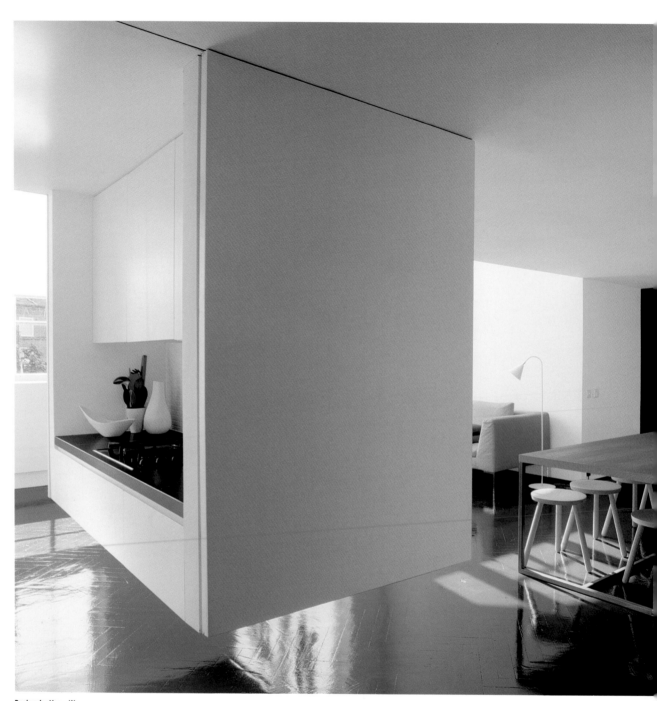

Design by Voon Wong
Photo © Henry Wilson

Design by Detail Architects
Photo © Jonathan Moore

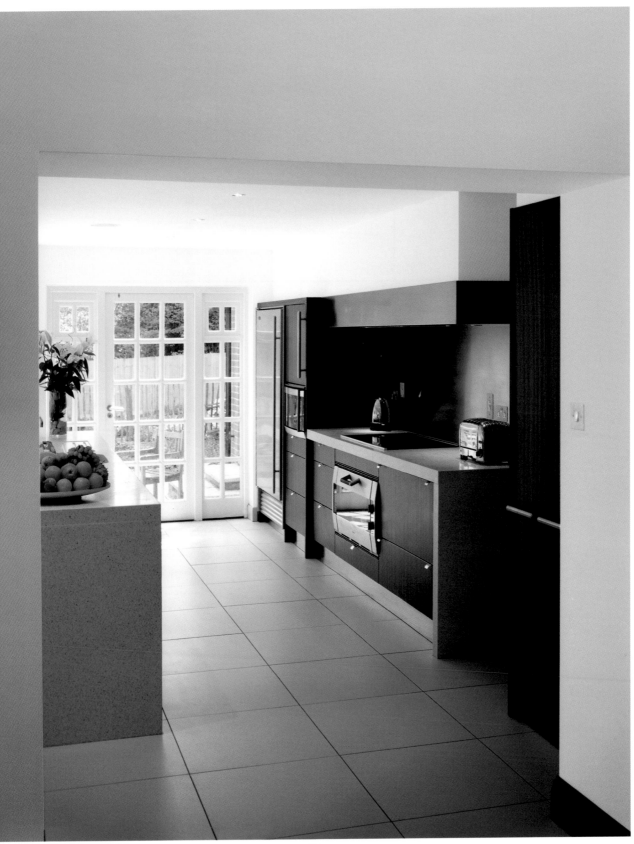

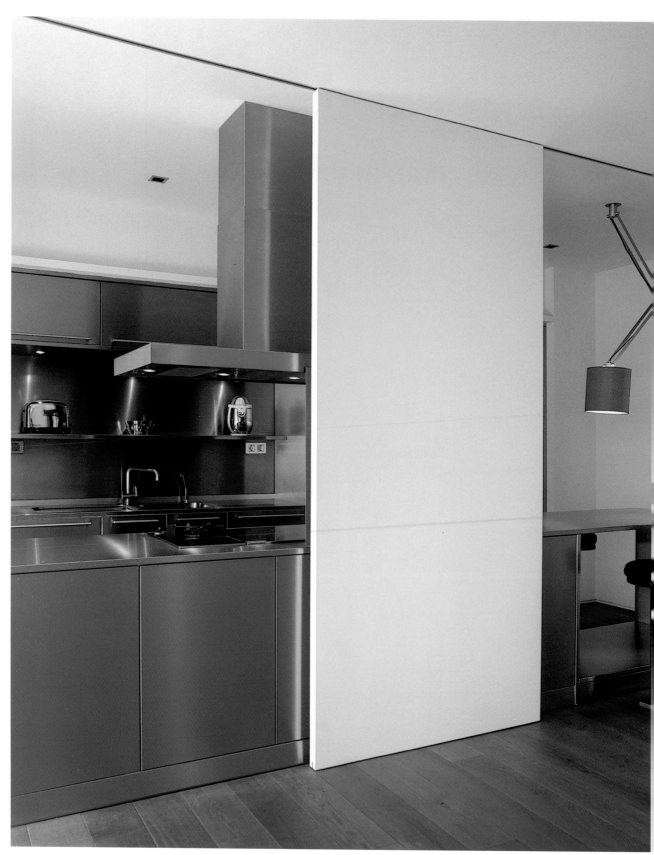

Design by Josep M. Font, Greek
Photo © Nuria Fuentes

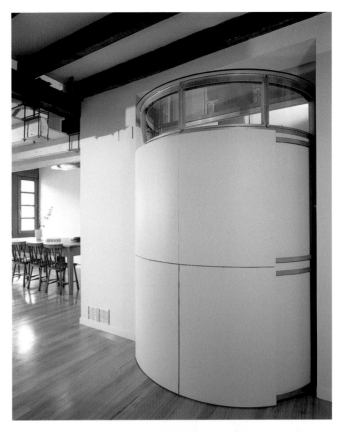

Both photos
Design by Miguel Usabiaga
Photo © José Manuel Bielsa

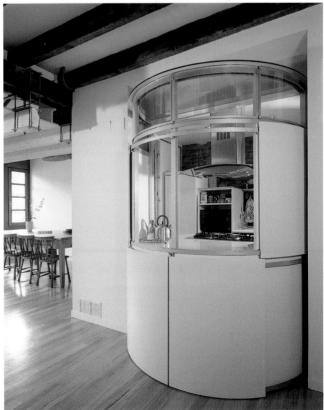

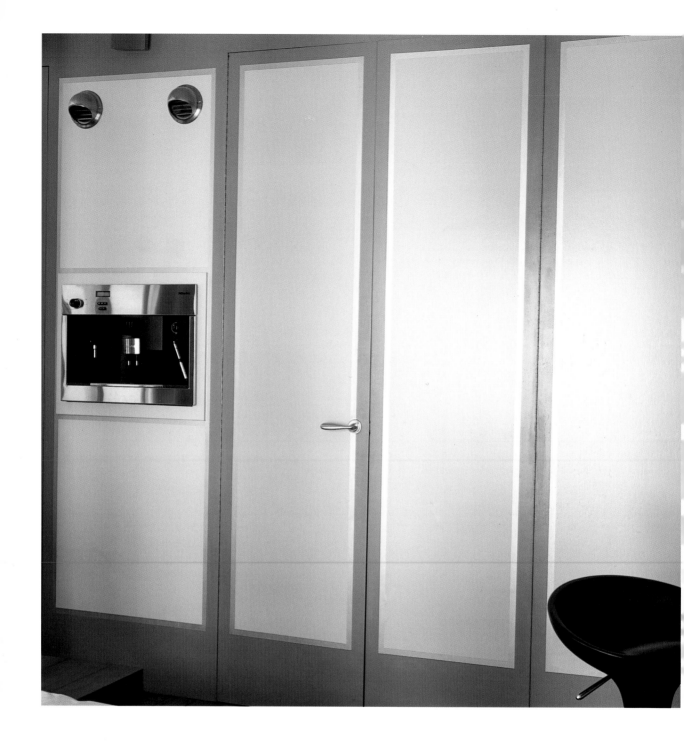

Both pages
Design by Peter Tyberghien
Photo © Alejandro Bahamón

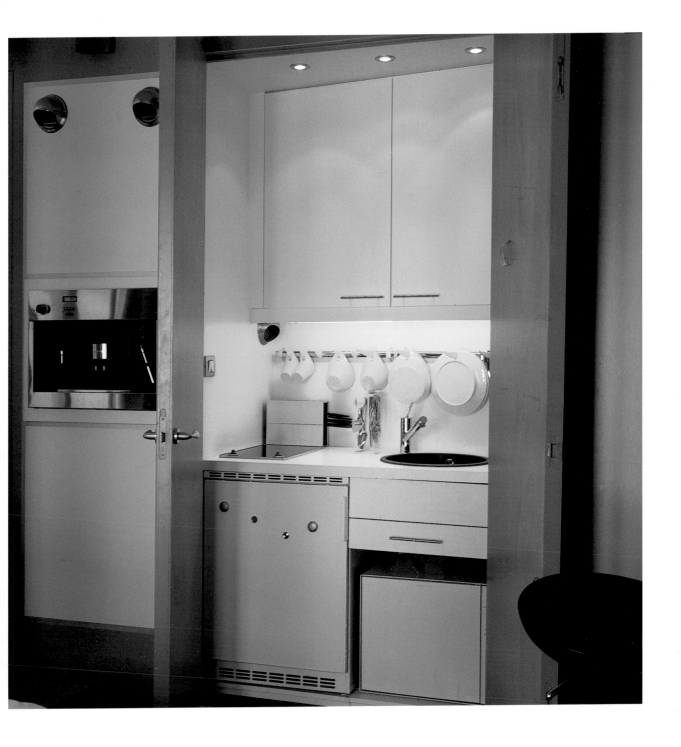

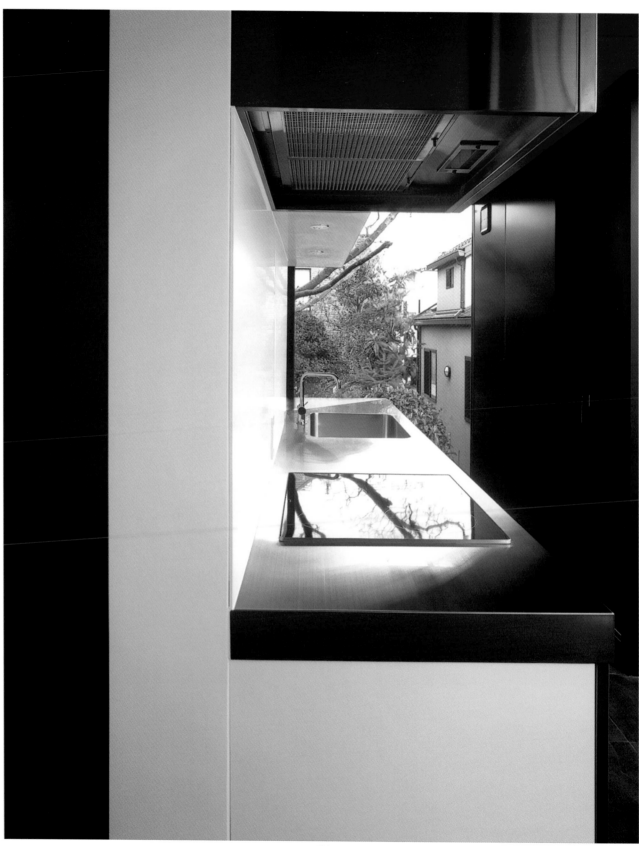

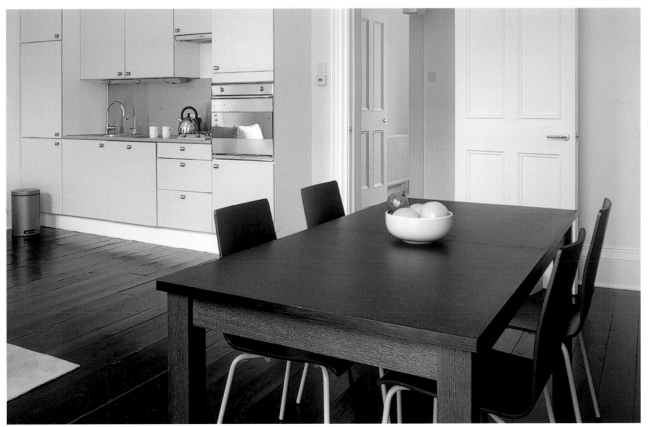

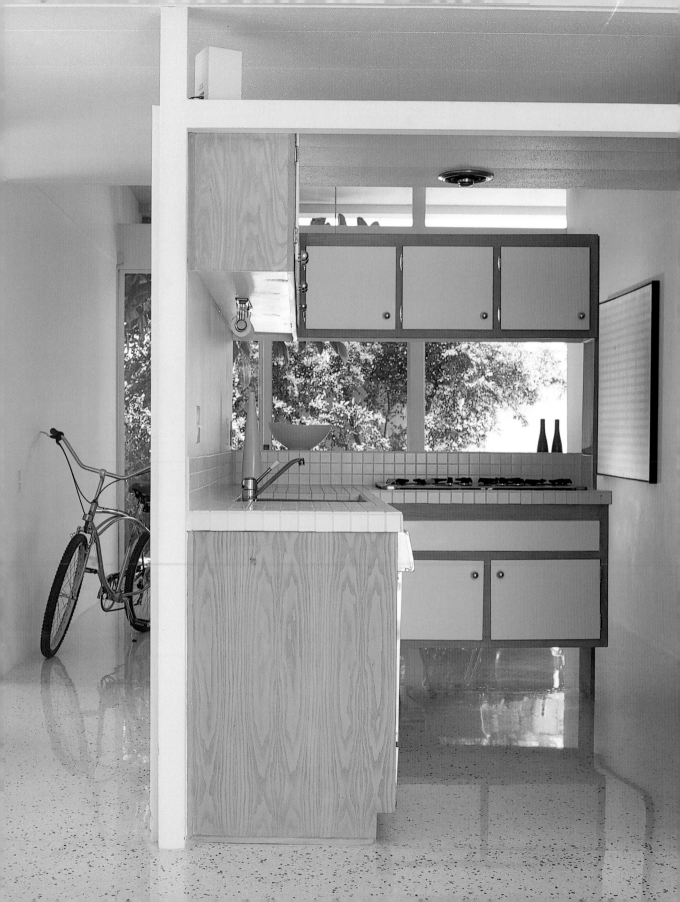

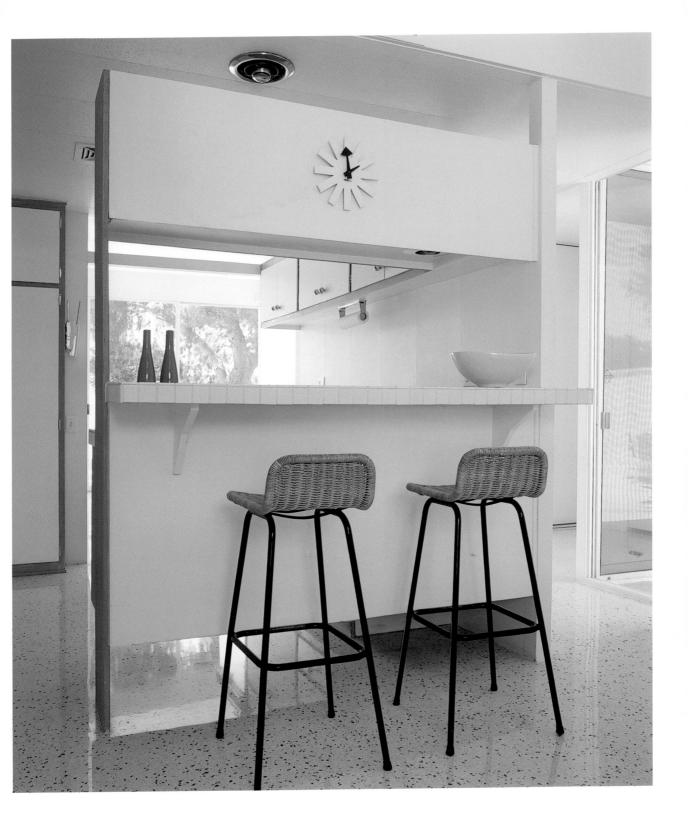

Both pages
Design by Donald Wexler
Photo © Undine Pröhl

Light colors

Design by Daniele Claudio Taddei
Photo © Bruno Helbling/Zapaimages

White and pale colors are the most suitable for small kitchens, since they blend into the surroundings and help to convey a sense of space and definition.

Weiß und andere helle Farbtöne bieten sich in kleinen Küchen besonders an, weil sie sich sehr gut in den vorhandenen Raum einfügen und den Eindruck von Weite und Aufgeräumtheit vermitteln.

Le blanc et les couleurs claires sont la meilleure solution pour les petites cuisines, car elles s'intègrent très bien à l'espace et transmettent une sensation de largesse et de clarté.

El blanco y los colores claros son la mejor alternativa para las cocinas pequeñas, ya que se integran muy bien en el espacio y transmiten sensación de amplitud y limpieza.

Il bianco e i colori chiari sono la migliore alternativa nelle cucine di piccole dimensioni visto che si integrano perfettamente allo spazio, trasmettendo inoltre una sensazione di ordine e di ampiezza.

Design by M. García, A. Baeza
Photo © Jose Luis Hausmann

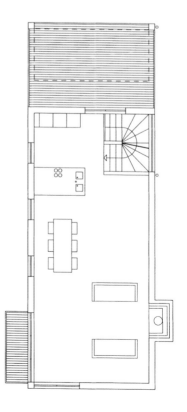

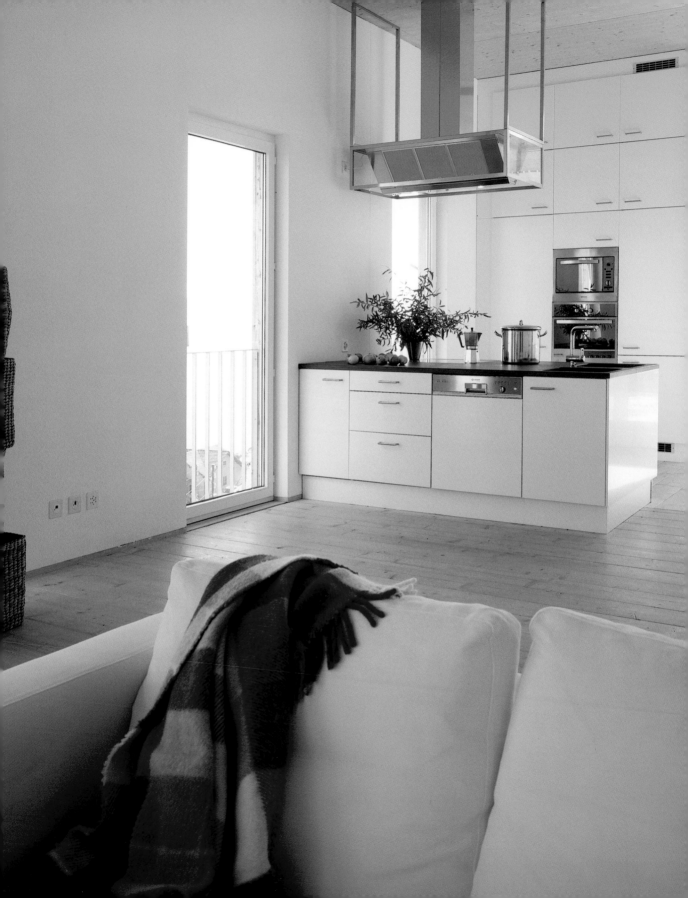

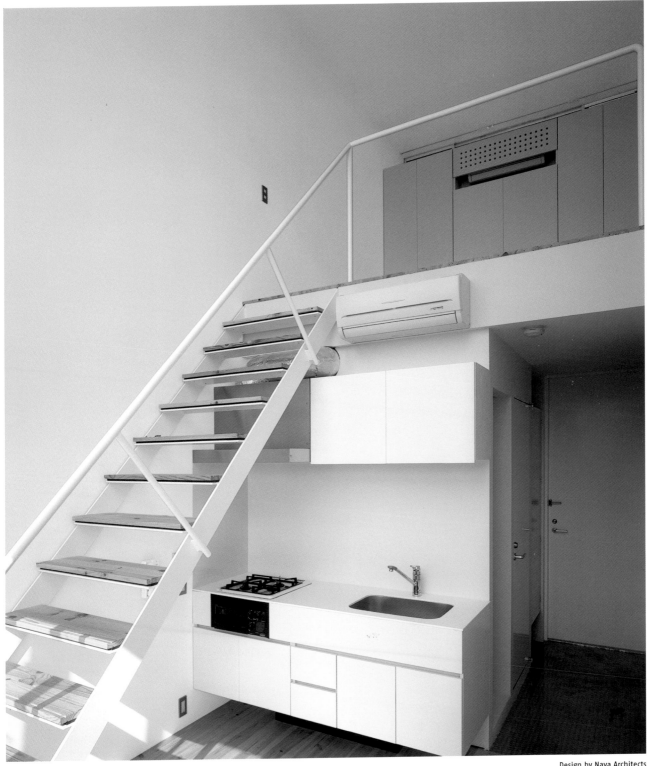

Design by Naya Architects
Photo © Nacása & Partners

Design by Pablo Uribe
Photo © Pep Escoda

465

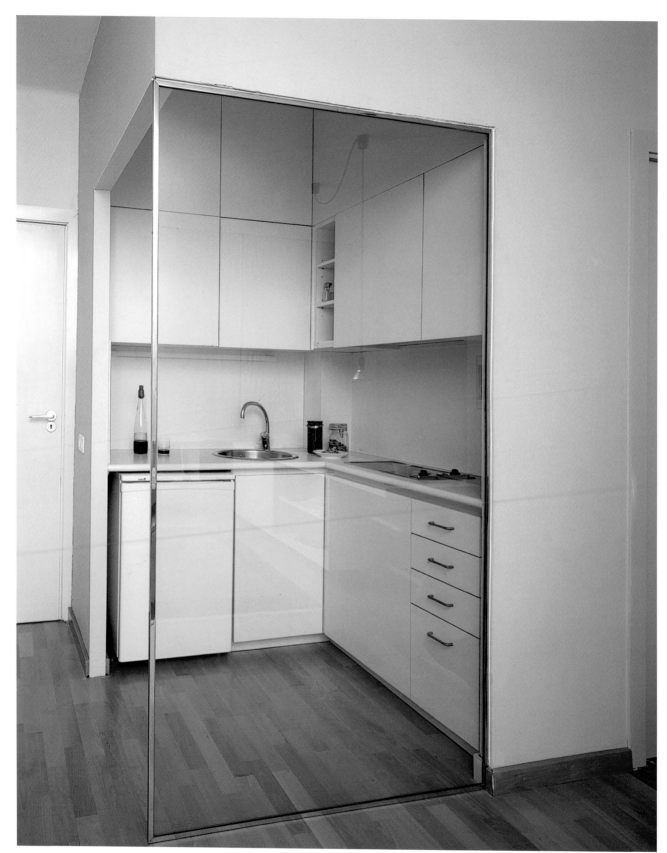

Both pages
Design by Sandra Aparicio, Ignacio Forteza
Photo © Eugeni Pons

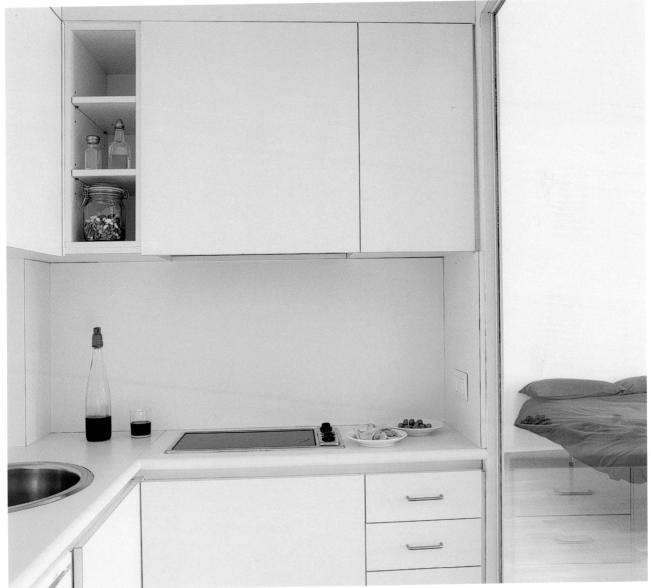

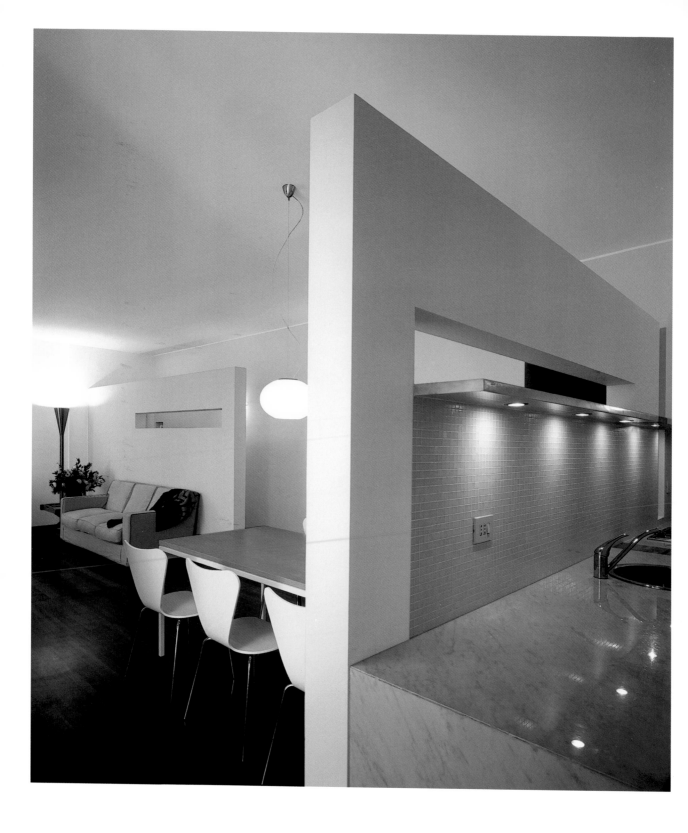

Both pages
Design by Luca Rolla
Photo © Andrea Martiradonna

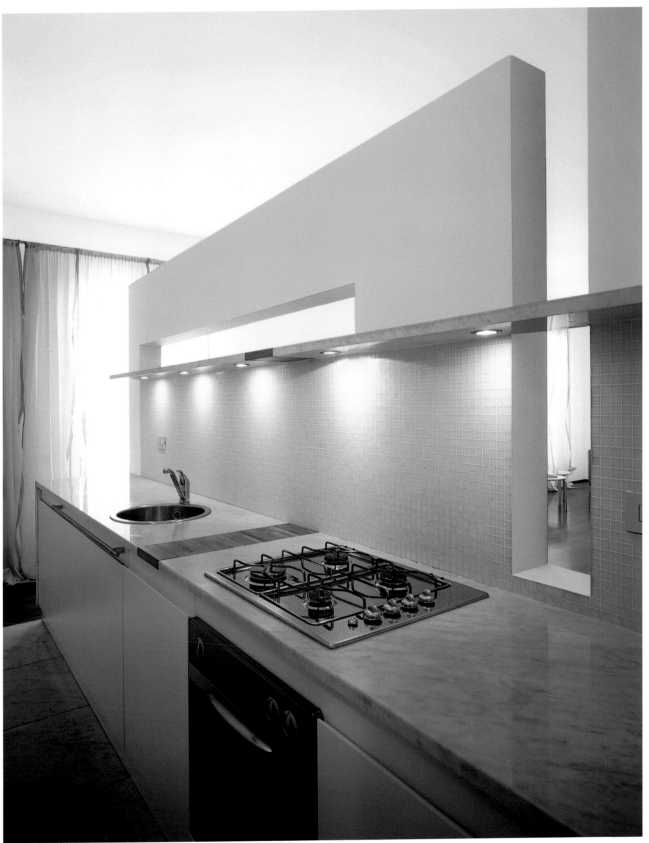

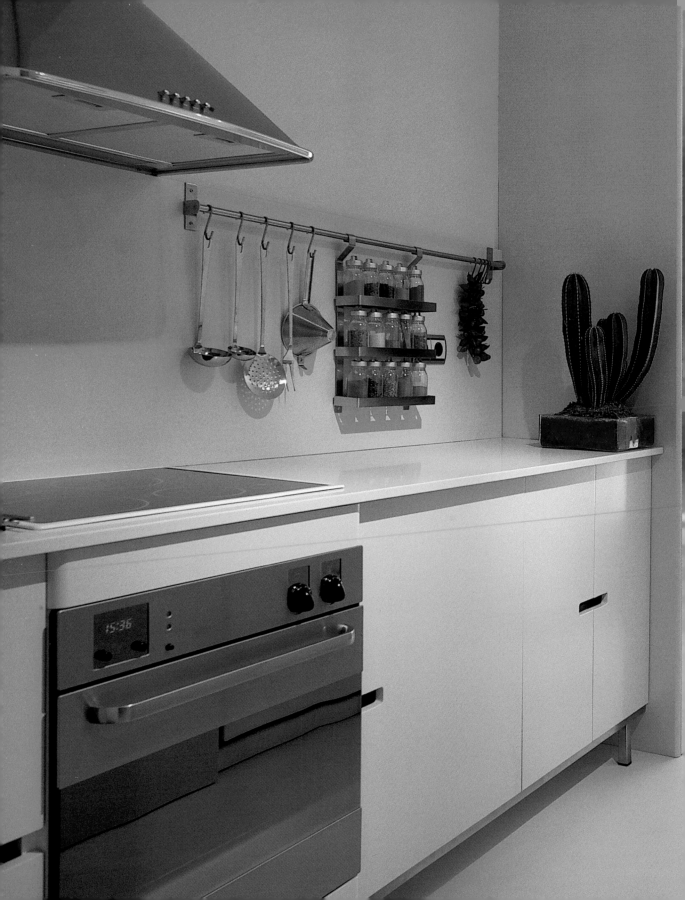

Design by Joan Estrada
Photo © Nuria Fuentes

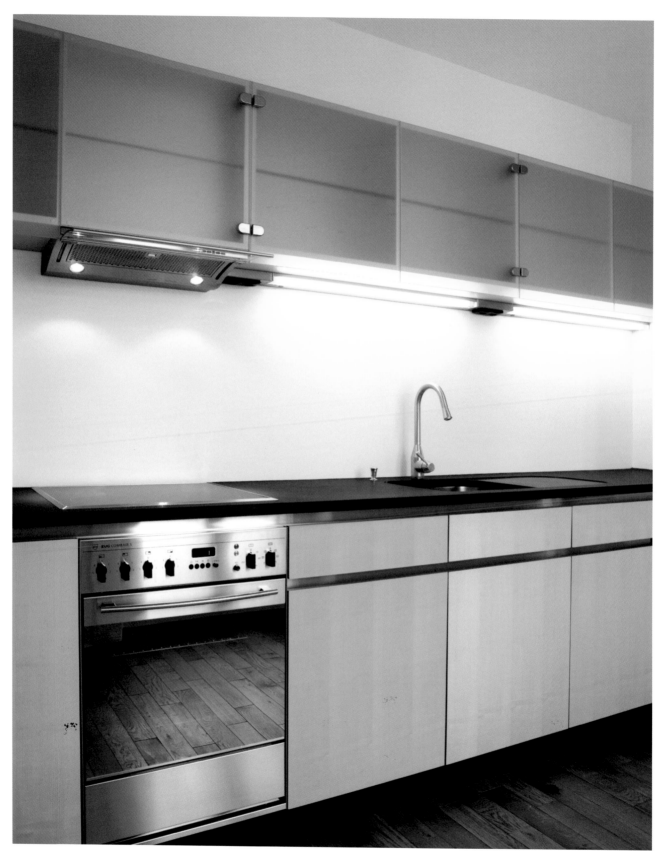

Design by Concept Consult Architects
Photo © Pierre Boss

Design by J. Sanahuela, E. Cubillos, J. M. Medrano
Photo © Joan Roig

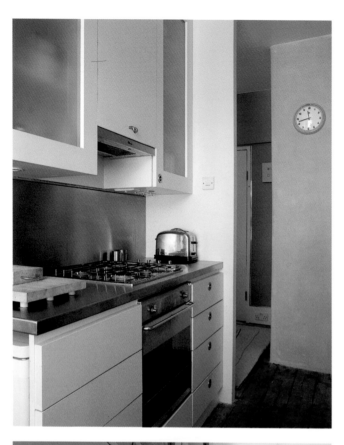

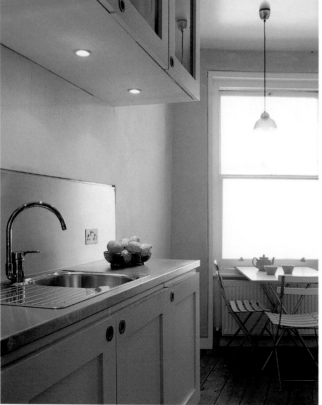

Both photos
Design by Elise Ovanessot/ Stephen Quinn
Photo © Jordi Miralles

Design by Rafael Berkowitz/RB Architect
Photo © James Wilkins

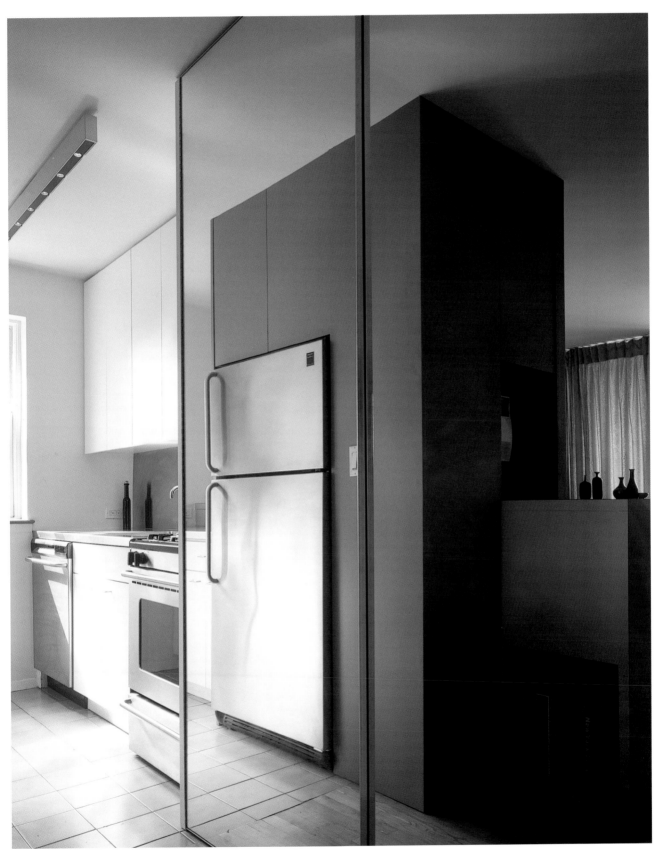

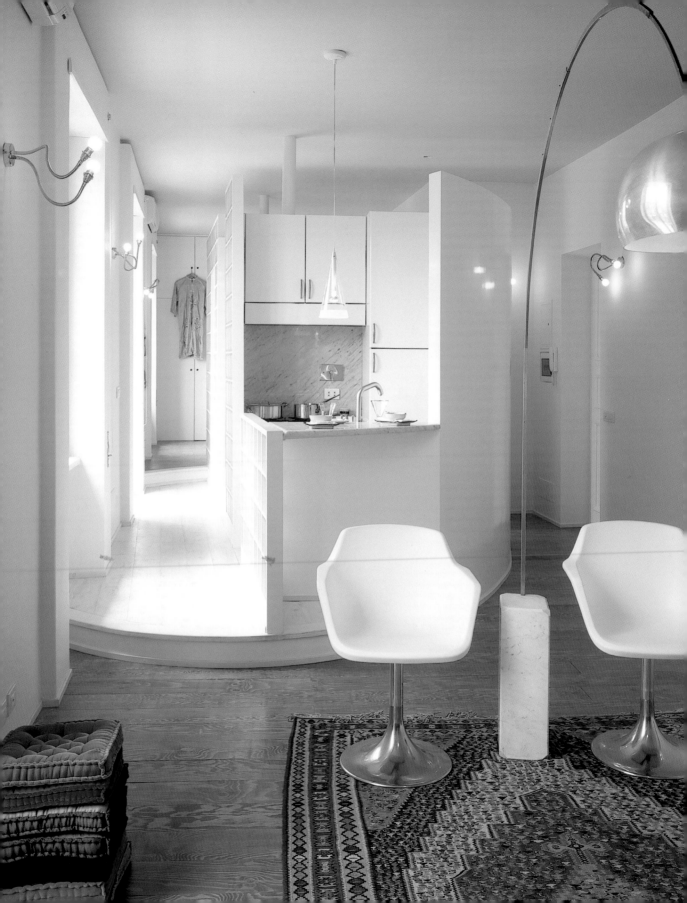

Both pages
Design by Massimo d'Alessandro & Associati
Photo © Andrea Martiradonna

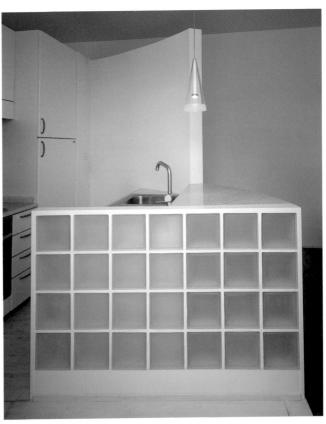

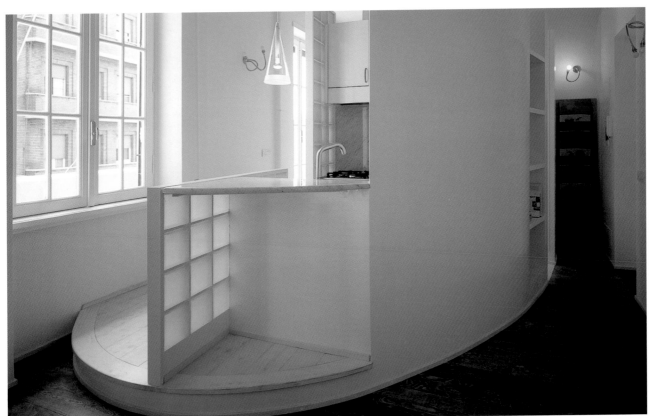

Industrial >>>>>>

Professional restaurant kitchens, which have recently become a prominent feature in restaurant design, have inspired a trend for industrial kitchens in private homes. Chiefly designed for professionals, they appeal to gourmets and culinary enthusiasts for their functional and aesthetic qualities.

Functionality is the buzz word in an industrial kitchen, where utensils are arranged in full view and all appliances are of the highest quality. Generally speaking, these are kitchens taking up a great deal of space subdivided into different areas with work surfaces for several people. There is no attempt to disguise any of the functions, facilities or service points, and floor-to-ceiling cabinets and abundant lighting assist every work station. Movable modules are also frequently used, chiefly to re-arrange space configurations as the need may arise.

Stainless steel is the most widely used material for industrial kitchen fittings. It is resistant, flexible and easy to clean, as well as easy to produce. Likewise, stainless steel electrical appliances are installed, thus creating aesthetic continuity. The ideal material for creating a warm ambience is wood, used either on embellishing finishes or as a worktop.

Professional kitchens, which have recently become a prominent feature in restaurant design, have inspired a trend for industrial kitchens in private homes.

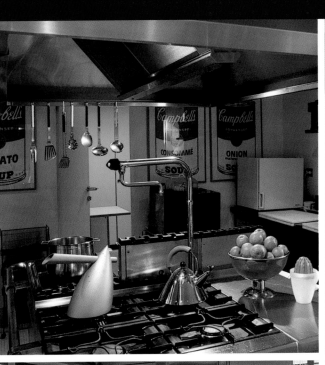

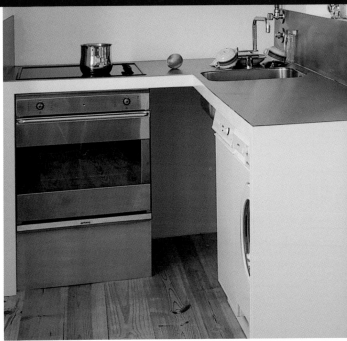

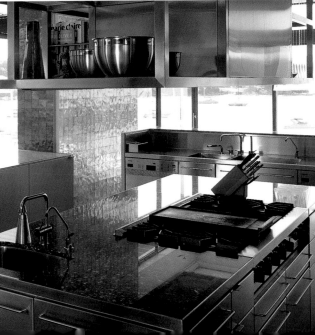

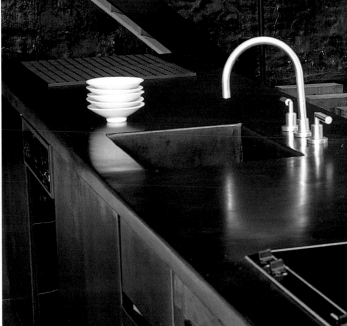

Industriell

In letzter Zeit sind professionelle Restaurantküchen ins Zentrum der Aufmerksamkeit gerückt und spielen eine wichtige Rolle bei der Einrichtung der Lokale.

Sie dienen als Anregung für die Gestaltung von Küchen mit industriellem Charakter in Privathäusern. Auch wenn diese Art Küche eigentlich für Profis konstruiert wurde, so wissen auch Hobbyköche eine funktionale und ästhetische Küche zu schätzen.

In der industriellen Großküche dominiert die Funktionalität. Alle Gerätschaften sind griffbereit in Sichtweite angeordnet und die Elektrogeräte gehören zur gehobenen Kategorie. Die Küchen sind großzügig angelegt und in verschiedene Arbeitsbereiche untergliedert. Die Arbeitsflächen bieten Platz für mehrere Personen. Die Installationen und Versorgungsleitungen sind in der Regel sichtbar verlegt. Geräumige Oberschränke und eine ausreichende Anzahl von Lichtquellen verbessern zusätzlich die Arbeitsbedingungen. Häufig findet man bewegliche Module, mit denen die Arbeitsbereiche nach Bedarf umgestaltet werden können.

Edelstahl ist das am häufigsten eingesetzte Material in dieser Art Küche, und zwar sowohl wegen der hervorragenden Verarbeitungseigenschaften in der Herstellung, aber auch weil es im Gebrauch flexibel einsetzbar, robust und leicht zu reinigen ist. Auch die elektrischen Geräte sind meist aus Edelstahl, sodass eine einheitliche Gesamtästhetik entsteht. Holz, entweder in einzelnen Elementen oder als Arbeitsfläche, eignet sich ideal, um der technisch-kühlen Atmosphäre einen wärmeren Touch zu verleihen.

Both pages
Design by Bone/Levine Architects
Photo © Jacek Kucy

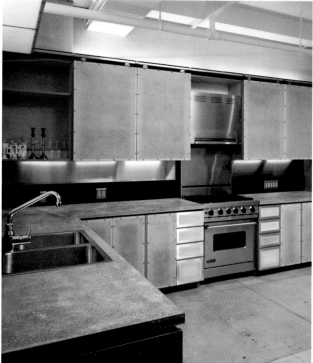

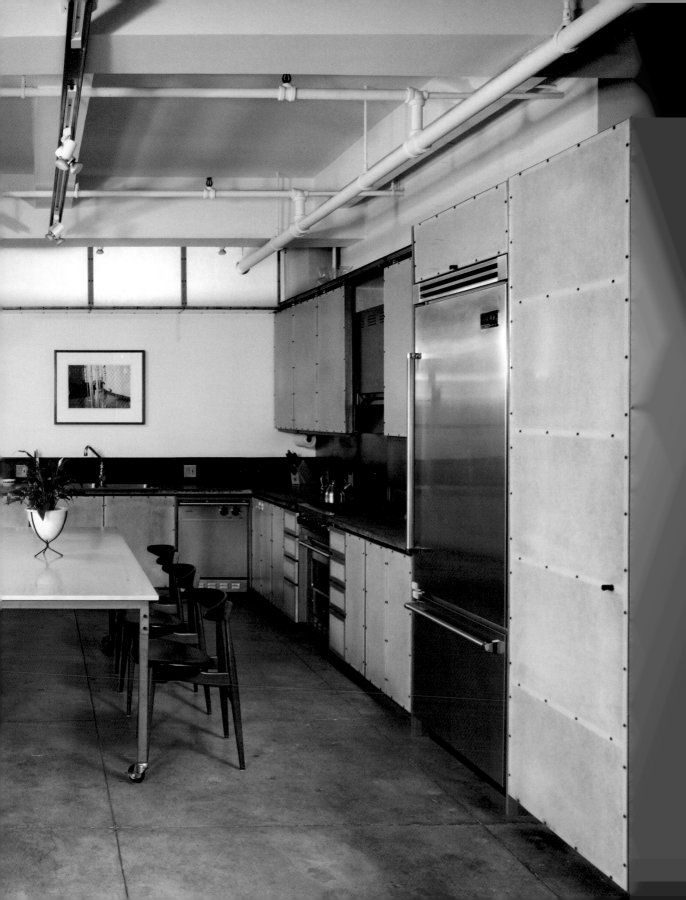

Industrielles

Les cuisines professionnelles des restaurants, occupent, depuis quelques temps, le devant de la scène dans le design des établissements, et sont la source d'inspiration des cuisines industrielles conçues pour les habitations. Et même si elles s'adressent en premier lieu aux professionnels, elles peuvent plaire aussi aux amateurs, pour leur aspect fonctionnel et esthétique.

Dans les cuisines industrielles, c'est la fonctionnalité qui prime. Les ustensiles sont visibles, les appareils et les électroménagers sont hauts de gamme. En général, ces cuisines occupent des espaces très amples et sont subdivisées en zones possédant une surface de travail suffisante pour accueillir plusieurs personnes. Il n'est pas très important que les installations et les sources d'alimentation soient visibles. Les placards en hauteur et les abondantes sources de lumière servent à améliorer les zones de travail. Les modules amovibles en sont aussi une caractéristique récurrente et servent à configurer l'espace de différentes manières au gré des besoins.

L'acier inoxydable est la matière la plus utilisée pour le mobilier de ce type de cuisine, tant pour sa résistance, flexibilité et facilité d'entretien que pour sa simplicité de manipulation en phase de production. Les appareils électriques sont en général aussi en acier, offrant ainsi une esthétique uniforme. Le bois, présent dans certains détails ou utilisé parfois pour les plans de travail, est idéal pour donner une touche de chaleur ambiante.

Both pages
Design by Alfons Soldevila
Photo © Jordi Miralles

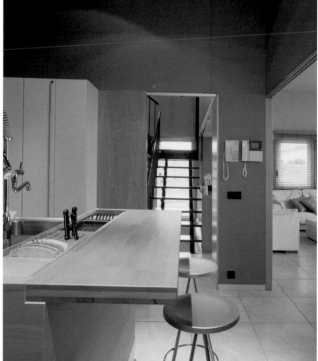

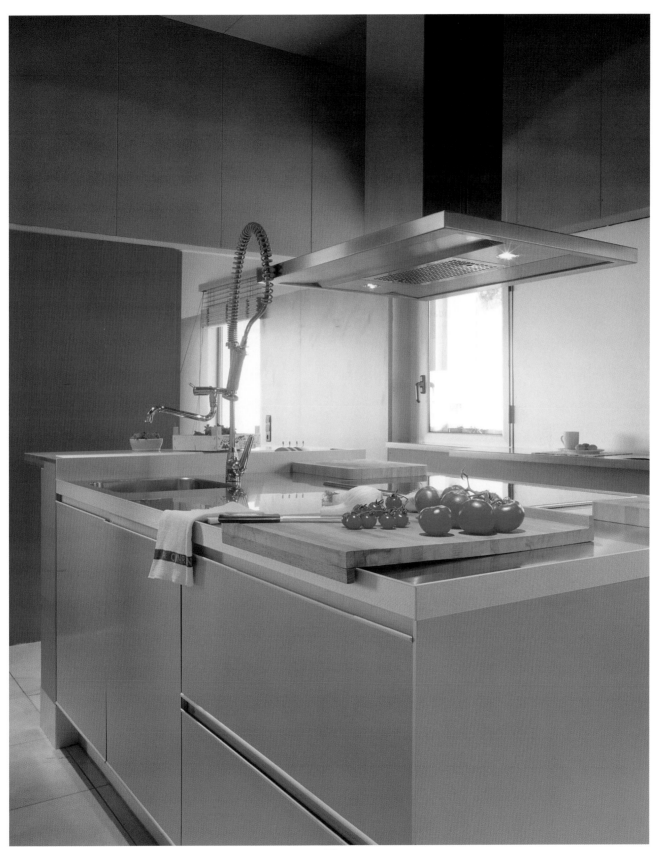

Industriales

Las cocinas profesionales de los restaurantes, que recientemente han tomado gran protagonismo en el diseño de locales, son la fuente en la que se inspiran las cocinas industriales diseñadas para las viviendas que, aunque se dirijan principalmente a los profesionales, pueden resultar atractivas también para los aficionados por su funcionalidad y por su aspecto.

En las cocinas industriales prima la funcionalidad, los utensilios se dejan a la vista y los aparatos y los electrodomésticos suelen ser de gama alta. En general, estas cocinas ocupan espacios muy amplios y están subdivididas en zonas que cuentan con superficies de trabajo suficientes para varias personas; no suele ser habitual que las instalaciones y las fuentes de suministro queden a la vista, y se emplean armarios altos y abundantes puntos de luz para mejorar las condiciones de las zonas de trabajo. Los módulos móviles también son una característica recurrente y sirven para crear diferentes configuraciones del espacio según las necesidades.

El acero inoxidable es el material más utilizado para el mobiliario de este tipo de cocinas, tanto por su resistencia, flexibilidad y facilidad de limpieza como por su sencilla manipulación en fase de producción. Los aparatos eléctricos también suelen ser de acero, de manera que se consigue una estética uniforme. La madera, presente en algunos detalles y utilizada a veces para las encimeras, es ideal para dar un toque cálido al ambiente.

Both pages
Design by Olson Sundberg Kundig Allen Architects
Photo © Undine Pröhl

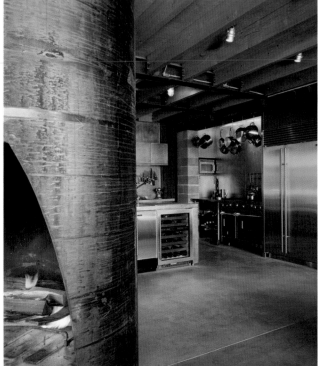

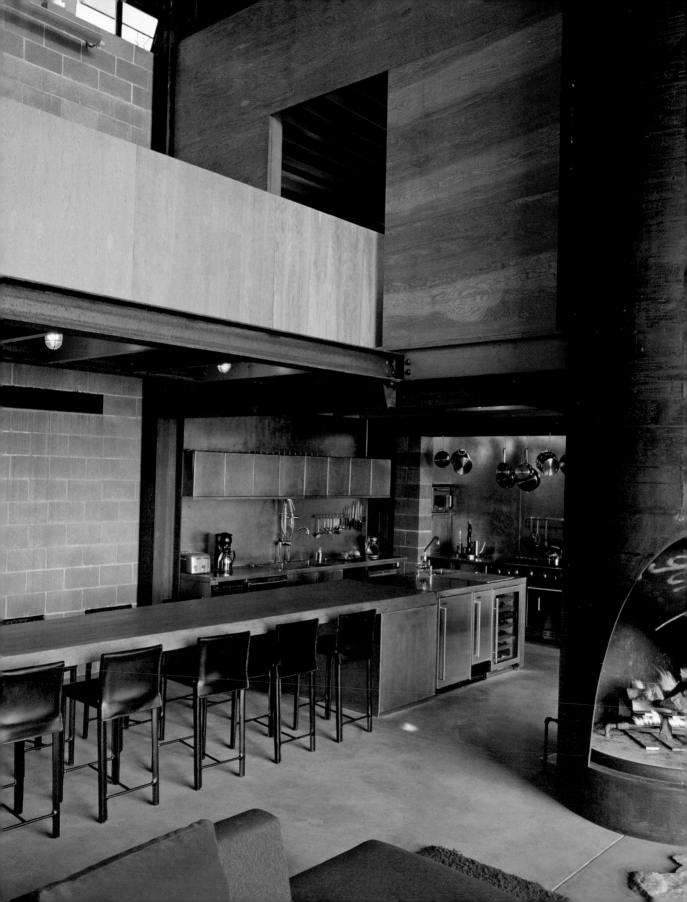

Industriali

Le cucine professionali dei ristoranti, che recentemente hanno assunto un protagonismo maggiore nel disegno dei locali, costituiscono la fonte di ispirazione delle cucine industriali realizzate per abitazioni private. Sebbene si rivolga principalmente ai professionisti, questo tipo di cucine può risultare attraente anche ad un pubblico amatoriale per via del suo aspetto e funzionalità.

Nelle cucine industriali prevale la funzionalità, gli utensili si lasciano a vista e di solito le apparecchiature e gli elettrodomestici sono di gamma alta. In genere, queste cucine occupano spazi molto ampi e sono divise in zone che presentano superfici di lavoro sufficienti per varie persone; poca importanza viene data al fatto che gli impianti e le fonti di alimentazione elettrica rimangano in vista e all'uso di armadi molto alti e abbondanti punti luce, per migliorare le condizioni delle zone di lavoro. Anche i moduli mobili sono una caratteristica ricorrente e servono a creare diverse configurazioni dello spazio a seconda delle varie esigenze.

L'acciaio inossidabile è il materiale più utilizzato per la mobilia di questo tipo di cucine, sia per la sua resistenza, flessibilità e facilità di pulizia sia per la facilità di lavorazione in fase di produzione. Di solito le apparecchiature elettriche sono anch'esse in acciaio, per cui si ottiene un'estetica abbastanza uniforme. Il legno, presente in alcuni particolari o utilizzato a volte per i piani di lavoro, è il materiale ideale per dare un tocco di calore all'ambiente.

Both pages
Design by Hideyuki Yamashita
Photo © Hideyuki Yamashita

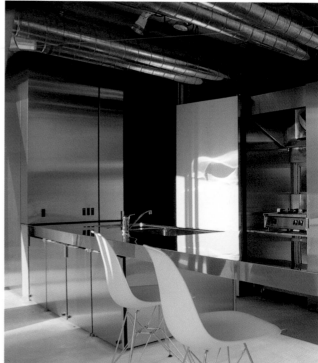

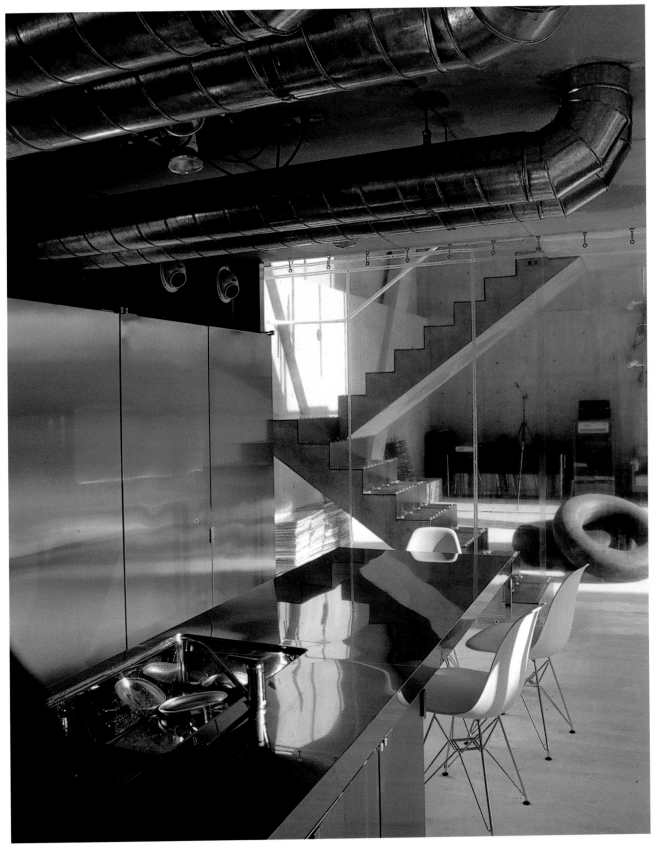

Both pages
Design by Desai/Chia Architecture
Photo © Paul Warchol

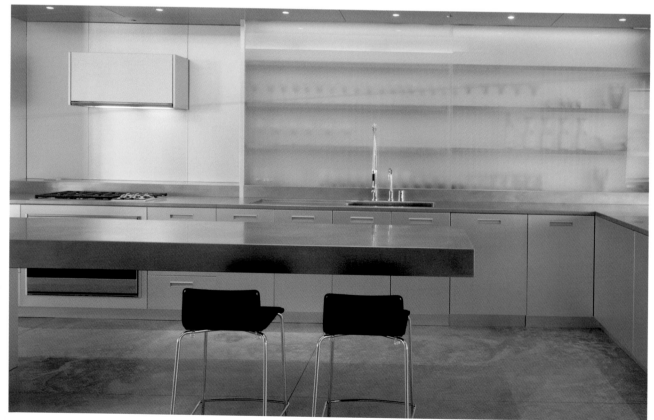

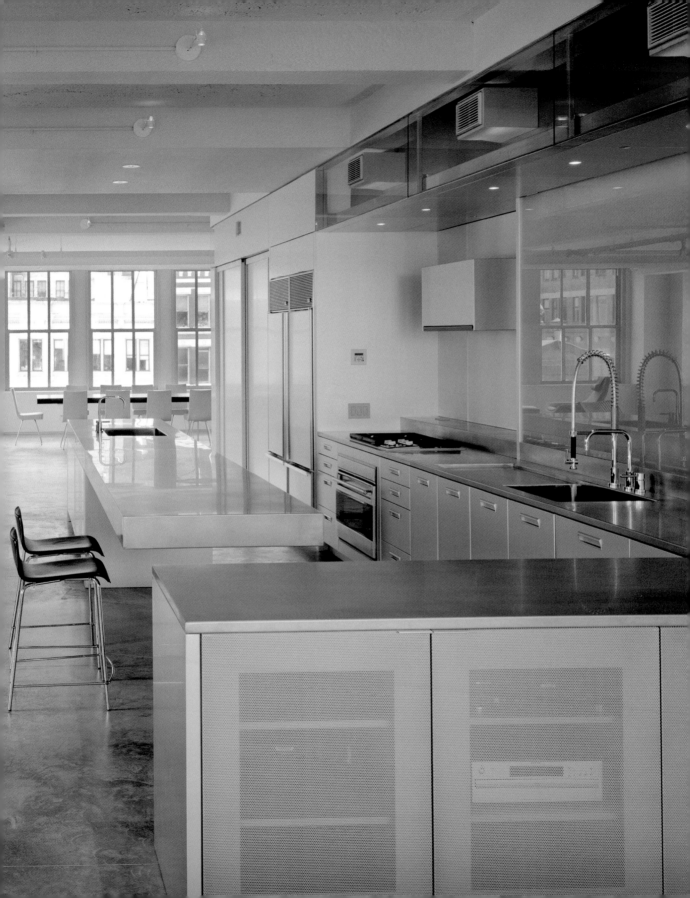

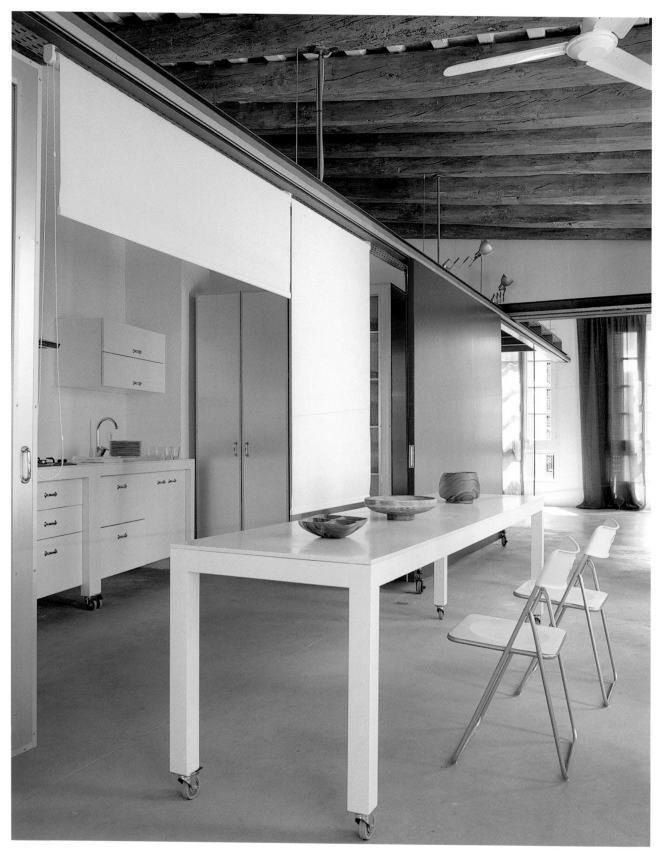

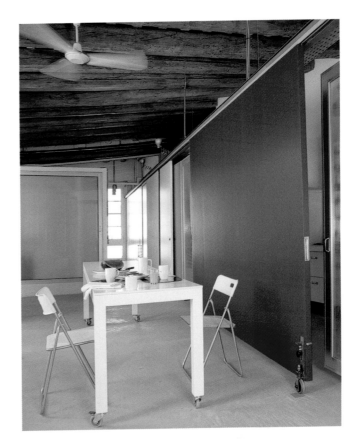

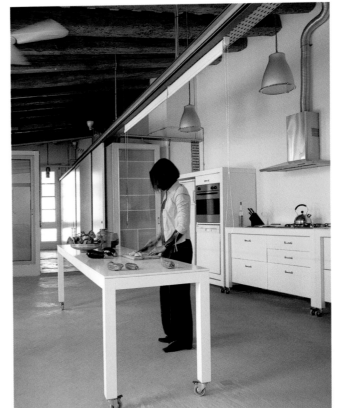

Design by Barrionuevo–Sierchuk Arquitectas
Photo © Adela Aldama

Design by B&B Estudio de Arquitectura S. Bastidas
Photo © Pere Planells

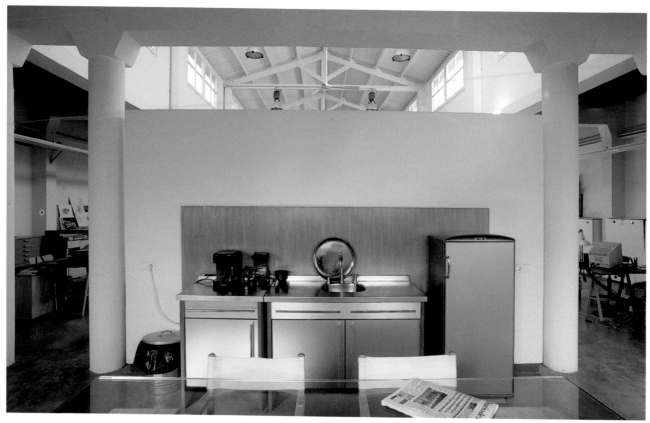

492

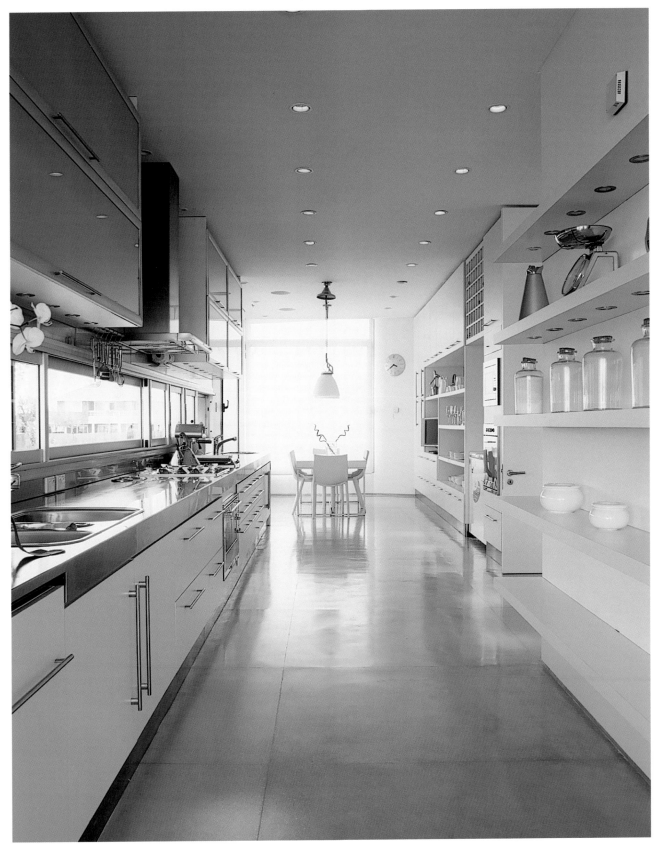

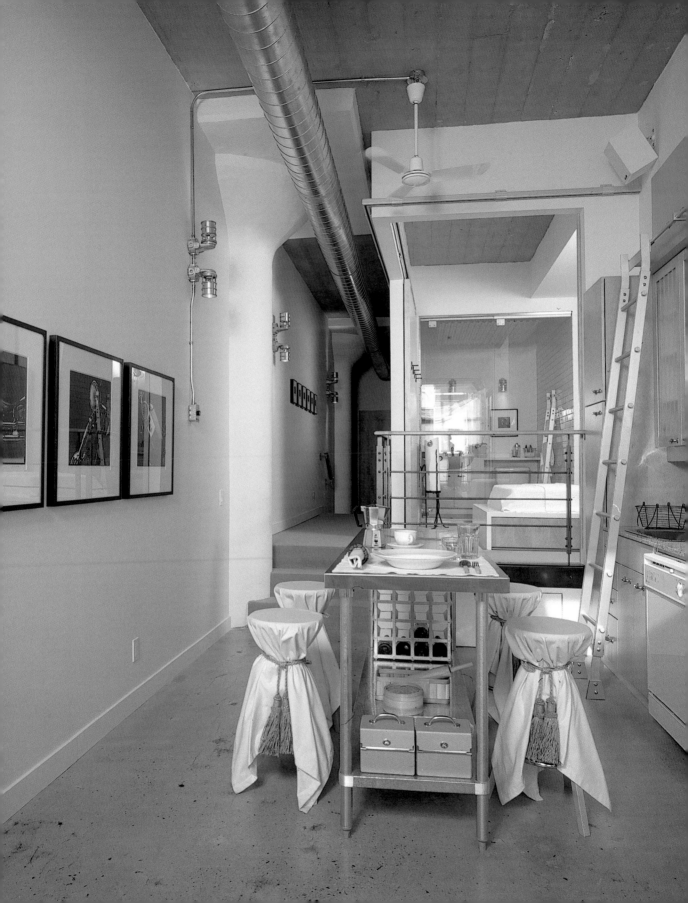

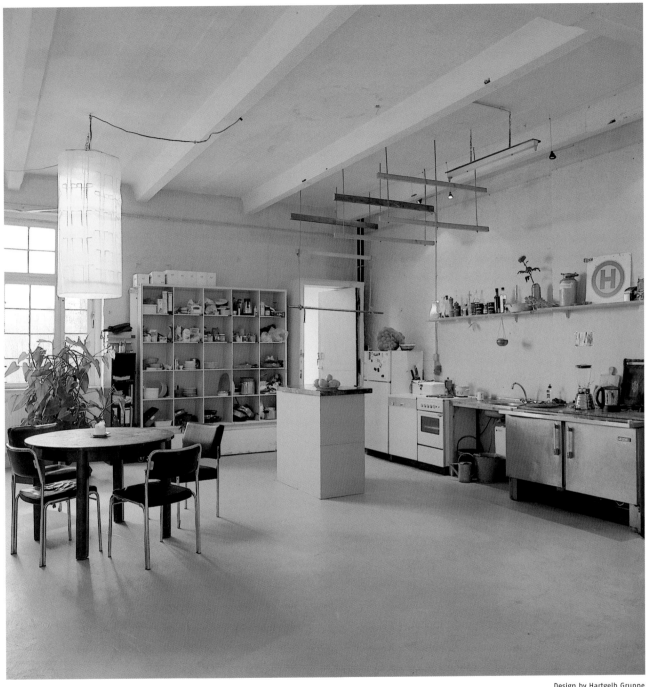

Design by Hartgelb Gruppe
Photo © Hendrik Blaukat

Design by Cecconi Simone
Photo © Joy von Tiedemann

495

Both pages
Design by Claudio Caramel
Photo © Paolo Utimpergher

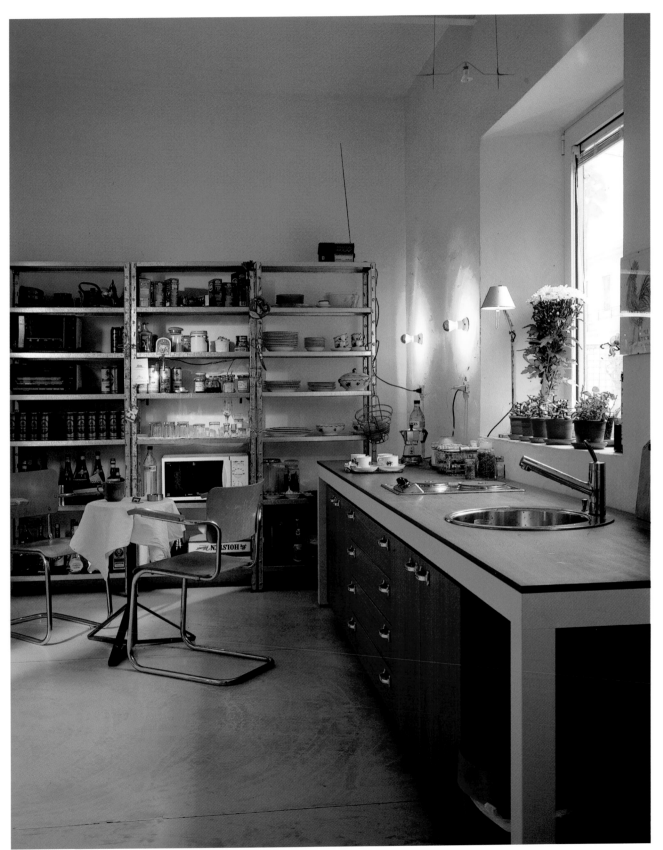

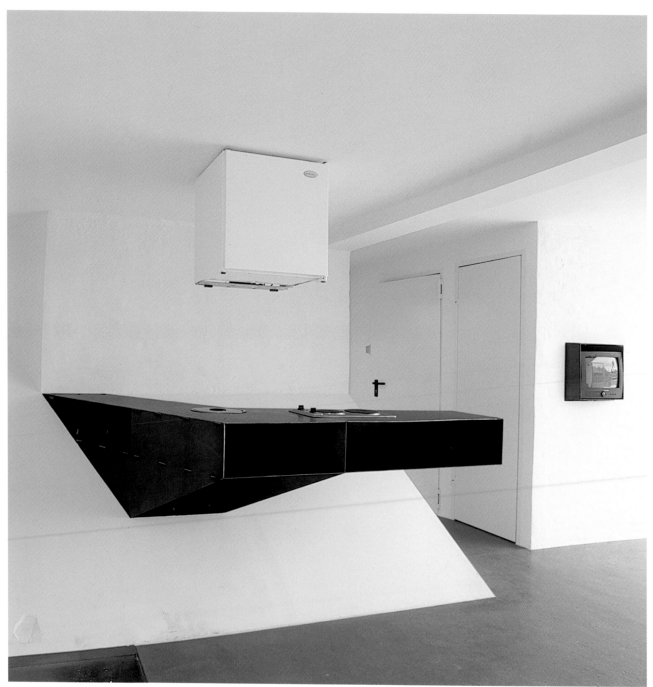

Design by Pool Architektur
Photo © Hertha Harnaus

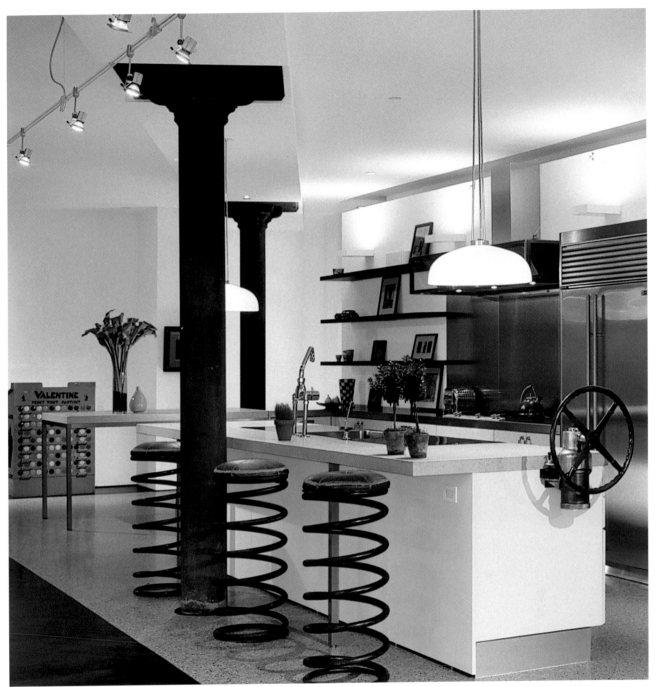

Design by Roger Ferris + Partners
Photo © Paul Warchol

Lofts

Design by Resolution: 4 Architecture
Photo © Reto Guntli/Zapaimages

Loft-type spaces in refurbished industrial buildings have played an important role in the development of this type of kitchens.

Lofts – entstanden aus der Idee, alte Industriebauten neu als Wohnraum zu nutzen – haben stark zur Entwicklung des Typs der industriellen Küche beigetragen.

Les espaces du type loft, dont l'origine provient de la récupération d'anciens espaces industriels, ont contribué en grande partie à l'essor de ce type de cuisine.

Los espacios del tipo loft, cuyo origen está en la recuperación de antiguos espacios industriales, han contribuido en gran medida al auge de estas cocinas.

Gli spazi tipo loft, le cui origini risalgono al recupero di vecchi magazzini industriali, hanno contribuito enormemente alla diffusione di questo tipo di cucine.

Design by Staughton Architects
Photo © Shannon McGrath

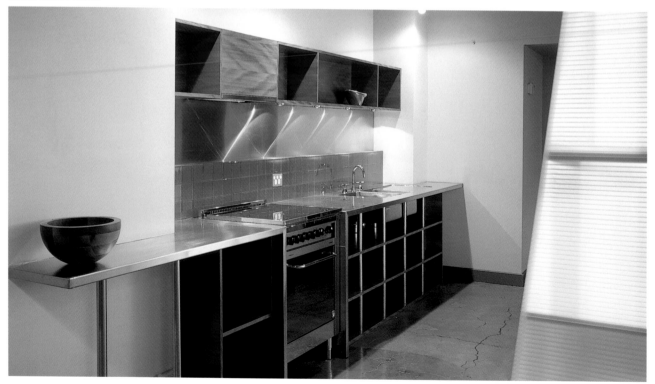

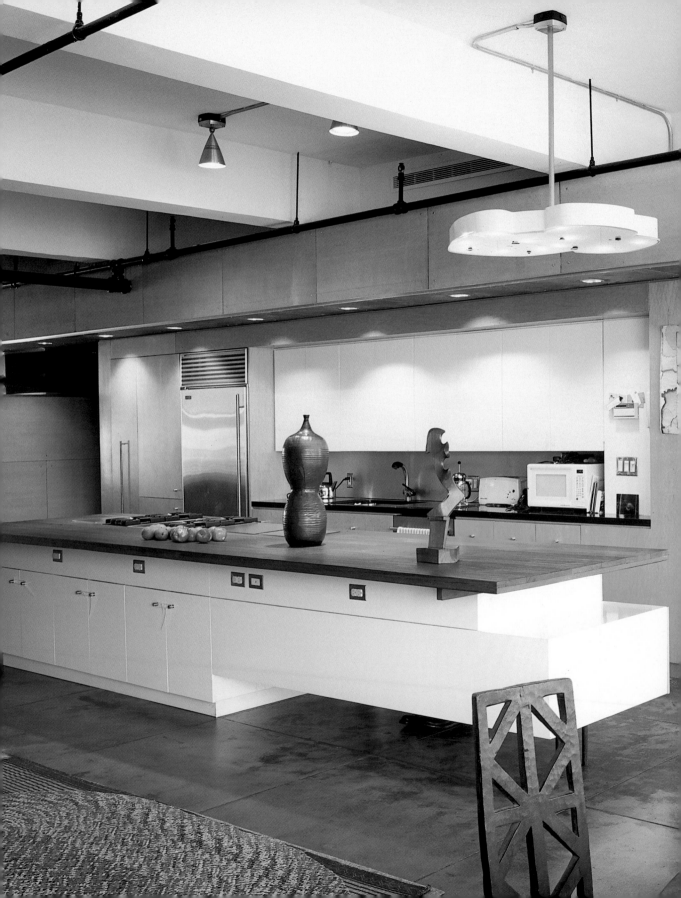

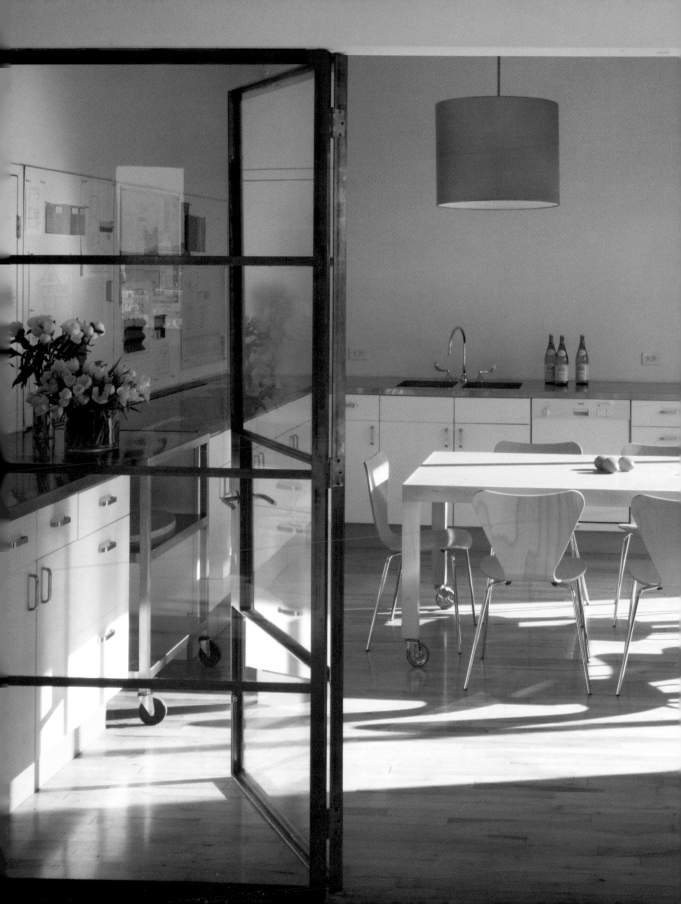

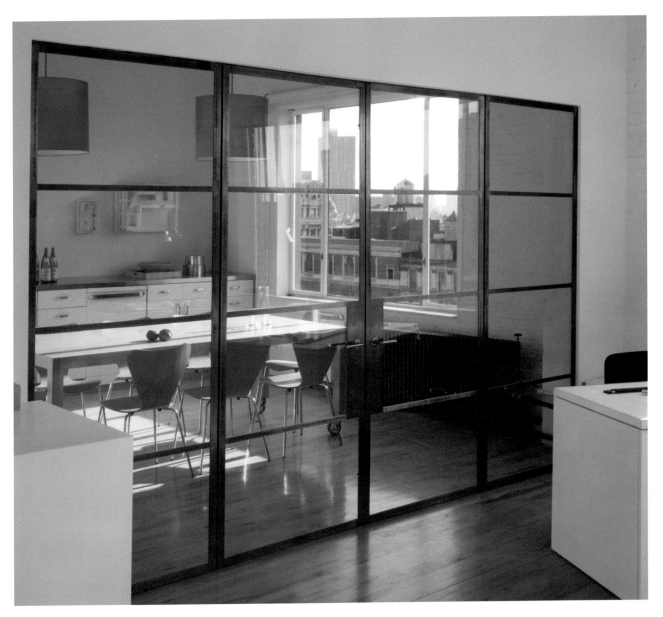

Both pages
Design by Page Goolrick Architect
Photo © John M. Hall

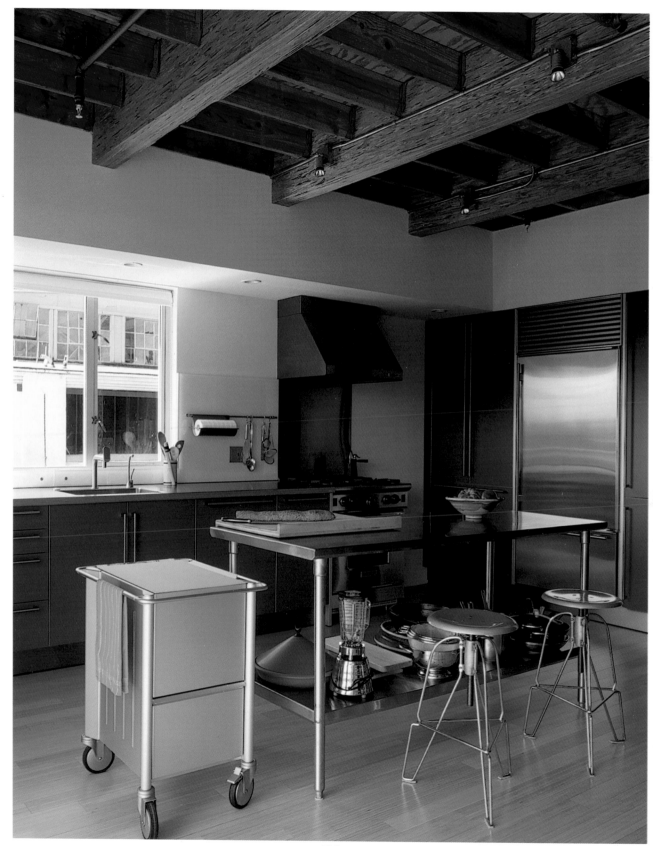

Both pages
Design by Mark Mack Architects
Photo © Undine Pröhl

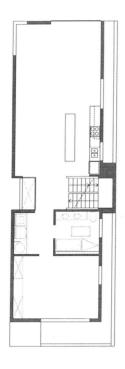

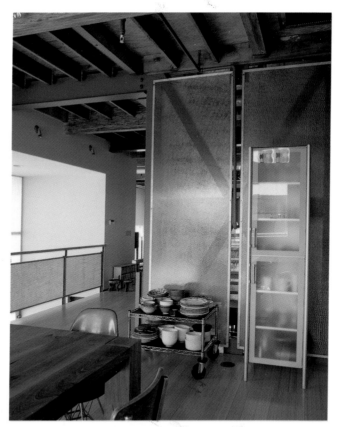

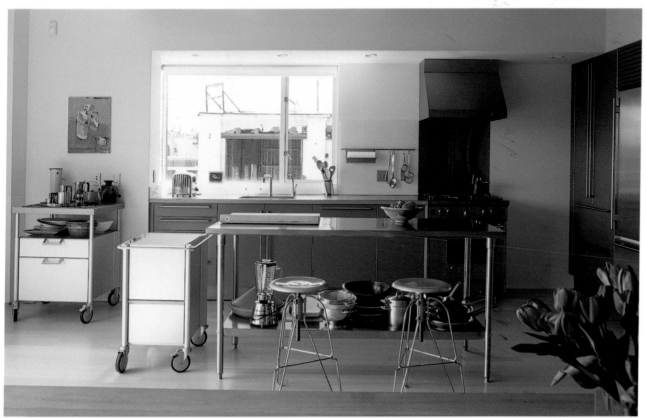

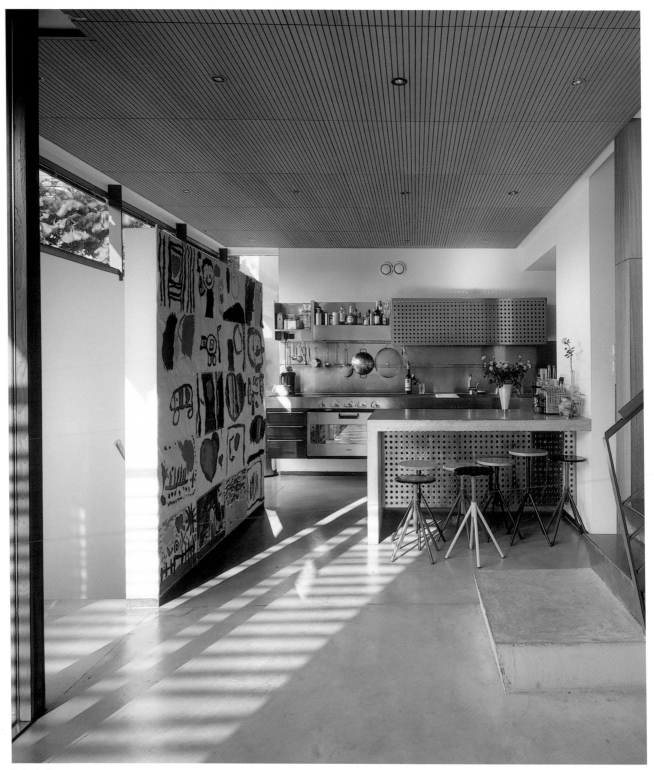

Design by Mecanoo
Photo © Christian Richters

Design by B&B Estudio de Arquitectura S. Bastidas
Photo © Pere Planells

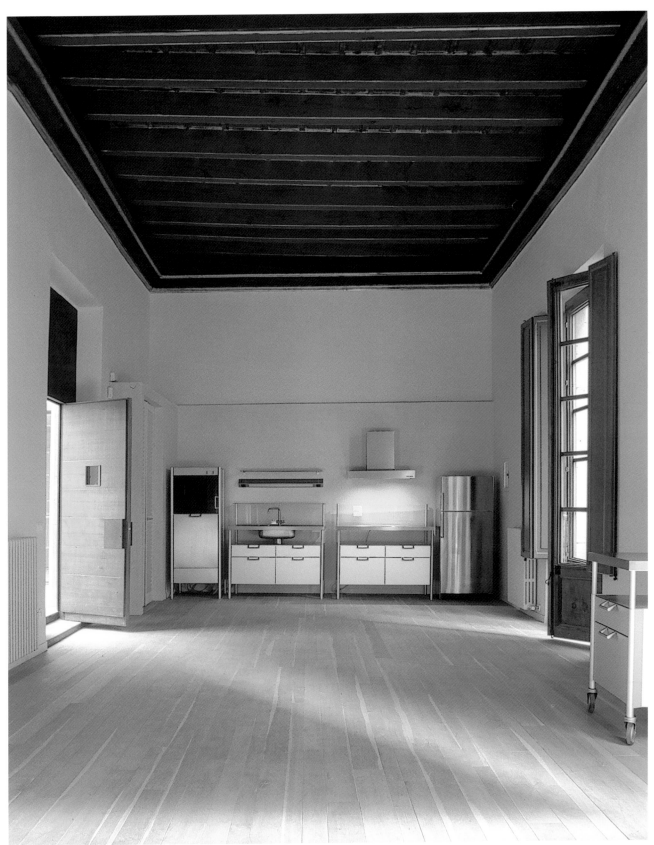

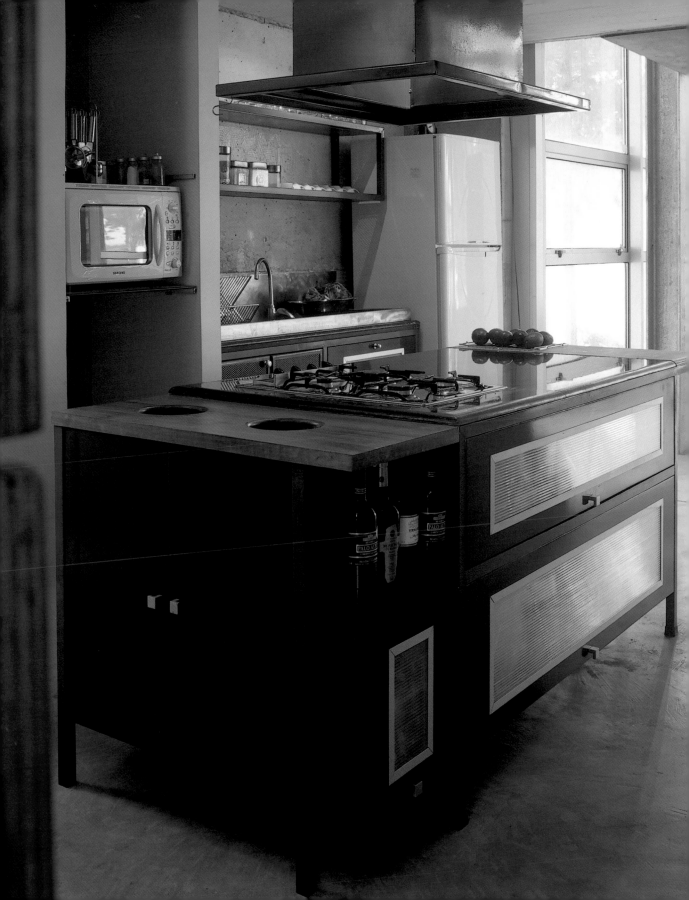

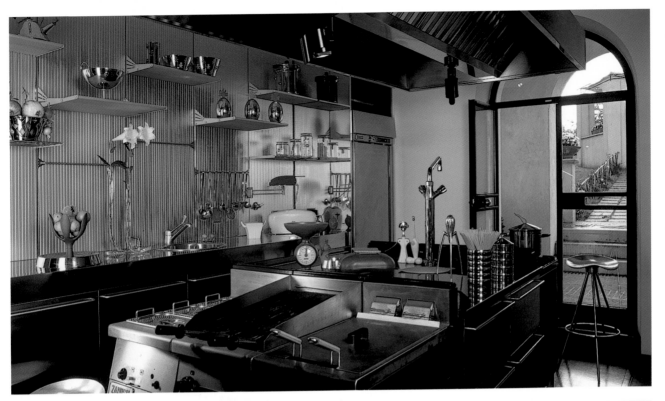

Design by Factoría Diseño y Construcción
Photo © José Luis Saavedra Morales

Both photos
Design by Patrizio Romano Paris
Photo © Reto Guntli/Zapaimages

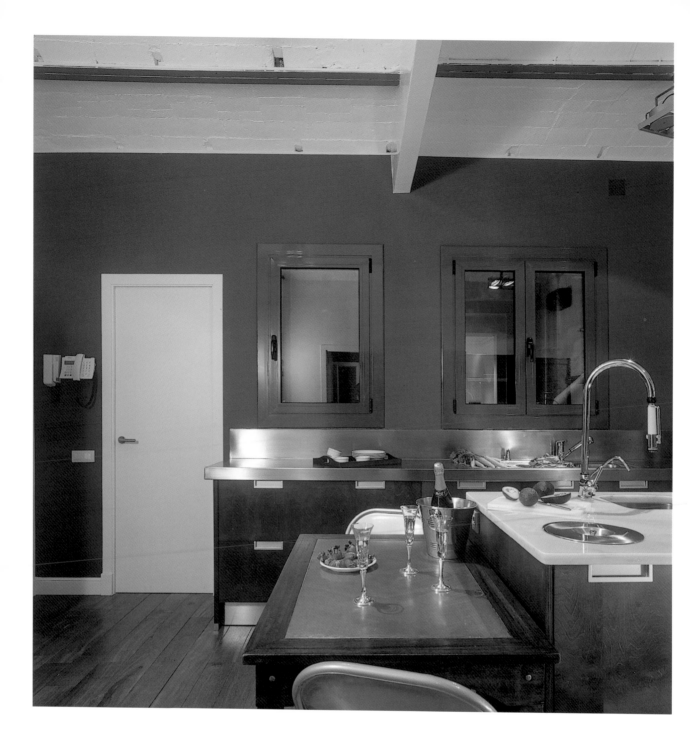

Both pages
Design by L'Eix
Photo © Jose Luis Hausmann

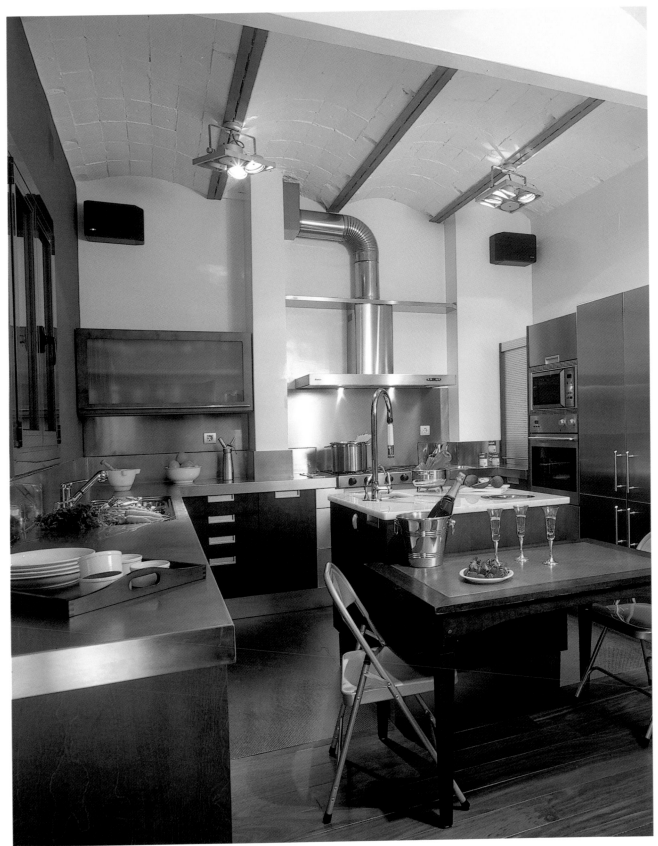

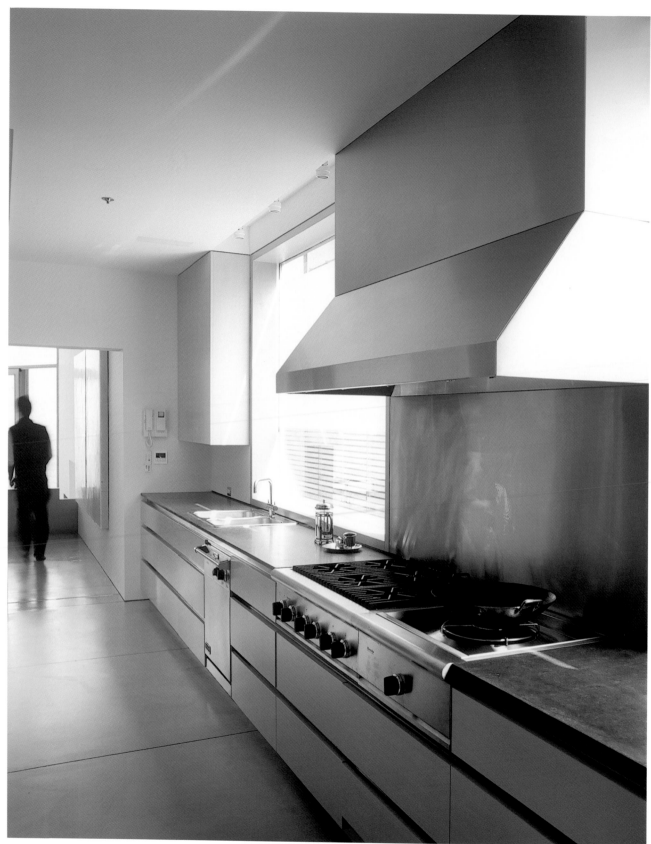

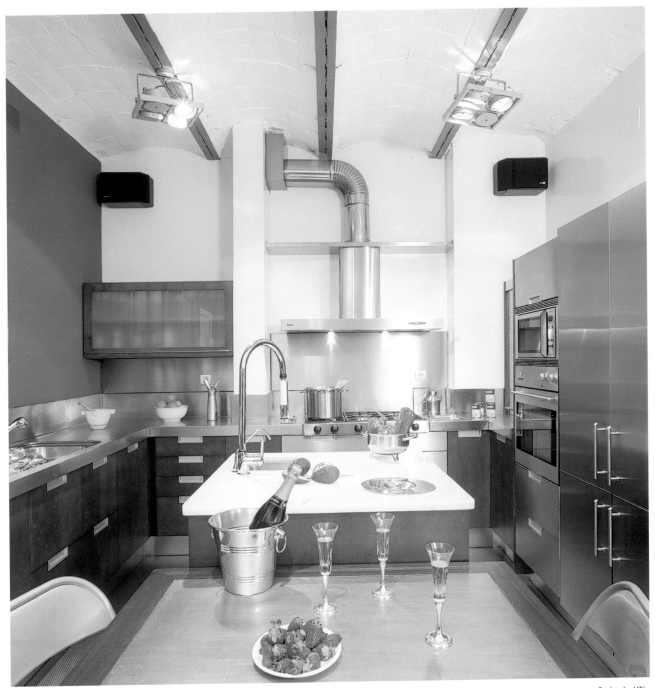

Design by L'Eix
Photo © Jose Luis Hausmann

Design by Patkau Architects
Photo © Undine Pröhl

Industrial look

Design by Inês Lobo
Photo © Sergio Mah

Industrial kitchens can be a source of inspiration when designing small or family kitchens, in particular with respect to the choice of materials and the arrangement of facilities.

Die Großküche mit ihrer rationellen Materialauswahl und der durchdachten Funktionalität kann vielfältige Anregungen bei der Gestaltung kleiner Küchen oder großer Familienküchen geben.

Les cuisines industrielles peuvent être source d'inspiration – dans le choix des matériaux et l'agencement des installations – pour la conception de cuisines de petites tailles ou familiales.

Las cocinas industriales pueden ser una fuente de inspiración –en lo que respecta a la elección de los materiales y a la disposición de las instalaciones– para diseñar cocinas pequeñas o familiares.

Le cucine industriali possono essere una fonte di ispirazione – per ciò che riguarda la scelta dei materiali e la disposizione degli impianti – per la progettazione e realizzazione di cucine piccole o familiari.

Design by Derek Wylie
Photo © Nick Cane

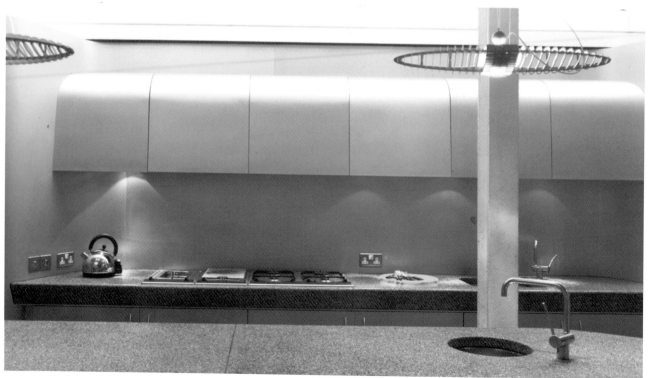

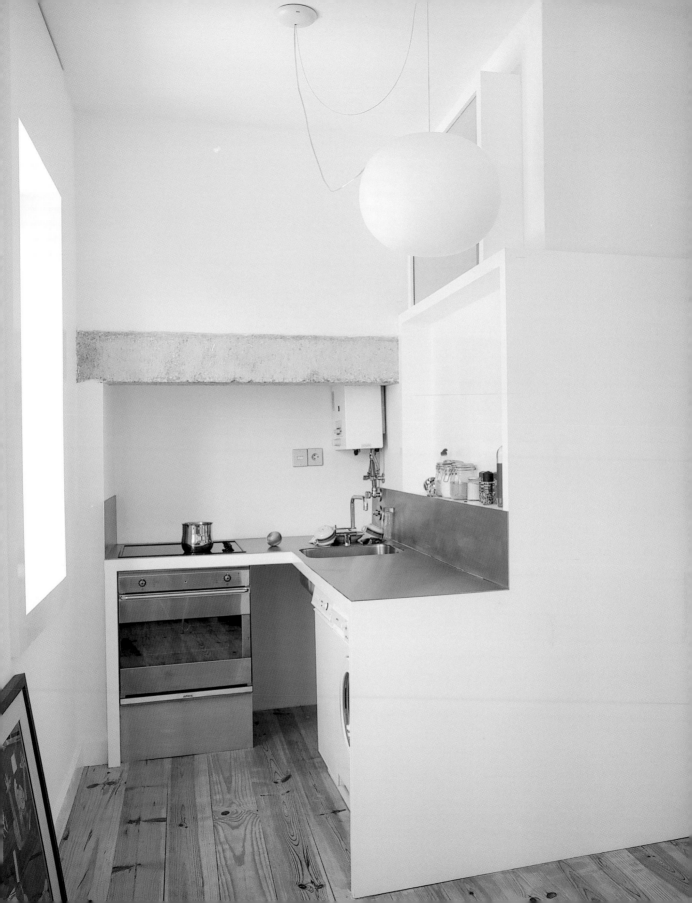

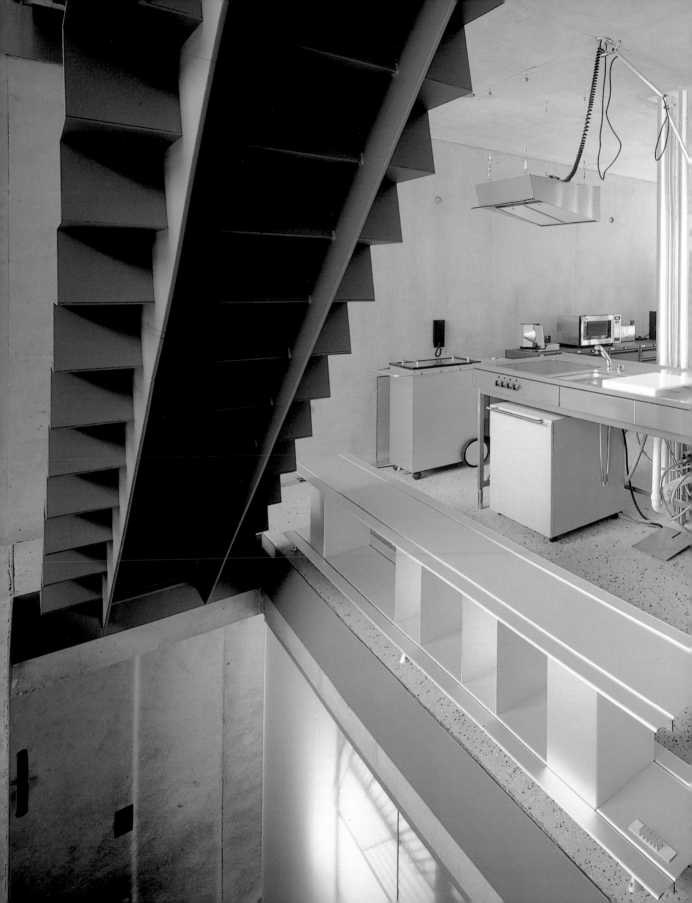

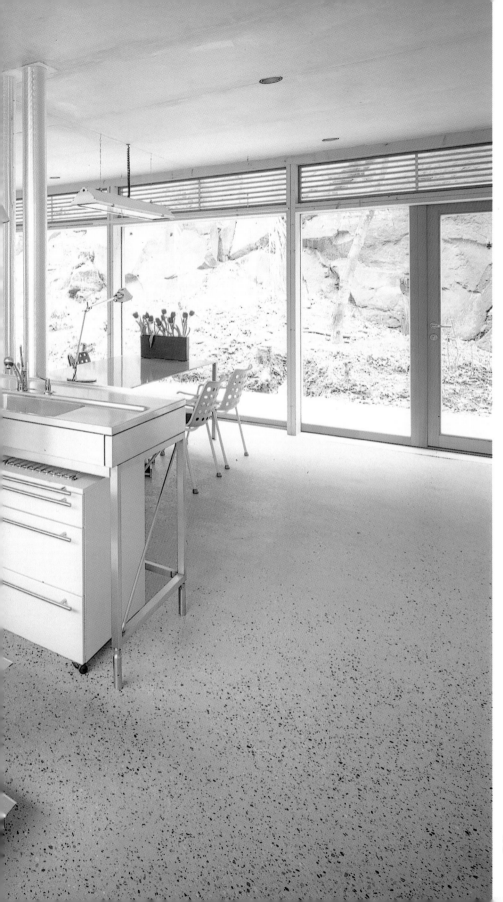

Design by AV1 Architekten
Photo © Michael Heinrich

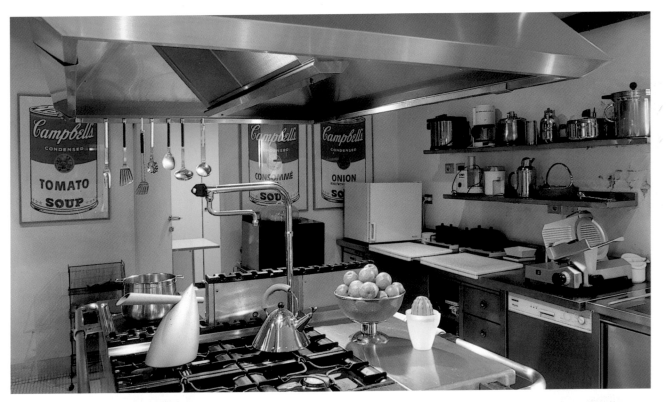

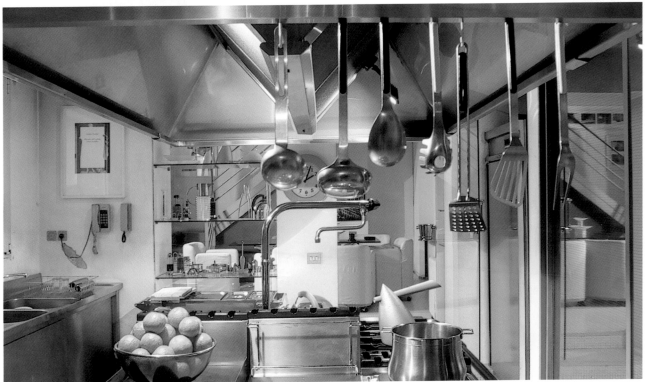

Both photos
Design by Patrizio Romano Paris
Photo © Reto Guntli/Zapaimages

Design by Lot-Ek
Photo © Paul Warchol

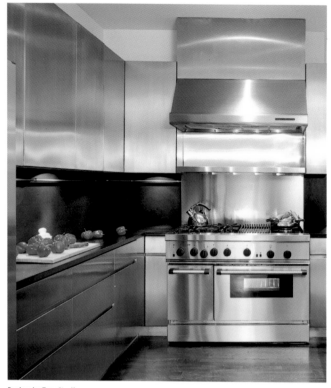

Design by Tow Studios
Photo © Björg Photography

Design by David Ling
Photo © Reto Guntli/Zapaimages

Design by Miller/Hull Partnership
Photo © Ben Benschneider

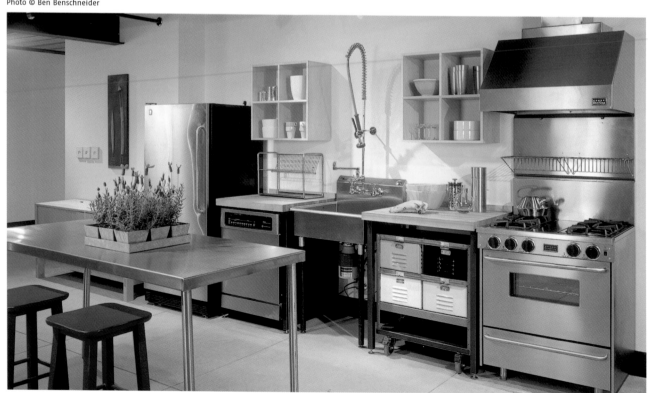

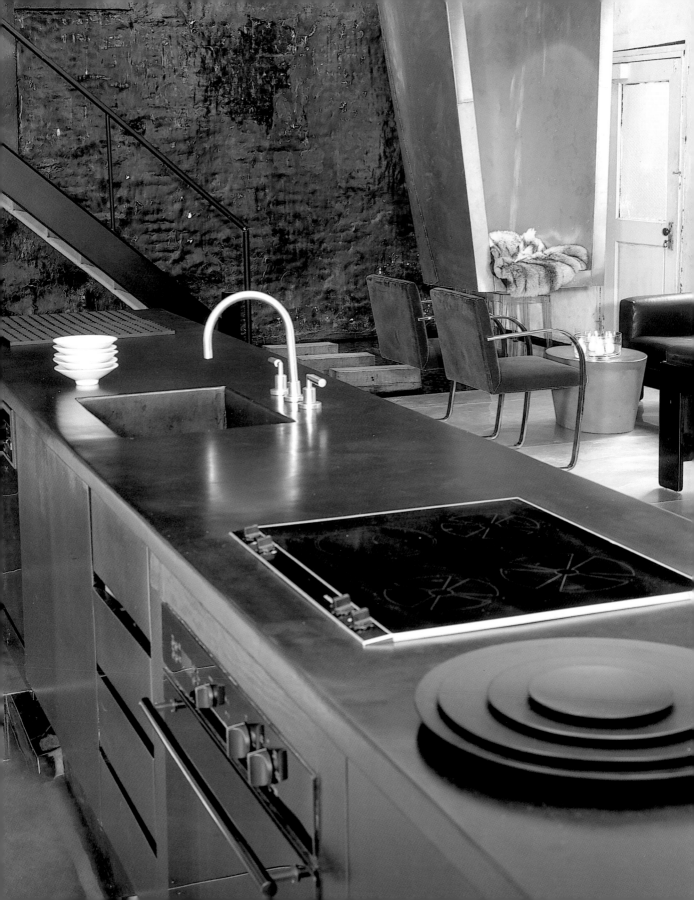

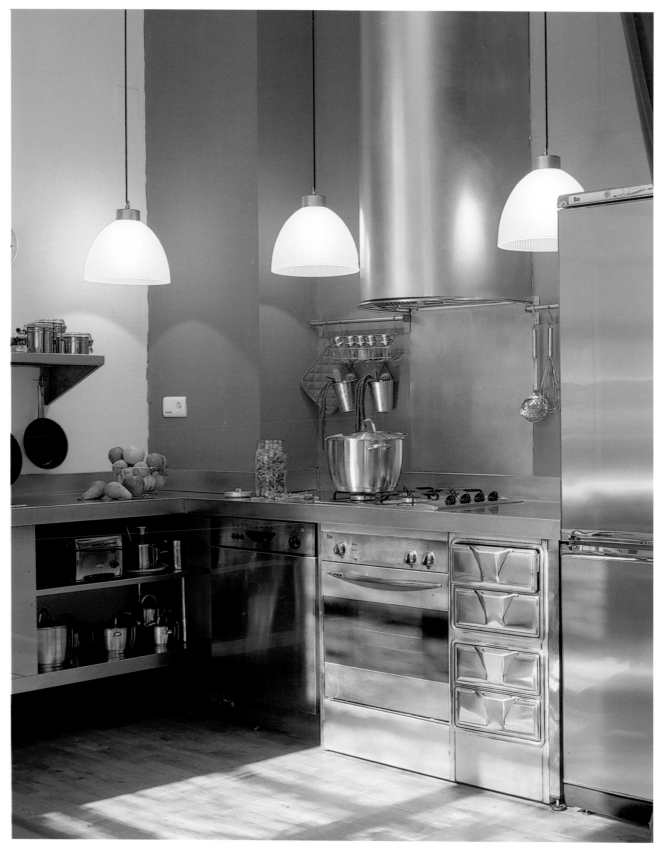

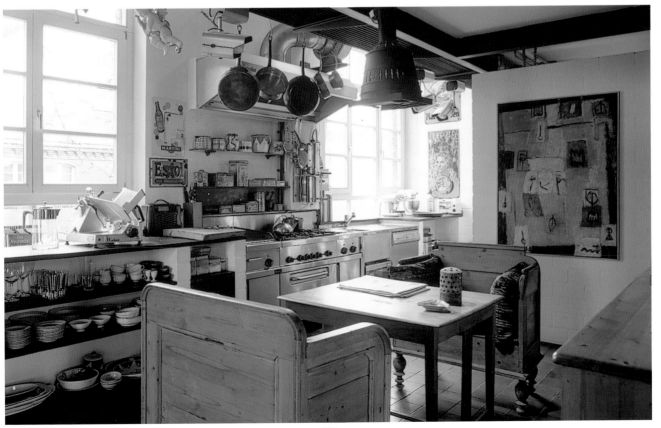

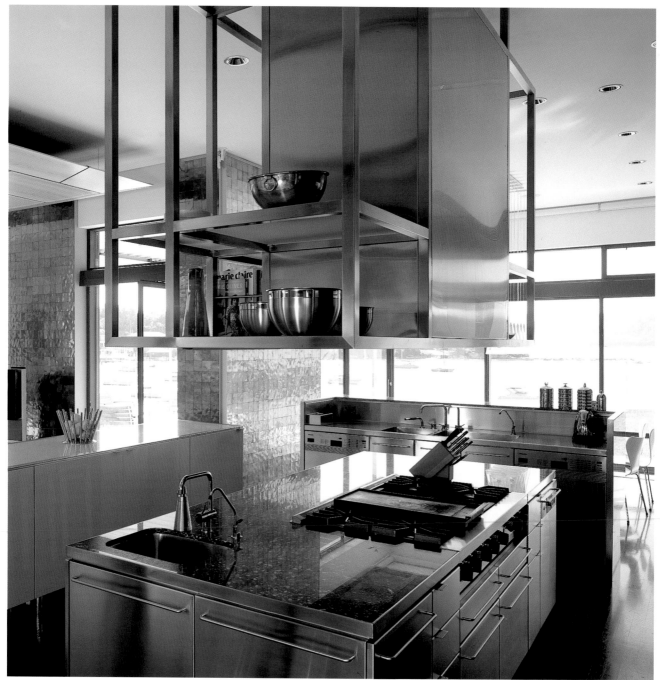

Design by Allen Jack & Cottier Architects
Photo © Richard Glover

Design by David Edgell
Photo © Andrew Wood

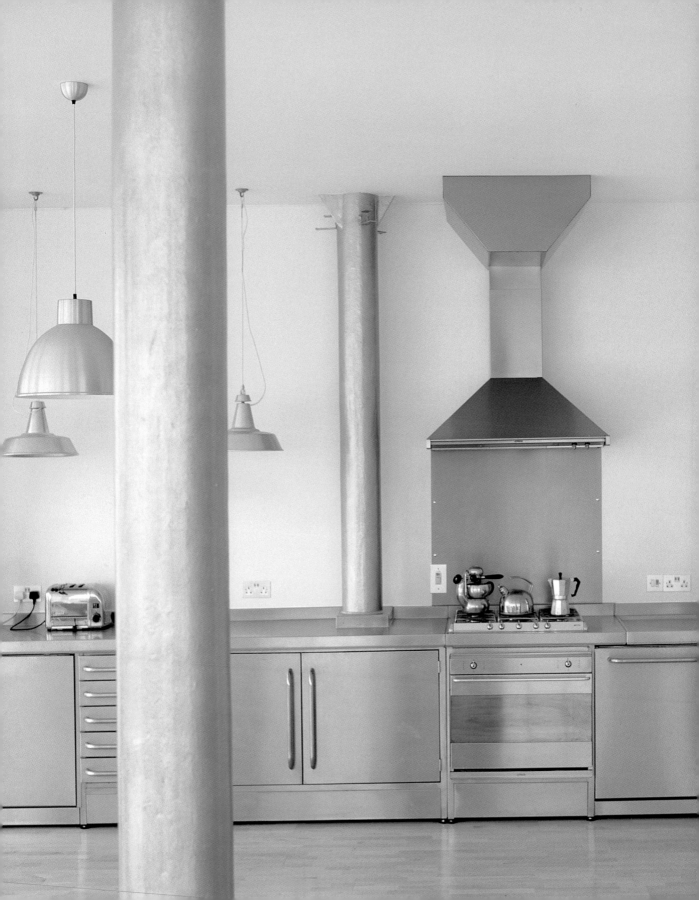

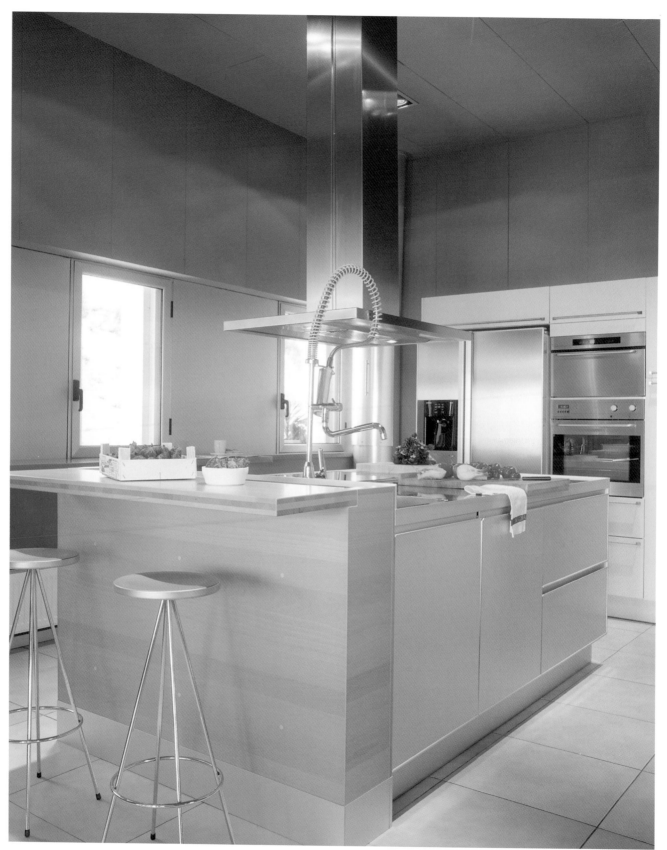

Both pages
Design by Alfons Soldevila
Photo © Jordi Miralles

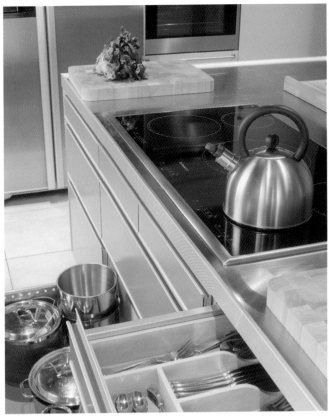

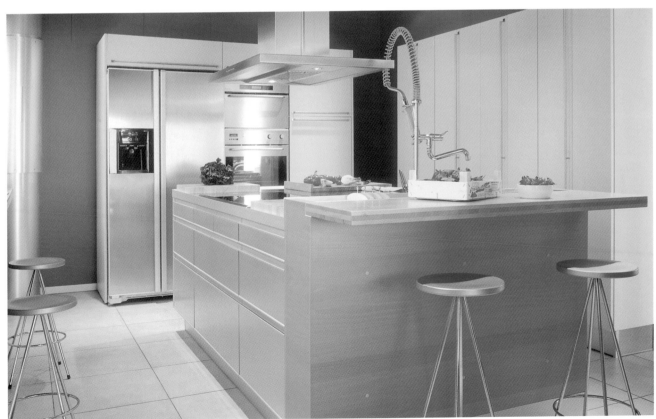